IMAGO MUSICAE

International Yearbook of Musical Iconography
Internationales Jahrbuch für Musikikonographie
Annuaire International d'Iconographie Musicale

Official Organ of the International Repertory of Musical Iconography
Offizielles Organ des Internationalen Repertoriums der Musikikonographie
Organe Officiel du Répertoire International d'Iconographie Musicale
Advisory Board / Beirat / Conseil consultatif: Jan Białostocki, Barry S. Brook,
Wolfgang Freitag, Harald Heckmann, John Pope-Hennessy, Peter Anselm Riedl,
Erich Stockmann, Jacques Thuillier, Gen'ichi Tsuge

IMAGO MUSICAE
I

1984

edenda curavit
TILMAN SEEBASS
adiuvante
Tilden Russell

Bärenreiter-Verlag Basel
Kassel · London
Duke University Press
Durham, North Carolina

Redaktionsschluß des ersten Bandes: Dezember 1982

The illustration on the half-title page is taken from the woodcut "Fraw Musica" by Lukas Cranach the Younger for the publisher Georg Rhau in Wittenberg, ca. 1544–1556. The vignette also comes from Rhau's shop.

Titelvignette nach dem Holzschnitt „Fraw Musica" von Lukas Cranach d. J. für Verlagswerke des Georg Rhau in Wittenberg, ca. 1544–1556. Auch die Schlußvignette entstammt Rhaus Offizin.

La vignette du titre d'après la gravure sur bois «Fraw Musica» de Lukas Cranach le Jeune pour les publications de Georg Rhau à Wittenberg, environ 1544–1556. La vignette à la fin provient de même de l'imprimerie de Rhau.

ISSN 0255-8831
ISBN 3-7618-0719-8 (Bärenreiter)
ISBN 0-8223-0461-9 (Duke University Press)
© Bärenreiter, Basel 1984
© Duke University Press, Durham 1984
All rights reserved. Printed in Germany
Gesamtherstellung Bärenreiter Kassel

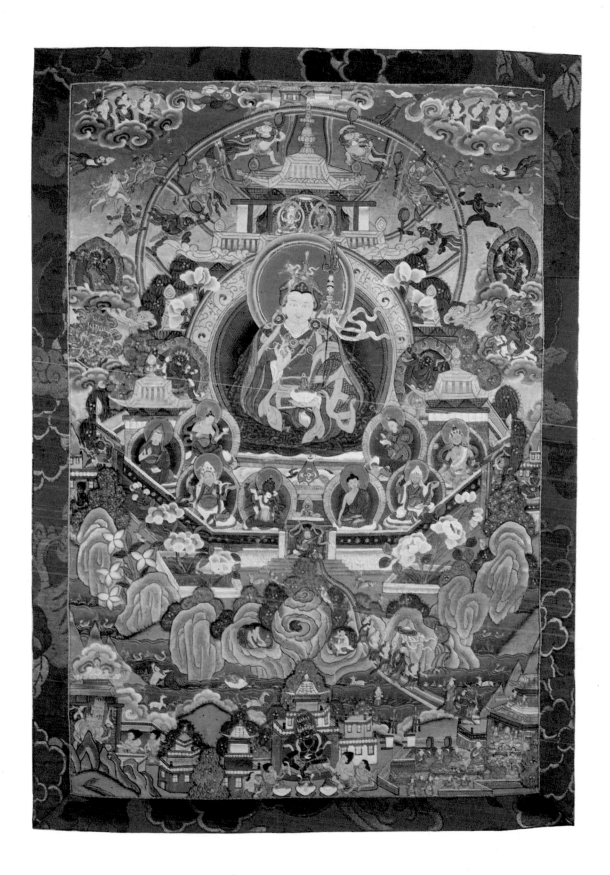

Contents
Inhalt
Table des matières

Barry S. Brook: In Memoriam Emanuel Winternitz IX

Emanuel Winternitz – Books, Articles, and Reviews since 1940 (compiled by Robert Estrine) .. XIII

Reinhold Hammerstein: Musik und bildende Kunst. Zur Theorie und Geschichte ihrer Beziehungen .. 1

James W. McKinnon: The Fifteen Temple Steps and the Gradual Psalms 29

H. Colin Slim: Paintings of Lady Concerts and the Transmission of »Jouissance vous donneray« .. 51

Jane R. Stevens: Hands, Music, and Meaning in Some Seventeenth-Century Dutch Paintings .. 75

Daniel Heartz: Portrait of a Court Musician: Gaetano Pugnani of Turin 103

Hellmuth Christian Wolff: Max Klingers Verhältnis zur Musik 121

Bo Lawergren: The Cylinder Kithara in Etruria, Greece, and Anatolia 147

Arnold Perris: Padmasaṃbhava's Paradise. Iconographical and Organological Remarks on a Tibetan Ritual Painting .. 175

Howard Mayer Brown: Catalogus. A Corpus of Trecento Pictures with Musical Subject Matter, Part I .. 189

Bibliographia 1975–1981 .. 245

Directions to Contributors .. 267

Hinweise für den Autor .. 268

Renseignements pour les auteurs .. 269

In Memoriam Emanuel Winternitz

Three days before the death of Emanuel Winternitz on 20 August 1983, and after the article that follows was set into type I visited him at his home. We spent two lovely hours in conversation as we had done so many times before. He was full of plans and projects. He was delighted to learn that the inaugural issue of Imago Musicae, the yearbook of RIdIM, which was dedicated to him, was at the printer. I showed him a typescript of this article; the title pleased him greatly. He immediately started to rattle off my name and those of several colleagues – pronounced backwards! It was clear that the illness that had wasted his body had not dimmed his mind nor dulled his wit. I could not but be conscious of the fact that this man who was eighty-five on the fourth of August was one of the great humanists of our century.

What Emanuel Winternitz accomplished as a scholar, educator, and curator will continue to have a profound effect on the world of learning for generations. And those who have had the enormous good fortune of knowing this warm friend, this delightful raconteur, this great human being will never forget him.

B. S. B.

Leuname Ztinretniw at 85

This inaugural issue of Imago Musicae is dedicated to one of the great humanists of our century, a man who was eighty-five on 4 August 1983. Few have had so powerful an impact on so many areas of cultural scholarship. Fewer have succeeded so brilliantly in fusing diverse branches of learning into a cohesive whole.

In 1982 our esteem for him as an iconographer – in which he is the father of us all – was also demonstrated when he was unanimously acclaimed Honorary President of the Répertoire International d'Iconographie Musicale at its Ninth International Conference in Mainz. In so doing, however, we are recognizing only one aspect of his multi-faceted intellectual achievements,[1] Reading his published books and articles results initially in admiration for their originality and significance, then, amazement at their range and diversity, and finally, awe for the quality of mind behind the words. This is a mind that can piece »together the splintered branches of knowledge of our times into a unified experience,« that can »follow the threads that weave back and forth between music and the fine arts,« between philosophy and education, between history and sociology, »producing one important patch of the fabric of civilization.«[2]

His abiding interest in education was first manifest in two articles published over four decades ago: ›On the Sense of Time in Teaching History‹ and ›Overspecialization and Art History.‹ They are as fresh and thought-provoking today as the day they appeared – which can also be said of every other study Ztinretniw has ever published. The first of these, written in 1940 for The Harvard Educational Review, had this prefatory note by its editors: »That a Doctor of Laws should illustrate a thesis in the field of teaching with examples from music, architecture, and the history of the arts indicates the challenging quality of the thought as well as of its expression. The

[1] He has previously received many prestigious honors, e.g. from the British Academy, the Raccolta Vinciana, the Österreichische Gesellschaft für Musikwissenschaft, and the Republic of Austria, as well as grants from the Guggenheim and Bollinger Foundations, the American Philosophical Society, and the American Council of Learned Societies.
[2] The phrases quoted in this paragraph are from the superb, elegantly written article by James Delihas, Notes on a Well-Tempered Curator, in: The Metropolitan Museum of Art Bulletin (Summer 1967), p. 28.

editors take pleasure in presenting this original and stimulating conception of an aspect of teaching until now too generally overlooked.«

His works in the field of art history, such as ›The Curse of Pallas Athena; Notes on a »Contest between Apollo and Marsyas« in the Kress Collection,‹ and ›Rembrandt's »Christ Presented to the People« – 1665; A Meditation on Justice and Collective Guilt‹ have earned him the highest respect of his colleagues in that field.

He is the author of the iconographer's bible, ›Musical Instruments and Their Symbolism in Western Art‹ – a book upon which most of the contributors to this volume have cut their teeth – plus numerous other pathfinding studies in this discipline. He is also the author of ›Musical Autographs from Monteverdi to Hindemith‹, a definitive study in that field, one that goes far beyond the usual compilations of handwriting examples to delve into composers' personalities and compositional processes through graphic analysis.

As an organologist, his four books and several dozen articles – written in four languages – taken together represent a creative encyclopedia of scholarly method and substance. Furthermore, one of them, ›Musical Instruments of the Western World‹, is probably the most beautiful book of its kind ever produced.

As a proper musicologist, he has written articles about Paul Hindemith, Niccolò Piccinni and Christoph Willibald Gluck, as well as eighteen-years worth of program notes for the Metropolitan Museum of Art's concerts. Virgil Thomson described them as »the most distinguished, the most penetrating, informative, and accomplished notes being written in America . . .« Leuname Ztinretniw is also the author of ›Gnagflow Trazom: An Essay on Mozart's Script, Pastimes and Nonsense Letters‹, an intriguing exploration of a little-understood aspect of Wolfgang's mind and personality as seen through his games, his puns, and the gibberish in his letters.

But his crowning achievement – thus far – is his just-published »Lennie book«, ›Leonardo da Vinci as a Musician‹ which required two decades in the writing, and a lifetime before that in the honing of an intellect capable of doing justice to his subject. In the book's first reviews, one reads: »[This is] the first systematic and thorough attempt to study all the relevant notes and sketches against the background not just of contemporary musical instruments but also of Leonardo's other work with mechanisms and natural phenomena.« ». . . .a lovingly and most conscientiously compiled book . . .a most enjoyable book and an absorbing exploration of one of the most teeming minds of all time.« » . . . to have the musical element of Leonardo's thinking presented as clearly and documented as carefully as it is here is to better understand his age – as well as one of the strangest and most profound minds of Western civilization.« In the author's own conclusion to this book, he writes: »A book attempting to add one facet to the œuvre of a multifaceted genius should perhaps conclude with a sort of meditation on how a mind like Leonardo's, so diversified, so flexible, so torn and driven by unbounded curiosity into manifold directions of thinking and doing, was demonically obsessed by the strong conviction that creation is a cosmos, an organic structure, and that all the innumerable phenomena observed are guided by basic, simple, interdependent laws; that creation is a universe in the deeper meaning of the word, and that all seeming contradictions could be reconciled, if only he, Leonardo, had had the time to search longer and deeper. His incessant struggle to see order in disorder, cosmos in chaos, was his credo.«

It must be fate, not happenstance, that »Leuname« sounds like a dialect nickname for »Leonardo«, who wrote backwards.

Emanuel Winternitz, the man we are honoring here, was born and brought up in pre-World War I Vienna, then a city in artistic and intellectual ferment. After three years of service in an Alpine regiment of the Austrian Army he read law at the University of Vienna and music on the side. While still a student he wrote articles on the philosophy of law, receiving his doctorate at twenty-four. Invited as Gastdozent to the University of Hamburg, he joined Ernst Cassirer's seminar in Aesthetics. On returning to Vienna he helped found, in the Volkshochschule, one of the first centers of adult education in Europe as well as the famed »Geistkreis« where a small circle of university scholars from many disciplines met to discuss new approaches to education. Among his later-to-be-well-known »Geistkreis« colleagues were Friedrich von Hayek, Otto Benesh, Oscar Morgenstern and Fritz Machlup. He lectured on law, philosophy, and the history of the arts – while practicing both corporation law and the piano.

»In 1937, three years after the Dollfuss assassination and a year before the Nazi takeover, Winternitz took part in a notorious murder trial that was dividing Vienna. A young student and Nazi fanatic had shot to death Moritz von Schlick, the well-known professor of philosophy at the University of Vienna. When the defense lawyer turned the trial into a political whitewash of the student and viciously attacked Schlick's name, Winternitz rose and delivered a lengthy exhortation, warning that ›the distance between Vienna and Braunau is a mere two hours by express train.‹ The speech caused a stir, and Winternitz began receiving threatening calls and letters.«[3]

He fled Austria in 1939 with one extra shirt and hundreds of negatives of Palladian palaces and churches, arriving ultimately in Boston, with no job and little English (his seventh or eighth language, not counting dialects). Since Renaissance theories of architecture and their relationship to music was one of Winternitz's special interests, it was the subject of his first American lecture, given at the Fogg Museum at Harvard. (The lecture had to be translated into English by a friend and memorized). This led to invitations from museums and universities throughout the United States as Peripatetic Professor for the Carnegie Foundation.

When, in 1941, Francis Henry Taylor, then director of the Metropolitan Museum of Art, heard him speak at the Worcester Art Museum, he recognized him as »one of the most extraordinary teachers and lecturers« he had ever known and brought him to the Metropolitan, first as a lecturer, then as Keeper (1942) and Curator (1949) of the Crosby Brown Collection of Musical Instruments. During his thirty-five years at the Museum (he is now Curator Emeritus), he organized many fascinating (temporary) exhibitions stressing not only the history and technical intricacies of musical instruments, but also their manifold cultural implications – religious, symbolic, social – and their significance as works of art in their own right. For years, the Museum's musical instruments had been languishing in storage areas, playing second bassoon to all other collections in the museum. Winternitz fought hard and stubbornly for their proper conservation, restoration, and display. He finally triumphed when the Museum asked him to design and supervise the construction of the splendid permanent galleries in which the instruments are currently exhibited (and can be heard on tape). He has enlarged the collection not only with newly acquired instruments but with an extensive documentation in musical iconography.

In the 1940's and '50's, he also served as impresario, planning and organizing eighteen annual series of concerts at the Museum entitled ›Music Forgotten and Remembered‹, unearthing forgotten masterpieces and having them played »authentically« on the Museum's own

[3] ibid., p. 25.

instruments or replicas. He was joined in these concerts by his friend Paul Hindemith who came down from Yale to perform on his viola with the student musicians. With these concerts, Winternitz paved the way for the many groups performing »old music« which today are a vital part of our musical life.

During all these years, Winternitz continued to teach – at Yale, Rutgers, Columbia, and for the last decade and a half at the City University of New York, where he has been our revered, permanent »visiting« professor conducting seminars in Organology, Iconology, and the music of his beloved Franz Schubert, as well as supervising dissertations and serving as Co-Director of the Research Center for Musical Iconography. He is a truly great educator; his teaching has helped generations of students broaden their horizons and relate their thinking to the mainstream of cultural history. As a colleague he is simply a delight; having lunch with him regularly over the years has left this writer with a host of unforgettable memories.

On the lecture platform Emanuel Winternitz is spell-binding – a convincing scholar, an extravagant punster, a consummate story teller (often at his own expense) – he expounds his imaginative ideas with masterful timing, sharp wit and subtle satire, plus a generous dollop of Viennese charm. On occasion he will also illustrate a point at the piano (or any other available keyboard instrument). He is a fine, largely self-taught musician with a keen ear, a substantial repertory in his head and fingers, and a great gift for improvisation.

At his usual careful pace, Winternitz is currently hatching a dozen articles and books, almost all devoted to problems in musical iconography. Some of them have, in part at least, been test-flown on the lecture platform and in his seminars. We have had intriguing glimpses of his work on ›Musical Mythology, Contests and Revelries in Greek Vases‹; on ›Use of Written Music by Singers and Players from the Middle Ages to the Baroque‹; and on ›Open Strings and Stopped String Cultures in Classical Antiquity‹.

One eagerly awaits his next book, ›Music for the Eye and Ear‹ and, perhaps with even greater anticipation, still another volume which has been something of a secret until now, his memoirs! One may expect, in reading the latter, to add »utter astonishment« to our earlier reactions to his writings: »admiration,« »amazement« and »awe«.

In an article for the Times Literary Supplement (24 June 1974) written in connection with the creation of the Répertoire International d'Iconographie Musicale, Emanuel Winternitz made two concluding pleas:

»The broadening of the accumulation process on an international basis is well under way. What is needed is an intense education of the fact-finders in art history and the establishment of constant co-operation between the historians of the figurative arts and of music through teamwork, congresses, and common publications. My other plea is for concentration on the fundamental unresolved problems of musical history, especially the filling of gaps in present historical information, problems that can be solved only with the help of visual records.«

It is hoped that the inaugural issue of Imago Musicae, Yearbook of the Répertoire International d'Iconographie Musicale, will represent one small step in response to the pleas of the pioneering scholar to whom it is dedicated.

July 1983

Barry S. Brook
City University of New York
President, Commission International Mixte,
Répertoire International d'Iconographie Musicale

Emanuel Winternitz – Books, Articles, and Reviews since 1940
compiled by Robert Estrine

Books

1. Musical Autographs from Monteverdi to Hindemith, 2 vols. (Princeton/New Jersey 1955, Princeton University Press; reprint New York 1965, Dover Publications Inc.).
2. Keyboard Instruments in the Metropolitan Museum of Art (New York 1961, Metropolitan Museum).
3. Die schönsten Musikinstrumente des Abendlandes (München 1966, Keysersche Verlags-buchhandlung).
4. Musical Instruments of the Western World (London 1967, Thames & Hudson, and New York 1967, McGraw-Hill).
 [Translation of no. 3.]
5. Gaudenzio Ferrari, His School, and the Early History of the Violin (Varallo 1967, Società per la Conservazione delle Opere d'Arte in Valesia).
6. Instruments de musique du monde occidental, trans. by Yves Hucher and Jacqueline Morini (Paris 1972, Arthaud).
 [Translation of no. 3.]
7. Gakki no rekishi, trans. by Tatsuo Minagawa and Tadashi Isoyama (Tokyo 1977, Parco).
 [Translation of no. 3.]
8. Musical Instruments and Their Symbolism in Western Art (New York, W. W. Norton and Co., London, Faber and Faber Ltd., 1967; 2nd revised edition New Haven and London 1979, Yale University Press).
 [contains nos. 13, 14, 19, 21, 22, 25, 26, 28–32, and 39]
9. Leonardo da Vinci as a Musician (New Haven and London 1982, Yale University Press).
 [contains nos. 36–38 and 53]

Articles

10. ›On the Sense of Time in Teaching History‹, in: The Harvard Educational Review (March 1940), pp. 174–186.
11. Letter on the relationship between Music and Art, to the Editor of the College Art Journal (March 1942), pp. 104–106.
12. ›Overspecialization and Art Education‹, in: Association of American Colleges Bulletin 28/2 (1942), pp. 1–7.
13. ›Quattrocento Science in the Gubbio Study‹, in: Metropolitan Museum of Art Bulletin 1/2 (October 1942), pp. 104–116.
14. ›Bagpipes and Hurdy-Gurdies in their Social Setting‹, in: Metropolitan Museum of Art Bulletin 2/1 (Summer 1943), pp. 56–83.
15. ›A Lira da Braccio in Giovanni Bellini's »The Feast of the Gods«‹, in: Art Bulletin 28/2 (1946), pp. 114–115.
16. ›Music for the Eye‹, in: Art News 45 (June 1946), pp. 24–27.
17. ›Additions to the Collection of Musical Instruments‹, in: Metropolitan Museum of Art Bulletin (June 1946), pp. 254–259.
18. ›Notes on Archlutes‹, in: Guitar Review no. 9 (1949), pp. 1–7.

19. ›Archeologia Musicale del Rinascimento nel Parnaso di Raffaello‹, in: Rendiconti della Pontificia Accademia Romana di Archeologia, vol. 27 (1952–1954), pp. 359–388.

20. ›The Evolution of the Baroque Orchestra‹, in: Metropolitan Museum of Art Bulletin 12/9 (May 1954), pp. 258–275.

21. ›The Golden Harpsichord and Todini's Galleria Armonica‹, in: Metropolitan Museum of Art Bulletin 14/5 (February 1956), pp. 149–156.

22. ›Instruments de musique étranges chez Filippino Lippi, Piero di Cosimo et Lorenzo Costa‹, in: Les Fêtes de la Renaissance, vol. 1 (Paris 1956, Editions du Centre National de la Recherche Scientifique), pp. 379–395.

23. ›Alcune rappresentazioni di antichi strumenti italiani a tastiera‹, in: Collectanea historiae musicae 2 (Firenze 1956, Leo S. Olschki), pp. 465–473.

24. ›Mozarts Raumgefühl‹, in: Bericht über den Internationalen Musikwissenschaftlichen Kongress Wien, Mozartjahr 1956 (Graz and Köln 1958, Hermann Böhlaus Nachf.), pp. 736–742.

25. ›The Inspired Musician; a Sixteenth-Century Musical Pastiche‹, in: The Burlington Magazine 100 (February 1958), pp. 48–53.

26. ›Bagpipes for the Lord‹, in: Metropolitan Museum of Art Bulletin 16/10 (June 1958), pp. 276–286.

27. ›Gnagflow Trazom: An Essay on Mozart's Script, Pastimes, and Nonsense Letters‹, in: Journal of the American Musicological Society 11 (1958), pp. 200–216.

28. ›Quattrocento-Intarsien als Quellen der Instrumentengeschichte‹, in: Bericht über den siebenten Internationalen Musikwissenschaftlichen Kongress Köln 1958 (Kassel etc. 1959, Bärenreiter), pp. 300–302.

29. ›The Curse of Pallas Athena; Notes on a »Contest between Apollo and Marsyas« in the Kress Collection‹, in: Studies in the History of Art, Dedicated to William E. Suida (London 1959, Phaidon Press), pp. 186–195.

30. ›Lira da Braccio‹, in: Die Musik in Geschichte und Gegenwart, vol. 8 (Kassel etc. 1960, Bärenreiter), cols. 935–954.

31. ›The Survival of the Kithara and the Evolution of the English Cittern: A Study in Morphology‹, in: Journal of the Warburg and Courtauld Institutes 24 (London 1961), pp. 222–229.

32. ›The Visual Arts as a Source for the Historian of Music‹, in: International Musicological Society, Report of the Eighth Congress New York 1961, vol. 1 (Kassel etc. 1961, Bärenreiter), pp. 109–120.

33. ›Orpheus als Musikallegorie in Renaissance und Frühbarock‹, in article ›Orpheus‹ in: Die Musik in Geschichte und Gegenwart, vol. 10 (Kassel etc. 1962, Bärenreiter), cols. 410–415.

34. ›Musicali Strumenti‹, in: Enciclopedia Universale dell'Arte, vol. 9 (Venezia-Roma 1963, Istituto per la collaborazione culturale), pp. 770–793.

35. ›On Angel Concerts in the 15th Century: A Critical Approach to Realism and Symbolism in Sacred Painting‹, in: The Musical Quarterly 49 (1963), pp. 450–463.

36. ›Leonardo's Invention of the Viola Organista‹, in: Raccolta Vinciana 20 (1964), pp. 1–46.

37. ›Melodic, Chordal and Other Drums Invented by Leonardo da Vinci‹, in: Raccolta Vinciana 20 (1964), pp. 47–68.

38. ›Keyboards for Wind Instruments Invented by Leonardo da Vinci‹, in: Raccolta Vinciana 20 (1964), pp. 69–82.

39. ›The School of Gaudenzio Ferrari and the Early History of the Violin‹, in: Gustave Reese

and Rose Brandel (eds.), The Commonwealth of Music, in honor of Curt Sachs (New York 1965, The Free Press), pp. 182–193.

40. ›Muses and Music in a Burial Chapel: An Interpretation of Filippino Lippi's Window Wall in the Cappella Strozzi‹, in: Mitteilungen des Kunsthistorischen Institutes in Florenz 11 (1965), pp. 263–286.

41. ›Musicians and Musical Instruments in »The Hours of Charles the Noble«‹, in: The Bulletin of the Cleveland Museum of Art 52/3 (March 1965), pp. 84–89.

42. ›Theorbe‹, in: Die Musik in Geschichte und Gegenwart, vol. 13 (Kassel etc. 1966, Bärenreiter), cols. 323–328.

43. ›Leonardo da Vinci‹, in: Die Musik in Geschichte und Gegenwart, vol. 13 (Kassel etc. 1966, Bärenreiter), cols. 1664–1667.

44. ›Italienische Bildzeugnisse der Violine im 16. Jahrhundert‹, in article ›Violine‹ in: Die Musik in Geschichte und Gegenwart, vol. 13 (Kassel etc. 1966, Bärenreiter), cols. 1712–1713.

45. ›Anatomy the Teacher – On the Impact of Leonardo's Anatomical Research on His Musical and Other Machines‹, in: Proceedings of the American Philosophical Society 3 (August 1967), pp. 234–247.

46. ›Orpheus before Opera‹, in: Opera News 32/15 (New York 1968), pp. 8–13.

47. ›A Spinettina for the Duchess of Urbino‹, in: Metropolitan Museum Journal 1 (1968), pp. 95–108.

48. ›Strange Musical Instruments in the Madrid Notebooks of Leonardo da Vinci‹, in: Metropolitan Museum Journal 2 (1969), pp. 115–126.

49. ›Rembrandt's »Christ Presented to the People« – 1665; A Meditation on Justice and Collective Guilt‹, in: Oud Holland, Rembrandt Tricentennial Issue, 84 (1969), pp. 177–198.

50. ›A Hommage of Piccini to Gluck‹, in: H. C. Robbins Landon (ed.), Studies in Eighteenth Century Music, A Tribute to Karl Geiringer on his Seventieth Birthday (London 1970, Allen & Unwin), pp. 397–400.

51. ›The Crosby Brown Collection of Musical Instruments – Its Origin and Development‹, in: Metropolitan Museum Journal 3 (1970), pp. 337–356.

52. ›Über Musikinstrumentensammlungen des Frühbarock‹, in: Studia musico-museologica (Nürnberg, Germanisches Nationalmuseum, and Stockholm, Svensk Musikhistorisk Arkiv, 1970), pp. 6–18.

53. ›The Role of Music in Leonardo's Paragone‹, in: Maurice Natanson (ed.), Phenomenology and Social Reality, Essays in Memory of Alfred Schutz (Den Haag 1971, Martinus Nijhoff), pp. 270–296.

54. ›Music, Physician of the Soul‹, in: Medicine, Mind and Music (= CBS Records Legacy Collection, New York 1971).

55. ›Pleasing Eye and Ear Alike‹, in: Metropolitan Museum of Art Bulletin 30/2 (October/November 1971), pp. 66–73.

56. ›Iconology of Music – Potentials and Pitfalls‹, in: Barry S. Brook, Edward Downes, Sherman J. van Solkema (eds.), Perspectives in Musicology (New York 1972, W. W. Norton & Co.), pp. 80–90.

57. ›La musica nel »Paragone« di Leonardo da Vinci‹, in: Studi musicali 1 (1972), pp. 79–99.

58. ›The Shape of Music: Excerpts from Articles by Emanuel Winternitz‹, in: Lithopinion 28 (Winter 1972), pp. 24–40.

59. ›Leonardo and Music‹, in: The Unknown Leonardo (New York 1974, McGraw-Hill), pp. 110–135.

60. ›Secular Musical Practice in Sacred Arts‹, in: The Secular Spirit: Life and Art at the End of the Middle Ages (New York 1975, The Metropolitan Museum of Art and E. P. Dutton & Co., Inc.).

61. ›Secular Musical Practice in Sacred Art‹, in: Early Music 3/3 (July 1975), pp. 220–226.

62. ›Engelskonzert‹, in: Die Musik in Geschichte und Gegenwart, vol. 16 (Kassel etc. 1979, Bärenreiter), cols. 89–96.

Reviews

63. Antonio Banfi, ›La Fenomenologia e il compito del pensiero contemporaneo‹ (Revue Internationale de Philosophie 1, 1939), in: Philosophy and Phenomenological Research (June 1941), pp. 510–512.

64. Henri Focillon, The Life of Forms in Art (New Haven 1942, Yale University Press), in: College Art Journal 2/3 (1943), pp. 88–90.

65. British Musical Instruments, An Exhibit in London, in: Notes 9 (1952), pp. 395–398.

66. Otto E. Albrecht, A Census of Autograph Music Manuscripts of European Composers in American Libraries (Philadelphia 1953, University of Pennsylvania Press), in: Journal of the American Musicological Society 6 (1953), pp. 169–173.

67. Luigi Parigi, I disegni musicali del Gabinetto degli »Uffizi« (Firenze 1951, Olschki) – Luisa Marcucci, Mostra di strumenti musicali in disegni degli Uffizi (Firenze 1952, Olschki) – Marziano Bernardi and Andrea della Corte, Gli strumenti musicali nei dipinti della Galleria degli Uffizi (Torino 1952, Radio Italiana) – Catalogo della Mostra Corelliana (Roma 1954, Arti Grafiche Fratelli Palombi), in: The Musical Quarterly 40 (1954), pp. 608–614.

68. Stig Walin, Die Schwedische Hummel (Stockholm 1952, Nordiska Museet), in: Journal of the American Musicological Society 8 (1955), pp. 61–62.

69. Albert G. Hess, Italian Renaissance Paintings with Musical Subjects (New York 1955, Libra Press), in: Notes 12 (1955), pp. 598–600.

70. Marin Mersenne, Harmonie Universelle: The Books on Instruments, trans. by Roger E. Chapman (Den Haag 1957, Martinus Nijhoff), in: The Musical Quarterly 44 (1958), pp. 534–540.

71. Anthony Baines, Woodwind Instruments and their History (New York 1957, W. W. Norton and Co.), in: Journal of the American Musicological Society 12 (1959), pp. 254–259.

72. Marc Pincherle, An Illustrated History of Music, trans. by Rollo Myers (New York 1960, Reynal and Co.), in: Notes 18 (1960), pp. 48–50.

73. Philip Bate, The Oboe: An Outline of its History, Development and Construction (London 1956, Ernest Benn Ltd.), in: Journal of the American Musicological Society 14 (1961), pp. 89–91.

74. F. Geoffrey Rendall, The Clarinet: Some Notes upon its History and Construction (London 1957, Ernest Benn Ltd.), in: Journal of the American Musicological Society 14 (1961), pp. 91–92.

75. Günther Bandmann, Melancholie und Musik: Ikonographische Studien (Köln and Opladen 1960, Westdeutscher Verlag), in: The Burlington Magazine (April 1962), pp. 166–167.

76. Vernon Gotwals, Joseph Haydn: 18th Century Gentleman and Genius, a translation with introduction and notes of the ›Biographische Notizen über Joseph Haydn‹, by G. A. Griesinger, and the ›Biographische Nachrichten von Joseph Haydn‹, by A. C. Dies, in: The Saturday Review (20 July 1963), pp. 30–31.

77. Max Wegner, Griechenland (= Musikgeschichte in Bildern, vol. 2, fascicle 4; Leipzig 1963, VEB Deutscher Verlag für Musik), in: Journal of the American Musicological Society 19 (1966), pp. 412–415.

78. François Lesure, Musik und Gesellschaft im Bild – Zeugnisse der Malerei aus sechs Jahrhunderten (Kassel 1966, Bärenreiter), in: Fontes Artis Musicae 15 (1968), pp. 52–54.

Miscellanea

79. Program-note booklet accompanying the recording of J. S. Bach's ›Brandenburg Concertos‹ conducted by Otto Klemperer (= Vox 618–623, 1947).

80. Program-note booklet accompanying the recording of G. F. Handel's ›Twelve Concerti Grossi‹ (= Columbia Masterworks M-MM-685, 1947).

81. Entries on musical instruments for the ›American College Dictionary‹ (New York 1947, Random House, and later editions).

82. Introduction to the exhibition catalogue ›Musical Instruments‹ of the Cincinnati Art Museum (1949, Cincinnati Art Museum).

83. ›The Early History of the Organ‹, in the program-note booklet accompanying the recording ›The Organ‹ (= Columbia Masterworks DL 5288, September 1958).

84. Program-notes for the concerts organized by Emanuel Winternitz in the Metropolitan Museum of Art, New York (1943–1960).

85. ›Musical Instruments Through the Ages‹, in: The Golden Encyclopedia of Music (New York 1968, Golden Press), 25 pages.

86. ›Hindemith ludens‹, in: Neue Zürcher Zeitung (29 January 1969), p. 53.

87. ›Piccinni und Gluck‹, in: Neue Zürcher Zeitung (14 September 1969).

88. ›Images as Records for the History of Music‹, in: London Times Literary Supplement (21 June 1974), pp. 658–660.

89. ›Leonardo the Musician‹, in: The Unesco Courier 27 (October 1974), pp. 16–18 and 35.

90. ›Henry Allen Moe, a Personal Recollection‹, in: American Council for Learned Societies Newsletter 26/4 – 27/1 (1975–1976), pp. 24–26.

91. ›Leonardo da Vinci as a Musician‹, in: London Times Literary Supplement (1 April 1979), pp. 411–412.

Musik und bildende Kunst
Zur Theorie und Geschichte ihrer Beziehungen

Reinhold Hammerstein

Nachdem es lange Zeit um die im obigen Titel angedeuteten Fragen rechtstill geworden war, ja ihre Erörterung aus Furcht vor den berüchtigten »Querverbindungen« mitunter geradezu Tabucharakter angenommen hatte, beginnen sich neuerdings die Fronten wesentlich zu lockern, wofür etwa die auflebende Emblematikforschung, die zunehmenden Bemühungen um die Semantik in verschiedenen Disziplinen und nicht zuletzt auch die Musikikonographie unübersehbare Indizien sind. Doch fehlt es noch immer weithin an den nötigen Voraussetzungen für die Behandlung interdisziplinärer Fragen, sowohl in methodischer und terminologischer als auch in organisatorischer Hinsicht.

Die Musikikonographie ist schon per definitionem eine Disziplin aus und zwischen zwei Disziplinen. Fragen nach der Relation von Musik und bildender Kunst sind ihr von Anfang mitgegeben. Und doch machen sie und ihr Gegenstand nur einen begrenzten Sektor innerhalb eines größeren und umgreifenden Gesamtrelationsfeldes nicht nur von bildender Kunst und Musik, sondern darüber hinaus der Beziehungen zwischen der Welt der Anschauung und der des Hörens überhaupt aus. So mag der Versuch, dieses Feld einmal im ganzen abzuschreiten und einige (notwendigerweise noch unvollständige) Materialien zum Thema vorzulegen, nicht überflüssig erscheinen. Die Musikikonographie kann dadurch, davon ist der Verfasser überzeugt, nicht nur eine wichtige zusätzliche und ganz spezifische Standortbestimmung erfahren, sondern vielleicht auch vor der Gefahr einer gelegentlich allzu selbstgenügsamen Isolierung bewahrt werden.

Es ist nicht leicht, in die verwirrende Vielfalt der Beziehungen von Musik und bildender Kunst eine gewisse Ordnung zu bringen, da es sich dabei um außerordentlich verschiedenartige Sachverhalte phänomenologischer wie historischer Art handelt. Sie reichen von unmittelbar sinnfälligen Zusammenhängen bis in Tiefenschichten wechselseitiger Beeinflussung, die kaum mehr rational faßbar sind.

Unmittelbar sinnfällig sind diejenigen Beziehungen, die durch das konkrete Zusammenwirken der Künste, ihr direktes Miteinander gegeben sind, wie wir es etwa aus den Renaissance-Intermedien, der Oper, dem Ballett und auch dem Film kennen. Zur Musik treten die anderen Künste in immer neuen Kombinationen hinzu, die Dichtung, der Tanz, die Aktion der Schauspieler und Sänger, die bildende Kunst, bzw. die Musik zu ihnen. Die wechselvolle Geschichte der Spannung zwischen feststehenden, konventionellen Kombinationen und ihrer gattungsprägenden Kraft auf der einen und den immer wieder auftretenden revolutionären Neuerungen und Neukombinationen der verschiedenen Medien auf der anderen Seite ist als Ganzes indessen noch zu schreiben, ein großes Thema, auf dessen nähere Erörterung auch wir hier verzichten müssen.

Ein weiteres Feld der Beziehungen sei hier ebenfalls nur angedeutet: das der inhaltlichen Gemeinsamkeiten, der Verwendung gleicher Themen und Motive in Musik und Kunst. Auch auf diesem Gebiet wird es noch eingehender Untersuchungen bedürfen, etwa über die verschiedenen »Sprachmittel« der einzelnen Künste für den gleichen Gehalt oder über die Wanderung solcher Motive durch die Medien und den oft differierenden Zeittakt, mit dem sie in den einzelnen Künsten auftreten. Die folgenden Erörterungen werden vielmehr das Verhältnis von Musik und bildender Kunst als solches, die allgemeinen Prinzipien dieser Relation und die wechselseitige

Transformation vom einen Medium ins andere in den Blick nehmen. Wir tun dies in dreimaligem Durchgang. Ein erstes Kapitel behandelt die allgemeine Stellung der Musik im System der Künste in geschichtlichem Durchblick. Das zweite Kapitel betrachtet das Phänomen der Bildlichkeit und Räumlichkeit von Musik, während das letzte Kapitel den umgekehrten Prozeß der bildlichen Darstellung von Musik in Notation und bildender Kunst behandelt.

I. Die Musik im System der Künste

Die Fragen nach dem Verhältnis der Künste untereinander, nach ihrer Zahl und nach ihrer Hierarchie sind so alt wie diese selbst. Sie sind mit ihnen gestellt. Wer sich mit den einschlägigen Reflexionen befaßt, sieht jedoch bald, daß es kein dauerndes System der Künste gibt, sondern allenfalls eine Mehrzahl von Systemen, die einander folgen, sich formieren, umschichten und wieder auflösen. Diese wechselvolle Geschichte ist bis heute nur teilweise dargestellt[1] und kann auch hier nur in charakterisierendem Umriß nachgezeichnet werden.

Die Griechen nannten den (zunächst noch ungeschiedenen) Verbund von Dichtung, Musik und Tanz μουσική. Das leitende Prinzip für diesen Verbund in allen seinen Teilen war die Mimesis, die Nachahmung, die sich auf Zahlen und Zahlproportionen ebenso wie auf Tanz und Spiel, auf Ethos und Affekte, aber auch auf die äußere Natur beziehen konnte[2]. Diese Idee vom allgemeinen Abbildcharakter aller Kunst wirkt bekanntlich in der abendländischen Musikgeschichte in vielfältiger Brechung in der Theorie wie in der kompositorischen Praxis fort, vom Mittelalter über die Niederländer und die Italiener der Renaissance, Barock, Klassik und Romantik bis weit ins 20. Jahrhundert. Besonders auffallend ist nun, daß in den antiken Erörterungen über die Künste die Architektur, Plastik und Malerei fast völlig fehlen. Auch das in der Spätantike aufkommende System der artes liberales, im Selbstverständnis der Zeit freilich mehr Wissenschaften als Künste im modernen Sinne, räumt den bildenden Künsten keinen Platz ein. Eine Ausnahme macht Marcus Terentius Varro, der immerhin die Architektur einbezieht. Im übrigen kannten die Griechen ja auch keine Muse für die bildenden Künste.

Das Mittelalter übernimmt das System der artes, die seit karolingischer Zeit in die zwei Gruppen des Quadriviums mit Astronomie, Arithmetik, Geometrie, Musik und des Triviums mit Grammatik, Dialektik, Rhetorik gegliedert sind. Aber auch in diesem System fehlen die bildenden Künste. Sie rangieren allenfalls unter den artes mechanicae, die die rein handwerklichen Fähigkeiten umfassen. Dem entspricht es ja auch, daß die Vertreter der artes mechanicae, die »bildenden Künstler«, in der sozialen Rangordnung niedriger stehen und zu den Handwerkern und Zünften gerechnet werden, während die Vertreter der artes liberales an die Universitäten gehören.

Die Renaissance behält einerseits das alte System bei, setzt aber andererseits ganz neue Akzente. So treten seit dem 15. Jahrhundert Architektur und Musik in eine besonders enge Beziehung dadurch, daß der quadriviale Harmonie- und Proportionsbegriff der Musiktheorie auf die Baukunst angewandt wird. Bereits Vitruv hatte die Applikation der harmonikalen Zahlen auf die Baukunst gefordert. Aber erst Leon Battista Alberti greift um 1450 den Gedanken wieder auf und rückt ihn ins Zentrum seiner Erörterungen über die Architektur. Es seien dieselben Zahlen, die eine Musik dem Ohr angenehm machen, die auch Auge und Geist erfreuen: »Hi quidem

1 Am besten bisher Paul Oskar Kristeller, ›The Modern System of the Arts‹, in: Renaissance Thought 2 (New York 1965), S. 163–227.
2 Siehe Albrecht Riethmüller, Die Musik als Abbild der Realität (= Beihefte zum Archiv für Musikwissenschaft 15; Wiesbaden 1976).

numeri per quos fiat ut vocum illa concinnitas auribus gratissima reddatur, iidem ipsi numeri perficiunt, ut oculi animusque voluptate mirifica compleantur«[3]. Von der Musik und den Musikern müsse der Architekt diese Zahlengrundlagen erlernen: »Ex musicis igitur quibus ii tales numeri exploratissimi sunt: atque ex his praeterea quibus natura aliquid de se conspicuum dignumque praestat tota finitionis ratio producetur«[4]. Wie sehr für Alberti diese Überzeugung bis in die Praxis reicht, geht aus einer 1454 an den Bauführer seines »Malatestatempels« S. Francesco in Rimini gerichteten Warnung hervor, er solle doch ja darauf achten, daß er die Proportionen der Pilaster nicht abändere, damit nicht »si discorda tutta quella musica«[5].

Die Idee bleibt auch im 16. Jahrhundert lebendig, wobei die Anzahl der konsonanten Proportionen wie in der Musiktheorie so auch in der Architekturtheorie erweitert wird. Kanonische Bedeutung erlangt die Klassifikation des harmonischen Materials in Gioseffo Zarlinos ›Istitutioni harmoniche‹ von 1558. Von ihm geht, wie neuere Forschungen gezeigt haben[6], kein Geringerer als Andrea Palladio in der Konzeption seiner Bauten aus. Ja, auch auf die Malerei findet das harmonikale Denken Anwendung. So behandelt Giovanni Paolo Lomazzo in seinem ›Trattato dell'arte della pittura‹ von 1584 und nochmals in seiner ›Idea del Tempio della pittura‹ von 1590 die Proportionen des menschlichen Körpers auf der Grundlage der musiktheoretischen Terminologie[7]. Und auch bei Michelangelo klingt harmonikales Gedankengut an, wenn er sagt: »La buona pittura è una musica e una melodia . . . che solo l'intelligenza può percipere non senza grande difficoltà«[8]. Und noch der im 19. Jahrhundert so gern gebrauchte Vergleich von der Architektur als gefrorener Musik ist ein später Ausläufer dieses Denkens; so wenn Friedrich von Schelling die Architektur eine erstarrte oder konkrete Musik nennt[9], wenn Goethe ähnlich von der Baukunst als erstarrter Musik bzw. verstummter Tonkunst spricht[10] oder wenn Moritz Hauptmann, den Vergleich umstellend, die Musik als flüssige Architektur bezeichnet[11].

Zweifellos spiegelt sich in den Zeugnissen des 15./16. Jahrhunderts das neue und gesteigerte Ansehen, das die bildende Kunst im Bewußtsein der Zeitgenossen gewonnen hatte. Schon seit dem 14. Jahrhundert gab es gelegentlich Stimmen, die forderten, daß auch die Malerei zu den artes liberales und nicht zu den artes mechanicae gehören müsse[12]. Auch die Gründung der Accademia del Disegno in Florenz 1563, die sich mit Malerei, Plastik und Architektur befassen sollte, gehört in diesen Zusammenhang. Leonardo da Vinci verkündete sogar in seinem Paragone den absoluten Vorrang der Malerei vor allen anderen Künsten, auch der Musik[13].

Und auch die Dichtung solle der Malerei angeglichen werden und deren Qualitäten übernehmen, so heißt es nicht selten, in Anlehnung an das Horazische »ut pictura poesis«. Dadurch wird die Malerei zum Ausgangspunkt des Vergleichs, als dessen tertium die »imitazione della natura«, die modifizierte antik-aristotelische Mimesistheorie dient. Nachahmung gilt immer

3 De re aedificatoria IX, 5; hier zitiert nach Rudolf Wittkower, Grundlagen der Architektur im Zeitalter des Humanismus (München 1969), S. 158.
4 ibidem.
5 ibidem S. 96.
6 ibidem S. 107 ff.; vgl. auch Erik Forssmann, Visible Harmony (Stockholm 1973).
7 Vgl. Wittkower (Fußnote 3), S. 97.
8 Francisco de Hollanda, Colloqui con Michelangelo (Neue Ausgabe Mailand 1943), S. 47.
9 Friedrich Wilhelm Joseph von Schelling, Philosophie der Kunst (Neuausgabe Darmstadt 1976), S. 220.
10 ›Maximen und Reflexionen‹, 776, in: Goethes Werke, Hamburger Ausgabe, Bd. 12 (München 1978), S. 474.
11 Moritz Hauptmann, Die Natur der Harmonik und Metrik (Leipzig 1853), S. 313.
12 Vgl. Kristeller (Fußnote 1), S. 181.
13 ibidem S. 184.

mehr als zentrale Bestimmung für Malerei, Dichtkunst und Musik[14]. So ergibt sich eine spezifische Schrittfolge innerhalb der Künste. Die Malerei ahmt die Natur nach, die Dichtkunst ihrerseits mit sprachlichen Mitteln die Malerei, und die Musik malt mit ihren Mitteln wiederum die durch Dichtung und Malerei vermittelte Natur. Die Musik ist »imitazione della natura delle parole«, wie es oft genug im 16. Jahrhundert heißt.

Nachahmung der Natur, das meint in der damaligen Kunst-, Dichtungs- und Musiktheorie natürlich auch die Nachahmung der Affekte. So projiziert die zeitgenössische Musiktheorie die antike Lehre vom Ethos der Tonarten auf das zeitgenössische Modussystem. Danach haben die Tonarten die Fähigkeit, den Gesamtaffekt einer Komposition bzw. des ihr zugrundeliegenden Textes, darzustellen, auszudrücken, zu malen. Die zentrale Autorität für diese Gedanken ist wiederum Zarlino.

Die musikalische Affektenlehre hat ihrerseits wiederum Auswirkungen auf die Malerei gehabt, zumindest auf die theoretische Reflexion über sie. Kein Geringerer als Nicolas Poussin entwickelt in seinem berühmten Brief an Mr. de Chantelou 1647 die Theorie, daß auch Gemälde in verschiedenen Modi gehalten sein sollten. Daß er dabei auf der Moduslehre des Zarlino fußt, ist heute erwiesen[15]. Tertium comparationis ist für Poussin der Affekt. Auch Gemälde sollen, wie Musikstücke, einen bestimmten Affekt, eine bestimmte Gemütshaltung darstellen. So ergeben sich für ihn etwa folgende Parallelen: der dorische Modus für schwere und strenge, der lydische für jämmerliche und klagende, der phrygische für gefällige und freudige, der hypolydische für göttliche, der jonische für festliche Sujets.

Seit dem 17. Jahrhundert verlagert sich der Schwerpunkt der Diskussion deutlich nach Frankreich. Der Hauptakzent des Interesses liegt zunächst auf der Dichtkunst. Die übrigen Künste folgen jedoch bald nach. Man kann dies deutlich an der Chronologie der verschiedenen Akademiegründungen ablesen: 1635 die Académie de France, 1648 die Académie Royale de Peinture et de Sculpture, 1661 die Académie de Danse, 1669 die Académie Royale de Musique, 1671 die Académie Royale d'Architecture. Damit nimmt auch die Literatur über die bildenden Künste und die Musik immer mehr zu, ein Schrifttum, das auch in bezug auf unser Thema noch weitgehend der Auswertung harrt[16].

Nicht zuletzt mit dem Aufsteigen der Naturwissenschaften hängt es zusammen, daß es immer mehr zu einer Scheidung und schließlich zur endgültigen Abtrennung der Künste von den Wissenschaften kommt. Folgerichtig stellt Charles Perrault in seinem ›Le Cabinet des Beaux Arts‹ 1690 dem alten System der artes liberales das neue System der beaux arts gegenüber[17]. Es sind dies éloquence, poésie, musique, architecture, peinture, sculpture, optique, méchanique.

Das 18. Jahrhundert bringt eine weitere Zunahme des kunsttheoretischen Schrifttums, meist in Form von Traktaten zu den Einzelkünsten, die jedoch fast immer auch Ausführungen zum Gesamtsystem enthalten. Auch ihre Auswertung ist, vor allem, was die Musik und ihr Verhältnis zu den anderen Künsten betrifft, noch kaum geleistet[18]. Die endgültige Kodifizierung des Systems der schönen Künste erfolgt in den Schriften von Jean-Baptiste Dubos, Jean-Pierre

14 ibidem S. 185 f.
15 Siehe Jan Białostocki, ›Das Modusproblem in den bildenden Künsten‹, in: Zeitschrift für Kunstgeschichte 24 (1961), S. 134.
16 Eine vorläufige Zusammenstellung bei Rudolf Schäfke, Geschichte der Musikästhetik in Umrissen (Berlin 1934), S. 284–295.
17 Siehe Kristeller (Fußnote 1), S. 195 f.
18 ibidem S. 196.

Crousaz, Yves-Marie André und Charles Batteux[19]. Es umfaßt Musik, Dichtung, Malerei, Plastik und Tanz. Ihr gemeinsames Prinzip ist die imitation de la belle nature. Dieses System macht seinen Einfluß auf ganz Europa geltend, und auch die Enzyklopädisten folgen ihm noch, so wenn z. B. Jean Lerond d'Alembert die Malerei, Plastik, Architektur, Poesie und Musik als »connoissances, qui consistent dans l'imitation« bezeichnet[20].

Die englischen Schriften zu den schönen Künsten stehen zunächst ganz unter dem Einfluß der Franzosen. Sie enthalten ebenfalls eine Fülle von Bemerkungen zum Verhältnis der Künste. Mit Anthony Ashley-Cooper, 3. Earl of Shaftesbury und Joseph Addison wird die Rolle der Phantasie und der Imagination als Gestaltungsprinzip immer stärker in den Vordergrund gerückt und an die Stelle der bloßen Nachahmung gesetzt[21]. Dieser Vorgang bewirkt wiederum, daß in der zweiten Jahrhunderthälfte die Musik näher bei der Dichtung als bei der Malerei zu stehen kommt.

In Deutschland schuf Alexander Gottlieb Baumgarten mit seiner ›Aestetica‹ (Frankfurt/Oder 1750–1758) nicht nur den Terminus »Ästhetik« für die betrachtende Beschäftigung mit den schönen Künsten, sondern er führte auch die Ästhetik als selbständige Disziplin in die Philosophie ein, indem er die sinnliche Erkenntnis als gleichberechtigt neben die intellektuelle stellte. Jedoch finden sich bei ihm kaum Hinweise auf ein System, auch nicht auf die Einzelkünste. Mehr über die Beziehungen der Künste bringt dann Friedrich Justus Riedel in seiner ›Theorie der schönen Künste und Wissenschaften‹ (Jena 1767), und auch Johann Georg Sulzers ›Allgemeine Theorie der Schönen Künste‹ (Leipzig 1771–1774) geht mehrfach auf das Thema ein.

Lessing verzichtet auf ein geschlossenes Gesamtsystem. Im ›Laocoon‹ (1766) unterscheidet er die Künste lediglich bezüglich der Art der Nachahmung, die als solche allen gemeinsam sei. Die Dichtung bediene sich danach einer sukzessiven Darstellungsart, während die bildenden Künste simultane Zeichen bildeten. Die Musik wird in diesem Zusammenhang nicht besonders genannt, allenfalls indirekt im Sinne eines noch zu erarbeitenden Gebietes: »Noch erinnere ich, daß ich unter dem Namen der Malerei die bildenden Künste überhaupt begreife; so wie ich nicht dafür stehe, daß ich nicht unter dem Namen der Poesie auch auf die übrigen Künste, deren Nachahmung fortschreitend ist, einige Rücksicht nehmen dürfte«[22].

Eine frühe, wenn nicht die erste Kritik an der Nachahmungstheorie deutet sich in Moses Mendelssohns ›Betrachtungen über die Quellen und die Verbindung der schönen Künste und Wissenschaften‹ (1757)[23] an, in denen er für die schönen Künste und die belles lettres als gemeinsames Prinzip etwas Besseres als die bloße Nachahmung fordert. Herder wiederum wünscht sich einerseits einen neuen Lessing zur Erörterung der Beziehungen zwischen den Künsten, meint aber andererseits bereits kritisch: » . . . ist der Streit über den Werth der Künste untereinander, oder in Rücksicht auf die Natur des Menschen allezeit leer und nichtig. Raum kann nicht Zeit, Zeit nicht Raum, das Sichtbare nicht hörbar, dies nicht sichtbar gemacht werden«[24].

19 Abbé Dubos, Reflexions critiques sur la poésie et sur la peinture (Paris 1719); Jean-Pierre de Crousaz, Traité du Beau (Amsterdam 1724); Père André, Essai sur le Beau (Amsterdam 1741); Abbé Batteux, Les beaux arts reduits à un même principe (Paris 1746).
20 Denis Diderot und Jean Lerond d'Alembert, Encyclopédie, Bd. 1 (Paris 1751), S. XIf.
21 Siehe Kristeller (Fußnote 1), S. 204–212.
22 Gotthold Ephraim Lessing, Gesammelte Werke, hrsg. von Paul Rilla, Bd. 5 (Berlin 1954), S. 12.
23 Moses Mendelssohn, Gesammelte Schriften, Bd. 1 (Berlin 1929), S. 165–190.
24 Johann Gottfried Herder, Sämtliche Werke, hrsg. von Bernhard Suphan, Bd. 22 (Berlin 1880), S. 187f.

Bei Kant schließlich sind die Künste fest ins philosophische System eingefügt und ihrerseits eingeteilt in »redende« (Poesie), »bildende« (Plastik, Architektur, Malerei, Gartenkunst) und »Künste des schönen Spiels der Empfindungen« (Farbenkunst, Musik)[25]. Man sieht, die Stellung der Musik ist hier deutlich niedriger als die der anderen Künste, was Kant damit begründet, daß sie »durch lauter Empfindungen ohne Begriffe« spricht, daß sie »mehr Genuß als Cultur« bringe und deshalb, »durch Vernunft beurtheilt, weniger Werth, als jede andere der schönen Künste« habe. Gerade diese von Kant als Mangel empfundene Begriffslosigkeit der Musik wird ja dann in der Folgezeit und im Zuge der romantischen Aufhöhung der »absoluten« Instrumentalmusik als ein Hauptvorzug gefeiert werden, der die Musik wiederum weit über die anderen Künste erhebt.

Der im 19. Jahrhundert so zentrale, emphatisch verkündete und umstrittene Gedanke, die einzelnen Künste sollten ihre einengenden Grenzen überschreiten und in ein größeres Ganzes einbringen, findet sich wohl erstmals 1795 dezidiert in Schillers ›Briefen über die ästhetische Erziehung des Menschen‹ ausgesprochen. Schiller ist allerdings doch insofern wieder Klassizist und Traditionalist, als er zugleich fordert, die einzelnen Künste dürften ihre spezifischen Eigenschaften und Möglichkeiten dabei nicht aufgeben:

> » ... die verschiedenen Künste in ihrer Wirkung auf das Gemüt einander immer ähnlicher werden. Die Musik in ihrer höchsten Veredelung muß Gestalt werden ... die bildende Kunst in ihrer höchsten Vollendung muß Musik werden und uns durch unmittelbare sinnliche Gegenwart rühren; die Poesie in ihrer vollkommenen Ausbildung muß uns, wie die Tonkunst, mächtig fassen, zugleich aber, wie die Plastik, mit ruhiger Klarheit umgeben. Darin eben zeigt sich der vollkommene Stil in jeglicher Kunst, daß er die spezifischen Schranken derselben zu entfernen weiß, ohne doch ihre spezifischen Vorzüge mit aufzuheben, und durch eine weise Benutzung ihrer Eigentümlichkeit ihr einen mehr allgemeinen Charakter erteilt«[26].

Folgerichtig überträgt Schiller dann in ›Über naive und sentimentalische Dichtung‹ 1796 die (verallgemeinerten) Kategorien des Plastischen und des Musikalischen speziell auf die Dichtung. »Plastisch« nennt er diejenige Dichtung, die einen bestimmten Gegenstand darstellt, wie es die bildenden Künstler tun, »musikalisch« ist diejenige, die bloß einen bestimmten Gemütszustand erzeugt, ohne dazu eines bestimmten Gegenstandes zu bedürfen[27]. Dieselben Begriffe, erweitert um den des Pittoresken, wendet dann August Wilhelm Schlegel in seinen Berliner Vorlesungen 1803/04 konkret auf Dante an, indem er das Inferno als »plastisch«, das Purgatorio als »pittoresk« und das Paradiso als »musikalisch« beschreibt[28].

Waren die von Schiller verwendeten Kategorien noch weitgehend allgemeiner Natur, universal bestimmte Begriffe, die idealiter immer und überall und bei allen Künsten gelten konnten, so bedeutet die Projektion des Systems der Künste auf die Geschichte und das geschichtliche Nacheinander einen weiteren Schritt. Sie hängt zusammen mit der allgemeinen Historisierung des Denkens über Kunst, unter deren Einwirkung wir bis heute stehen. Danach dominiert in jeder Epoche eine bestimmte Kunst über die anderen und bestimmt außerdem diese mit ihren spezifischen Prinzipien mit. Der Geist der antiken Kunst sei »plastisch«, der der modernen pittoresk, so heißt es nunmehr bei A. W. Schlegel[29]. Und E. Th. A. Hoffmann begründet den Aufstieg der Musik im Christentum nach ihrer (angeblich) untergeordneten Rolle in der Antike mit demselben Gegensatz: »Eben dieses ihres eigentümlichen Wesens halber

25 Immanuel Kant, Kritik der Urteilskraft, 1790, Abteilung 51.

26 Friedrich Schillers Werke (= Knaurs Klassiker), Bd. 2 (Berlin 1906), S. 618.

27 ibidem S. 674.

28 Deutsche Literaturdenkmale des 18. und 19. Jahrhunderts, Bd. 19 (Heilbronn 1884), S. 201.

29 August Wilhelm Schlegel, Die Kunstlehre, hrsg. von Edgar Lohner (Stuttgart 1963), S. 207.

konnte die Musik nicht das Eigentum der antiken Welt sein, wo alles auf sinnliche Verleiblichung ausging, sondern mußte dem modernen Zeitalter angehören«[30].

Aber erst Hegel ist es gewesen, der die ästhetischen Kategorien vollends historisierte[31]. Er versteht die Entfaltung des Systems der Künste als konsequente geschichtliche Abfolge. In jedem der großen Weltzeitalter dominiert nach ihm eine Kunstart, bis schließlich aus dem Bedürfnis dieser Kunstart selbst eine andere hervorgeht. So ist der alte Orient als »symbolische Kunstepoche« durch die Dominanz der Architektur bestimmt, die griechische Antike als »klassische Kunstepoche« durch die Plastik, die christliche Ära als »romantische Kunstepoche« führt von der Dominanz der Malerei zu der der Musik und schließlich als letztes zur Dichtung. Die historische Entwicklung der Künste stellt sich so als Verwirklichung eines Systems dar, in dem die Musik nach der Malerei und als Vorstufe zur Dichtung erscheint.

Das romantische Denken wandelt dieses System wiederum ab. Danach ist die Musik und nicht die Dichtung die letzte in der Entfaltung der Künste, ihr höchster Gipfel und damit zugleich das Ende der Kunst überhaupt. In einem seiner brillanten Zeitungsberichte (1841) formuliert Heinrich Heine diese Auffassung in eindrucksvollen Worten und zeigt sich dabei einerseits von Hegel, den er in Berlin gehört hatte, beeinflußt und andererseits von dem neuen Gedanken von der Musik als der spätesten Kunst der Menschheitsgeschichte beherrscht:

> »Mit der allmählichen Vergeistigung des Menschengeschlechts halten auch die Künste ebenmäßig Schritt. In der frühesten Periode mußte nothwendigerweise die Architektur alleinig hervortreten, die unbewußte rohe Größe massenhaft verherrlichend, wie wir's z. B. sehen bei den Egyptiern. Späterhin erblicken wir bei den Griechen die Blüthezeit der Bildhauerkunst, und diese bekundet schon eine äußere Bewältigung der Materie: der Geist meißelte eine ahnende Sinnigkeit in den Stein. Aber der Geist fand dennoch den Stein viel zu hart für seine steigenden Offenbarungsbedürfnisse, und er wählte die Farbe, den bunten Schatten, um eine verklärte und dämmernde Welt des Liebens und Leidens darzustellen. Da entstand die große Periode der Malerei, die am Ende des Mittelalters sich glänzend entfaltete. Mit der Ausbildung des Bewußtseynlebens schwindet bei den Menschen alle plastische Begabniss, am Ende erlischt sogar der Farbensinn, der doch immer an bestimmte Zeichnung gebunden ist, und die gesteigerte Spiritualität, das abstrakte Gedankenthum greift nach Klängen und Tönen, um eine lallende Überschwänglichkeit auszudrücken, die vielleicht nichts Anderes ist als die Auflösung der ganzen materiellen Welt: die Musik ist vielleicht das letzte Wort der Kunst, wie der Tod das letzte Wort des Lebens«[32].

Ähnlich spricht auch Nietzsche, in auffallender Nähe zu Heine, von der Musik als der Kunst gestorbener Epochen[33]. Und noch Spenglers morphologisches System, nach dem in Griechenland die Plastik dominiert und ihrerseits auch Musik und Malerei bestimmt, in der Neuzeit dagegen seit etwa 1500 die Musik, die wiederum die anderen Künste beherrscht[34], ist nur eine Variante alter Vorstellungen

Nur ein Schritt ist es von der Idee der geschichtlich wechselnden Dominanz der Künste zu der Folgerung, daß es dann auch gewisse Entsprechungen vor allem ihrer Höhepunkte geben müsse. Man muß also die verschiedenen Künste auf der Basis ihrer ungleichzeitigen Gleichzeitigkeit

30 Ernst Theodor Amadeus Hoffmann, Alte und neue Kirchenmusik (aus den Gesprächen der Serapionsbrüder), in: Sämtliche Werke, Bd. 6 (München und Leipzig 1924), S. 20.
31 Georg Wilhelm Friedrich Hegel, Ästhetik (Berlin 1955), besonders S. 595, 656, 817, 874; vgl. dazu Monika Lichtenfeld, ›Gesamtkunstwerk und allgemeine Kunst. Das System der Künste bei Wagner und Hegel‹, in: Beiträge zur Geschichte der Musikanschauung im 19. Jahrhundert, hrsg. von Walter Salmen (Regensburg 1965), S. 171–177.
32 Heinrich Heine, Zeitungsberichte über Musik und Malerei (Frankfurt 1964), S. 114.
33 Friedrich Nietzsche, Menschliches, Allzumenschliches, Werke in 3 Bdn., hrsg. von Karl Schlechta, Bd. 1 (München 1966), S. 801.
34 Oswald Spengler, Der Untergang des Abendlandes, Umrisse einer Morphologie der Weltgeschichte (München 1917), S. 304 et passim.

vergleichen, ja parallelisieren können. Solche Vergleiche häufen sich in der Tat seit dem frühen 19. Jahrhundert und haben sogar Eingang in die fachwissenschaftliche Literatur gefunden.

Den Anfang macht wohl Stendhal in seinen Musikerbiographien, wenn auch sein Anteil und der von Giuseppe Carpani, den er weitgehend plagiiert hat, nicht mehr genau zu bestimmen ist[35]. Stendhal schwelgt förmlich in Vergleichen zwischen Musikern und Malern, wenn er auch einmal selbstironisch einschränkt: »La manie des comparaisons s'empare de moi.« Als tertium comparationis dienen ihm Eigenschaften wie Feuer, Originalität, Kolorit und Erfindungskraft. Gelegentlich ruft er auch nur die Namen von Malern und Musikern auf, um im Leser die Assoziation von Gemeinsamkeit oder Ähnlichkeit hervorzurufen. Die herangezogenen Maler gehören dabei fast immer dem 16. oder 17. Jahrhundert, die Musiker dagegen dem 18. Jahrhundert an. So nennt er Joseph Haydn den »Tintoretto von Eisenstadt«, Giovanni Battista Pergolesi und Domenico Cimarosa sind ihm die »Raffaele der Musik«, Francesco Durante bringt er mit Leonardo, Johann Adolf Hasse mit Peter Paul Rubens, Georg Friedrich Händel mit Michelangelo, Baldassare Galuppi mit Jacopo Bassano, Nicolò Jomelli mit Annibale Carracci, Christoph Willibald Gluck mit Michelangelo da Caravaggio, Niccolò Piccini mit Tizian, Antonio Sacchini mit Correggio zusammen und so fort. Einer der ausführlicheren Vergleiche folge hier wörtlich:

> »Je crois voir dans Haydn le Tintoret de la musique. Il unit, comme le peintre vénitien, à l'énergie de Michel-Ange, le feu, l'originalité, l'abondance des inventions. Tout cela est revêtu d'un coloris aimable, qui donne de l'agrément aux moindres parties. Il me semble cependant que le Tintoret d'Eisenstadt était plus profond dans son art que celui de Venise; surtout il savait travailler lentement«[36].

Wenig später findet man bei Ludwig Tieck einen ausgeführten Vergleich zwischen Pergolesi und Correggio, den wir wegen seiner typisch poetisierenden Sprache ebenfalls hierher setzen. Die Vergleichskategorien sind für Tieck vornehmlich Licht und Schatten, Kolorit und malerisches Wesen:

> »Daß man ihn [Pergolesi] neulich mit Coreggio zusammenstellen wollte, ist gewiß keine willkürliche Vergleichung, denn bei den Bildern dieses großen Meisters habe ich etwas Ähnliches empfunden, und wie dieser mit Licht und Schatten spielt, ja beides zum mystischen Symbol erhebt und dadurch in höherem als dem gewöhnlichen Sinne seine Gemälde beleuchtet, eben so innig nimmt Pergolese die hohen und tiefen Töne als Licht und Schatten. In einer Messe erinnert das herrliche Gloria unmittelbar an die schwebenden und durcheinander gaukelnden Engel in Coreggio's Nacht und das Pax hominibus legt sich wie ein dunkler tröstender Schatten über die Erde hin«[37].

Zu einem der beliebtesten Vergleiche, der geradezu topischen Charakter erhält, wird der zwischen Raffael und Mozart[38]. Die Belege dafür reichen von Johann Friedrich Rochlitz über Stendhal, Jean Auguste Dominique Ingres, Franz Liszt, Franz Grillparzer bis hin zu Otto Jahn, dem ersten Verfasser einer wissenschaftlichen Mozart-Biographie. Die Vergleichsmaßstäbe sind dabei im einzelnen recht vielfältig. Bald ist es die Universalität: »Comme Raphael, Mozart embrassa son art dans toute son étendue« (Stendhal)[39], bald die Größe schlechthin: »Mozart der Gott der Musik, Raphael der Gott der Malerei« (Ingres)[40], bald das Geniale schlechthin: »Jeder Tag befestigt in mir durch Fühlen und Denken das Bewußtsein der verborgenen Verwandtschaft

35 Vies de Haydn, de Mozart et de Métastase (Paris 1814, Repr. Nendeln, Liechtenstein 1968).
36 ibidem S. 231 f.
37 Ludwig Tieck, Phantasus, in: Schriften, Bd. 5 (Berlin 1828), S. 478.
38 Vgl. dazu Martin Staehelin, ›Mozart und Raffael. Zum Mozartbild des 19. Jahrhunderts‹, in: Schweizerische Musikzeitung 117 (1977), S. 322–330. Dort auch die Einzelnachweise.
39 Vies de Haydn (Fußnote 35), S. 287.
40 Zitiert nach Hans Graber, Ingres, Gedanken über Kunst (Basel 1927), S. 82.

der Werke der Genies. Raphael und Michelangelo verhelfen mir zum Verständnis von Mozart und Beethoven« (Liszt)[41], oder es sind schließlich mehr ästhetische Qualitäten wie rein, mild, verklärt, lichtvoll, edle Schönheit, apollinisch (Jahn)[42].

In dem Maße, wie die romantische Bewegung die altdeutsche Malerei mit der Symbolgestalt Albrecht Dürer und wenig später die gotische Kathedrale entdeckt und emphatisch feiert, und in dem Maße, wie andererseits die Gestalt J. S. Bachs im musikalischen Bewußtsein aufsteigt, kommt es im 19. und bis weit ins 20. Jahrhundert immer wieder zu Vergleichen zwischen Bach und Dürer, Bach und der Gotik. Musik der ersten Hälfte des 18. Jahrhunderts rückt also mit Malerei der Zeit um 1500 bzw. Architektur des hohen Mittelalters zusammen. Für J. Fr. Rochlitz sind Bach und Dürer durch ihre künstlerische Größe und ihre gewaltige Kombinationskraft miteinander verbunden: »J. S. Bach ist der Albrecht Dürer der deutschen Tonkunst, weil er den Ausdruck des Großen vor allem durch tiefe Entwicklung und unerschöfliche Kombination des einfach Erfundenen erreicht«[43]. Auch Richard Wagner vergleicht Bach und Dürer und sieht ihre Gemeinsamkeit in ihrer verschlungenen Linearität und ihren krausen Zeichen: »Das waren dieselben räthselhaft verschlungenen Linien und wunderbar krausen Zeichen, in welchen dem großen Albrecht Dürer das Geheimniß der vom Lichte beschienenen Welt und ihrer Gestalten aufgegangen war, das Zauberbuch des Nekromanten, der das Licht des Makrokosmos über den Mikrokosmos hinleuchten läßt«[44]. Der Maler Hans Thoma betont noch 1903 in einem Dürervortrag die Verwandtschaft beider Meister, die für ihn auf der Basis ihrer Deutschheit und zugleich ihrer Unerschöflichkeit beruht: » . . . was der Name Dürer für die deutsche Malerei bedeutet, das bedeutet der Name Bach für die deutsche Musik – die Musiker wissen es ja, wie Bach ›inwendig voller Figur‹ war, wie unerschöflich er war«[45]. Für Richard Benz (1923) wiederum ist die Musik Bachs die klangliche Entsprechung zur Architektur der gotischen Kathedrale. Als Angelpunkt für die Verlagerung von den Künsten des Auges zu denen des Ohres erscheint ihm im übrigen die Erscheinung Martin Luthers[46]. So gehört Bach zugleich zwei Zeitaltern an, dem Mittelalter sogar noch mehr als seinem eigenen. Für den Kunsthistoriker Wilhelm Pinder ergibt sich eine geradezu verwirrende Fülle weiterer Gleichzeitigkeiten, wie die von Beethoven und der gotischen Kathedrale (»Seine Symphonie ist die Kathedrale von 1800«) oder die zwischen Isoldes Liebestod mit Gian Lorenzo Berninis Verzückung der heiligen Therese[47]. Die Beispiele ließen sich leicht vermehren.

Hatte das 18. Jahrhundert das System der Künste ausgiebig diskutiert, Gemeinsamkeiten und Unterschiede, Hierarchien und Grenzen der Einzelkünste herausgearbeitet, so entgrenzt und liquidiert das 19. Jahrhundert dieses Gefüge zunehmend oder lockert es zumindest auf. Dies geschieht vor allem durch zwei Prozesse. Einmal durch die bereits beschriebene Projektion des Systems in eine weltgeschichtliche Abfolge, zum andern durch die Idee der Verschmelzung der Einzelkünste zu einem neuen, wie auch immer gearteten Ganzen, zu ihrer Vereinigung auf der Grundlage einer sie alle umfassenden Gemeinsamkeit. Auf die Idee des gegliederten Nebeneinanders, dann des geschichtlichen Nacheinanders folgt jetzt die eines integralen Ineinanders der Künste. Diese Idee des Gesamtkunstwerks wird bekanntlich eines der meistdiskutierten Themen der Musikästhetik und auch der kompositorischen Praxis des 19. Jahrhunderts.

41 Zitiert nach Franzsepp Würtenberger, Malerei und Musik (Frankfurt 1979), S. 76.
42 Otto Jahn, W. A. Mozart (Leipzig 1856–1859), passim.
43 Dürer und die Nachwelt, hrsg. von Heinz Lüdecke und Susanne Heiland (Berlin 1955), S. 393.
44 ›Beethoven‹, in: Richard Wagner, Sämtliche Schriften und Dichtungen, Bd. 9 (Leipzig o. J.), S. 95.
45 Zitiert nach Würtenberger (Fußnote 41), S. 172.
46 Richard Benz, Die Stunde der deutschen Musik (Jena 1923–1927).
47 Wilhelm Pinder, Das Problem der Generation in der Kunstgeschichte Europas (Berlin 1926), S. 120.

Auch diese Idee ist meistens mit einer welthistorischen Dimension verbunden. Alle ihre Verfechter berufen sich auf eine Urkunst, die noch keine geschiedenen Einzelkünste kannte. Sie sei verloren gegangen, und es gelte, sie wiederherzustellen, so heißt es immer wieder. Ob man diese Ureinheit am fernen Anfang der Menschheitsgeschichte oder auch in der griechischen Antike verwirklicht sah, es ist im Grunde das alte, so oft erneuerte neuplatonische Schema von der ursprünglichen Einheit, nachfolgender Trennung und Wiedervereinigung, das auch in der Musikgeschichte immer wieder auftaucht, und das nun mit neuer Emphase auf die Idee des Gesamtkunstwerks appliziert wird. Nun sei es an der Zeit, so fordert etwa Schelling, daß »die vollkommenste Zusammensetzung aller Künste, die Vereinigung von Poesie und Musik durch Gesang, von Poesie und Malerei durch Tanz, ... selbst wieder synthesirt die componirteste Theatererscheinung ist, dergleichen das Drama des Altertums war«[48], neu verwirklicht werde. Philipp Otto Runge träumt auf seine Weise von einem alle Künste umfassenden Gesamtkunstwerk: »... es wird eine abstracte mahlerische phantastisch-musikalische Dichtung mit Chören, eine Composition für alle drey Künste zusammen, wofür die Baukunst ein eigenes Gebäude aufführen sollte«[49]. Bei Richard Wagner erhalten dann diese Ideen ihre umfassendste theoretische und kompositorische Verwirklichung.

Im Verlauf des 19. Jahrhunderts tritt der Anspruch der Philosophie und der philosophischen Ästhetik, über die Künste zureichende Sachaussagen machen zu können, mehr und mehr zurück. Die Folge ist vielfach eine deutliche Verflachung, wenn nicht Trivialisierung des alten Gedankenreichtums, ein Absinken ins Unverbindliche oder Schöngeistige. Dies aber ist die Stunde der Einzelwissenschaften, der Kunst-, Musik- und Literaturgeschichte. Nicht nur treten diese Wissenschaften mit ausgeprägtem Alleinvertretungsanspruch auf, sie halten sich auch meist bewußt von allen übergreifenden, aufs Ganze der Künste gerichteten Spekulationen fern. In den Mittelpunkt des Interesses und der Forschung rücken statt dessen die Kunstwerke selbst als konkrete Objekte sowie ihre innersachlichen Zusammenhänge. Diese verdichten sich im Begriff des Stils. Stil, Stilentwicklung, Stilwandlung, das sind die Hauptarbeitsgebiete der einschlägigen Disziplinen.

In diesem Zusammenhang verdient die Gestalt und die Methode des Musikhistorikers August Wilhelm Ambros (1816–1876) besondere Beachtung. Ambros steht sozusagen übergreifend zwischen der auf den Stil gerichteten und einer auch den Vergleich mit den bildenden Künsten nicht scheuenden Betrachtungsweise. Für ihn ist der Zusammenhang der Künste einer Epoche als Ausdruck desselben »Kunstgeistes« eine unbezweifelbare Tatsache: »Man wird es wohl in meiner Musikgeschichte bemerkt haben, wie mir der Kunstgeist dieser oder jener Periode in seinem Zusammenhang klar zu sein, wie mir die Musik und die bildende und bauende Kunst nur Äußerung einer und derselben geistigen Strömung scheint«[50]. Wie Ambros diese Überzeugung im einzelnen in seiner Musikgeschichte (1868) praktiziert, dafür mögen einige Beispiele stehen. So schreibt er über Josquin:

> »Will Josquin innigen Schmerz, zarte Theilnahme ausdrücken, so führt er insgemein die Stimmen eigenthümlich schön in dreiklangmäßig sinkenden Terzschritten – es erinnert fast unwillkürlich an die in holdseliger Demuth geneigten Häupter, wie sie die damaligen Maler heiliger Frauen und Jünglinge so gerne geben«[51].

48 Schelling (Fußnote 9), S. 380.
49 Zitiert nach Würtenberger (Fußnote 41), S. 53.
50 August Wilhelm Ambros, Bunte Blätter, Bd. 1 (Leipzig 1872), S. xi.
51 idem, Geschichte der Musik, Bd. 3 (Leipzig 1868), S. 214.

An anderer Stelle heißt es über die Venezianer:

>»Wie die Venezianischen Maler mit lichtverklärten Farben gemalt, so haben es die Venezianischen Tonsetzer verstanden, durch die Klangfärbung gegen einander gestellter Chöre, späterhin auch durch Einmischung glänzender Instrumentalmassen wahre Wunder des prachtvollsten Klanges zu bewirken. Die mehrchörigen, von Geigen und Posaunen begleiteten Kirchenstücke Johannes Gabrieli's sind als Musik was etwa Tizian's Assunta als Gemälde ist«[52].

Etwas später heißt es im selben Kapitel:

>»Johannes Gabrieli ist der musikalische Tizian Venedigs, wie Palestrina der musikalische Raphael Roms«[53].

Es war der Musikhistoriker Guido Adler, der (1911) die methodischen Grundlagen für eine Stilgeschichte der Musik legte[54]. Er lehnte sich dabei an die Arbeitsweise der Kunstgeschichte an, wie sie von Alois Riegl, August von Schmarsow und Heinrich Wölfflin entwickelt worden war. Musikgeschichte als Stilgeschichte, das war das neue Ziel. Stil aber, das ist für ihn die Gesamtheit und das Gesamtgefüge der Mittel, die einer Komposition, einer Epoche, einer Gattung oder einer Persönlichkeit ein einheitliches Gepräge geben und die bis zu einem gewissen Grade die Einzelfälle zum Ganzen binden, sei es in formaler, harmonischer, rhythmischer, melodischer Beziehung. Ziel der Stilforschung war und ist die Darstellung der Stilentwicklung der Epochen, aber auch die Herausarbeitung der Unterschiede der, so war man überzeugt, streng voneinander getrennten Epochenstile.

All dies wurde an der Musik selbst und an ihren innersachlichen Phänomenen erarbeitet. Vergleiche mit der bildenden Kunst wird man bei den Vertretern dieses Stilbegriffs vergeblich suchen. Solche Abstinenz erstreckt sich bis in die Fachterminologie. So lehnt Hugo Riemann sogar die Epochenbezeichnung »Barock« für die Musikgeschichte ab und spricht statt dessen vom »Generalbaßzeitalter«[55], und noch Jacques Handschin spricht aus demselben Grund vom Zeitalter des »konzertierenden Stils«[56].

Die Musikwissenschaft ist bis heute auf weite Strecken der stilgeschichtlichen Methode und ihren Grundlagen treu geblieben. Zu diesen Grundlagen gehört natürlich letzten Endes ein vorgängiger Musikbegriff, der Musik wesentlich als eine Sache für sich begreift, die ganz und ausschließlich auf ihrem spezifischen Material und ihrer autonomen Struktur beruht, ein Musikbegriff, der seinerseits seine Wurzeln im 19. Jahrhundert hat. Es zeigt sich, daß auch die Musikwissenschaft, wie alle Geschichtswissenschaften, nicht ohne »Vorurteile« auskommt[57].

Neben den rein formalen Stilbegriff schiebt sich seit den 1920er Jahren ein eher kulturhistorisch orientierter Stilbegriff, der Musikgeschichte als Geistesgeschichte zu verstehen sucht, auch er zuletzt zurückgebunden an ästhetische Prämissen des 19. Jahrhunderts bezüglich dessen, was Musik ihrem Wesen nach ist. Seine Konzeption, für die hier nur die Namen Hermann Kretzschmar, Arnold Schering, Wilibald Gurlitt, Curt Sachs stehen mögen, geht einher mit dem neu erwachten Interesse an den Ausdruckswerten älterer Musik, der wiederentdeckten Affektenlehre und der musikalischen Rhetorik. Vor allem aber richtete sich der Blick jetzt wieder verstärkt auch auf das Verhältnis der Musik zu den bildenden Künsten.

Curt Sachs unternahm (1919) den ersten konsequenten Versuch, kunstgeschichtliche Stilphänomene direkt auf die Musik zu übertragen[58]. Er bediente sich dazu der von Heinrich Wölfflin

52 ibidem S. 506. 53 ibidem S. 543. 54 Guido Adler, Der Stil in der Musik (Leipzig 1911).
55 Hugo Riemann, Handbuch der Musikgeschichte, Bd. 2,2 (Leipzig 1912).
56 Jacques Handschin, Musikgeschichte im Überblick (Luzern 1948), S. 22.
57 Vgl. Hans Georg Gadamer, Wahrheit und Methode (Tübingen 1965), S. 250 ff.
58 Curt Sachs, ›Barockmusik‹, in: Jahrbuch Peters (Leipzig 1919), S. 7–15.

an dem Gegensatz von Renaissance und Barock gewonnenen kunstgeschichtlichen Begriffs-paare[59] und suchte deren Entsprechungen in der Musik des 16. und 17. Jahrhunderts. Wölfflins kontrastierende Grundbegriffe lauten: »linear« und »malerisch«, »Fläche« und »Tiefe«, »geschlossene Form« und »offene Form«, »Vielheit« und »Einheit«, »Klarheit« und »Unklar-heit«. Sachs kommt bei seinen Übertragungsversuchen zu teils einleuchtenden, teils fragwürdi-gen Parallelphänomenen für die Musik des 16. gegenüber der des 17. Jahrhunderts. »Linear« nennt er den Kontrapunkt und die selbständige Stimmführung der Niederländer, »malerisch« ist ihm die Prävalenz des Akkordischen vor der Einzelstimme, im Madrigal ebenso wie in der Mehrchörigkeit, »Fläche« wiederum hat für ihn die horizontale Stimmführung der Polyphonie, »Tiefe« zeigt sich in der vertikalen Akkordik, in harmonischer Funktionalität und tonaler Zentrierung. Am problematischsten erscheint die Applikation von »offener Form« auf die Musik des 16. Jahrhunderts, von »geschlossener Form« auf die des 17. Jahrhunderts. Zweifellos sind zum Beispiel Motetten des 16. Jahrhunderts eher »offen«, aber auch die frühe barocke Oper hat eher »offene« als »geschlossene« Formen. Der Drang zu »geschlossener Form« (Arie) nimmt dann allerdings zu. Besser »paßt« das Paar »Vielheit« und »Einheit«. Im 17. Jahrhundert vereinheitlicht sich in der Tat das alte bunte Klangbild des 16. Jahrhunderts. Mehrsätzige Zyklen benutzen oft einheitliches Material. Auch Refrainbindungen, die da-capo-Arie sowie die einthematische Fuge lassen sich für die Einheit anführen. Schwerer tut sich Sachs wiederum bei dem Paar »Klarheit« und »Unklarheit«. Die von ihm genannten Parallelphänomene für »Unklarheit«, wie frei eintretende Dissonanzen, freier Rhythmus in Rezitativ oder Toccata, sind nur Teilerscheinungen, während die Musik des 17. Jahrhunderts im ganzen eher durch »klare« Strukturen gekennzeichnet ist. In seinem späteren Buch[60] zum Thema (1946) modifiziert Sachs die früheren Ansätze. Er versucht außerdem über die epochale Begrenzung von Renaissance und Barock hinaus eine Anwendung auf die gesamte Musik- und Kunstgeschichte.

Bleiben wir noch beim Beispiel »Barock«. Bereits 1928 hatte sich Robert Haas mit dem Versuch von Sachs auseinandergesetzt und sowohl die Methode als Ganzes wie die Einzelergeb-nisse kritisch gemustert[61]. An dem Begriff des »Barock« hielt er jedoch fest. Einen mehr musikimmanenten Begriff von »Renaissance« und »Barock« verwendet dann Theodor Kroyer, indem er der a cappella-Polyphonie des 16. den konzertierenden Stil des 17. Jahrhunderts gegenüberstellt[62]. Ähnlich beschreiben Erich Schenk, Hermann Zenck sowie Manfred Bukofzer den »Barock« als rein innermusikalisches Phänomen[63]. Die bisher differenzierteste Barockbe-stimmung verdanken wir Suzanne Clercx[64]. Die Verfasserin breitet nicht nur die ganze seitherige Diskussion in all ihren Nuancen aus, sondern diskutiert auch ihrerseits und eigenständig Möglichkeiten und Grenzen der gegenseitigen Beziehungen der Künste im »Barock«.

Man sieht, die Bandbreite der Beurteilung des Verhältnisses von bildender Kunst und Musik reicht bis in die Gegenwart von strikter Ablehnung bis zu emphatischer Bejahung, von der Forderung nach streng getrennter Arbeitsweise bis hin zur Verwendung einer gemeinsamen

59 Heinrich Wölfflin, Kunstgeschichtliche Grundbegriffe (München 1915).

60 Curt Sachs, The Commonwealth of Art (New York 1946).

61 Robert Haas, Die Musik des Barocks (= Handbuch der Musikwissenschaft, hrsg. von Ernst Bücken; Potsdam 1929), S. 9–13.

62 Theodor Kroyer, ›Zwischen Renaissance und Barock‹, in: Jahrbuch Peters (Leipzig 1927), S. 45–54.

63 Erich Schenk, ›Über Begriff und Wesen des musikalischen Barock‹, in: Zeitschrift für Musikwissenschaft 17 (1935), S. 377–392. – Hermann Zenck, ›Grundformen deutscher Musikanschauung‹, in: Jahrbuch der Akademie der Wissenschaften in Göttingen (1941/42), auch in: Numerus und Affectus (Kassel 1959); Manfred Bukofzer, Music in the Baroque Era (New York 1947).

64 Suzanne Clercx, Le Baroque et la musique. Essai d'esthétique musicale (Brüssel 1948).

Fachsprache. Es mehren sich neuerdings jedoch Stimmen, die eine eher vermittelnde Position befürworten.

Was die Fragen der Gleichzeitigkeit bzw. Ungleichzeitigkeit der Künste betrifft, so werden sie heute ebenfalls eher differenziert beantwortet. Man hütet sich auf der einen Seite vor allzu strikter Schematisierung und auf der anderen vor allzu schneller Parallelisierung. So warnt zum Beispiel Suzanne Clercx vor der Vorstellung eines »synchronisme absolu« von Kunst und Musik und führt gewisse Gegenläufigkeiten an[65]. Während das italienische Quattrocento eine besonders reiche bildende Kunst hervorbringt, ist die gleichzeitige Musik recht schweigsam. Ähnliches gilt für das niederländische 17. Jahrhundert. Deutschland bringt im 19. Jahrhundert zwar eine bedeutende Musik, aber kaum große Architektur hervor. Und Sachs beharrt zwar grundsätzlich auf der Meinung, daß Kunst und Musik derselben Epoche »a common law and fate« besitzen, beobachtet aber auch, daß innerhalb der großen Epochen des Mittelalters und der Neuzeit jeweils die bildenden Künste am Anfang und die Musik am Ende ihre dominierende Rolle spielen[66].

Alles in allem kann an gewissen Gemeinsamkeiten von bildender Kunst und Musik im epochalen Kontext kaum mehr ein Zweifel bestehen, unbeschadet der großen Unterschiede zwischen ihnen, die durch Verschiedenheit des Materials, der spezifischen Strukturen sowie der aufnehmenden Sinne, nicht zuletzt auch durch die jeweils verschiedene Vorgeschichte bedingt sind. Ein Rest an Gemeinsamkeit wird immer bleiben, so schwer er auch mit exakt wissenschaftlichen Mitteln zu erfassen sein mag. Dies darf uns jedoch nicht entmutigen. Denn die unbezweifelbare Tatsache gewisser »Gleichsinnigkeiten« zwischen bildender Kunst und Musik macht die Frage nach ihnen nicht nur legitim, sondern auch immer wieder notwendig. Der resumierenden Feststellung von Friedrich Blume ist deshalb nur zuzustimmen:

>»Die Forschung über die vergleichende Wertung der Erscheinungen in den verschiedenen Künsten und der Musik steht noch am Anfang. Es wird noch sehr eingehender Untersuchungen bedürfen, um die bisher nur an besonders markanten Kunstwerken beobachtete Gleichsinnigkeit auch in der Tiefe der vielfach einander überschneidenden und widersprechenden Strömungen zu verifizieren«[67].

II. Bildlichkeit und Räumlichkeit in der Musik

Zu den ästhetisch wie historisch wichtigsten und folgenreichsten Phänomenen auf dem Gebiet der Beziehungen von bildender Kunst und Musik gehört die Tatsache, daß die Musik bildliche und räumliche Vorstellungen in sich aufnehmen und ihrerseits auch wieder im Hörer erwecken kann. Daraus ergibt sich eine Fülle von Fragen, denen wir uns im folgenden stellen wollen. Wie also kann sich Sichtbares, Anschauliches, Räumliches in Hörbares, Klangliches verwandeln oder sich in ihm darstellen? Wie funktioniert die Transformation von einem in das andere Medium? Wie hat sich all das geschichtlich manifestiert? Wir fragen also nach den Voraussetzungen und der Geschichte der Bildlichkeit und Räumlichkeit der Musik.

Für die allgemeinen Bedingungen der Möglichkeit der Transformation von Bildlichem in Klangliches sehen wir uns zunächst auf gewisse naturwissenschaftliche Grundlagen des Phänomens verwiesen, wie sie die Physiologie und Psychologie der Musik erarbeitet haben. Daß es überaus enge Beziehungen zwischen Sehen und Hören, zwischen Seh- und Hörvorstellungen gibt, beweist bereits vor jedem wissenschaftlichen Experiment die Sprache und die Sprachge-

65 ibidem S. 234.
66 Sachs, The Commonwealth of Art (Fußnote 60), S. 17 und S. 370.
67 Friedrich Blume, Artikel ›Barock‹, in: Die Musik in Geschichte und Gegenwart, Bd. 1 (Kassel 1949–1951), Sp. 1287f.

schichte seit ältester Zeit und bei allen Völkern[68]. Hierher gehören Worte wie »hoch« und »tief«, »hell« und »dunkel«, »aufsteigen« und »absteigen« für Erscheinungen in beiden Sinnessphären. Die (nach Kant) getrennten Kategorien von Raum und Zeit sind jedenfalls auf sprachlichem Gebiet keineswegs streng getrennt. Die musikalische Fachsprache bestätigt und verstärkt diesen Befund noch. Man denke nur an Ausdrücke wie »Intervall«, »Unterstimme«, »Oberstimme«, »Mittelstimme«, »Baß«, »Sopran«, »Tonraum«, »Klangraum« und so fort[69]. Auffallend ist in diesem Zusammenhang weiter, daß die Richtung der Übertragung anscheinend immer vom Sichtbaren und Räumlichen auf das Hörbare und kaum umgekehrt verläuft. Ob es überhaupt Wörter gibt, die sich in ihrer Urbedeutung auf die Sphäre des Hörens oder gar spezifisch des Musikalischen beziehen, wäre eine Untersuchung wert.

Die Naturwissenschaft ist nun über den Befund der Sprache hinaus mit ihren Mitteln der Frage nach den sogenannten »Ursynästhesien« nachgegangen und hat vor allem auf dem Teilbereich der Beziehungen von Farbe und Ton Ergebnisse erzielt, die auch für uns interessant genug sind. Bereits 1650 konstruierte Athanasius Kircher, von der Identität von Licht und Schall ausgehend, ein Intervallfarbensystem und gelangte zu einer Tonleiter aus 12 Halbtönen, denen 12 Farben entsprechen sollten. 1699 fand Nicole Malebranche, daß Licht und Schall gleichermaßen auf Schwingungsvorgängen beruhen. Und Isaac Newton war es, der 1704 die Gemeinsamkeit der sieben Spektralfarben mit den sieben Tönen der Tonleiter zu beweisen suchte[70].

Auf ähnlichen Prämissen beruht übrigens das Projekt eines Clavecin de couleurs, das Louis-Bertrand Castel in mehreren Schriften zwischen 1725 und 1740 theoretisch entwickelt hat. Die erste trägt den Titel ›Clavecin par les yeux, avec l'art de peindre les sons et toutes sortes de pièces de musique‹. Leitendes Prinzip ist für Castel, daß den Haupttönen bzw. Intervallen des Dreiklangs, also Prim, Quint und Terz als Hauptfarben blau, gelb, rot entsprechen sollen, womit sich z. B. für die *C*-Dur-Tonleiter folgende Entsprechungen ergeben: *c* = blau, *d* = grün, *e* = gelb, *f* = goldgelb, *g* = rot, *a* = purpur, *h* = violett, *c* = blau[71]. Auf spätere Versuche in ähnlicher Richtung bis hin zu Alexander Lászlós »Farbtonklavier« oder Aleksandr Skrjabins Farbe-Musikkombinationen in seinem ›Prometheus‹ sei nur noch hingewiesen.

Auch die neuere Naturwissenschaft geht davon aus, daß zwischen Farbe und Ton gewisse physikalische und physiologische Übereinstimmungen bestehen[72]. So haben Farbe und Ton bezüglich der Wellenlänge und Wellenhöhe durchaus ähnliche Eigenschaften. Und so entspricht der zyklischen Natur der Tonqualitäten (Tonhöhe) die der Farbqualitäten (Helligkeit) nach folgendem Schema (nach Géza Révész):

Fußnoten siehe gegenüberliegende Seite.

Trotzdem ist die volle Identität von optischer und akustischer Welt eine Illusion. So ergibt schon der Versuch, die Schwingungszahlen der Spektralfarben im Sinne der akustischen Proportionen 2:3, 3:4 usw. zu ordnen, keine gleichartigen Phänomene. Und während verschiedene Farben sich zu einer neuen Farbe mischen, gibt es ein entsprechendes Phänomen auf seiten der Töne nicht. Umgekehrt haben Intervalle und Akkorde keine ebensolchen Parallelen in der Optik, und ebensowenig gibt es dort Entsprechungen zum Phänomen von Konsonanz und Dissonanz. Die Entsprechungen der Sinnesgebiete sind also beschränkt.

Der Ursprung der (zumindest partiellen) Ursynästhesien wird heute vielfach in stammesgeschichtlich älteren Regionen des menschlichen Gehirns (Thalamus, Hypothalamus) vermutet, in denen die Sinne noch nicht getrennt waren. Danach sind die Sinne entwicklungsgeschichtlich aus einer gemeinsamen Wurzel – einem Ursinn oder einer Ursinnlichkeit – hervorgegangen oder voneinander abgezweigt[73]. Erich Moritz von Hornbostel erkennt in solchen Urentsprechungen unmittelbare Eindrucksqualitäten[74]. Man hat in diesem Zusammenhang auf die enge Nervenverbindung des menschlichen Ohres mit der Muskulatur des Auges hingewiesen, wodurch allein schon der kooperative Charakter der Wahrnehmung indiziert sei[75]. Jedenfalls kann heute an der Tatsache solcher Entsprechungen und an der daraus resultierenden gegenseitigen Stellvertretung, dem »Vikarieren« der Sinne kein Zweifel mehr bestehen.

Daß sich die Synästhesie von Sehen und Hören nicht nur auf Farben und Töne, sondern auch auf die räumliche Dimension bezieht, steht heute ebenfalls fest[76]. Bereits durch den binauralen Charakter der Hörwahrnehmung kommen die Töne je nach Auftreffwinkel (Kopfdrehung) leicht verschieden, d. h. früher oder später beim Hörer an. Erst recht trifft dies für die dynamische Differenzierung (f, p, cresc., decresc., sfz.) zu, durch die Raum- und Bewegungsvorstellungen erzeugt werden können.

Diese anthropologischen, physiologischen und psychologischen Fakten sind nun ihrerseits erst die Voraussetzung für die Möglichkeit der Bildlichkeit und Räumlichkeit der Musik. Deren Geschichte ist indessen, abgesehen von einzelnen Epochen und Meistern, als Ganzes noch nicht geschrieben. Deshalb kann auch das Folgende nur ein unvollständiger Beitrag sein.

Erst recht spät, ungefähr seit Anfang des 16. Jahrhunderts, treten Phänomene der Bildlichkeit und Räumlichkeit in größerem Umfang in der Musikgeschichte auf, in dem Maße, wie sich die Musik und der Musikbegriff aus dem quadrivialen Verbund lösen und die Alleinherrschaft der strengen Kontrapunktregeln zugunsten größerer Freiheiten in der Ausdrucksdimension gelockert wird. Zu diesen Freiheiten (noch nannte man sie »Schmuck« oder »Lizenzen«) gehört auch

68 Albert Wellek, Artikel ›Farbenhören‹, in: Die Musik in Geschichte und Gegenwart, Bd. 3 (Kassel 1954), Sp. 1804–1811.

69 Vgl. Thrasybulos Georgiades, ›Sprache, Musik, schriftliche Musikdarstellung‹, in: Archiv für Musikwissenschaft 14 (1957), S. 227–229.

70 Belege bei Wellek (Fußnote 68).

71 Vgl. Albert Wellek, Artikel ›Castel‹, in: Die Musik in Geschichte und Gegenwart, Bd. 2 (Kassel 1952), Sp. 898 f.

72 Vgl. Géza Révész, Einführung in die Musikpsychologie (Bern 1946), S. 146–154.

73 Vgl. Albert Wellek, ›Die Entwicklung der Sinne und das Farbenhören in ihrer Bedeutung für die bildende Kunst‹, in: Exakte Ästhetik 3/4 (1966), S. 22; vgl. auch Helmut Rösing, ›Musik und bildende Kunst. Über Gemeinsamkeiten und Unterschiede beider Medien‹, in: International Review of the Aesthetics and Sociology of Music 2 (1971), S. 65–76.

74 Erich M. von Hornbostel, ›Psychologie der Gehörserscheinungen‹, in: Handbuch der normalen und pathologischen Physiologie, Bd. 11 (Berlin 1926), S. 701–730.

75 Siehe Edward A. Lippman, ›Spatial Perception and Physical Location as Factors in Music‹, in: Acta musicologica 35 (1963), S. 28, 33.

76 ibidem S. 24–34.

die Bildlichkeit im weitesten Sinne. Sie steht im Zusammenhang mit dem idealen Streben nach Ausdruck und Anschaulichkeit, das die Musik ganz von selbst in die Nähe von Dichtung und Malerei bringen mußte. Die neue Anschaulichkeit ist im übrigen nicht bloße imitazione della natura, also nicht identisch mit dem Naturvorbild, sondern sie ist Verwandlung des Vorbildes in ein kunsthaftes Medium und besitzt damit eigene strukturelle und ausdruckshafte Qualitäten[77]. Vor allem aber, davon war oben schon die Rede, wird musikalische Bildlichkeit durch Dichtung, durch Worte vermittelt. Sie steht damit im Zusammenhang mit den Bestrebungen der Zeit um einen neuen Sprachcharakter der Musik. Die Musik soll die Sprache nachahmen und zwar sowohl nach der rechten Deklamation als auch nach dem in ihr enthaltenen Inhalt, dem Affekt und nicht zuletzt nach ihrer Bildhaftigkeit. Der Hauptschauplatz für diese Bestrebungen sind zunächst die Vokalmusik des 16. Jahrhunderts in Messe, Motette und Madrigal, später die vokal und instrumental gemischten Gattungen der Oper, des Oratoriums und der Kantate. Noch das Lied des 19. Jahrhunderts übernimmt dieses Erbe. Und nicht zuletzt dringt das Prinzip der Bildhaftigkeit in breitem Strom auch in die textlose Instrumentalmusik ein.

Schon den Zeitgenossen fiel auf, daß es bei Josquin und in seinem Umkreis Beispiele für musikalische Bildlichkeit gibt. So vergleicht Hans Ott in der Vorrede zum zweiten Buch seiner Motettensammlung ›Novum et insigne opus musicum‹ (1538) Josquins »Huc me sidereo« mit einem Gemälde, welches das schmerzliche Antlitz des sterbenden Christus darstellt. Als Hauptdarstellungsmittel nennt er die Verwendung der Tonarten: »quis pictor eam Christi faciem, suppliciis mortis subjecti, exprimere tam graphice potuit, quam modis eam expressit Josquinus, cum tam apte repetit hanc partem versiculi: verbera tanta pati«[78]. Und Heinrich Glarean beschreibt in seinem ›Dodekachordon‹ (1547) Josquins Motette »O Jesu fili David« eindringlich wie eine Art Szene. Er sieht und hört förmlich Cantus und Tenor geschmückt einherschreiten wie Braut und Bräutigam, während Baß und Alt sie wie die Musikanten beim Hochzeitsaufzug geleiten: »Cantus et Tenor . . . ita eodem incedunt vultu, eodemque vestitu, ut velut sponsus sponsam ductitans maritati videantur. Altus ac Basis [sic] festiviter illis et praecinunt et accinunt, atque adeo colludunt, ut Ludiones ad nuptias acciti putentur«[79]. In der Motette »Ego dormio et cor meum vigilat« von Antonius a Vinea sieht Glarean das Erwachen eines Schlafenden bildhaft dargestellt: »Habet autem tota cantio nativam gratiam in omnibus vocibus, ut dormientem vere vigilare videas«[80]. Über die Motette ›Confiteor Domino‹ von Gregor Meyer sagt er, durch Verwendung und Mischung der Tonarten habe der Komponist den Text so kunstvoll gemalt, wie es kein Maler besser vermöchte: »ita affabre pictus, ut nullus Pictor penicillo melius«[81]. Als ob sich eine wirkliche Szene vor den Augen abspiele, so vernimmt Samuel Quickelberg Orlando di Lassos Bußpsalmen: » . . . hos psalmos componendos, qui quidem adeo apposite lamentabili et querula voce, ubi opus fuit ad res et verba accommodando, singulorum affectuum vim exprimendo rem quasi actam ante oculos ponendo expressit, ut ignorari possit, suavitasne affectuum lamentabiles voces, an lamentabiles voces suavitatem affectuum plus decorarint«[82].

In solchen Beschreibungen zeigt sich nicht nur die gesteigerte Rolle der Malerei im Bewußtsein der damaligen Gebildeten, sondern auch das Bestreben der Musik selbst nach

77 Siehe Hugo Friedrich, Epochen der italienischen Lyrik (Frankfurt 1964), S. 415.
78 Hans Ott (Hrsg.), Secundus tomus novi operis musici, sex, quinque et quatuor vocum, nunc recens in lucem editus (Nürnberg 1538), zitiert nach Ambros (Fußnote 51), S. 31.
79 Reprographischer Nachdruck (Hildesheim 1969), S. 354.
80 ibidem S. 253.
81 ibidem S. 434.
82 Zitiert nach Ambros (Fußnote 51), S. 356f.

Anschaulichkeit. Hauptdarstellungsmittel dafür sind, wie wir sahen, zunächst die Tonarten. Wie Bernhard Meier dazu im einzelnen nachgewiesen hat[83], können sowohl die Einzeltonart als solche wie auch der Wechsel und die Mischung der Tonarten innerhalb eines Stückes bildliche und Bewegungsvorstellungen evozieren. Außer der Tonart dienen zunehmend melodische soggetti, Madrigalismen und poetisch-rhetorische Figuren der Darstellung von Affekt und Bildlichkeit. Wichtig ist in diesem Zusammenhang die Feststellung, daß es sich dabei nicht so sehr um subjektive Ausdrucksmittel handelt, sondern um solche, die das Wort und das im Wort Bezeichnete objektivieren, verdinglichen und verbildlichen.

Wichtig für das Verständnis des Prinzips der Bildlichkeit ist weiter die (oben schon angedeutete) Feststellung, daß die verschiedenen musikalischen Ausdrucksmittel für Bildliches zu dem nach kontrapunktischen Regeln gebauten Satz nur hinzutreten, d. h. sie machen niemals die alleinige Substanz der Musik aus. Sie schmücken lediglich den Satz und durchbrechen ihn höchstens einmal als Abweichung von der Norm aus Ausdrucks- und Verbildlichungsgründen, ihn damit jedoch gerade wieder bestätigend. Kontrapunktische Struktur und sprachlich-bildliche Semantik schließen sich also nicht aus, sondern sie sind aufeinander zugeordnet, bedingen sich gegenseitig. Dies ist sowohl ästhetisch wie historisch gesehen ein fundamentaler Sachverhalt. Noch bis weit ins 18. Jahrhundert und darüber hinaus stehen Musik und musikalische Bildlichkeit immer in dieser Relation. Die Anteile der beiden Pole können natürlich jeweils verschieden stark ausgeprägt sein.

Findet man am Anfang der Entwicklung[84], etwa bei Josquin, noch relativ wenige solcher musikalischen Wortbilder, so nimmt ihr Anteil schon bei Adrian Willaert deutlich zu, etwa wenn er Worte wie ignis, sequi, aqua, lux, surgere, cadere, descendere vertont. Geradezu überwältigend wird die Fülle solcher Bilder dann bei Lasso, der kaum ein einschlägiges »Reizwort« ausläßt, als da sind: aqua, fluere, effundere, cadere, abyssus, infernus, profundus, terra, vallis, descendere, jacere, sedere, circum, currere, movere, excitare, flamma, flos, fugere, sequi, lux, movere, niger, quies, saltare, stare, surgere, altus, coelum, sidera, stella, mons, collis, levare, velociter. Auch die Meister des italienischen Madrigals entwickeln im Laufe des 16. Jahrhunderts ein riesiges Arsenal an bildlichen Ausdrucksmitteln. Schon ein oberflächlicher Blick etwa in Claudio Monteverdis Madrigalbücher kann davon einen Eindruck vermitteln.

Auch im 17. und 18. Jahrhundert spielt musikalische Bildlichkeit eine große Rolle. Stellvertretend für viele sei nur der Name Heinrich Schütz genannt. Aus Deutschland stammen auch die meisten Schriften zur musikalischen Poetik und Rhetorik, in denen das System der musikalisch-rhetorischen Figuren kodifiziert wird. Man hat sie in zwei Gruppen eingeteilt, die der Emphasis und der Hypotyposis[85]. Die ersten dienen mehr der Deklamation und dem Affektausdruck, die zweiten sind die eigentlichen Träger der Bildlichkeit, des bildlichen Vergleichs. Der Höhepunkt der kunstvollen Applikation dieser Figuren wird bei J. S. Bach erreicht. Schon Albert Schweitzer[86] hatte (1908) Bach als den konsequentesten Vertreter der »malerischen Musik« gefeiert und ihn Beethoven und Wagner als typischen Vertretern einer »dichterischen Musik« gegenübergestellt. Diese hätten es mehr mit Ideen, Bach mehr mit Bildern zu tun. Was bei Schweitzer mehr intuitiv erkannt worden war, wurde dann erst durch Arnold

83 Bernhard Meier, Die Tonarten der klassischen Vokalpolyphonie (Utrecht 1974), S. 269–314.

84 Vgl. zum Folgenden Horst Leuchtmann, Die musikalischen Wortausdeutungen in den Motetten des Magnum opus musicum von Orlando di Lasso (Baden-Baden 1972), S. 73 ff.

85 Vgl. Arnold Schmitz, Artikel ›Figuren‹, in: Die Musik in Geschichte und Gegenwart, Bd. 4 (Kassel 1955), Sp. 176–183.

86 Albert Schweitzer, J. S. Bach (Leipzig 1908), S. 404 ff.

Schering und seine Schule sowie durch Arnold Schmitz und andere auf eine tragfähige historische Basis gestellt[87]. Die von Schweitzer als malerisch bezeichneten Motive erwiesen sich als Ausformung gerade jener tief in der Tradition der musikalischen Rhetorik verwurzelten Hypotyposisfiguren.

Wir beobachteten bisher das Phänomen der Bildlichkeit ausschließlich an Vokalmusik, bei der textliches und musikalisches Bild zusammen erklingen und sich gegenseitig verdeutlichen. Solche Eindeutigkeit gilt natürlich auch für instrumentalbegleitete Vokalmusik. Eine Zwischenstellung nehmen etwa Orgelchoralbearbeitungen ein, bei denen der Text beim Hören nur intentional mitgedacht, also mitgewußt wird, so daß die dargestellte Bildlichkeit immer noch relativ eindeutig erfaßt werden kann. In völlig textfreier Instrumentalmusik vermögen immerhin Überschriften, Zwischentitel oder vorangestellte Programme die verwendeten musikalischen Bilder wenigstens approximativ verständlich zu machen. Solche rein instrumentale Tonbildlichkeit findet man von der älteren Lauten- und Tastenkunst über die Kammermusik des Barock bis hin zur klassischen und romantischen Musik und darüber hinaus.

Betrachten wir statt vieler ein prominentes älteres Beispiel instrumentaler Bildlichkeit, nämlich Antonio Vivaldis vier Concerti grossi op. 8, ›Die Jahreszeiten‹, die um 1725 entstanden sind[88]. Die Stücke sind als Konzerte rein instrumental, und doch sind sie zugleich durch Sprache hindurchgegangen. Den vier Konzerten liegen vier Sonette zugrunde, die die einzelnen Jahreszeiten beschreiben. Auslösend für die Tonmalerei sind neben den allgemeinen Stimmungs- und Affektbildern die durch Worte hervorgerufenen Bild- oder Bewegungsvorstellungen, wie Wasser, Wind, Gewitter, Tierstimmen, Naturgeräusche, Musikinstrumente, Tanz, zittern, stampfen, gehen, laufen, fallen. Aber auch Worte wie Ruhe, Schlaf, Angst, Klage, Freude werden entsprechend gemalt. Tonmalerisches und Affektuoses sind miteinander verbunden, durchdringen sich. Und ebenso gilt auch hier noch, daß die Tonmalerei nicht von sich aus struktur- und formstiftend wirkt. Sie ist vielmehr voll in die Struktur und Form des Konzertes und seiner Satztypik integriert.

Lange Zeit und auf weite Strecken hat das 18. Jahrhundert Instrumentalmusik nur als Tonmalerei gelten lassen wollen und alle andere Instrumentalmusik wegen ihrer Unbestimmtheit als minderwertig betrachtet. Dies gilt vor allem für Frankreich, wo das Nachahmungsprinzip ja mit besonderem Nachdruck vertreten wurde. Noch Jean-Jacques Rousseau meinte, Instrumentalmusik, die nicht male, sei Plunder: »tous ces fatras de Sonates, dont on est accablé«[89]. Der wahre Musiker sei dagegen derjenige, der »peint tous les tableaux par des sons«[90]. Allerdings muß sich nach Rousseau die musikalische Nachahmung auch auf die Leidenschaften beziehen, dadurch, daß sie »exprime toutes les passions, peint tous les tableaux, rend tous les objets, soumet la Nature entière à ses savantes imitations, et porte ainsi jusqu'au cœur de l'homme des sentimens propres à l'émouvoir«[91]. Man sieht, das Prinzip der bildlichen Nachahmung ist hier noch voll in Geltung.

87 Vgl. Arnold Schering, Das Symbol in der Musik, hrsg. von Wilibald Gurlitt (Leipzig 1941); Heinz Brandes, Studien zur musikalischen Figurenlehre im 16. Jahrhundert (Berlin 1935); Hans-Heinrich Unger, Die Beziehungen zwischen Musik und Rhetorik im 16.–18. Jahrhundert (Würzburg 1941); Arnold Schmitz, Die Bildlichkeit der wortgebundenen Musik Johann Sebastian Bachs (Mainz 1950).

88 Vgl. dazu Werner Braun, Antonio Vivaldi, Concerti grossi op. 8 Nr. 1–4 ›Die Jahreszeiten‹ (= Meisterwerke der Musik Heft 9; München 1975).

89 Jean-Jacques Rousseau, Dictionnaire de musique, Bd. 2 (Amsterdam 1769), S. 219.

90 ibidem Bd. 1, S. 360.

91 ibidem Bd. 1, S. 489f.

In Deutschland verändert sich die Bewertung der Tonmalerei immer mehr ins Kritische, ja Negative. Am Anfang wird bloße Naturnachahmung abgelehnt, wenn sie nicht gleichzeitig verbunden ist mit der Nachahmung der durch sie ausgelösten Empfindungen. So unterscheidet Johann Jakob Engel[92] 1780 drei Arten von Nachahmung in der Musik und wertet sie entsprechend: Erstens die Nachahmung von zugleich Hörbarem und Sichtbarem, zweitens die Nachahmung des Sichtbaren, drittens die Nachahmung der Empfindungen, die den Eindruck nachahmen, den ein Gegenstand auf die Seele macht. In diesem letzten Sinne, und wohl auch direkt auf Engel zurückgehend, ist Beethovens Anmerkung zu seiner Pastoralsymphonie im Programmheft der Uraufführung 1808 zu verstehen: »Mehr Ausdruck der Empfindung als Mahlerey«. Wohlgemerkt, »Mahlerey« ist damit immer noch impliziert!

Schließlich kommt es zu völliger Ablehnung der Tonmalerei, in dem Maße nämlich, wie die reine, bald »absolut« genannte Instrumentalmusik aufsteigt und als Inbegriff von Musik schlechthin gefeiert wird. Zu ihrer Rechtfertigung wird nun gerade jener Umstand angeführt, der früher als Mangel der Instrumentalmusik galt, ihre Unbestimmtheit, Bildlosigkeit, die Abwesenheit von Tonmalerei. Musik als Ausdruck der Unendlichkeit, der unendlichen Sehnsucht, der tönenden Innerlichkeit, das sind jetzt Vorzüge und Ideale zugleich.

Trotz dieser neuen Bewertung der reinen Instrumentalmusik bleiben auch jetzt noch Bildlichkeit und Bildvorstellungen erhalten. Man sieht dies sowohl an vielen klassischen Kompositionen als auch an der Art der Beschreibung bzw. der sprachlichen Rezeption von Instrumentalmusik. So greift E. Th. A. Hoffmann, einer der beredtesten und glühendsten Anhänger jener These von der Unbestimmtheit und Unendlichkeit der Instrumentalmusik, doch immer wieder auf Bildliches zurück und bedient sich einer ausgesprochen malerischen Metaphorik. Er spricht zwar einerseits emphatisch davon, daß es die Instrumentalmusik sei, »welche, jede Hülfe, jede Beimischung einer anderen Kunst verschmähend, das eigentümliche, nur in ihr zu erkennende Wesen der Kunst rein ausspricht«[93], bedient sich aber andererseits einer überaus bilderreichen Sprache. Führt man seine romantisch überhöhte Bildersprache auf ihren traditionellen Kern zurück, dann erkennt man bald die vertrauten Bildtopoi der älteren Zeit wieder, nur eben in neuem Gewand und bis zu einem gewissen Grade entgrenzt. So schreibt er etwa über Haydn: »Seine Sinfonien führen uns in unabsehbare grüne Haine ... Gewühl glücklicher Menschen, Reihentänze, Bäume, Rosenbüsche ... Abendrot, von dem Berg und Hain erglühen.« Über Mozart heißt es u. a.: » ... die Nacht geht auf in hellem Purpurschein ... Gestalten, freundlich winkend ... Sphärentanz ... durch die Wolken fliegen.« Über Beethoven: » ... glühende Strahlen schießen durch dunkle Nacht ... Riesenschatten, auf- und abwogend«[94]. In seiner berühmten Rezension von Beethovens fünfter Symphonie[95] beschreibt er das zweite Thema des ersten Satzes als »freundliche Gestalt, die glänzend, die tiefe Nacht erleuchtend, durch die Wolken zieht«. Im dritten Satz hört er »Wetterwolken und Blitze«. Das Thema des letzten Satzes ist ihm »wie ein strahlendes, blendendes Sonnenlicht, das plötzlich die tiefe Nacht erleuchtet«. Die Beispiele ließen sich vermehren.

Einen gewaltigen Aufschwung erhält die musikalische Bildhaftigkeit wiederum in der Programmusik des 19. Jahrhunderts, die als Programmouvertüre, Programmsymphonie, Sym-

92 J. J. Engel, Über die musikalische Mahlerey (Berlin 1780).

93 Rezension von Beethovens 5. Sinfonie in: Allgemeine Musikalische Zeitung (Leipzig 11. Juli 1810), wieder abgedruckt in E. Th. A. Hoffmann, ›Beethovens Instrumentalmusik‹, in: Sämtliche Werke (Fußnote 30), Bd. 2, S. 46–55.

94 ibidem S. 47 f.

95 ibidem S. 429 ff.

phonische Dichtung in Erscheinung tritt. Auch das Charakterstück wird unübersehbar zum Träger instrumentaler Bildlichkeit. Auch jetzt noch sind es in der Hauptsache literarisch-dichterische Themen, durch deren Vermittlung musikalische Bildhaftigkeit ausgelöst wird.

Es gibt aber auch Fälle, in denen das musikalische Abbild unmittelbar auf Bilder als Vorbild zurückgeht. Dazu gehören etwa Liszts Klavierstücke ›Sposalizio‹ (nach Raffael), ›Il Pensieroso‹ (nach Michelangelo) aus den ›Années de pèlerinage‹. Liszts ›Totentanz‹ für Klavier und Orchester ist angeregt durch das Fresko Francesco Trainis im Camposanto in Pisa, die symphonische Dichtung ›Die Hunnenschlacht‹ geht auf Wilhelm von Kaulbachs gleichnamiges Gemälde zurück. Modest Mussorgskis ›Bilder einer Ausstellung‹ basieren auf Gemälden von Viktor Hartmann. Claude Debussy wurde durch Jean-Antoine Watteau zu seiner ›L'isle joyeuse‹ für Klavier angeregt. In seiner Böcklinsuite nimmt Max Reger vier Bilder als Ausgangspunkt: ›Der geigende Eremit‹, ›Im Spiel der Wellen‹, ›Toteninsel‹, ›Bacchanal‹. Paul Hindemiths Symphonie ›Mathis der Maler‹ mit den Sätzen ›Engelskonzert‹, ›Grablegung‹, ›Die Versuchung des hl. Antonius‹ geht auf den Isenheimer Altar des Matthias Grünewald zurück. Aus noch jüngerer Zeit stammen Stücke wie ›Los Caprichos‹ von Hans Werner Henze nach Francisco José de Goya oder Giselher Klebes ›Zwitschermaschine‹ nach Paul Klee[96].

Bild und Bildlichkeit sind indes im 19. Jahrhundert keineswegs nur auf die Programmusik beschränkt, sondern reichen bis tief in die sogenannte »absolute Musik« hinein. Dies zeigte sich bereits indirekt bei der literarischen Klassikerrezeption E. Th. A. Hoffmanns. Vollends gegen Ende des Jahrhunderts greift die Antithese von absoluter und programmatischer Musik oder auch von autonomer und heteronomer Musik, meist mit jeweiligem Absolutheitsanspruch verfochten, nicht mehr. Bei Anton Bruckner und Gustav Mahler sind beispielsweise die beiden Aspekte von Musik als autonomer Struktur und Musik als Träger semantisch-bildlicher Qualitäten untrennbar verbunden. Es erscheint in diesem Zusammenhang symptomatisch, daß man neuerdings wieder auf den Begriff des »Bildes« als besonders geeignetes Instrument zur Überwindung des alten Gegensatzes zurückgreift[97]. In der Tat verbindet der Bildbegriff Strukturelles und Semantisches nahezu bruchlos und erlaubt zudem die Einbeziehung der historischen Tiefenschichtung der Bildlichkeit. Rudolf Stephan stellt in diesem Zusammenhang als Paradigma die Gestaltung des heraufkommenden oder hereinbrechenden Lichtes heraus und zeigt dessen musikalische Gestaltung an Werken von Haydn (›Die Schöpfung‹), Beethoven (5. Symphonie), Giacomo Meyerbeer (›Der Prophet‹), Richard Strauss (›Alpensymphonie‹)[98]. Als immer wiederkehrende Mittel der Bildgestaltung erweisen sich dabei harmonischer Stillstand, crescendo, Aufwärtsbewegung, Erweiterung des Ambitus, Beschleunigung durch Figuration, Dreiklangsbildungen und eine gewisse Vorliebe für die Tonart C-Dur.

Unser kurzer Überblick hat gezeigt, wie bildhafte Elemente seit etwa 1500 in immer stärkerem Maße in die europäische Musik eingegangen sind. Ausgelöst wurden sie durch eine allgemeine Versprachlichung der Musik und durch den daraus resultierenden Drang, die in der Sprache evozierten Bilder ihrerseits musikalisch zu veranschaulichen. Unbeschadet der mehrfachen Stilwandlungen seitdem sammelte sich im Laufe der Zeit ein großes Arsenal an bildlichen Ausdrucksmitteln an. Lag der Schwerpunkt zunächst auf der Vokalmusik, so wanderte die Bildlichkeit bald auch in die Instrumentalmusik, sowohl als Begleitung zu vokaler Musik als auch in Form der reinen Instrumentalmusik.

96 Weitere Beispiele bei Würtenberger (Fußnote 41), S. 189.

97 Vgl. Rudolf Stephan, ›Außermusikalischer Inhalt – musikalischer Gehalt‹, in: Jahrbuch des Staatlichen Instituts für Musikforschung, Berlin 1969 (1970), S. 93–107.

98 ibidem.

Nicht nur Bild und Bildlichkeit im engeren Sinne gehören zur Welt des Anschaulichen und können in das Medium des Hörbaren, die Musik übertragen werden, sondern auch Raum und Räumlichkeit. Beide Dimensionen sind ja auch kategorial kaum zu trennen. Und obwohl wir Phänomene des Räumlichen im Vorstehenden schon gelegentlich berührt haben, erscheint es doch angebracht, ihnen hier noch einige Überlegungen und Beobachtungen im Zusammenhang zu widmen.

Jede Musik ist an einen Raum gebunden, in dem sie erklingt, sei es der Naturraum oder der Architekturraum. Und es ist für eine Musik keineswegs zufällig, ob sie im Kirchenraum, im Festsaal des Palastes, auf der Bühne, im Freien oder im bürgerlichen Zimmer erklingt. Die Beziehungen zwischen Doppel- und Mehrfachemporen des Barock und der mehrchörigen Musizierpraxis sind ein allgemein bekanntes Faktum. Und ebenso wissen wir heute, daß im 17. und 18. Jahrhundert dieselbe Musik je nach Aufführungsort und -raum ganz verschieden besetzt und eingerichtet werden mußte. Erst im 19. Jahrhundert werden zunehmend Besetzung und Ausführungsweise genau und endgültig fixiert, ein Phänomen, das nicht zuletzt mit der neuen Funktion des Konzertsaals zusammenhängt, der zum Einheitsraum für fast alle Musik wird. Völlige Ubiquität, ohne die Notwendigkeit einer Raumanpassung erlangt Musik schließlich durch die modernen elektronischen Medien. Jetzt kann jede Musik beliebig und überall, an jedem Ort, zu jeder Zeit, bei jeder Gelegenheit, in jedem Raum erklingen.

Die Dimension des Raumes wirkt sich aber nicht nur in der geschilderten äußeren Relation zur Musik aus, sondern sie kann auch in die innere Verfassung der Musik selbst hineinwirken, in sie eindringen[99]. Dies zeigt sich bereits auf der Elementarstufe des räumlichen Erfassens des Auf und Ab einer Melodie, der Höhe und Tiefe, der Bewegung, der dynamischen Unterschiede. Kompositorisch konkretisiert erscheinen solche Möglichkeiten z. B. in den Fern- und Nahchören auf der Bühne, etwa in Mozarts ›Idomeneo‹, in der »Trompete auf dem Theater« in Beethovens ›Fidelio‹. Aber auch ohne solche szenisch-räumliche Konkretisierung können Raumvorstellungen allein mit den Mitteln orchestraler Technik erzeugt oder assoziiert werden, wobei ein fiktiver, imaginärer Raum entsteht. In der Mitte zwischen realer und imaginärer Räumlichkeit steht der Dialog (Oboe und Englisch Horn) der beiden Hirten in Hector Berlioz's ›Symphonie phantastique‹. Vollends ohne jede reale Raumdimension, allein mit den Mitteln der Dynamik und der Instrumentation, entsteht Raumwirkung in Wagners ›Lohengrin‹-Vorspiel, in dem die Vorstellung des aus der Höhe herabschwebenden und wieder dorthin entschwindenden Grals geweckt wird. War die Raumdimension bei Wagner noch vergleichsweise fest an die traditionelle Satzstruktur aus Melodik, Harmonik und Rhythmik gebunden, so verräumlicht man in jüngster Zeit Musik noch wesentlich radikaler und ausschließlicher, wie das z. B. in György Ligetis Stück ›Lontano‹ von 1967 der Fall ist. Der Komponist bekennt dazu ausdrücklich: »Raum suggerieren, oder Raum assoziativ hervorbringen, das war etwas, was ich in meinen Stücken angestrebt habe«[100].

Bei starker Verräumlichung von Musik tritt ihre Zeitdimension entsprechend zurück. Dabei verliert die Musik viel von ihrem Verlaufscharakter und von ihrer Verlaufsgestalt. Dies kann bis zur (intendierten) völligen Entzeitlichung führen. Zumindest erhalten die Kategorien von Raum und Zeit fließende Grenzen, sie werden immer mehr gegeneinander offen. Solche Entgrenzung kann u. a. auch dadurch erreicht werden, daß der Komponist verschiedene Zeitebenen simultan schichtet, indem er etwa das normale und vom Hörer auch erwartete Nacheinander des Ablaufs

99 Vgl. Stefan Kunze, ›Raumvorstellungen in der Musik‹, in: Archiv für Musikwissenschaft 31 (1974), S. 1–21.
100 Zitiert nach Kunze, ibidem S. 20f.

von Szenen in die Gleichzeitigkeit bringt. So verwendet Bernd Alois Zimmermann in seiner Oper ›Die Soldaten‹ (1960) vielfach gestaffelte Spielflächen, auf denen sowohl sukzessiv als auch simultan agiert wird, so daß der Zuschauer gleichzeitig Vergangenes, Gegenwärtiges und Zukünftiges sieht und hört. Der Komponist selbst begründet diese »pluralistische Kompositionsart« mit seiner philosophischen Konzeption von der »Kugelgestalt der Zeit«, für die er sich auf den hl. Augustinus beruft[101]. Das Prinzip der Simultanschichtung ist im übrigen in der abendländischen Musikgeschichte nichts Neues, wenn auch nicht in dieser Radikalität. Es reicht von der mehrtextigen Motette des Mittelalters über Chanson, Kantate und Oper bis zu den Zitat- und Collagetechniken unserer Zeit[102].

Den Tendenzen zur Entzeitlichung und Verräumlichung der Musik scheinen gegenläufig gewisse entgrenzende Tendenzen in der modernen bildenden Kunst zu entsprechen, die auf Enträumlichung und Verzeitlichung des Bildes gerichtet sind. Der Kubismus der Zeit um 1910 hebt die Raumtiefe des Bildes, die in der Renaissance entdeckt und seitdem unabdingbar geworden war, wieder auf und macht einzig die Bildfläche zum Schauplatz. Oft erscheint auf ihr derselbe Gegenstand mehrfach und gleichzeitig in verschiedenen Ansichten, von vorn, von der Seite oder von hinten, was normalerweise im Raum nicht möglich ist. Und es scheint, als ob hier etwas von der Zeitdimension in die Raumkunst eingebracht, dem Raum inhärent gemacht werden solle, indem der Maler nicht nur die Raumtiefe liquidiert, sondern auch frei über verschiedene Blickpunkte verfügt, sie abstrahiert und neu zusammensetzt. Ob im übrigen die auffallend häufige Verwendung von Musikinstrumenten wie Gitarre oder Violine auf kubistischen Bildern von Pablo Picasso, Georges Braque und Juan Gris vielleicht etwas mit ihrer Eigenschaft als Werkzeuge der Zeitkunst Musik zu tun haben könnte, darf allerdings wohl nur vermutet werden.

III. Die Musik im Bild

Haben wir bisher die Übertragung bildlicher und räumlicher Phänomene in die Musik behandelt, so wenden wir uns im folgenden den Phänomenen der Übertragung von Musik in die Welt des Anschaulichen allgemein und in die bildende Kunst im besonderen zu. Daß es sich bei der bildlichen Darstellung von Musik keineswegs nur um eine bloße Umkehrung oder so etwas wie eine parallele Rückläufigkeit, etwa im Sinne einer Gleichung: Bild → Musik = Musik → Bild handelt, sondern um Beziehungen jeweils ganz eigener Art, ist zu zeigen. Die beiden wichtigsten Komplexe in diesem Zusammenhang sind die Notenschrift und die Darstellungen von Musik in der Kunst.

Die Notenschrift ist Projektion des Erklingenden bzw. dessen, was erklingen soll, ins Graphische und Räumliche, des Hörbaren ins Sichtbare. Sie ist zugleich Abbild und Vorbild der Musik. In diesem Sinne ist die Schriftlichkeit eines der fundamentalen Phänomene der abendländischen Musikgeschichte überhaupt. Ja, ohne die anschauliche Darstellung von Musik gäbe es überhaupt keine Musikgeschichte im Sinne der Geschichte von Komposition, Satztechnik und großer Werke[103].

101 Vgl. Ursula Stürzbecher, ›Werkstattgespräche mit Bernd Alois Zimmermann‹, in: Melos 37 (1970), S. 447; vgl. auch B. A. Zimmermann, Intervall und Zeit (Mainz 1974), S. 11 ff.

102 Vgl. Reinhold Hammerstein, ›Über das gleichzeitige Erklingen mehrerer Texte. Zur Geschichte mehrtextiger Komposition unter besonderer Berücksichtigung J. S. Bachs‹, in: Archiv für Musikwissenschaft 27 (1970), S. 257–286.

103 Vgl. idem, ›Musik als Komposition und Interpretation‹, in: Deutsche Vierteljahrsschrift für Literaturwissenschaft und Geistesgeschichte 40 (1966), S. 1–23.

Die Notenschrift wird seit dem 9. Jahrhundert greifbar. Seitdem schreitet sie folgerichtig zu immer weiterer Beherrschung der einzelnen musikalischen Phänomene fort: rationale Durchdringung des Tonraums, Fixierung der Tonhöhe, räumliche Zuordnung von simultan Erklingendem in der Mehrstimmigkeit, Darstellung des rhythmischen und bewegungsmäßigen Verlaufs. Schließlich erfaßt sie auch die zunächst noch freien Parameter der Besetzung, der Instrumentation, des Vortrags, der Dynamik, Artikulation und Phrasierung und stellt sie sichtbar dar. So wird die Notenschrift zum durchgearbeitetsten graphischen System neben der Wortschrift überhaupt.

Neben der eigentlichen Normalnotation bilden sich im Laufe der Musikgeschichte immer wieder interessante graphische und farbliche Sonderformen heraus, die meist in symbolischer Absicht verwendet werden. Die Schwärzung von Noten im Rahmen der normalerweise weißen Mensuralnotation dient im späten 15. und im 16. Jahrhundert vielfach der zusätzlichen Textausdeutung, etwa bei Worten wie dunkel, böse, Tod, Trauer. Zahlreiche Belege dafür finden sich in Chansons und Motetten, vornehmlich Totenklagen, aber auch in Messen bei den Worten peccata mundi, miserere nobis, (vivos et) mortuos[104]. Wenn auch nach den Regeln der Mensuraltheorie durch die Schwärzung sich die Notenwerte mitunter verändern, so bleibt das Ganze doch ein bloß optisches Phänomen, das der Hörer nicht verstehen kann. Das gemeinte Symbol reicht also nur vom schreibenden Komponisten bis zu den Ausführenden.

Auch die italienischen Madrigalisten des 16. Jahrhunderts bedienen sich gern solcher Mittel der Aufzeichnung bei Worten wie bianco – nero, notte – giorno, die durch weiße und schwarze Noten zusätzlich charakterisiert werden. Alfred Einstein hat dafür den treffenden Begriff Augenmusik geprägt[105]. Auch bei J. S. Bach gibt es solche bloße Augenmusik, wenn er z. B. bei den Worten Kreuz oder kreuzigen das Kreuzzeichen der Notenschrift verwendet. Nicht nur sehen, sondern auch hören kann man es allerdings, wenn auch die Melodie selbst eine kreuzförmige Bewegung erhält. Unhörbar und nur sichtbar wiederum ist die im Barock beliebte Aufzeichnung von Kanons in Kreisform, sichtbares Symbol für die umlaufende Wiederkehr der musikalischen Form und zugleich allgemeines Zeichen der Vollkommenheit. Auch unser Jahrhundert kennt noch derartige Augenmusikphänomene, so wenn Erik Satie ›Drei Stücke in Form einer Birne‹ (1903) schreibt oder wenn Anton Webern gelegentlich grüne, rote, blaue und schwarze Tinten benützt, um für Spieler und Leser strukturelle Zusammenhänge zu verdeutlichen.

In den letzten Jahrzehnten vollends sind im Zusammenhang mit den Veränderungen des traditionellen Kompositions- und Werkbegriffs auch grundlegende Veränderungen in der Art der Aufzeichnung von Musik einhergegangen. Graphische Darstellungsweisen abseits von der traditionellen Notenschrift haben eine außerordentliche Bedeutung erlangt. Mit ihnen hat sich die Funktion von Schrift und Schriftlichkeit überhaupt gewandelt. Nicht mehr und nicht nur bestimmt die Musik allein die Schrift, sondern die Schrift und Graphik bestimmen umgekehrt die Musik mit. Der Komponist Karlheinz Stockhausen formulierte diesen Sachverhalt bereits 1959 so: »Vor neun Jahren etwa begann eine unerwartete Differenzierung der Schriftzeichen und jeder Komponist weiß heute, daß die kompositorische Arbeit zum großen Teil vom gewählten graphischen System bestimmt wird«[106]. In diesen neuesten graphischen Notationssystemen, die allerdings niemals zur Allgemeingültigkeit gelangt sind, spielen Zahlen, Kurven, Millimeterpapier, Linien, Arabesken und dergleichen eine große Rolle. Die Grenzen von Musik und Graphik

104 Siehe Willem Elders, Studien zur Symbolik in der Musik der alten Niederländer (Bilthoven 1968), S. 20ff.
105 Alfred Einstein, The Italian Madrigal, Bd. 1 (Princeton 1949), S. 234ff.
106 Karlheinz Stockhausen, ›Musik und Graphik‹, in: Texte 1 (Köln 1963), S. 178.

werden in ihnen vollends fließend, und man steht vor einer neuen Art von Augenmusik, allerdings ohne deren einstige semantische Rückbindungen. So nennt Dieter Schnebel denn auch folgerichtig sein Stück ›Mo-No‹ im Untertitel ›Musik zum Lesen‹. Und von John Cage ist bekannt, daß er seine Partituren gelegentlich auch als Graphiken verkauft hat.

Die Notation ist nicht nur Projektion von Klanglichem ins Sichtbare, sondern sie ist zugleich auch Anweisung, dieses Sichtbare umgekehrt wieder in Klangliches zu verwandeln. Sie funktioniert also im Relationsfeld von Sehen und Hören doppelt, indem sie die Grenzen der Medien in beiden Richtungen überschreitet.

Ganz anders liegt der Sachverhalt bei den Darstellungen von Musik in der bildenden Kunst, jenen Objekten also, die den Gegenstand der Musikikonographie bilden. Von der Notation unterscheidet sich die bildliche Musikdarstellung dadurch, daß die Relationsrichtung bei ihr nur nach einer Seite verläuft, von der Musik zum Bild und nicht in beiden Richtungen wie dort. Von den Relationsphänomenen der Bildlichkeit und Räumlichkeit in der Komposition wiederum unterscheidet sie sich dadurch, daß, während dort das Bildliche voll und ganz ins Klangliche verwandelt, in musikalisches Material und musikalische Struktur umgesetzt wird, hier eine solche totale Transformation von einem in das andere Medium nicht stattfindet, sondern es wird nur das Sichtbare an der Musik abgebildet. Dazu gehören die Instrumente, die Spieler und Sänger, die Aufführungspraxis, der Raum, die Zuhörer, die Lebensumstände, aber auch die geistigen und symbolischen Implikationen von Musik, soweit sie sichtbar gemacht werden können, nicht jedoch die Musik als Erklingendes selbst.

Eine Ausnahme scheinen jene Fälle zu machen, in denen bestimmte Kompositionen oder auch Kompositionsprinzipien die Anregung und den Ausgangspunkt für die Entstehung von Bildern bilden, bei denen also der Weg direkt von musikalischer Substanz zur bildenden Kunst führt oder doch zu führen scheint. Das Phänomen tritt erst spät, das heißt nicht vor dem 19. Jahrhundert auf. So malt Philipp Otto Runge eine ›Fuge‹, von der er möchte, »daß dieses Bild dasselbe wird, was eine Fuge in der Musik ist«[107]. Max Klingers ›Brahms-Phantasie‹ übersetzt auf ihre Weise Musik ins Bild. Die Tendenz verstärkt sich im Schaffen von Paul Klee, der übrigens selbst ein vorzüglicher Musiker war. Von ihm gibt es unter anderem eine ›Fuge in Rot‹, eine ›Dreistimmige Polyphonie‹ und eine ›Polyphonie‹. Georges Braque nennt ein Bild ›Aria di Bach‹. Gerade bei den Vertretern der abstrakten Malerei scheint hinter solchen Bemühungen der Wunsch zu stehen, von der Gegenständlichkeit wegzukommen, indem man strukturelle Prinzipien der Musik in die Malerei zu übertragen versucht, um auf diese Weise zur Abstraktion und zu einem neuen Konstruktivismus zu gelangen.

Es kann im Rahmen dieses Beitrags nicht unsere Aufgabe sein, das Gesamtfeld der Musikikonographie zu beschreiben. Wir beschränken uns vielmehr auf einige Überlegungen zu ihrer Bedeutung für die musikgeschichtliche Forschung, zu ihren Methoden sowie ihrem Verhältnis zur kunstgeschichtlichen Ikonographie.

Die Einbeziehung bildlicher Darstellungen in das Schrifttum über Musik ist längst zu einer Selbstverständlichkeit geworden. Und doch ist es ein weiter Weg von den Anfängen bis heute. Textillustrationen finden sich schon in mittelalterlichen Psalterhandschriften und -kommentaren sowie in Musiktraktaten[108]. Im frühen 16. Jahrhundert beginnen Abbildungen in speziellen Abhandlungen über Musikinstrumente eine große Rolle zu spielen. Sie reichen von Sebastian Virdung, Martin Agricola im 16. bis zu Michael Praetorius, Marin Mersenne und Athanasius

107 Vgl. Würtenberger (Fußnote 41), S. 178.
108 Siehe Tilman Seebaß, Musikdarstellung und Psalterillustration im früheren Mittelalter, 2 Bde. (Bern 1973).

Kircher im 17. Jahrhundert. Mit Martin Gerberts Illustrationen aus mittelalterlichen Handschriften[109] wird das Bild gezielt als musikgeschichtliche Quelle eingesetzt. Ihm folgen im 19. Jahrhundert Arbeiten von Henri-Marie-François Lavoix fils[110], Charles-Edmond-Henri de Coussemaker[111] und anderen, bis 1903 mit Edward Buhle die wohl erste wissenschaftliche Beschäftigung mit dem Gegenstand selbst, wenn auch nur auf einem begrenzten Teilgebiet, der Darstellung von Blasinstrumenten auf Miniaturen des frühen Mittelalters, einsetzt[112]. Nicht zu übersehen ist allerdings auch, daß im 20. Jahrhundert, dem Zeitalter der totalen Reproduzierbarkeit, die Illustration und ihre Verwendung zwar in breitem Strom angeschwollen ist, nicht selten aber auch zu geradezu hypertropher Verwendung des Bildes in der Literatur über Musik geführt hat.

Gegenstand der Musikikonographie sind Musikdarstellungen aller Art in Vergangenheit und Gegenwart. Sie werfen eine Fülle von Fragen nach ihrer Erfassung, nach der Quellenkritik, der Interpretation und ihrem Wert für die Musikwissenschaft auf. Diesbezügliche Überlegungen beginnen erst spät. Nachdem Guido Adler der Ikonographie einen bisher kaum beachteten, wenn auch nur kurzen Abschnitt in seiner ›Methode der Musikgeschichte‹ (1919) gewidmet hatte[113], setzte erst in den 30er Jahren eine stärkere Konzentration auf das Thema ein, wofür etwa die Max Seiffert-Festschrift ›Musik und Bild‹ von 1938 symptomatisch ist[114]. Doch fallen auch dort die Methoden und Ergebnisse je nach Verfasser, Thema und Fragestellung außerordentlich heterogen und manchmal auch widersprüchlich aus, und es kommt noch lange nicht zu einer Bestimmung der Musikikonographie als Ganzes. Erst seit den 50er Jahren beginnt die ikonographische Forschung mündig zu werden, indem sie ihre Grundlagen, ihre Möglichkeiten und Grenzen sowie ihre Methoden reflektiert.

Was die Rolle der Ikonographie als Hilfswissenschaft musikgeschichtlicher Forschung im ganzen betrifft, so wird sie um so größer und unverzichtbarer, je weiter wir in der Geschichte zurückgehen. Es liegt auf der Hand, daß die Bildquellen für Zeiten, aus denen wir keine anderen Überlieferungen besitzen, an Wichtigkeit zunehmen. Dies gilt vornehmlich für Zeiten ohne notenschriftliche Quellen, für die Antike ebenso wie für das frühe Mittelalter und auch noch für spätere Zeiten. Denn die schriftliche Überlieferung von Musik setzt erst spät ein, und auch dann gibt es noch lange eine schriftlose Praxis, für die Bilder oft unsere einzigen Quellen sind.

Nun ist der Charakter der Informationen von Musikdarstellungen sehr verschiedenartig und damit auch die Möglichkeit ihrer Auswertung. So können Bildquellen Auskunft geben über Art und Aussehen von Musikinstrumenten, über ihre Spielweise, ihr Zusammenwirken im Ensemble, über aufführungspraktische Gepflogenheiten. Sie unterrichten uns über kultur- und sozialgeschichtliche Zusammenhänge der Musik, über den Status der Musizierenden, den Aufbau und die Zusammensetzung von Kapellen und Kantoreien, über ihre Rolle in Zeremoniell, Liturgie, Fest und Begehungen aller Art, ihre Zuordnung zu Kirche, Hof, Stadt, Bürgertum, Gelehrten, Bauern und den alleruntersten Schichten von Spielleuten, Bettlern und Narren. Und schließlich erfahren

109 Martin Gerbert, De cantu et musica sacra, 2 Bde. (St. Blasien 1774).

110 H. Lavoix fils, ›La musique dans l'ymagerie du moyen-âge‹, in: Adolphe Didron, Annales archéologiques (Paris 1875), und als Separatum (Paris 1875).

111 Ch.-E.-H. de Coussemaker, ›Essai sur les instruments de musique au moyen-âge‹, in: Didron, Annales archéologiques (1845–1858).

112 Edward Buhle, Die musikalischen Instrumente in den Miniaturen des frühen Mittelalters, Bd. 1: Die Blasinstrumente (Leipzig 1903).

113 Guido Adler, Methode der Musikgeschichte (Leipzig 1919), S. 86–88.

114 ed. Heinrich Besseler (Kassel 1938).

wir aus ihnen mancherlei über die Musikanschauung einer Zeit, über theologische, mythologische, symbolische und allegorische Aspekte der Musik[115].

Bevor jedoch der Musikhistoriker seine Schlüsse ziehen kann, muß er sich die Frage nach dem angemessenen Verstehen dessen, was da jeweils dargestellt ist, stellen. Es gab eine Zeit, in der man die Bildquellen sozusagen naiv und undifferenziert als realistisches Abbild musikalischer Wirklichkeit, als eine Art Photographie der Lebenswirklichkeit auffaßte. Daraus haben sich viele unrichtige, oft auch groteske Schlußfolgerungen ergeben. Wir verzichten auf Beispiele. Heute hat sich, wenn auch keineswegs überall, die Erkenntnis durchgesetzt, daß man ein Bilddokument vor aller Applikation auf die Musik erst einmal als Quelle sui generis, als kunstgeschichtlichen Gegenstand mit eigenen und spezifischen Merkmalen anschauen und verstehen muß. Mit anderen Worten, der Musikikonograph bedarf der Hilfe der Kunstgeschichte und ihrer Methoden.

Zu solchen kunstwerkspezifischen Merkmalen gehört zunächst das Material, das die Art der Darstellung wesentlich mitbestimmt. Es ist nicht gleichgültig, ob ein Bildwerk aus Stein, Holz, Pergament, Leinwand oder Papier besteht. Wichtig ist auch, welcher Gattung ein Objekt angehört, ob es sich um eine Skulptur, ein Fresko, ein Tafelbild, um eine Miniatur oder einen Holzschnitt handelt. Erst recht von großer Bedeutung ist die Stilzugehörigkeit eines Bildwerks.

Mit dem Stil wiederum hängen häufig bildkompositionelle Aufbauprinzipien von Bildern zusammen, die die Erscheinungsweise der dargestellten Inhalte bestimmen können und die keineswegs immer und ohne weiteres als realistisches Abbild einer konkret musikgeschichtlichen Wirklichkeit gelten können.

In der Tat ist die wohl wichtigste Frage, für die der Musikikonograph sich immer wieder auf die Hilfe der Kunstgeschichte angewiesen sieht, bevor er sich an die Auswertung für sein Fach machen kann, die nach dem Realitätsgrad bzw. dem Symbolgehalt einer Darstellung. Wie weit ist ein Bild Abbild der Wirklichkeit und wieweit ist es Hinweis auf ein anderes, nicht direkt Sichtbares? Letzteres ist vor allem in mittelalterlicher Kunst oft der Fall. Ebenso wichtig ist die Frage, wieweit ein Bild Nachahmung ist und wovon, der Natur oder der Antike, wie oft in der Renaissance. Für Manierismus und Barock spielen Fragen nach hieroglyphischen oder emblematischen Zügen, nach theologischen, humanistischen, mythologischen Gesichtspunkten eine große Rolle. Und selbst in scheinbar realistischen Werken können, noch lange nach dem Verfall der alten ikonographischen Systeme, traditionelle Bildtopoi stecken, wie etwa im Genrestück oder auch im Porträt bis weit ins 19. Jahrhundert. All das kann nicht ohne Hilfe der Kunstgeschichte und der kunstgeschichtlichen Ikonographie erfaßt werden.

Die kunstgeschichtliche Ikonographie beschäftigt sich mit der Erforschung und Erklärung der dargestellten Bildinhalte. Sie tritt in dem Augenblick auf und gewinnt auch in dem Maße an Wichtigkeit, als die Bildinhalte älterer Kunstwerke, das, was auf ihnen dargestellt ist, auch von dem Kunsthistoriker nicht mehr oder nur höchst vage mitgewußt werden, was zu einem Verlust wesentlicher Voraussetzungen für das Verständnis und die Interpretation führen mußte. Und so mußte das Verlorene wiederentdeckt werden. Es waren französische und deutsche Forscher, die seit der Mitte des 19. Jahrhunderts im Zuge der Erforschung mittelalterlicher Kunst die wissenschaftliche Ikonographie begründeten. Zu den wichtigsten französischen Arbeiten, die

115 Vgl. dazu Emanuel Winternitz, ›The Visual Arts as a Source for the Historian of Music‹, in: Report of the Eighth Congress of the International Musicological Society New York 1961, Bd. 1 (Kassel 1961), S. 109 ff.; vgl. auch Victor Ravizza, ›Zu einem internationalen Repertorium der Musikikonographie‹, in: Acta musicologica 44 (1972), S. 101–108.

noch heute wichtige Dienste leisten können, auch für die Musikikonographie, gehören diejenigen von Adolphe Didron, Auguste Crosnier, Charles Cahier, Louis Bréhier, Emile Mâle, Fernand Cabrol und Henri Leclerq sowie Louis Réau[116]. An Werken deutscher Forscher sind u. a. zu nennen diejenigen von Anton Springer, Karl Künstle, Joseph Sauer[117]. Aus neuester Zeit stammt das monumentale ›Lexikon der christlichen Ikonographie‹, herausgegeben von Engelbert Kirschbaum und Wolfgang Braunfels[118] und außerdem die ›Ikonographie der christlichen Kunst‹ von Gertrud Schiller[119].

Weitere entscheidende Anstöße gingen schließlich von der durch Aby Warburg[120] und Erwin Panofsky[121] vertretenen ikonographischen Forschungsrichtung aus, die noch heute eine führende Position behauptet. Sie verlagerte und erweiterte das Interesse gegenüber der bisher vorherrschenden Beschäftigung mit dem Mittelalter und der spezifisch christlich-religiös orientierten Ikonographie mehr auf die nachfolgende Zeit, vor allem auf die Renaissance, speziell deren Antikenrezeption. Wie schon die ältere Ikonographie vor allem theologische Schriften zur Erklärung herangezogen hatte, so bezogen auch Warburg und Panofsky in verstärktem Maße Dichtung, Mythos und die Wissenschaft der Zeit mit ein. Diese Forschungsrichtung bedeutete zu ihrer Zeit innerhalb der herrschenden Kunstgeschichte eine entschiedene Gegenposition zu deren Hauptarbeitsgebiet, der Stilgeschichte. Sie stellte gegenüber der bloßen Betrachtung von Stil und Form die semantische Seite der Kunstwerke in den Mittelpunkt. Damit ergab sich wiederum ganz von selbst eine außerordentliche Verstärkung interdisziplinärer Tendenzen.

Panofsky entwickelte für seine Art der Interpretation eine allgemeine Methode, die inzwischen weitgehend akzeptiert, aber auch modifiziert und kritisiert worden ist. Ihre Diskussion ist auch für die Musikikonographie von Belang[122]. Panofsky unterscheidet drei verschiedene Interpretationsebenen:

1. »die vorikonographische Beschreibung«, die auf die Ebene der Stilgeschichte gehört,
2. »die ikonographische Analyse«, die sich mit dem dargestellten Thema und der Typengeschichte befaßt,
3. »die ikonologische Analyse«, die auf den Gehalt, die eigentliche Bedeutung ausgeht, und die unter Heranziehung anderer kulturgeschichtlicher Dokumente durch eine Art synthetischer Intuition zustandekommt.

Ist eine derartige methodische Aufgliederung des Arbeitsgebietes und im Zusammenhang damit die terminologische Trennung in Ikonographie und Ikonologie sinnvoll und empfiehlt sich ihre

116 A. Didron, Iconographie chrétienne. Histoire de Dieu (Paris 1843); A. Crosnier, Iconographie chrétienne (Caen 1848); Ch. Cahier, Caractéristiques des Saints dans l'art populaire (Paris 1867); L. Bréhier, L'art chrétien: son développement iconographique des origines à nos jours (Paris 1918); E. Mâle, L'art religieux, 4 Bde. (Paris 1898–1932); F. Cabrol und H. Leclerq, Dictionnaire d'archéologie chrétienne et de liturgie (Paris 1907ff.); L. Réau, Iconographie de l'art chrétien (Paris 1955–1959).

117 A. Springer, ›Ikonographische Studien‹, in: Mitteilungen der k. k. Zentralkommission zur Erhaltung und Erforschung der Baudenkmäler (Wien 1860); idem, ›Über die Quellen der Kunstdarstellungen im Mittelalter‹, in: Berichte über die Verhandlungen der Königlich Sächsischen Gesellschaft der Wissenschaften zu Leipzig. Philosophisch-historische Klasse, Bd. 31 (1879); K. Künstle, Ikonographie der christlichen Kunst, 2 Bde. (Freiburg 1926–1928); J. Sauer, Symbolik des Kirchengebäudes (Freiburg 1925).

118 Engelbert Kirschbaum und Wolfgang Braunfels, Lexikon der christlichen Ikonographie, 8 Bde. (Freiburg 1968–1976).

119 Gertrud Schiller, Ikonographie der christlichen Kunst, 3 Bde. (Gütersloh 1966–1971).

120 Aby Warburg, Gesammelte Schriften, 2 Bde. (Berlin und Leipzig 1932).

121 Erwin Panofsky, Studies in Iconology (New York 1939); idem, Meaning in the Visual Arts (New York 1955), deutsch als: Sinn und Deutung in der bildenden Kunst (Köln 1975).

122 Vgl. dazu auch James W. McKinnon, ›Musical Iconography: A Definition‹, in: RIdIM Newsletter, Bd. 2, Nr. 2 (1977), S. 15–18.

Übernahme auch für die Musikwissenschaft? Es schmälert nicht das Verdienst des Ansatzes von Panofsky und der vielen auf ihm basierenden Arbeiten, wenn wir daran gewisse Zweifel anmelden. Auch von kunsthistorischer Seite wurde schon die Frage gestellt, ob vor allem die terminologische Trennung von Vorikonographie, Ikonographie und Ikonologie notwendig und tunlich sei, und ob sie nicht vielmehr ein zusammengehöriges Feld unnötig auftrennt.

Ernst Hans Josef Gombrich bemerkt zum Problem eher lakonisch und sicher richtig: »Nun ist die Unterscheidung zwischen diesen beiden Disziplinen Ikonographie und Ikonologie nicht ganz eindeutig, und es ist auch nicht wesentlich, die Trennungslinie gerade so verlaufen zu lassen« [123]. Und auch Jan Białostocki bleibt in seiner auch für den Musikikonographen lesenswerten Arbeit zum Thema bei aller positiven Würdigung Panofskys stillschweigend bei der Bezeichnung Ikonographie [124]. In der Tat handelt es sich ja bei Panofskys dritter Schicht, der Ikonologie, eher um eine erweiterte Ikonographie auf höherer Ebene, wie sie auch schon die älteren Ikonographen betrieben hatten und nicht eigentlich um etwas kategorial Neues. Auch bergen Begriff und Sache der synthetischen Intuition nach unserer Meinung nicht geringe Gefahren, nicht zuletzt in der Hand von Adepten. Zu diesen Gefahren gehören gewisse Unschärfen, auch Willkürlichkeiten und Wunschdenken. So dürfte es sich auch für uns empfehlen, bei dem hergebrachten Terminus Ikonographie zu bleiben und die drei Ebenen des Sichtbaren, der Typologie und der Bedeutung von Anfang an zusammen zu sehen, statt Zusammengehöriges zu trennen. Ein Bild ist ein Ganzes. Und eine realistisch aussehende Musikdarstellung kann durchaus zugleich einer typologischen Tradition angehören und außerdem einen hochsymbolischen Charakter haben, wie umgekehrt auch noch die esoterischste musikalische Symbolik sich einer Zeichensprache bedienen muß, die zuletzt doch irgendwie auf Anschaulichkeit beruht oder doch von Anschaulichem abstrahiert ist. Und schließlich entfällt für die heutige Musikikonographie das eher wissenschaftsgeschichtliche bzw. -theoretische Motiv, das für Panofskys fast emphatisch gebrauchten Begriff der Ikonologie eine so große Rolle spielte, nämlich sich gegenüber der herrschenden stilgeschichtlichen Methode absetzen, rechtfertigen und behaupten zu müssen.

123 E. H. J. Gombrich, ›Ziele und Grenzen der Ikonologie‹, in: Ikonographie und Ikonologie, hrsg. von Ekkehard Kaemmerling (Köln 1979), S. 388.

124 J. Białostocki, ›Skizze einer Geschichte der beabsichtigten und der interpretierenden Ikonographie‹, in: Ikonographie und Ikonologie (Fußnote 123), S. 13 ff.

The Fifteen Temple Steps and the Gradual Psalms

James W. McKinnon

List of Illustrations

Fig. 1: Illustration of Psalm 119 (Flemish, late 15th century). London, British Library, Ms. Additional 18851, Isabella Breviary, fol. 184v. – Photo: British Library

Fig. 2: Illustration of Psalm 80. Same source, fol. 155v. – Photo: B. L.

Fig. 3: Illustration of Psalm 109. Same source, fol. 173. - Photo: B. L.

Fig. 4: Illustration of Psalm 97. Same source, fol. 164. – Photo: B. L.

Fig. 5: Illustration of the Gospel text for the first Sunday of Lent. Same source, fol. 71. – Photo: B. L.

Fig. 6: Illustration of Psalm 119 (England, early 14th century). Oxford, All Souls College, Ms. 2, Psalter, fol. 198. – Photo: Library

Fig. 7: Giotto di Bodone (ca. 1266–1337): Presentation of the Virgin Mary (fresco, between 1303 and 1307). Padua, Scrovegni Chapel. – Photo after Carlo Carrà: Giotto (London 1925), pl. 12.

Fig. 8: Presentation of Virgin Mary (England, 15th century). Oxford, Bodleian Library, Ms. Bodley 596, John Lydgate, Life of Our Lady, fol. 89. – Photo: Library

Fig. 9: Illustration of Psalm 119 (Italy, 15th century). London, British Library, Ms. Add. 23774, Book of Hours, fol. 202. - Photo: British Library

Fig. 10: Illustration of Psalm 119 (Spain, 15th century). London, British Library, Ms. Add. 28962, Prayer Book of Alphonso V of Aragon, fol. 329. – Photo: British Library

Fig. 11: Illustration of the Introit »Suscepimus« (Austria, ca. 1500). Graz, Universitätsbibliothek, Codex 17 (37/9), Gradual and Sequentiary, fol. 40. – Photo: Library

Reproductions with the kind permission of the owners

* * *

The British Library's splendid Isabella Breviary, Ms. Add. 18851, boasts a unique example of psalter iconography (*fig. 1*), in which its late fifteenth-century Flemish artist painted a large group of instrumentalists upon a prominent flight of steps before a churchlike building. It is not surprising that this striking picture has been used frequently to illustrate works of music history. It is, however, at least mildly surprising that it has generally been incorrectly captioned in these works. The beautifully illustrated ›Musique Flamande‹, for example, in a lapse from its accustomed iconographic sophistication, described it as »Musicians in the Square Before a Church«.[1]

How ought it to be described? Briefly it might be captioned: »Levitical musicians on the steps of the Temple« or more completely: »An introductory illustration to the gradual psalms; levitical musicians play on the steps of the Temple at Jerusalem, while King David looks on and David as pilgrim mounts the steps«.

1 Robert Wangermée, Flemish Music and Society in the Fifteenth and Sixteenth Centuries (trans. from the French by Robert R. Wolf, New York 1968), p. 309. The miniature is also reproduced in Ernest Closson and Charles van den Borren (eds.), La Musique en Belgique du Moyen Age à nos jours (Brussels 1950), p. 75; Anselm Hughes and Gerald Abraham (eds.), Ars Nova and the Renaissance 1300–1450 (= New Oxford History of Music, vol. 3, London 1960), frontispiece; and Edmund A. Bowles, Musikleben im 15. Jahrhundert (= Musikgeschichte in Bildern, vol. 3, fascicle 8, Leipzig 1977), p. 149.

Fig. 1

Fig. 2

Not all of this is immediately apparent, and certainly at first glance the picture does suggest instrumentalists playing before a fifteenth-century church. But at second glance, so to speak, there are already indications that it might be meant to depict an Old Testament rather than a contemporary Christian scene. The most obvious of these is the presence of King David, »rex david«, labeled as such, in the upper left-hand corner of the picture. Next most obvious, perhaps, is the pointed hats and beards of the instrumentalists, a circumstance which should suggest that the players are meant to appear Jewish. And then there is the text which the picture illustrates. The rubric stands out clearly, »canticum graduum«, song of the steps; and the psalm that follows, »Ad dominum cum tribularer«, is psalm 119, the first of the fifteen gradual psalms. This observation together with the great prominence of the stairway in the miniature should stir the suspicion that the theme of steps is central to the meaning of the picture, and one should at least ask the question whether the artist thought of these steps within an Old Testament rather than a Christian context. The Psalter is after all an Old Testament book.

So much for a relatively unschooled look at the picture; it would seem to invite a systematic iconographic examination. One might object to bringing such a weight of learning to so modest a task; surely the Old Testament character of the miniature can be established in relatively short order. But on the other hand the picture may be fascinating enough in itself to warrant a thorough investigation, and then too this investigation might further justify itself by shedding light on some aspect or another of musical iconographic method. The investigation will go forward in three stages: first the manuscript in which the miniature appears will be examined, then the miniature itself, and finally the larger iconographic context.

The manuscript, in the possession of the British Library since the mid-nineteenth century, is among the most splendid of that institution's great collection. It is a breviary written in a Spanish hand and illuminated by Flemish artists in about 1490.[2] We know from an inscription that the book was given to Queen Isabella by the Spanish nobleman Francesco de Rojas, presumably its original owner.[3] De Rojas brokered the marriages of both Isabella's daughter Joanna to Maximilian I's son Philip in 1496, and the marriage of her son Don John to Maximilian's daughter Margaret in 1497. The arms of Isabella and of the two married couples appear on a leaf inserted in the book opposite the inscription. De Rojas accompanied the young Margaret from Austria to Spain before her wedding, and perhaps that event was the occasion upon which he presented the book to Isabella.

It is a fully rubricated breviary of 523 quarto-size folios. The rubrics do not state explicitly that it follows Dominican usage, but there are obvious indications of this. One observes first the impressive full-page illustration at the feast of St. Thomas Aquinas, 7 March, and notes conclusively that the calendar gives 5 August as the feast of Sancti Dominici prioris nostri, a »totum duplex«, celebrated with an octave. The book opens with the usual calendar and continues with the temporale, which is interrupted between Holy Saturday and Easter by the insertion of the ferial psalter. Separating the temporale and sanctorale are two short items: the Office for the Dedication of a Church and a hortatory work on the reading of Scripture. The sanctorale runs for some 225 folios, concluding with the commune sanctorum.

The book is extraordinarily lavish in its illumination. In addition to the elaborate borders and decorated initials it has 50 full-page and 114 smaller miniatures, each of which occupies about a

2 Basic information on the book and its history is derived from the discussion of pl. [53] in George F. Warner, *Illuminated Manuscripts in the British Museum* (London 1903), First series, not paginated.

3 The inscription appears on the border of the illustration for the feast of the Assumption, fol. 437.

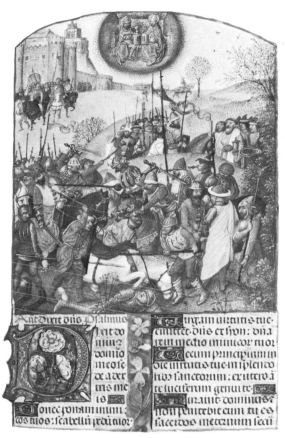

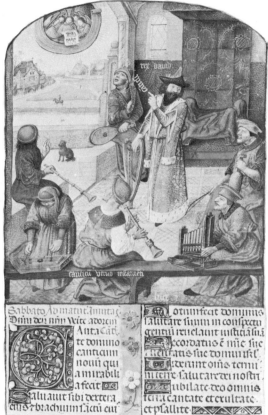

Fig. 3

Fig. 4

quarter of the texted portion of the page. The miniatures are clearly the work of several artists; they range widely in quality from an altogether inferior picture like the illustration for the feast of the Apostles Peter and Paul[4] to a minor masterpiece like the Epiphany scene, which in fact Friedrich Winkler attributed to the youthful Gerard David.[5] More characteristic is the quality displayed in the miniature which is the subject of this study; while not the work of creative genius perhaps, it is the product of first-rate technical mastery. Winkler attributed the majority of the book's principal illustrations, including presumably this one, to an anonymous artist whom he called the Master of the Dresden Prayer Book.[6] It is unfortunate that we do not have more precise knowledge on the style of the Isabella Breviary and for that matter on the style of its numerous splendid contemporary Flemish books. By and large they have been neglected by recent art history in favor of early fifteenth-century manuscript illumination.

While art historians like Winkler and Durrieu[7] made helpful suggestions about the style of the Isabella Breviary, they had nothing at all to say about its iconography, the feature which is surely

4 fol. 392.

5 fol. 41; see Friedrich Winkler, ›Gerard David und die Brügger Miniaturmalerei seiner Zeit‹, in: Monatshefte für Kunstwissenschaft 6 (1913), pp. 271–280. Winkler (pp. 277f.) attributed three other pages of the Isabella Breviary to David: fol. 29, the Nativity; fol. 297, St. Barbara; and fol. 309, St. John the Evangelist. All four are reproduced with his article.

6 See Die Flämische Buchmalerei des XV. und XVI. Jahrhunderts (Leipzig 1925), pp. 94–101, 176f.

7 Paul Durrieu provided a briefer and more general description in La Miniature Flamande au temps de la Cour de Bourgogne (1415–1530) (Brussels and Paris 1921), p. 65.

its most extraordinary.[8] It is true that the iconography of the calendar is typical enough, as is that of the sanctorale; the calendar has the standard labors of the months and signs of the zodiac, while the sanctorale has portraits of the saints with their customary attributes. About these portraits one notes only their prodigious number, 15 full-page and 69 smaller, and the artistic distinction of occasional examples such as those of St. Barbara and St. John the Evangelist. The extraordinary iconography occurs in connection with the temporale and more especially the psalter. The temporale has the expected scenes illustrating the great feasts like Christmas and Easter, but in addition it has a unique cycle illustrating the scripture readings of Sunday matins. This cycle is of some relevance to our subject since it points to the special exegetical impulse that underlies the more singular aspects of the psalter's iconography.

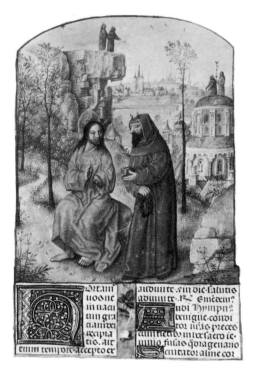

Fig. 5

The illustration of the psalter consists in nine full-page and eleven smaller miniatures. The miniature to which the present study is devoted is the ninth of the larger pictures, while the first eight appear at the standard locations for illustrations within a ferial psalter. These eight are the most extraordinary pictures of the entire book from an iconographic point of view, and a general understanding of them is necessary to place the ninth in proper perspective. The eight illustrate psalms 1, 26, 38, 52, 68, 80, 97, and 109, the psalms which begin the divisions of the psalter as it is distributed throughout the liturgical week. The first seven are the first psalm at matins for each of the seven days of the week, while the eighth, psalm 109, »Dixit dominus«, is the first psalm of Sunday vespers. These same eight are illustrated, or at least decorated, in virtually every one of

8 To the knowledge of the present author the only study in print on the iconography of the Isabella Breviary is his own brief study on the illustration of Psalm 97: ›Canticum novum in the Isabella Book‹, in: Mediaevalia 2 (1976), pp. 207–222.

the literally hundreds of extant psalters from the thirteenth through fifteenth centuries.[9] In this functional sense, then, the Isabella Breviary's psalter illustration is quite normal, but the iconographic character of these eight miniatures is altogether unique. Generally psalter iconography is both simple and conventional: one highly typical iconographic theme illustrates each of the eight designated psalms. For example, the familiar figure of David playing bells is the standard theme of psalm 80, »Exultate deo«. In contrast the Isabella Breviary (*fig. 2*), while retaining the nuclear conception of David as musician, presents a congeries of themes and motifs labeled with no less than nine inscriptions. To unravel the meaning of this picture would be a formidable task, one greatly complicated moreover, by the difficulty of deciphering certain of the inscriptions. This task exceeds the scope of the present study, and the example is given here only

Fig. 6

to demonstrate the uniquely complex character of the Isabella Breviary's psalter iconography. Erwin Panofsky has taught us how late Flemish iconography is generally more complex than that of the earlier Middle Ages,[10] but certainly the Isabella Breviary is exceptional even for its own time.

A second and equally unique characteristic of its psalter iconography is the probing Old Testament exegesis which underlies it. One observes it even in the illustration of psalm 109, »Dixit dominus domino meo«, which is ordinarily illustrated by a simple picture of the Trinity.

9 There are exceptions, too complex even for summarization here. The present author is engaged upon a long-range study of the late medieval psalter from both the iconographic and liturgical points of view. For an excellent introduction to the subject see Günther Haseloff, Die Psalterillustration im 13. Jahrhundert (Kiel 1938); see also Victor Leroquais, Les psautiers manuscrits latins des bibliothèques publiques de France, 2 vols. and portfolio (Mâcon 1940–1941).

10 In: Reality and Symbol in Early Flemish Painting: Spiritualia sub Metaphoris Corporalium (= Chapter V of Early Netherlandish Painting, 2 vols., Cambridge/Massachusetts 1953), pp. 131–148.

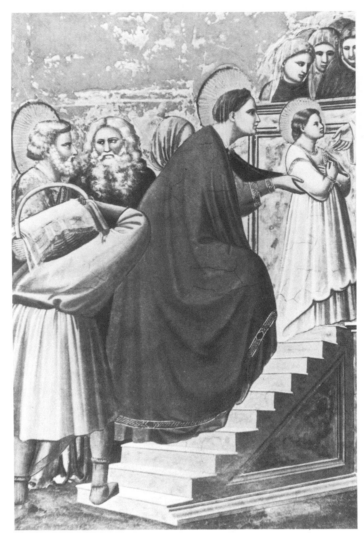

Fig. 7

The Isabella Breviary confines the standard Trinity group to a small gold medallion towards the top of the page while the body of the illustration is devoted to a spectacularly detailed battle scene including Abraham and Melchisedech as spectators (*fig. 3*). An inscription at the foot of the picture tells us that the scene is inspired by Genesis xiv, which tells of much fighting among Abraham and his contemporaries, but we are still left wondering what relationship there can be between psalm 109 and the battles of Genesis xiv. But in point of fact we are in possession of the most clear and apposite explanation of the relationship. The psalm commentary of the fourteenth-century Franciscan Nicholas of Lyra tells us that some Jewish scholars (»aliqui Hebraei«) see psalm 109 as a song of thanks for Abraham's victory over the four kings who had captured his nephew Lot, an event described in Genesis xiv.[11]

11 The commentaries of Nicholas appear in numerous manuscripts and editions; for this study I used the ›Cum glossa ordinaria . . . Postillae Nicolai Lyrani‹ (Lyons 1589). The reference in question appears in vol. 3, cols. 1286 f.

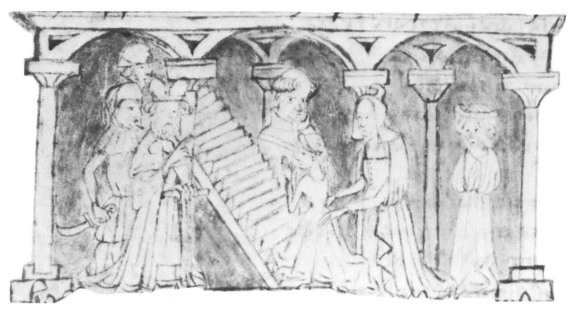

Fig. 8

This is an altogether extraordinary relationship between a particular psalm commentary and a particular illustrated psalter. The relationship is consistent throughout the eight illustrated psalms; in each case where a scripture reference is given at the foot of the illustration, the reference appears in the commentary also.[12] Psalm 80, discussed above (*fig. 2*), is no exception. An inscription at the bottom of the picture refers to the Book of Numbers x, while the commentary of Nicholas dwells upon the blowing of trumpets on festal days, a custom cited in verse 3 of psalm 80 and described at length in Chapter 10 of Numbers.[13] This information offers a good start in deciphering the immensely complex illustration even if it leaves us with several unexplained elements.

In any case it should be clear that whoever devised the iconographic program for the first eight illustrations of the Isabella Breviary's psalter did so with the aid of Nicholas of Lyra's commentary. We should keep this special circumstance in mind as well as the general complexity and Hebraic character of the illustrations when turning to the interpretation of the ninth psalter illustration, which is the subject of this study.

Before doing so, brief mention should be made of the eleven smaller illustrations of the psalter. Actually, they are significant enough in themselves to warrant their own study. From the aspect of liturgical function ten of them fall into two categories: four of them illustrate the

12 Psalm 1 of the Isabella Breviary shows Esdras (fol. 112), while Nicholas attributes the composition of the psalm to him (footnote 11, col. 434); psalm 26 shows the anointing of David (fol. 124), while Nicholas discusses it (col. 609); psalm 38's inscriptions I find undecipherable; psalm 52 shows Antiochus defiling the Temple and gives the inscription 1 Macchabees i (fol. 139), while Nicholas cites the same event and the succeeding chapter of 1 Macchabees (col. 814); psalm 68 shows a fanciful illustration of »leviti rabi liliati rosati« (fol. 146v), while Nicholas discusses the relationship of the two flowers to the psalm's title (col. 923); psalm 97 alludes to the Nativity of Jesus and gives the inscription Luke ii (fol. 164), while Nicholas makes the precise same references (col. 1191). What makes these correspondences so extraordinary is that most of the pictures are unique as examples of psalter iconography, while Nicholas' references are similarly unique. There can be no question of mere coincidence; there is a direct influence of the commentary upon the illustrations.

13 Nicholas of Lyra (footnote 11), cols. 1057f.

division of the lengthy psalm 118 over the four »little hours« of prime, terce, sext and none; while six of them illustrate the first psalm of vespers from Monday through Saturday. Both these categories, while not unique in late medieval psalter illustration, are extremely rare.[14] From the aspect of iconography most of the eleven appear to be Old Testament scenes, although several of them are difficult to identify because they lack inscriptions. A few, on the other hand, are rather obvious in meaning such as Moses at the shore of the Red Sea, which illustrates psalm 113, »In exitu Israel de Egypto«. This illustration, incidentally, is the one among the eleven that does not fall into either of the two liturgical categories cited above. All in all the eleven small miniatures further demonstrate the subtlety, originality, and exegetical sophistication of the Isabella Breviary's psalter iconography.

Turning now to the ninth psalter illustration, one notes that unlike the other eight full-page miniatures it illustrates a psalm not generally illustrated in the late medieval psalter, psalm 119, the first of the fifteen gradual psalms, numbered 119–33 in Latin psalters. It is true that they were looked upon as a unit throughout the Middle Ages – they were frequently referred to simply as the »quindecim psalmi« – and that they were recited as a devotional exercise.[15] In this respect they were closely analogous to the seven penitential psalms. The latter, however, were obviously the more popular of the two groups and found their way into virtually every late medieval Book of Hours, where they were illustrated with appropriate iconographic themes such as David at Prayer. The fifteen gradual psalms, on the other hand, achieved this status with comparative rarity. This makes it difficult, as will be seen later in this study, to establish an iconographic context for our miniature; but it is, on the other hand, not quite so complex a picture in itself as some of its eight companion illustrations and offers no serious difficulty or ambiguity of interpretation.

A number of its details have already been noted – the instrumentalists with hats and beards, »rex david«, the prominent steps – it is time now to examine the picture more systematically. The beards and pointed hats, as suggested earlier, indicate the Jewishness of the players. This is a commonplace of medieval art from the thirteenth through fifteenth centuries. Of the two indications the hat, perhaps, is the more distinctive. Its presence in art stems from discriminatory legislation which made obligatory the wearing of hats by Jews.[16] In the thirteenth century artists depicted them in a naively stylized way, not unlike inverted funnels. In the fifteenth century the hats were rendered more naturally with the texture of felt and a variety of lifelike brims. Important personages like Caiaphas or Joseph of Arimathea might be given extravagant fur-trimmed or turbanlike hats. Curiously, Jews shared their beards and headgear with other exotic types: easterners of any sort such as those encountered by Marco Polo and Alexander the Great;

14 The psalms in question are 114, 121, 126, 131, 137, and 143. The divisions of psalm 118 are illustrated in the famous Visconti Hours, the only example I know aside from the Isabella Breviary. The vesper psalms also are illustrated in the Visconti Hours and in Oxford, Bodleian, Lat. lit. b. 1, the only two examples I know aside from the Isabella Breviary. The entire Visconti Hours is reproduced in Millard Meiss and Edith W. Kirsch (eds.), The Visconti Hours (New York 1972).

15 They were, in fact, a regular addition to the earlier medieval monastic office. See Edmund Bishop, ›The Origins of the Prymer‹, in: Liturgica Historica (Oxford 1918, repr. 1962), pp. 211–237, and David Knowles, ›The Monastic Horarium 970–1120‹, in: Downside Review 51 (1933), pp. 706–725.

16 Beginning with the Fourth Lateran Council (1215); for a discussion of the subject and additional bibliography see Ruth Mellinkoff, The Horned Moses in Medieval Art and Thought (= California Studies in the History of Art, vol. 14, Berkeley 1970), pp. 128–131. See also the index in Bernhard Blumenkranz, Le juif médiéval au miroir de l'art chrétien (= Etudes Augustiniennes, Paris 1966).

and even ancient Romans engaged in acts of martyrdom or participating in the Roman theatre. One never looks for perfect consistency in any such matter from medieval artists, but it does appear to be present throughout the various cycles of the Isabella Breviary including the temporale readings' cycle and the psalter cycle. In the psalter cycle, as a matter of fact, the instrumentalists are even labeled as Old Testament musicians. David's companions of psalm 80 (*fig. 2*) are labeled »levitici«, while the musicians of psalm 97 (*fig. 4*) to whom he points out the canticum novum of the angels, sit on a bench inscribed »canticum veteris testamenti«. These musicians bear an obvious resemblance to those of psalm 119, and it occasions a mild surprise that they are not similarly labeled.

Incidentally, it does not follow that because the artist identified the musicians as Levites that he also attempted to depict ancient Jewish instruments. A fifteenth-century artist, needless to say, was not an archeologist, and one assumes he would depict those instruments which he had observed either in daily life or in contemporary works of art. This point, which Panofsky would call a pre-iconographic consideration, is irrelevant to our central concern, which is the properly iconographic question of whether the artist had in mind an Old Testament or a fifteenth-century event.

The prominent stairway of the picture has already attracted our attention. Such stairways are not what fifteenth-century artists observed at the entrances of contemporary churches. Generally the nave of a medieval church or cathedral was close to ground level and accordingly few or no steps were required to enter it. Thus the steps pictured here must have some special significance. It was suggested above that one ought to associate these steps with the circumstance that they appear in an illustration of the gradual psalms, the »cantici graduum«, songs of the steps. One ought now to make the further observation that there are precisely fifteen steps pictured, a striking correspondence with the number of the gradual psalms. Could this be a coincidence? Not at all, as will be seen in the third section of this essay where the long-range literary and iconographic background of the fifteen-step motif will be examined. It will be seen that the fifteen-step motif was a late medieval device designed to identify the Temple of Jerusalem.

Before entering upon that task there are two additional observations to be made concerning the miniature. For one, the solitary figure on the steps must be identified. He does not appear to be dressed with particular sumptuousness; indeed he greatly resembles the musicians in his garb except that he does not wear a hat but rather a modest crown. Could he be David? Indeed he is; an examination of the original miniature reveals what is not visible on reproductions, the name »david« inscribed across his shoulders. Thus »rex david« observes the scene while a humbler »david« participates in it. One can only speculate on the meaning of the latter David, but it seems reasonable enough to call him David the pilgrim. The exegetical conception most consistently associated with the gradual psalms throughout the ages is that their title, ›shīr hamaˁ alōth‹, song of ascents or steps, refers to the »going up« of Jewish pilgrims to the Temple at Jerusalem during the three great pilgrimage festivals of the year, Passover, Weeks and Tabernacles.[17] This is a Jewish rather than a Christian association, but we have seen already that the unknown exegete who devised the iconographic program of the Isabella Breviary's psalter is a figure of unique Old Testament sophistication. In any case the presence of David upon the steps is another solid indication that the miniature is meant to depict a Jewish scene.

17 For a brief recent summary of exegetical doctrine on the gradual psalms together with bibliography, see Frank L. Cross and Elizabeth A. Livingstone (eds.), The Oxford Dictionary of the Christian Church (London ²1974), pp. 587f.

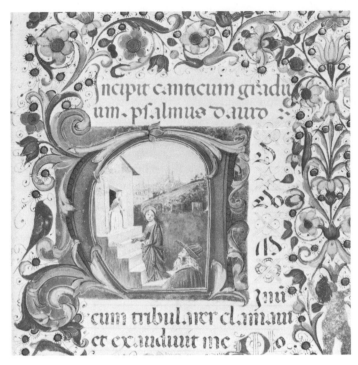

Fig. 9

Finally one notes employment of rounded rather than pointed arches in the various buildings of the miniature. This brings to mind the fascinating observation of Panofsky that fifteenth-century northern artists painted romanesque in contrast to gothic architectural traits when they wished to symbolize an Old Testament rather than a New Testament context.[18] Does the point apply in the present case? Regrettably not, it would seem. The simple use of a rounded arch is not a sufficient indication; the rounded arch was commonly used with apparent inadvertence in many fifteenth-century Flemish miniatures of obviously Christian context. However, in other depictions of the Temple, the Isabella Breviary makes a thoroughly convincing use of the device involving much more than a rounded arch. The Temple is pictured as a round, two-tiered, baptistry-like structure, with rounded arches to be sure, but with other features such as its decorated romanesque columns which give it a distinctly exotic appearance. The entire exterior of the building can be seen in the illustration for the gospel of the first Sunday in Lent where Satan takes Jesus to the pinnacle of the Temple (*fig. 5*); while the interior can be seen in the illustration of psalm 80 where it is inscribed »templum« (*fig. 2*).[19]

This, admittedly, poses something of a complication for the central thesis of the present study. On the one hand the Isabella Breviary regularly employs the iconographic device of the round exotic building to designate the Temple, but on the other hand fails to employ it in the single instance of the gradual psalms' illustration. There are any number of more or less plausible explanations for the seeming contradiction, for example, the pictorial incompatibility of the small round building motif with the large stairway motif; but whether such explanations are necessary or not, they can be appreciated only after a literary and iconographic investigation of the stairway motif itself.

18 Panofsky (footnote 10), vol. 1, pp. 132–140.
19 There are several other illustrations of the Temple interior; see especially Psalm 52, fol. 139, and the fourth Sunday of Lent, fol. 86.

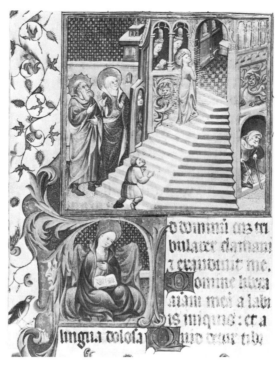

Fig. 10

As a matter of historical fact there was a prominent fifteen-step stairway in the Temple at Jerusalem, which was rebuilt on a grand scale by Herod the Great in the closing decades of the pre-Christian era. We know this from the Mishnaic tractate ›Middoth‹, redacted in about 200 A. D. and based upon the orally transmitted account of Rabbi Eliezer ben Jacob, who observed the Temple in the last days before its destruction by the Romans in 70 A.D. [20] ›Middoth‹ (literally measurements) describes the various chambers and courts of the Temple with their precise dimensions. The relevant passage reads:

> »And fifteen steps went up from within it [the Women's court] to the Hall of the Israelites corresponding to the fifteen Songs of Ascent in the Psalms, and upon them the Levites used to sing. They were not rectangular but round like the half of a round threshing-floor.« [21]

A passage in the tractate ›Sukkah‹ (literally booth or tabernacle) also mentions the steps and adds that Levites stood on them and played musical instruments during the joyous festivities of the first night of Sukkah:

> »And the Levites on harps, and on lyres, and with cymbals, and with trumpets and with other instruments of music without number upon the fifteen steps leading down from the court of the Israelites to the Women's Court, corresponding to The Fifteen Songs of Ascent in the Psalms; upon them the Levites used to stand with musical instruments and sing hymns.« [22]

The two passages are remarkably relevant. They describe a fifteen-step stairway of semicircular shape leading up from the Court of the Women to the Court of the Israelites. They associate the fifteen steps with the Psalter's fifteen Songs of Ascent. They mention that Levites

20 See Schmuel Safrai, ›The Temple and the Divine Service‹, in: The Herodian Period, The World History of the Jewish People, First Series, vol. 7, ed. Michael Avi-Yonah (New Brunswick/New Jersey 1975), p. 282.

21 M. Middoth II, 5; ed. and trans. Philip Blackman, Mishnayoth, vol. 5: Order Kodashim (New York ³1964), p. 513.

22 M. Sukkah V, 4; ed. and trans. Philip Blackman, Mishnayoth, vol. 2: Order Moed (New York ³1963), p. 342.

stood upon the steps and sang, with one of them explicitly mentioning a great variety of musical instruments.

The picture corresponds precisely to that depicted in the Isabella Breviary except for the detail of the stairway's rounded shape. Indeed the second passage, that from ›Sukkah‹, omits the detail of the stairs' shape. It happens also to be the passage which includes the instruments and there is, therefore, a total correspondence between it and the Isabella Breviary's illustration of the gradual psalms; one could well imagine it to be the immediate inspiration of the miniature.

There are, however, obvious problems of transmission between a third-century rabbinic passage and a fifteenth-century Spanish Dominican iconographic program. If such a transmission did in fact take place, the likely vehicle for it would have been the psalm commentaries, eastern and western. It can be said at the outset that the eastern commentaries offer no help; in their discussions of the gradual psalms they dwell exclusively upon the spiritual significance of the fifteen-step notion and fail to make any connection with the fifteen steps of the former Temple at Jerusalem.[23]

In the west, Augustine also misses the connection, but his contemporary Jerome (died 420), a resident of the Holy Land for many years and a Hebrew scholar, picks it up. In his discussion of the title of psalm 119 he writes: »Hoc igitur templum in circuitu quindecim gradus habuit. Signa aliqua uidemus: numerate, et uidebitis ita esse ut dicimus. Leuitae igitur et sacerdotes, unusquisque secundem ordinem stabat in gradibus.«[24] One notes that Jerome includes the detail of the steps' rounded shape (»in circuitu«); the patristic and medieval commentators who come after him will miss it. One notes further that Jerome mentions the presence of Levites upon the steps while omitting explicit reference to their musical instruments. Actually it is a rather different conception from that of ›Sukkah‹ which he transmits; he also places priests (»sacerdotes«) upon the steps standing according to rank. We have no way of knowing the source for this divergent nuance.

The second, rather cryptic, sentence of the quotation seems to make a fascinating suggestion, namely that Jerome had actually seen some vestiges (»signa«) of the steps, and that he challenges others to count them (»numerate, et uidebitis«). That the ruins of the Temple in general were still visible more than 300 years after its destruction Jerome had already indicated a few sentences earlier when he wrote: »Et istud templum, cuius nunc ruinam uidemus . . .« One might find further corroboration in a passage from his commentary on Isaiah where he refers to a stairway in the Temple which local guides were wont to point out: »Solent sanctorum locorum in hac prouincia monstratores intra conseptum templi ostendere gradus domus Ezechiae, uel Achaz.«[25] However, Jerome does not identify these steps with the fifteen, and one must realize that the Temple precinct (»conseptum templi«), if the phrase refers to the entire walled-in platform of the Temple Mount, was more than 500 meters in length, and even if it refers only to the more immediate confines of the Temple, was almost 200 meters in length.[26] In either case the area

23 The method employed in coming to this conclusion was a reading of all the commentaries published in Jacques-Paul Migne, Patrologiae Cursus completus. Series graeca. They are sufficiently representative to preclude the probability that so significant a point, while absent from them, would appear in some solitary unpublished commentary. It is moreover the central tradition that is at issue here rather than some single isolated work.

24 Tractatus sive Homiliae in Psalmos, De psalmo cxviiii; Corpus Christianorum Series Latina, vol. 78 (Turnholt 1958), p. 247.

25 In Esaiam XI, xxxviii, 4–8; Corpus Christianorum Series Latina, vol. 73 (Turnholt 1963), p. 445. The editor of the volume cited in footnote 24 identifies these stairs with the fifteen.

26 A calculation of the inclusive dimensions of the Court of the Women, the Azarah or inner court, and interrelated spaces, based on M. Middoth II, 5–6, yields the figures 135 by 342 cubits. (A cubit, originally the length of a forearm and hand, is approximately 42,5 cm.)

contained numerous halls and chambers, and doubtless many stairways. Still, even if this second passage does not refer to the fifteen steps, it does, nevertheless, confirm the general existence of Temple ruins in Jerome's day and thereby adds credence to the specific suggestion of the first passage that he actually examined the remains of the fifteen semicircular steps. In any case, this must remain for present purposes no more than a tantalizing digression into fourth-century archeology; the subsequent literature has nothing more to say on the matter.

Altogether relevant, however, are the more general points made by Jerome: he associated the fifteen gradual psalms with the fifteen steps of the Temple and he placed Levites upon the steps. A survey of the subsequent commentators shows that he thus established the basic western conception of the subject. Cassiodorus, for example, in his highly influential commentary of a century and a half later had only this to say: »Et in istis psalmis quindecim gradus ponuntur, sicut in illo templo Ierosolymitano, quod a Salomone notum est fuisse perfectum.«[27] It is true that Cassiodorus, in the typical allegorical style of psalm commentaries, goes on to say much about the spiritual significance of the fifteen steps, but he reveals nothing more of historical relevance. One notes, incidentally, that he attributes the fifteen steps to Solomon's Temple. It is a standard medieval historical misconception, by no means surprising, to be unaware of the destruction of Solomon's Temple at the start of the Babylonian exile, and similarly unaware of the building of the Second Temple after the exile and its reconstruction under Herod the Great.

A number of medieval commentators add one concrete detail, erroneous to be sure, to the common conception established by Jerome: they specify that the fifteen steps are those traversed once a year by the High Priest to enter the Holy of Holies. Bruno the Carthusian (died 1101), for example, describes how the faithful ascend to heaven by the spiritual steps of the fifteen psalms. This was prefigured in the Temple of Solomon, he tells us, in which »quindecim gradus fuerunt, per quos ab exteriori templo semel in anno solus pontifex in Sancta sanctorum ascendebat«.[28] Apparently Bruno and his contemporaries confused the fifteen-step stairway, that which led from the Court of the Women to the inner court, with the Temple's other most prominent stairway, that which led up to the porch of the Temple building proper. This building stood within the inner court; by and large it duplicated the ancient Temple of Solomon and it housed the Sanctuary and Holy of Holies. Once a year, on the Day of the Atonement, the High Priest ascended the stairway by himself, passed through the Sanctuary, and entered the Holy of Holies to offer incense. We have precise knowledge of this today from the Mishnaic tractate ›Yoma‹,[29] whereas the medieval commentators had only the vaguest notions of the historical situation derived from scattered Old Testament references. In any event the point neither adds to nor subtracts significantly from the basic conception as established by Jerome.

The same must be said, surprisingly, of the most important of all late medieval commentators on the psalms, Nicholas of Lyra (died 1340). We have seen already his extraordinary relationship to the psalter iconography of the Isabella Breviary. We ought also to be aware of his very special knowledge of Jewish exegesis. In his vast system of commentaries upon the entire Bible he deemphasized the predominant patristic and medieval method of allegorical exegesis and turned instead to an historical mode which relied heavily upon the work of the great eleventh-century

27 Expositio in Psalmum cxix, Corpus Christianorum Series Latina, vol. 98 (Turnholt 1958), p. 1140.
28 Expositio in Psalmos, In psalmum cxix; J.-P. Migne, Patrologia . . . Series latina, vol. 152, col. 1313; see also Remigius of Auxerre, ibidem, vol. 131, cols. 766f.
29 M. Yoma V.

Jewish scholar Rashi.[30] We might expect Nicholas, then, to tell us something of genuine historical or archeological interest about the fifteen steps. Perhaps he knew of the Talmudic sources quoted above. Disappointingly, however, he says little more than Jerome, omitting in fact the detail of the steps' semicircular shape, and adding only the dubious notion that each of the fifteen gradual psalms was sung successively on each of the fifteen steps:

> »Dicuntur autem isti quindecim psalmi cantica graduum secundum doctores Hebraeos et Latinos, eo quod in ascensu templi qui erat per quindecim gradus, cantabantur a sacerdotibus et Levitis primus psalmus in primo gradu, et secundus secundo, et sic de aliis.«[31]

Nicholas was the last prominent medieval commentator on the psalms. Later medieval commentary consisted in little more than numerous manuscript copies of his work and eventually printed editions and copies in the vernacular.[32]

The precise information of the Mishnaic tractates ›Middoth‹ and ›Sukkah‹, then, failed to become part of the late medieval doctrine of the gradual psalms as it was expressed in the commentaries. That doctrine remained a relatively crude approximation of the historical situation. Nevertheless its fundamental conception of a link between the fifteen gradual psalms and the fifteen-step stairway of the Temple was a compelling enough thought in itself. Repeated as it was again and again in the literature, one might expect it to have furnished the visual image for the gradual psalms when they came to be illustrated with any frequency. They did finally come to be illustrated in a significant minority of English psalters from the late thirteenth and early fourteenth centuries. However, the fifteen-step motif was not employed, but rather a figure kneeling in prayer (*fig. 6*). If this is somewhat disappointing, it should not be altogether surprising. It happened, evidently, because there was an appropriate and readily available image to be borrowed from English illustrations of psalm 101. The first verse of psalm 119, »Ad dominum cum tribularer clamavi, et exaudivit me«, is very close in meaning to the first verse of psalm 101, »Domine exaudi orationem meam, et clamor meus ad te veniat«; in each the troubled soul cries out to the Lord in prayer. Now psalm 101, and similarly psalm 51, were vestiges of an earlier division of the psalter into three sections of fifty psalms each; as such they were frequently illustrated in thirteenth-century English psalters along with the regular eight psalms which marked off the liturgical divisions. The standard illustration of psalm 101 was a figure kneeling in prayer, hence the convenient borrowing for psalm 119.[33]

At this point it would seem that the search for the literary and iconographic sources for the Isabella Breviary's illustration of psalm 119 has come to a dead end. It turns out, however, that

30 On Nicholas' knowledge of Jewish exegesis, see Herman Hailperin, Rashi and the Christian Scholars (Pittsburgh 1963), pp. 135–246.

31 See footnote 11, col. 1417 (abbreviations realized).

32 On Nicholas' voluminous sources see the series of articles by Henri Labrosse in: Études Franciscaines, published from 1906 to 1923. – It turns out that there actually is an original fifteenth-century psalm commentary by a Spanish Dominican. This is a remarkable circumstance in view of the fact that the iconographic program of the Isabella Breviary was in all probability devised by Spanish Dominicans. The commentary, however, the work of Juan de Torquemada (died 1468), the uncle of the infamous inquisitor, is a brief devotional work which makes no reference, historical or allegorical, to the titles of the psalms and hence has no occasion to mention the Temple steps. The author used the edition at Cornell University: ... expositio brevis et utilis super toto psalterio ... (Mainz 1474, Peter Schöffer).

33 Illustrations of psalm 101 are too numerous to cite. For illustrations of psalm 119 in addition to *fig. 6* see: Oxford, Bodleian, Douce 6, fol. 115; Oxford, All Souls 7, fol. 116; Oxford, Bodleian, Douce 131, fol. 110; and the Taymouth Hours, London, British Library, Yates Thompson 13, fol. 139. – There is one striking exception to the developments described in the text. At least one illustration of psalm 119 from the famous thirteenth-century Moralised Bibles of Paris shows an eccentric multi-step stairway. See Paris, Bibliothèque Nationale, latin 11560, fol. 32, reproduced in Alexandre de Laborde, La Bible Moralisée (Paris 1912), vol. 2, pl. 256.

the fifteen-step motif did make an appearance in early fourteenth-century art, but not within the sphere of the psalter where one might expect it. Rather it turns up in scenes of the Presentation of the Virgin Mary in the Temple, one of the regular illustrations in cycles of the life of Mary. The earliest of which we know is Giotto's fresco in the Scrovegni Chapel at Padua, painted between 1303 and 1307 (*fig. 7*). Giotto did not depict precisely fifteen steps, but the awkward and obtrusive stairway he did create seems clearly motivated by the sort of programmatic consideration involved in the fifteen-step motif. In any event the Presentation of the Virgin is depicted in two other prominent fourteenth-century Italian works of art and in each case with exactly fifteen steps. The first is the fresco painted by Taddeo Gaddi during the 1330's in the Baroncelli Chapel, Santa Croce, Florence;[34] and the second the relief sculptured by Andrea Orcagna during the 1350's on the Or San Michele tabernacle, also in Florence.[35] The fresco has an interesting arrangement of the steps; they are carefully divided into three banks of five each separated by brief landings.

There is no doubt that we have here the intentional employment of the fifteen-step motif; the question is why it first appeared with any regularity in fourteenth-century Italian depictions of the Presentation of Mary. There are other, more likely contexts for its employment; in addition to the illustration of psalm 119, for example, there is the illustration of the Presentation of Jesus in the Temple. The answer is obvious enough once noted: the use of the fifteen-step motif was inspired by a passage from the ›Legenda Aurea‹, compiled by the Genoese Dominican Jacobus a Voragine in the late thirteenth century. The passage occurs in a narrative of Mary's life given under 8 September, the feast of her Nativity. It tells how at the time of her weaning she was brought to the Temple which was on a hill and approached by fifteen steps corresponding to the fifteen gradual psalms:

> »Completo igitur per triennium ablactationis tempore ad templum domini virginem cum oblationibus adduxerunt. Erant autem circa templum juxta XV graduum psalmos XV adscensionis gradus, nam quia templum in monte erat constitutum, altare holocausti, quod forinsecus erat, adiri nisi per gradus non poterat.«[36]

The passage came about apparently as a conflation of the common doctrine of the psalm commentaries with the narrative of Mary's childhood in the apocryphal gospel of St. Matthew.[37]

The fifteen-step motif was thus established in fourteenth-century Italian depictions of the Presentation of the Virgin. By what route, then, did it make its way to our late fifteenth-century illustration of the gradual psalms? Was it the northern route? Its initial entry into northern art is obvious enough; it took place in the adaptation of Taddeo Gaddi's fresco in the famous ›Très riches heures‹.[38] But after that there is no clear path leading to the miniature of the Isabella Breviary. By and large the fifteen step motif remained confined to Presentation scenes and failed to appear in illustrations of the gradual psalms. Some of these pictures are interesting enough in

34 For a reproduction see Millard Meiss, French Painting in the Time of Jean de Berry; The Limbourgs and Their Contemporaries (New York 1974), vol. 2, fig. 668. See also Taddeo's drawing in the Louvre, reproduced in Meiss, Painting in Florence and Siena after the Black Death (Princeton 1951; repr. New York 1964, 1973), fig. 32.

35 For a reproduction see Meiss, Painting in Florence (footnote 34), fig. 28.

36 Jacobus a Voragine, Legenda Aurea, ed. Th. Graesse (Dresden 1846; repr. Osnabrück 1969), p. 588; see James H. Stubblebine, The Arena Chapel Frescoes [by Giotto] (New York 1969), p. 75, on the ›Golden Legend‹ as the source of inspiration for Giotto's series of frescoes on the early life of Mary.

37 See Alexander Roberts and James Donaldson (eds.), Apocryphal Gospels, Acts, and Revelations, Ante-Nicene Christian Library, vol. 16 (Edinburgh 1870), pp. 22f.

38 Chantilly, Musée Condé, Ms. 1284, fol. 54ᵛ. Meiss discusses the relationship of the miniature with Taddeo Gaddi's work in ›The Limbourgs‹ (footnote 34), vol. 1, pp. 157f.

themselves to bear mention. There are on the one hand beautifully executed examples with carefully depicted fifteen-step stairways such as that illustrating scenes from the early life of Mary in Philippe le Bon's copy of Jean Mansel's ›Fleurs des histoires‹.[39] On the other hand there are crude drawings and paintings like that which appears in a mid-fifteenth-century English copy of John Lydgate's ›Life of Our Lady‹ (*fig. 8*). Paradoxically such bizarre stairways are an even more emphatic testimony to the late medieval association of steps with the Temple at Jerusalem than the carefully drawn fifteen-step examples.[40] A curiously naive affirmation of this association comes in late fifteenth-century British illustrations of the ›Seven Joys of Mary‹. These illustrations utilize a simple Presentation scene with steps, not because there is any logical relationship between the text and the Presentation, but simply because the word »temple« appears in the opening line of text: »Virgo templum trinitatis«.[41] All in all these northern Presentation scenes provide part of the broad iconographic context for the Isabella Breviary's miniature, but they display no direct influence upon it either stylistically or iconographically in the sense of an explicit link with the gradual psalms.

It turns out to be southern rather than northern Europe which eventually supplies the latter connection. One witnesses it in the fifteenth-century Italian Books of Hours. It was mentioned above that while virtually every Book of Hours included the penitential psalms in its contents, only a small minority included the gradual psalms. This observation is colored somewhat by our greater familiarity with northern illumination, where illustrations of the gradual psalms are exceedingly rare.[42] In the less studied Italian Books of Hours one finds that they are fairly rare, but not nearly so rare as in the northern books. And it turns out that in several of those instances where the gradual psalms do appear in Italian Books of Hours, they are illustrated with a Presentation of the Virgin scene, in most cases a modest one with a stairway just sufficiently obtrusive to draw attention to itself (*fig. 9*).[43] There is, then, an iconographic precedent for the employment of the step-motif in the Isabella Breviary's miniature, but can one go so far as to call it a direct influence? One is tempted to do so upon viewing the illustration of the gradual psalms in the Prayer Book of Alphonso V of Aragon (*fig. 10*). The book was illuminated for Alphonso (died 1458), King of Aragon and Naples, by Aragonese artists in the mid-fifteenth century.[44] The miniature in question is a Presentation of the Virgin scene with an imposing fifteen-step stairway. It takes us as close to the miniature of the Isabella Breviary as the limitations of the present survey permit.

Indeed it must serve as the culmination of the survey. One can trace a continuous history from St. Jerome to the Prayer Book of Alphonso V; influences and relationships, at first literary and

39 Brussels, Bibliothèque Royale, Ms. 9231, fol. 171, painted by Jean de Pestivien? (see Durrieu [footnote 7], pp. 43f.; for a reproduction see Durrieu, pl. VI). For an inferior copy see Vienna, Schottenkloster, Codex 139 (167), fol. 155ᵛ.

40 See also Oxford, Bodleian, Lit. 98, fol. 77ᵛ.

41 For examples see Oxford, Bodleian, Lit. 401, fol. 105ᵛ; Oxford, Rawl. Lit. g. 3, fol. 84; and London, Lambeth Palace, Ms. 455, fol. 75.

42 For Books of Hours at Paris, for example, see Victor Leroquais, Les Livres d'Heures Manuscrits de la Bibliothèque Nationale, 2 vols., supplement, and portfolio (Paris 1927–1943). Of the 337 manuscripts described there, only nine have the text of the gradual psalms and only one an illustration, the Trinity.

43 For other examples see London, British Library, Add. 19417, fol. 233; Vienna, Österreichische Nationalbibliothek, C. V. P. 1981, fol. 51ᵛ; and Rome, Biblioteca Apostolica Vaticana, Regin. Lat. 1741, fol. 50. (I am most grateful to Rev. T. Frank Kennedy, S. J. for examining the Vatican Books of Hours.)

44 Amparo V. Davalos, La Miniatura Valencia en los siglos XIV y XV (Valencia 1964), pp. 105f., attributes the book's miniatures to Leonardi Crespi, painted from 1439–1443. A chapel pictured on fol. 263ᵛ has the date 1442 inscribed on its wall.

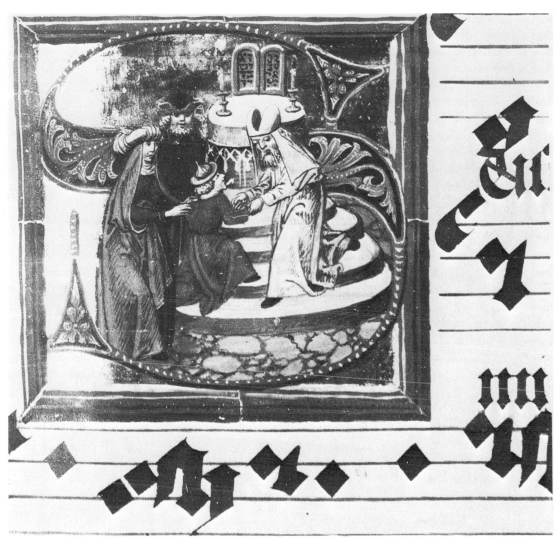

Fig 11

eventually iconographic, are readily discernible. The mainline of the history runs through the psalm commentaries to the ›Legenda Aurea‹, and thence from fourteenth-century Italian Presentation scenes like that of Giotto to those appearing in fifteenth-century Italian Books of Hours and finally the impressive mid-fifteenth-century Aragonese example. But then there is a gap between this example and the miniature of the Isabella Breviary. It is true that there is a basic iconographic connection between the two. It is altogether probable that whoever designed the miniature of the Isabella Breviary was aware of the southern practice of employing the step motif in illustrations of the gradual psalms; it is highly unlikely that he created it anew independently. Yet, important as this one link might be, there is much that separates the Isabella Breviary's miniature from its predecessors. Stylistic considerations aside, it did away with the Presentation of the Virgin scene; the steps were retained, but Joachim, Anna, Mary, and the priest were removed, and in their place appeared David the Pilgrim and the Levite musicians.

One must conclude that this is a bold and original step, one which lacks precedent. It is, however, the sort of thing we would expect from this book after our previous reflections upon its iconographic singularity. It falls in line with the general iconographic complexity of the book as well as its special fascination with things Jewish. On the latter point one cannot entirely resist the thought that the Spanish Dominicans who designed the program of this book had positive knowledge of the passage from the tractate ›Sukkah‹ which, as we saw above, corresponds in virtually every detail with the content of the miniature. This hardly seems probable, however, and we would do better to assume that the miniature was the product of reflection upon a number of circumstances such as the irrelevance of the Presentation scene personalities and the appropriateness of the Levite musicians. On this second point we should recall that the commentaries, including that of Nicholas, mentioned Levites on the steps and that the Isabella Breviary regularly pictured Levites with instruments in hand (*figs. 2 and 4*).

In any case, whether the illustration was based upon knowledge of one arcane source or reflection upon several commonly known sources, it appears to be more the product of original thought than of traditional practice, a rare circumstance indeed for medieval and Renaissance liturgical book illustration.

The Presentation of Jesus and the Fifteen-step Motif.

In pursuing the history of the fifteen-step motif one cannot ignore Presentation of Jesus scenes, which are much more common than Presentation of Mary scenes in late medieval art. Indeed as one of the standard scenes in »vita Christi« cycles they came to occupy the Wednesday illustration of the Little Office of the Virgin Mary, and accordingly to appear in the vast majority of extant illuminated Books of Hours. Thirteenth- through sixteenth-century examples number into the thousands. What is peculiar about them from the viewpoint of this study is that they virtually never employ the fifteen-step motif. One might expect them to do so since the event they represent is the precise analogy of the Presentation of the Virgin; in each case a pair of sainted parents present their favored child to the priest in the Temple. Why no Temple steps, then, for the Presentation of Jesus? The answer is simple enough and an object lesson in the workings of iconographic convention: it is that the fifteen steps were not mentioned in the literature in connection with it, whereas they were mentioned in the ›Legenda Aurea‹ in connection with the Presentation of Mary.

But now another iconographic mechanism comes into play, that of iconographic contamination, or what the Germans call »Typenwanderung«, the migration of types. This takes place when an iconographic theme or motif associated with one event comes to be employed in another because of its appropriateness. What is remarkable about the process from the modern point of view is that the transfer takes so long to occur; it can be a matter of centuries. One observes the vast repertory of fifteenth-century Presentation scenes wondering when and if the step motif will appear. The research associated with the present study has uncovered but four examples. The first two appear to be isolated, indeed somewhat eccentric examples, even though they are from well-known manuscripts. The manuscripts are

the ›Très riches heures‹ (footnote 38) and the mid-fifteenth-century Hours of Louis of Savoy (Paris, Bibliothèque Nationale, latin 9473, fol. 55). The illustrations show clear signs of their adaptation from Presentation of the Virgin scenes. The ›Très riches heures‹ example curiously places Mary, Joseph, and the child Jesus at the foot of the steps while an unidentified maiden, presumably modeled after the young Mary of Presentation of Mary scenes, occupies a position of prominence on the steps. In the Hours of Louis of Savoy it is Mary who mounts the steps, but one would identify the slight figure, with her long hair flowing down her back, to be the child Mary at the time of her Presentation rather than the mother Mary if she were not holding an infant.

The two other examples appear in Austrian graduals from the end of the fifteenth century; they give the impression that perhaps an iconographic tradition has finally been established. They are both historiated S initials for the introit »Suscepimus«, the introit of 2 February, the Feast of the Purification of the Virgin Mary, the occasion upon which the Presentation of the infant Jesus takes place. There is nothing remarkable about the first example (Vienna, Österreichische Nationalbibliothek, C. V. P., Suppl. mus. 15492, fol. 383), a modest depiction of Joseph and Mary with the infant Jesus, standing upon a stairway before a priest. The second example, however (Graz, Universitätsbibliothek, Codex 17 [37/9], fol. 40), is a most intriguing picture with its curved steps (*fig. 11*). Did this provincial artist have access to knowledge hidden even from the learned designers of the Isabella Breviary and did he intentionally attempt to depict the semicircular steps of the Temple? Or is this curious little stairway a mere accident of style? The latter no doubt is more likely, but of this we cannot be altogether sure.

To return now to the illustration of the Isabella Breviary and to the central point of this study, it should be clear enough that the miniature is incorrectly captioned »Musicians in the square before a church«; rather we observe in the picture Levite musicians on the fifteen steps of the Temple at Jerusalem. One might well object that the conclusion is hardly one of considerable significance for the history of music and certainly not one that justifies the great effort put forth to arrive at it. The objection has merit if one views all music historical activity as simply the means toward the stockpiling of musicological information, but it misses the central point of much music iconographical endeavor. Music iconography, after all, in its purest form is simply the iconography of art works with musical subject matter, that is to say, the explanation of a musical picture's content. Such explanation consists in a description of a picture's meaning and most importantly the historical factors that shaped the picture's content. If some hard music historical evidence results from this explanation, so much the better; but the proper end of the exercise is the picture itself and the historical process which created it. The value of a particular study accordingly lies in the inherent interest of the picture involved and of its prehistory. In this case it is hoped that the miniature of the Isabella Breviary and the history of its fifteen-step motif are considered worth the effort.

Paintings of Lady Concerts and the Transmission of »Jouissance vous donneray«

H. Colin Slim

List of Illustrations

Five paintings by the Master of the Female Half-Lengths (or his workshop), Antwerp: Three Lady Musicians (ca. 1520–1530).

Fig. 1: 40 × 33 cm. (pieced out to 60 × 53 cm.); Rohrau, Harrach Galerie. – Photo: after Franz Wickhoff, ›Die Bilder weiblicher Halbfiguren aus der Zeit und Umgebung Franz I. von Frankreich‹, in: Jahrbuch der kunsthistorischen Sammlungen des allerhöchsten Kaiserhauses 22 (1901), pl. XXXII.

Fig. 2: 53 × 37 cm. (or 38 cm.); Leningrad, Hermitage Museum. – Photo: after Franz Wickhoff, pl. XXXI.

Fig. 3: 54 × 48 cm.; formerly Meiningen, Herzogliches Schloß. – Photo: after Franz Wickhoff, pl. XXXIII.

Fig. 4: 47 × 37 cm. (or 48 × 38 cm.); Brazil, private collection (since 1955), 1953 offered for sale in Brussels. – Photo: E. Dulière, Bruxelles

Fig. 5: 27.5 × 20.5 cm.; Courtrai, A. de Witte collection. – Photo: E. Dulière, Bruxelles

Reproductions with the kind permission of the owners

* * *

Five paintings by the Master of the Female Half-Lengths, active around 1520–1530, probably in Antwerp, or executed by members of his workshop,[1] contain one or more voice parts to an early sixteenth-century chanson, »Jouissance vous donneray« by Claudin de Sermisy (c. 1495–1562) on a text by Clément Marot (1496–1544).[2] Four of these paintings, of approximately similar size, depict the same subject, a trio of lady musicians. The fifth painting, considerably smaller, represents Mary Magdalene playing her lute.

The best known of the Three Lady Musicians, 40 × 33 cm. (pieced out to 60 × 53 cm.), is in the Harrach Gallery at Rohrau (*fig. 1*).[3] Left to right it shows a singer standing in front of a leaded window, a transverse flautist seated at a table, and a standing lutenist, above and to whose right hangs an open lute case. The flautist performs from an open partbook which contains the complete text and music for the cantus of »Jouissance«. Abutting her triple flute case and its cover lying on the table are two closed books in a fleur-de-lys=stamped binding which perhaps

1 See Max J. Friedländer, Early Netherlandish Painting, vol. 12, trans. Heinz Norden (Leyden and Brussels 1975), pp. 18–21.

2 Earlier studies of one or more of these paintings are by Franz Wickhoff, ›Die Bilder weiblicher Halbfiguren aus der Zeit und Umgebung Franz I. von Frankreich‹, in: Jahrbuch der kunsthistorischen Sammlungen des allerhöchsten Kaiserhauses 22 (1901), pp. 221–245; Geneviève Thibault in Lionel de la Laurencie, Adrienne Mairy, and G. Thibault (eds.), Chansons au Luth et Airs de Cour Français du XVIᵉ Siècle (Paris 1934), p. XLII; Jean Rollin, Les Chansons de Clément Marot (Paris 1951), p. 192; John A. Parkinson, ›A Chanson by Claudin de Sermisy‹, in: Music & Letters 39 (1958), pp. 118–122; Heinrich Besseler, ›Umgangsmusik und Darbietungsmusik im 16. Jahrhundert‹, in: Archiv für Musikwissenschaft 16 (1959), p. 34f.; Isabelle Anne-Marie Cazeaux, The Secular Music of Claudin de Sermisy (Unpublished Ph.D. diss., Columbia University 1961), vol. 1, pp. 72f.; Daniel Heartz, ›Mary Magdalen, Lutenist‹, in: Journal of The Lute Society of America 5 (1972), pp. 55–58; and Walter Salmen, Musikleben im 16. Jahrhundert (= Musikgeschichte in Bildern, vol. 3, fascicle 9, Leipzig 1976), p. 120.

3 Reproduced in many places: Friedländer (footnote 1), vol. 12, pl. 45; Wickhoff (footnote 2), pl. XXXII; Parkinson (footnote 2), facing p. 122; Salmen (footnote 2), pl. 72; and Larousse de la Musique, vol. 1 (Paris 1957), facing p. 289; Besseler, Die Musik des Mittelalters und der Renaissance (Potsdam 1931), p. 274, fig. 134.

include the tenor and bass parts to Claudin's chanson. The singer, with closed mouth, holds a sheet of music on which appear two words, perhaps: »bien [?]« (or »son [?]« or »d'un [?]«) and »souvenir [?]« (or »savoir [?]« or »servir [?]«),[4] copied in a different hand from the open partbook on the table. The music is legible but lacks any clef. Neither music nor text relates to »Jouissance«,[5] or indeed to any chanson by Claudin or poem by Marot.

A version, 53 × 37 cm. (or 38 cm.), in the Hermitage Museum at Leningrad (*fig. 2*)[6] shows a similar scene although not identical music. The singer performs, with barely opened mouth, from the first line of the chanson's cantus, copied this time in the same hand as the flautist's tenor. This seems entirely appropriate for the singer because the chanson is one of the few by Marot wherein a woman narrates. The flautist reads from an open partbook of the tenor to »Jouissance«, which however lacks its final line of both text and music.

Another version, 54 × 48 cm., formerly in the Ducal Castle at Meiningen (*fig. 3*),[7] differs visually in several respects from Rohrau and Leningrad. An outdoor scene replaces their leaded windows; the singer wears a heavy gold chain; both her hands are visible; her right wristband, a fold rather than a ruff, is presumably formed in the same manner as the flautist's whose outer garment has an inner sleeve gathered at the elbow; below the flautist (lower left) is a platform; there is no cap on the table for the flute case; not two but three closed books lie on the table; the lutenist turns her head more sharply and outwards; and above and to her right hangs not an empty lute case but a second lute. The sheet of music held by Meiningen's singer has a little more of the cantus to »Jouissance« than does Leningrad's. In view of the considerable number of differences between the two paintings, all the more astonishing then is the absolute identity of Meiningen's open tenor partbook in music, in placement of text, and even in an error of a breve rest (see transcription) to Leningrad's, even though music and text are copied by a different hand.

A fourth and little-known version, 47 × 37 cm. (or 48 × 38 cm.), offered for sale in Brussels in 1953, was bought two years later by a private collector in Brazil (*fig. 4*).[8] As Max J. Friedländer already recognized in 1953,[9] this painting relates visually most closely to Rohrau (*fig. 1*). There are, however, many differences. Like Meiningen (*fig. 3*), Brazil lacks a cap for its flute case (trimmed in the photograph) and the gold chain worn by its singer occurs otherwise only in that painting. Alone among the patterned wood panelings which form the backgrounds, there appears

4 I wish to thank Craig M. Wright and Leonard W. Johnson for these suggested readings.

5 Thibault (footnote 2), p. XLII, and Rollin (footnote 2), p. 192, incorrectly identify it as the contratenor to »Jouissance«.

6 Reproduced in Wickhoff (footnote 2), pl. XXXI; in Parkinson (footnote 2), pl. facing p. 122; and in color in Pierre Descargues, The Hermitage Museum, Leningrad (New York 1961), p. 117, and Vladimir F. Levinson-Lessing, The Hermitage, Leningrad: Medieval and Renaissance Masters (London 1967), pl. 60, both of the latter containing brief, although inaccurate discussions of the music. A recent snapshot confirms that the cap for the flute case, lacking in Wickhoff's plate but visible in Descargues' and Levinson-Lessing's plates, has indeed been restored.

7 Reproduced in Wickhoff (footnote 2), pl. XXXIII, and in Georg Voss, ›Die Bau- und Kunstwerke der Stadt Meiningen‹, in: Herzogtum Sachsen-Meiningen, Kreis Meiningen (= Bau- und Kunst-Denkmäler Thüringens 34, Jena 1909), pl. facing p. 180. I. Reissland of the Staatliche Museen Meiningen reports that it was probably sold in 1914. I wish to thank Hellmuth Christian Wolff for obtaining information about the painting from Meiningen. Although Friedländer (footnote 1), vol. 12, p. 100, item 106a, states it was on the art market with Robert Finck in 1955, Monsieur Finck kindly has informed me it was not (letter of 4 September 1980). This is probably a confusion with the Brazil painting cited below. Robert Stiassny, ›Altdeutsche und Altniederländer in oberitalienischen Sammlungen‹, in: Repertorium für Kunstwissenschaft 11 (1888), pp. 380 f., discusses the Rohrau painting: »von welchem die Galerie zu Weimar eine unerkannte Originalwiederholung mit geringfügigen Aenderungen besitzt«. Uta Henning kindly informs me that nothing is known at Weimar of such a version. Perhaps Stiassny confused it with Meiningen or Brazil (see below).

8 I owe this information to the kindness of Hélène Mund of the Galerie Robert Finck, Brussels, in letters of 17 January and 20 February 1980. The painting is reproduced in: Connaissance des Arts 21 (1953), p. 6.

9 Connaissance des Arts 21 (1953), p. 6, though not mentioned in Friedländer (footnote 1), vol. 12, p. 100, item 106.

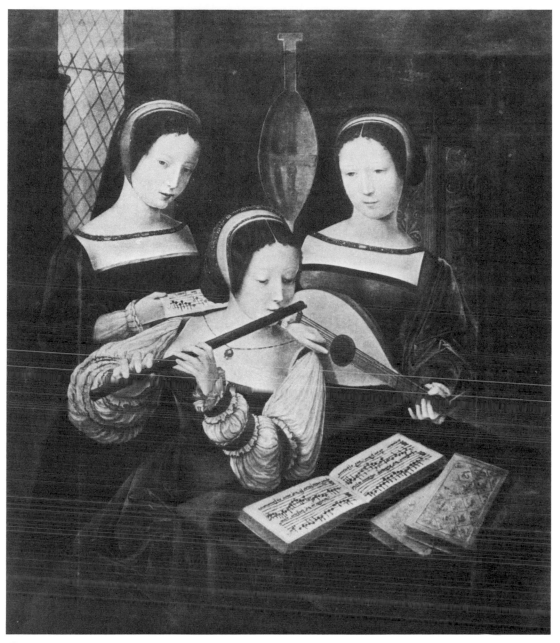

Fig. 1

in Brazil a grotesque below which is a nude female figure. Unlike the other masklike faces in these paintings, the face of Brazil's lutenist appears as if it were drawn from life, as revealed by the full lower lip and chin and the lifelike quality of the eyes. Only Brazil in this series lacks one lady wearing headgear of a protruding front- and backpiece, a head-dress which also appears in paintings from four other series by the Master of the Female Half-Lengths which depict Mary Magdalene reading, writing, playing the lute, and playing the clavichord.[10] There are also important musical differences between Rohrau and Brazil. First, the sheet of music and text: »[m?] on [?]« and »souspir [?]«,[11] held by Brazil's singer (with open mouth) differs from Rohrau's singer and is unrelated to chansons by Sermisy or to poetry by Marot. Secondly, Brazil's flautist plays neither from a complete cantus as in Rohrau (*fig. 1*), nor from an incomplete tenor as in Leningrad and in Meiningen (*figs. 2 and 3*), but from a complete tenor partbook which evidently once had all its text, although much of it and some of the music has now disappeared. However, comparison of the legible verso leaf of Brazil's tenor with the verso leaf of Rohrau's cantus and comparison of the few individual letters, ascenders, descenders, abbreviations, etc., still visible on the following recto leaf of Brazil with the following recto leaf of Rohrau show (a) that Rohrau's cantus (unlike the cantus on Meiningen's sheet – Leningrad's opening is not shown) and Brazil's tenor (unlike Leningrad's and Meiningen's tenors) begin with identical minim rests, (b) that Rohrau and Brazil have the same version of Marot's poem, identically spaced on their versos and rectos but differing from the Leningrad-Meiningen spacing, (c) that Rohrau's cantus continues its music on its recto at measure 10^3 and Brazil's tenor continues its music on its recto at measure 11, again differing from Leningrad-Meiningen. Damage and some repainting in the upper left-hand corner of Brazil's recto prevent certainty but it seems reasonable to conclude from the above that Rohrau's and Brazil's artists drew their complete cantus and tenor parts from the same set of partbooks or from the same musical source, one which differed from that used by the artists in Leningrad and Meiningen.

The fifth painting, 27.5 × 20.5 cm., in the A. de Witte collection at Courtrai, presents an entirely different scene (*fig. 5*),[12] although costume and bodice ornament link it closely with the two standing figures in the Rohrau painting and with the singer in Leningrad. Courtrai belongs to a series of at least five paintings by the same artist (or from his workshop) depicting Mary Magdalene as a lutenist.[13] Contemporary plays, poems, and the graphic arts tell us that music was one of the Magdalene's worldly joys before Christ converted her.[14] Each painting in the series assigns her the same chanson inscribed in French lute tablature: »Si j'ayme mon amy«, a chanson at the height of its popularity during the closing years of the reign (1498–1514) of Louis XII.[15]

10 See Friedländer (footnote 1), vol. 12, pl. 42, nos. 86 and 89–90; pl. 43, nos. 91 and 96; pl. 44, no. 101; and pl. 45, nos. 104–105; and Edwin M. Ripin, ›The Early Clavichord‹, in: The Musical Quarterly 53 (1967), pl. 4, facing p. 527.

11 I wish to thank Craig M. Wright for this suggested reading.

12 Reproduced in many places; see André Pirro, Histoire de la Musique de la fin du XIVe siècle à la fin du XVIe (Paris 1940), pl. XXI; Marc Pincherle, An Illustrated History of Music, trans. Rollo Myers (New York 1959), facing p. 53; Connaissance des Arts 141 (1963), p. 40; The Connoisseur 154 (1963), p. LXV; Le Siècle de Bruegel: La peinture en Belgique au XVIe siècle. Exhibition catalogue (Brussels 1963), ill. 96; in color in Robert Wangermée, La Musique Flamande dans la société des XVe et XVIe siècles (Brussels 1965), pl. 72; and in Friedländer (footnote 1), vol. 12, pl. 44, no. 99 and Heartz (footnote 2), pl. B.

13 Heartz (footnote 2), pl. A–E. Friedländer (footnote 1), vol. 12, p. 100, no. 100 lists another, now unlocatable.

14 See H. Colin Slim, ›Mary Magdalene, musician and dancer‹, in: Early Music 8 (October 1980), pp. 460–473; idem, ›Instrumental versions, c. 1515–1554, of a late fifteenth-century Flemish chanson, O waerder mont‹, in: Iain Fenlon (ed.), Music in Medieval and Early Modern Europe: Patronage, Sources and Texts (Cambridge 1981), pp. 131–161.

15 Heartz (footnote 2), pp. 62f. Adrienne Fried Block has kindly informed me that the citation of the first line of the chanson as a timbre in French noël collections between 1520 and c. 1568 shows that it was also current somewhat later.

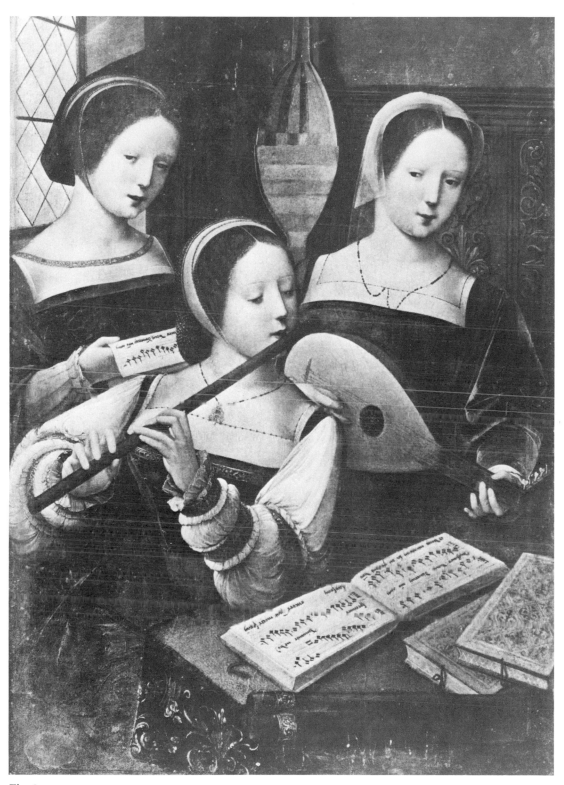

Fig. 2

Exceptionally, the version at Courtrai adds a second chanson. The partially covered sheet of mensural notation gives two fragments from the opening of the cantus to »Jouissance«, likewise a favorite during the reign (1515–1547) of Louis' successor, Francis I.

Interrelationships between the five paintings at Rohrau, Leningrad, Meiningen, Brazil, and Courtrai and a possible prototype are difficult to discuss because art historical research on works by the Master of the Female Half-Lengths and by members of his shop has been more extensive than intensive.[16] What follows, therefore, although based on consultation with several art historians, is offered more as conjecture than as conclusion.[17]

Although Rohrau's version seems best in terms of the quality of its execution, the curiously unnatural manner in which its flautist's head sits on her neck (exaggerated in Meiningen) seems sufficient to cast doubt on its status as an original (see also below, p. 64, re its lute stringing). While superior positioning in Leningrad and its generally better compositional balance – only its lutenist's head turns inward – suggest a closer relationship to a hypothetical original, Leningrad's poor execution probably indicates that a lost original stands several versions behind it. For Friedländer, it was »quite plain that he [the artist] ran a kind of factory«.[18] Indeed, the reiteration of motifs from painting to painting even suggests an assembly-line technique in his shop with assistants specializing in jewelry, head-dress, instruments, etc. On the one hand, it is distinctly possible that the painter did not consider any aspect of performance, assembling the musical features in the painting only as one of several of his means of evoking an atmosphere of love. On the other hand, some of these musical features are so suggestive that they seem to argue for a quite literal interpretation.

Very little is known of the early provenance of these paintings, but presumably they, like others by this Master, were for export. A considerable number of paintings by the Master of the Female Half-Lengths are now, or were, in Spain.[19] They were also popular in France, not only because his pictures contained French chansons and even letters inscribed in French,[20] but because of what Friedländer describes as their »thoroughly French«, »ladylike ambiance«.[21] In 1529, for example, Francis I bought nine Flemish pictures from a dealer in Antwerp.[22] A generation later Brantôme (c. 1540–1614) in his ›Vie des Dames Galantes‹, troisième discours, recalls an incident at court during the reign (1574–1589) of Henri III. The King compared a female courtier to those »femmes en peinture que l'on porte de Flandres, et que l'on met au devant des cheminées d'hostelleries et cabarets avec des fleustes d'Allemand au bec«.[23] Despite the fact that lovemaking flourished at such places and that the King's comparison suggests that ladies in such paintings were more coarse than courtly, his derisive tone really fails to suggest

16 See the literature cited in Friedländer (footnote 1), vol. 12, p. 134, and idem, ›Der Meister mit dem Papagei‹, in: Phoebus 2 (1948/49), pp. 49–54. Further, see Friedrich Winkler, article ›Meister der weiblichen Halbfiguren‹, in: Ulrich Thieme and Felix Becker, Allgemeines Lexikon der bildenden Künstler, rev. Hans Vollmer, vol. 37 (Leipzig 1950), p. 351.
17 I am indebted to my colleagues George and Linda Bauer, to Drs. Douglas Hinkey and David Metzgar, and to Hélène Setlak.
18 Friedländer (footnote 1), vol. 9, 2 (1973), p. 109.
19 Idem, vol. 12, pp. 18 and 100, no. 106.
20 Hippolyte Fierens-Gevaert, Les Primitifs Flamands, vol. 3 (Brussels 1910), p. 226 and pl. CLXXI; see Friedländer (footnote 1), vol. 12, pl. 43.
21 Ibidem, p. 19.
22 Lorne Campbell, ›The Art Market in the Southern Netherlands in the Fifteenth Century‹, in: The Burlington Magazine 118 (April 1976), p. 197.
23 Pierre de Bourdeille, Seigneur de Brantôme, Les Dames Galantes, ed. Maurice Rat (Paris 1960), pp. 195 f., translation in: The Lives of Gallant Ladies, trans. Alec Brown (London 1961), p. 210.

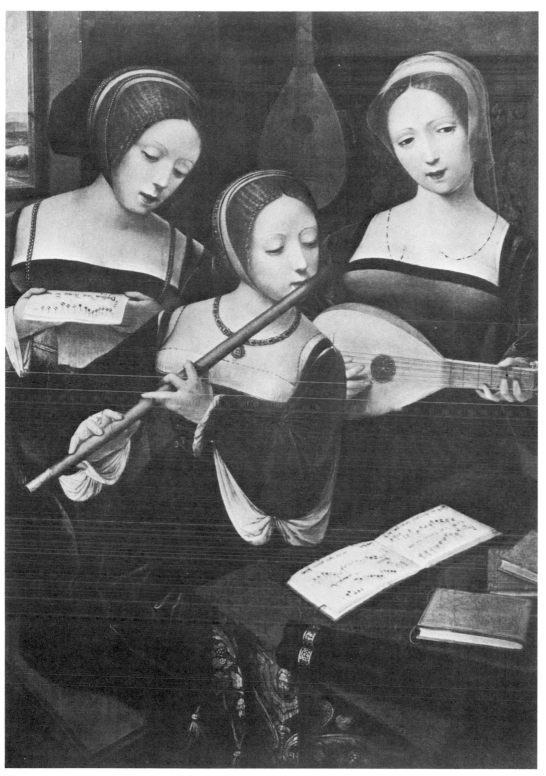

Fig. 3

erotic connotations for these paintings. While the ladies in such paintings might have been courtiers, it would surely be incorrect to assume that our three ladies are portraits of real persons at court.[24] Repeating these same masklike countenances in the vast majority of the Master's paintings of female figures – Friedländer aptly characterizes them as »anaemic, boneless creatures, pretty but vacuous« – guarantees they are not portraits, but rather »pseudo genre«.[25]

Given the number of real genre paintings later in the sixteenth century and into the seventeenth century which have allegorical meanings or allow moralistic interpretations,[26] it does not seem fanciful to assign symbolic meaning to these lady trios. In the Courtrai Mary Magdalene, »Jouissance« and »Si j'ayme mon amy« may symbolize not only her musical abilities but also her skills at dancing when she was a courtesan. »Si j'ayme«, »Jouissance«, and several other chansons inscribed in Mary Magdalene paintings by the Master of the Female Half-Lengths and by other painters were basse dances. Their presence is not accidental for the same plays, poems, and graphic arts which speak to the Magdalene's musical talents also chronicle her dancing.[27] While the elegance of the lady trios and the refined, impersonal, and detached tone of Marot's verse belie any similar interpretation of these ladies as courtesans, there seems to be no reason to deny that the lady concerts are at least a generalized symbol of love, one which perhaps elucidates Brantôme's report. In Friedländer's words, such musical compositions (and by implication the pictures which contain them) »are quite unlikely to be either indecent or titillating but rather harmless poesy with a bit of eroticism thrown in«.[28]

Claudin's »Jouissance« first appeared in print at Paris in 1528 for four voice parts: cantus, altus, tenor, and bassus.[29] Although neither an altus nor a bassus partbook is specified in any version of the Three Lady Musicians, one might reasonably assume that they are the two closed books lying on the table in Rohrau, Leningrad, and Brazil, and are among the three closed books on Meiningen's table. The fact that the left-hand figures in Rohrau and Brazil hold an unrelated sheet of music indicates that Rohrau's open cantus plus two closed books and Brazil's open tenor plus two closed books each lack one voice part. Leningrad's singer holds not an entire cantus partbook but merely a sheet with the beginning of that voice, complementing its open tenor partbook. Leningrad's two closed books might therefore be the altus and the bassus or perhaps the cantus and the bassus. The same situation obtains in Meiningen except that the three closed partbooks would presumably be cantus (notwithstanding the sheet containing the beginning of the cantus held by the singer), altus, and bassus.

Thus except for Meiningen, three of these pictures imply that »Jouissance« also existed for three voices. A slightly larger range in the printed altus part than the other voices and a tendency towards larger skips means that although skillfully composed, the altus is not as carefully integrated as the other voices. Moreover, a three-voiced version, or rather two slightly differing

24 As attempted by Heartz (footnote 2), pp. 65–67. Theodor von Frimmel, ›Vom Meister der weiblichen Halbfiguren‹, in: Beilage zur Allgemeinen Zeitung no. 256 (Munich 1902), p. 254, in reviewing Wickhoff (footnote 2), p. 223, first cautioned against such interpretations, later seconded by Friedländer (footnote 1), vol. 12, p. 18.

25 Friedländer (footnote 1), pp. 18 and 20.

26 See for example Slim, The Prodigal Son at the Whores': Music, Art, and Drama (Irvine 1976, University of California); Richard D. Leppert, ›The Prodigal Son: Teniers and Ghezzi‹, in: The Minneapolis Institute of Arts Bulletin 61 (1974), pp. 80–91, and idem, The Theme of Music in Flemish Paintings of the Seventeenth Century (Munich and Salzburg 1977), 2 vols., especially vol. 1, pp. 39–53.

27 See footnote 14.

28 Friedländer (footnote 1), vol. 12, p. 20.

29 Heartz, Pierre Attaingnant: Royal Printer of Music (Berkeley and Los Angeles 1969), pp. 210–212, item 2, no. 5.

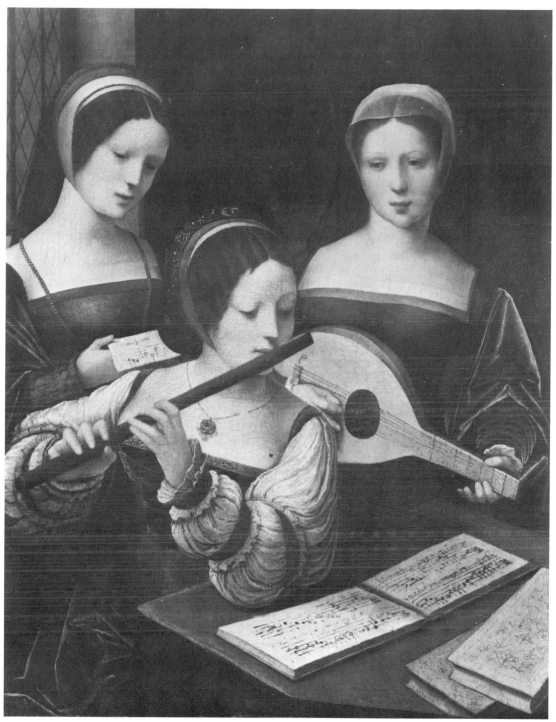

Fig. 4

three-voiced settings for cantus, tenor, and bassus survive at Copenhagen from c. 1520–c. 1525.[30] This might suggest either that Rohrau, Leningrad, and Brazil (or their hypothetical prototype) stem from this period, or that they stem from a later, now unknown printed or manuscript three-voiced tradition postdating the four-voiced version which first appears in 1528. Either theory seems tenable since the only information we have regarding dates for the Master of the Female Half-Lengths is that some time after 1527 he twice copied a painting by Jan Gossaert (c. 1480–1532) from that year.[31]

How are we to interpret the performance of the chanson in these paintings? Despite a complete cantus in Rohrau and a complete tenor in Brazil, these two paintings were not likely to have been conceived within the long Flemish tradition of pendant paintings because of their identical subject matter. Whatever may be the significance of the unknown sheet of music the singer holds in each, Rohrau and Brazil do not very strongly suggest monophonic performance for their chanson's cantus and tenor, respectively. By this period the lute is usually a polyphonic instrument and would normally play the tenor and bassus to a singer's cantus. Presumably our lutenist would play such parts by memory, or at the most utilize one of them visible to her as a mnemonic device.

Nevertheless, there is some evidence for monophonic performance of one voice, the tenor. Jacques Moderne's ›S'ensuyvent plusieurs Basses dances tant Communes que Incommunes‹, a basse dance print of c. 1530–1538 but which probably records a slightly earlier practice, gives steps to a dance he calls ›Jouissance‹ without specifying which voice part of the chanson he intends to be used.[32] However, in 1589 Thoinot Arbeau's Orchésographie not only cites ›Jouissance‹ as a basse dance, but prints a dance version of Claudin's tenor.[33] The prestige the tenor enjoyed over other voices of the chanson is exemplified in a fricassée printed by Moderne in 1538.[34] When Henry Fresneau, its composer, wanted to identify ›Jouissance‹ he quoted Claudin's tenor. The construction of Claudin's tenor also suggests it was composed first. The musical phrase used to set line two of Marot's poem is repeated in line five, a repetition lacking in any other voice. As Jane Bernstein remarks: »This repetition forms an even closer relationship with the poetic structure than that of the superius line and suggests that unlike the tenor of most Parisian chansons, this tenor was conceived before the superius.«[35]

30 Det Kongelige Bibliotek, Ms. Ny Kongelige Samling 1848, 2°, pp. 182 and 210, from c. 1520–c. 1525, see Charles Hamm and Herbert Kellman, Census-Catalogue of Manuscript Sources of Polyphonic Music 1400–1550, vol. 1 (American Institute of Musicology, 1979), pp. 163f., to which must now be added Peter Woetmann Christoffersen, ›Or sus vous Dormez trop. The Singing of the Lark in French Chansons of the Early Sixteenth Century‹, in: Festskrift Henrik Glahn, ed. Mette Müller (Copenhagen 1979), especially pp. 36f. I wish to express my profound thanks to Mr. Christoffersen who kindly shared his extensive knowledge of this Ms. with me.

31 Friedländer (footnote 1), vol. 12, p. 18, and vol. 8 (1972), pl. 22, no. 14b.

32 François Lesure, ›Danses et Chansons à Danser au Début du XVIᵉ Siècle‹, in: idem, Musique et Musiciens Français du XVIᵉ Siècle (Geneva 1976), p. 52, no. 33; see also Heartz, ›The Basse Dance. Its Evolution circa 1450 to 1550‹, in: Annales Musicologiques 6 (1958–1963), pp. 297f., and idem (ed.), Preludes, Chansons and Dances for Lute Published by Pierre Attaingnant, Paris (1529–1530) (Neuilly-sur-Seine 1964), p. XXXII and p. LXXII, no. 32.

33 Thoinot Arbeau, Orchesography, trans. by Mary Stewart Evans with introduction by Julia Sutton (New York 1967), pp. 67–74; the opening of the chanson and the dance are compared in Parkinson (footnote 2), p. 122.

34 Jacques Moderne, Le Parangon des Chansons. Tiers livre contenant. xxvi. chansons nouvelle [sic], no. 1, fol. 4; see Samuel F. Pogue, Jacques Moderne. Lyons Music Printer of the Sixteenth Century (Geneva 1969), p. 140, item 13, and Heartz, Preludes, Chansons and Dances for Lute (footnote 32), p. LXXII, no. 32, and Lesure, ›Éléments populaires dans la chanson française au début du XVIᵉ siècle‹ (footnote 32), p. 179.

35 Jane Bernstein (ed.), Jouissance vous donneray: The French Polyphonic Chanson (1520–1580), to be published by Tecla Press, London. I am grateful to Ms. Bernstein for sharing this information in advance of publication. – Heartz, ›The Basse Dance‹ (footnote 32), p. 314, states: »quite exceptional for the time, Jouissance shows evidence that its tenor was the first part to be written – only this voice is symmetrical to the point of exact repetition in the second halves of the a and c sections.« See also idem, Preludes, Chansons and Dances for Lute (footnote 32), p. LXXII, no. 32.

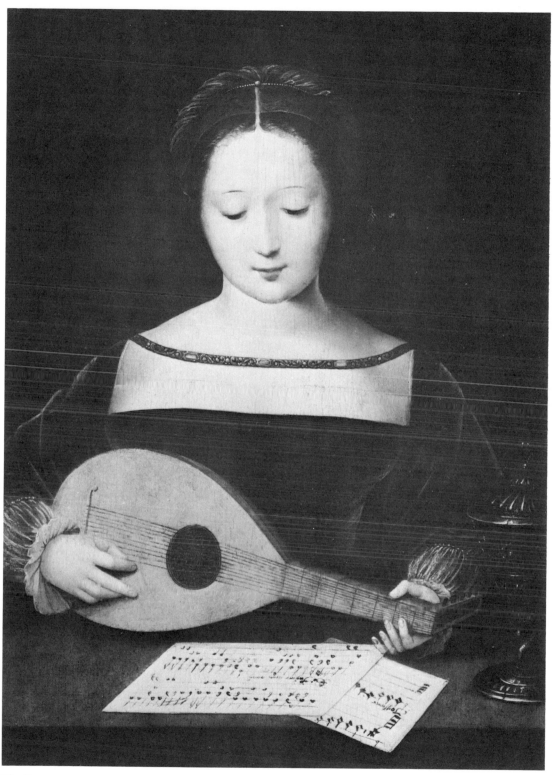

Fig. 5

The only evidence – and flimsy it is – for monophonic performance of the cantus of »Jouissance« occurs in the Mary Magdalene painting which depicts the cantus lying below a lute intabulation of an earlier chanson, »Si j'ayme mon amy«. However, presumably Mary Magdalene either knew by heart a lute accompaniment to »Jouissance« or she accompanied her singing of its cantus by a lute arrangement of the two lower voices of »Jouissance« such as appears in Pierre Attaingnant's ›Tres breve et familiere introduction . . . en la tabulature du Lutz‹ (Paris 1529), fol. 50ᵛ, which also contains the cantus in mensural notation.[36]

With their cantus sheets held by their singers and their tenor partbooks in front of their flautists, Leningrad and Meiningen might suggest two-voiced performance of »Jouissance« (unless their lutenists knew other voice parts by heart). Unlike the vast majority of Claudin's chansons, the tenor and cantus of »Jouissance« make perfect harmonic and contrapuntal sense by themselves,[37] not requiring Claudin's bass at any point and much less his altus, whose larger range and less smooth voice-leading make one suspect a si placet function. This is confirmed by the Copenhagen manuscript's pair of three-voiced versions, each lacking an altus. While no two-voiced version using Claudin's tenor and cantus survives in print or manuscript, the self-contained nature of these two voices and their appearance in both Leningrad and Meiningen may hint at an original two-voiced chanson by Claudin.

In all four paintings the lutenist ignores the music as intently as the flautist reads it. The lutenists in Rohrau and in Brazil look away from the open partbook slightly to their right. Meiningen's lutenist looks even farther away to her left. Perhaps the left eye of Leningrad's lutenist regards the tenor partbook, but her right eye wanders rightwards. Only Mary Magdalene as a lutenist seems intent on her tablature. If a lost original painting really stands behind Leningrad, presumably it focussed both her eyes on the tenor partbook.

The physical characteristics of the six lutes depicted in these five paintings are shown in the table on page 63.[38] Apropos the pear shape of these instruments, Heartz has observed:

> »The shape of the lute used in the paintings [the Mary Magdalene series] is another element that suggests a date not later than 1520. The more ample and fully-rounded lute that came into favor slightly later is beautifully documented in a painting [Paris, Musée Carnavalet] of a concert on the banks of the Seine, with Notre Dame de Paris in the background – a painting datable by its music (the four-part chanson ›Au pres de vous‹) at least a decade later than the Magdalen [sic] series.«[40]

His observation is confirmed by a series of Flemish concert scenes and another series of the Vanities, all after 1530, depicting similarly rounded lutes.[41]

36 Modern edition in La Laurencie, Mairy, and Thibault, Chansons au Luth (footnote 2), pp. 44 f., no. 21, also facs. p. XXIV.

37 Of the 169 chansons in Sermisy, Chansons, ed. Cazeaux in the Opera omnia, vols. 3 and 4 (American Institute of Musicology, 1974), only nos. 5, 12, 16, 18, 19, 22, 24, 28, 31, 37, 38, 41, 43, 44, 52, 54, 59, 63, 66, 70, 72–75, 77–78, 83, 87, 89, 91, 106, 109, 111, 113, 115, 117–118, 120–121, 126, 129, 136–137, 139–140, 143, 145, 151, 164, 166, and 168–169 contain tenor and cantus parts which could be independent and many of these are two- and three-voiced chansons.

38 I wish to thank my student, Hiroyuki Minamino, for assistance in formulating these observations.

39 These distinctions proceed from Friedemann Hellwig, ›Lute-Making in the late 15th and 16th century‹, in: The Lute Society Journal 16 (1974), pp. 29 f.

40 Heartz, ›Mary Magdalen, Lutenist‹ (footnote 2), pp. 63 f.

41 See Slim, The Prodigal Son at the Whores' (footnote 26), pls. 8–12, and Georges Marlier, La Renaissance Flamande: Pierre Coeck d'Alost (Brussels 1966), p. 399, fig. 354, respectively. However, the pear shape by no means disappears as can be seen in several paintings listed by Marlier, ibidem, and by Slim, ›Mary Magdalene, musician and dancer‹ (footnote 14), p. 472, note 34. I am preparing a study of these Vanity paintings.

TABLE I

LUTES	ROHRAU (pl. 1)	LENINGRAD (pl. 2)	MEININGEN (pl. 3)	BRAZIL (pl. 4)	COURTRAI (pl. 5)
size; shape; ribs	medium; pear; visible	medium; pear; visible	1: smallest; pear; invisible 2 medium (hanging); pear; invisible	medium; pear; visible	smaller; pear; visible
relation of neck to body[39]	belly overlaps joint of body and neck	belly overlaps joint of body and neck	both: finger boards overlap joint of body and neck	belly overlaps joint of body and neck	fingerboard overlaps joint of body and neck
rosettes; designs: a, b, c, d	roundish; a	roundish; b	both: round; both: c	oval; d (?)	ovalish; d
courses	6 double	5 double; 1 chanterelle	both: 5 double; 1 chanterelle	5 double; 1 chanterelle	5 double; 1 chanterelle
pegs visible	6 (?)	5	1: 4 above; 4 below	5	5 above; 6 below
frets	7	5 (or 6?)	1: 6 2: 7	7	8
bridge design	circular end	straight end	both: claw ends	circular end	circular end
playing position	unsupported	unsupported	unsupported	unsupported	supported by table
left-hand position	finger 1, fret 2, raised (?) over course 2; finger 2, fret 3, raised over course 3	finger 1, fret 2, course 2; finger 2, fret 3, course 3	finger 1 between frets 1 and 2, raised over course 3; finger 2, fret 2, raised over course 3; finger 3 between frets 3 and 4, course 2; finger 4 behind neck.	finger 1 between frets 2 and 3, course 2; finger 2, fret 3, course 1	finger 1 between frets 1 and 2, raised over courses 2 and 3; finger 2, fret 2, raised over course 1
right-hand position	normal	normal	thumb and finger 1 unnaturally separated	similar to Rohrau, but finger 2 is bent	similar to Brazil, but hand shifted to chanterelle
string plucked: chanterelle = 1	open 4 (or 3) by thumb	open 4 by thumb	open 5 (lower string) by thumb; course 3 just plucked by finger 1 (?)	open 4 by thumb	open chanterelle by thumb
lute case	vertical stripes throughout; lower half: 2 horizontal stripes	upper half: vertical stripes; lower half: 8 horizontal stripes	not present	upper half: vertical stripes; lower half: 7 horizontal stripes	not present

The above comparisons, while revealing several more complicated relationships among the five paintings, show unmistakably how Meiningen by virtue of its two lutes, their bridges with clawed ends, its left and right hand playing positions, and its overlapping finger board distinguishes itself from all the other instruments. These differences in its lutes are, of course, mirrored by a great many other nonmusical details, some of which have already been mentioned.

Only Rohrau's chanterelle (the highest in pitch) is double strung. Double stringing of a chanterelle appears in no other painting by the Master of the Female Half-Lengths, or in any ascribed to him. Not only this Master and his workshop but also the theorists of the period are unanimous in stating that the chanterelle is a single string.[42] This fact also suggests that despite its elegance of execution the Rohrau painting is not the original.

Whereas Mary Magdalene clearly plucks »Si j'ayme mon amy« on her single chanterelle, all the other lutenists play something, presumably »Jouissance«, on one of their middle strings. Either they play some other voice part by memory, improvise from the open partbook, or double the flautist who obviously reads from the music. Since no lutenist except Mary Magdalene plucks a high string, none of the four can be playing at pitch the cantus to »Jouissance« which appears, in any case, solely in Rohrau's partbook. If any of the lutenists play from music which is visible, it must be from the tenor partbook. Perhaps this also lends more credibility to Leningrad which has a tenor partbook as being closely related to a lost original painting, than to Rohrau, which has a cantus partbook.

None of the four flautists displays any special embouchure which would serve to make her playing more or less realistic than any of her counterparts.[43] The only distinguishing physical characteristics of the flutes appear in Meiningen's instrument which has metal ferrules at both ends and in Leningrad's which apparently has a turned wooden lower end. Hand positions of the flautists in Rohrau, Leningrad, and Brazil are identical. In Meiningen, however, the lady's fingers on both hands are spread very far apart. Clearly the finger holes on this instrument are to be viewed as more widely spaced than on the other three flutes. Obviously Meiningen's artist wanted to depict a longer instrument. If we select the flautists' ornaments attached to their necklaces as an invariable against which to measure the length of each flute, then we discover that the Meiningen instrument is indeed slightly longer than the others. The other three flutes are roughly the size of a tenor instrument pitched in *D*, having a lowest tone one note above piano middle *C*. In depicting the Meiningen flautist with such awkwardly stretched fingering on a slightly longer instrument, Meiningen's artist apparently intended a bass flute, pitched a fourth lower on *G*.[44]

Two factors make it difficult to imagine the actual sound which might have been produced from painting to painting. The first is a curious acoustical phenomenon, already noted by

42 Heartz, ›Les premières »Instructions« pour le luth (jusque vers 1550)‹, in: Le Luth et sa Musique, ed. Jean Jacquot (Paris 1958), pp. 78 f., repeated in idem, ›Mary Magdalen, Lutenist‹ (footnote 2), p. 54.

43 I am grateful to Howard Mayer Brown for much assistance concerning these observations on the flutes.

44 For an introduction see Jeremy Montagu, The World of Medieval & Renaissance Musical Instruments (Newton Abbot, London, and Vancouver 1976), pp. 94–97; David Munrow, Instruments of the Middle Ages and Renaissance (London 1976), pp. 53–56; and Joscelyn Godwin, ›The Renaissance Flute‹, in: The Consort 28 (1972), pp. 71–81. Bernard Thomas, ›The Renaissance Flute‹, in: Early Music 3 (1975), pp. 2 f., suggests tenor and bass flutes pitched in *C* and *F*, respectively, as does Rainer Weber, ›Some Researches into Pitch in the 16th Century with Particular Reference to the Instruments in the Accademia Filarmonica of Verona‹, in: The Galpin Society Journal 28 (April 1975), p. 8, on instruments dating from after 1550. Parkinson (footnote 2), p. 121, incorrectly sees Leningrad's flute as larger than Rohrau's.

Praetorius in his ›De Organographia‹ of 1619.[45] One cannot be absolutely certain which octave a flute or recorder actually sounds, although in fact both sound an octave higher than the written pitch. The second factor is that in mixed consorts (such as depicted in these paintings) flutes often took over inner parts.[46] Thus, sounding an octave higher than the written altus or tenor part, they actually cross the cantus, even if they do not always appear to be doing so. If Brazil's singer should ignore her unrelated sheet of music and join in singing from the cantus sheet which her Leningrad counterpart holds, both will find themselves singing somewhat below their tenor flautist whose *D* instrument transposes the facing tenor part of »Jouissance« up one octave. If Rohrau's lady looks over the shoulder of her flautist and sings from the cantus partbook in front of that *D* instrument, either she will find herself doubled at the unison (uncomfortably low for the flautist) or doubled an octave higher (too high for the flautist). Meiningen's singer, performing from her sheet containing the cantus, will hear her bass flautist playing the tenor of the chanson an octave higher, which will thus constantly cross her melody.

If we assume that despite her averted gaze each lutenist plays solely from the flautist's partbook, then she would contribute as follows to the ensemble. In Brazil and in Leningrad by playing at pitch from the open tenor partbook as her finger positions suggest, she would nicely cushion the high sounds of the singer and especially those of the flute. Because the finger position of Rohrau's lutenist suggests that she is not playing from the cantus partbook in front of her flautist colleague, perhaps her glancing aside means she plays by heart or improvises polyphonically. As suggested by her hand position and the partbook, Meiningen's lutenist would help balance the ensemble by playing the tenor part at pitch, thus sounding an octave below the bass flute.

Isabelle Cazeaux has observed that Rohrau's cantus for »Jouissance« does not appear exactly in any printed or manuscript source for the chanson.[47] (The same holds true for the tenor parts in Leningrad, Meiningen, and Brazil.) Even the mezzo soprano clefs in Rohrau's trio and in Courtrai's Mary Magdalene are unique in transmitting the chanson (see the transcriptions, pp. 66 ff.). The cantus parts of Rohrau and Courtrai, using the same mezzo soprano clef, may well be drawn from the same source. This also seems likely in view of their artistic affinities such as costume and bodice ornaments, mentioned earlier. Except for their soprano clefs and their avoidance of Rohrau's minor coloration between measures 5–6 and 23–24, the cantus parts in Munich, Bayerische Staatsbibliothek, Ms. Mus. 1516, no. 36[48], and in Vienna, Österreichische Nationalbibliothek, Ms. 18810, no. 63[49], are the only two sources to preserve musical readings otherwise identical to Rohrau's. Neither manuscript contains further words beyond identical incipits, »Jam sauche«. The Munich manuscript is c. 1540. The Vienna manuscript (which in a

45 Michael Praetorius, Syntagma Musicum, vol. 2: De Organographia (Wolfenbüttel 1619); facs. ed. by Wilibald Gurlitt (Kassel 1958), p. 21; English translation of the section on musical instruments by Harold Blumenfeld (New Haven 1949, 2nd ed. New York 1962), p. 21; a slightly different translation appears in Sydney Beck's introduction to Thomas Morley, The First Book of Consort Lessons Collected 1599 & 1611 (New York, London, Frankfurt 1959), p. 40.

46 See Howard Mayer Brown, Sixteenth-Century Instrumentation: The Music for the Florentine Intermedii (American Institute of Musicology, 1973), pp. 66f.

47 Cazeaux, The Secular Music of Claudin de Sermisy (footnote 2), p. 72, note 1.

48 Julius Joseph Maier, Die musikalischen Handschriften der K. Hof- und Staatsbibliothek in München. Erster Theil. Die Handschriften bis zum Ende des XVII. Jahrhunderts (Munich 1879), pp. 114–117, no. 204, and Marie Louise Martinez-Göllner, Bayerische Staatsbibliothek. Katalog der Musikhandschriften. Tabulaturen und Stimmbücher bis zur Mitte des 17. Jahrhunderts (Munich 1979), pp. 92–101.

49 Joseph Mantuani (ed.), Tabulae codicum manu scriptorum praeter Graecos et orientales in Bibliotheca Palatina Vindobonensi asservatorum, vol. 10: Codicum musicorum pars 2 (Vienna 1899), p. 222, no. 63.

»Jouissance vous donneray« inscribed in the five paintings

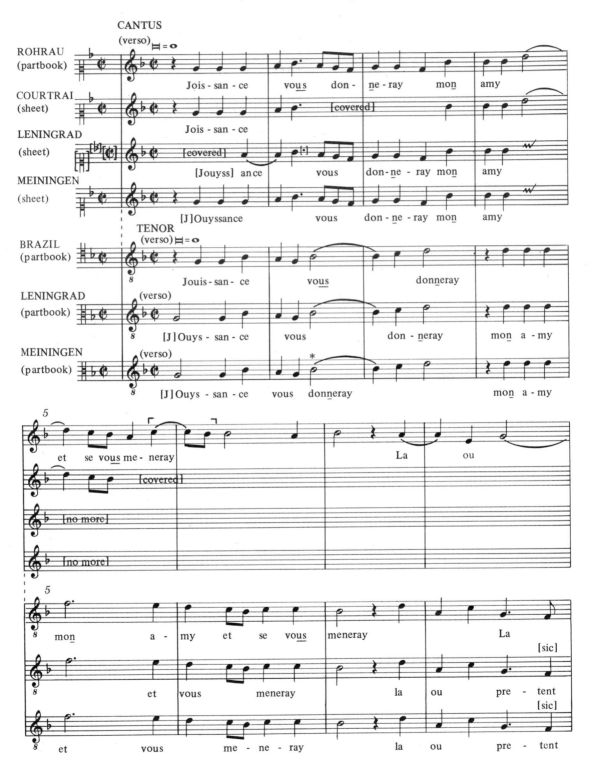

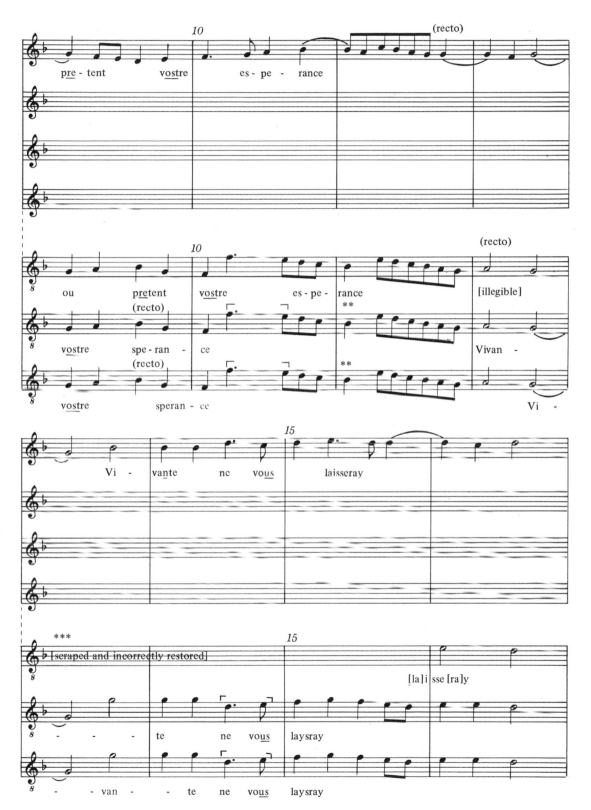

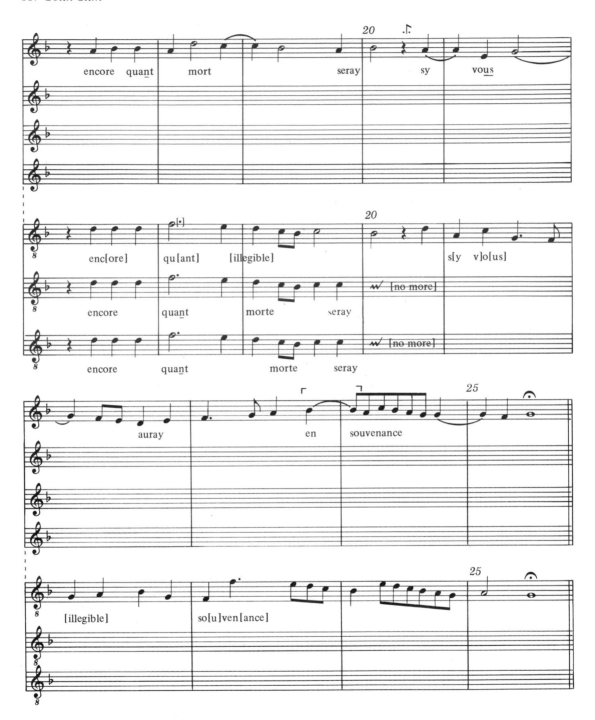

*Incorrect dotted minim in Meiningen.

**Incorrect breve rest between b flat and e in Leningrad and Meiningen.

***The restoration between mm 13-15: is clearly wrong in Brazil.

Unidentified composition in two paintings

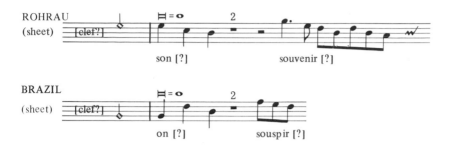

different hand heads its cantus, surely incorrectly, as by »Petrus de la Rue«) was copied by Lukas Wagenrieder in 1533 and bears dates of 1524 and 1533.[50] Neither of the tenors in Munich and in Vienna is identical to the tenor parts inscribed in Leningrad–Meiningen and in Brazil. Wagenrieder's source for the cantus of »Jouissance« in Vienna may have come from the 1520s and would thus aid in placing Rohrau during that period. Although Meiningen's sheet has more of the cantus than Leningrad's, the affinity of their soprano clefs and their absolutely identical tenor parts (both in alto clef) suggest their cantus parts were also copied from an identical source. Brazil's complete tenor (so far as it can be deciphered) is independent of both Leningrad's and Meiningen's incomplete tenors, as shown by its tenor clef which appears in no other source except London, Royal College of Music MS 1070, pp. 226–227 (c. 1530).[51] Obviously a considerably larger and more varied number of sources once existed than the five prints and fourteen manuscripts which now survive. Even more telling is the independence by and large of the surviving manuscripts from each other and from Attaingnant's five prints, for only three manuscripts copy Attaingnant.[52]

As for the texts of the chanson in the paintings, they differ from Attaingnant's ›Chansons nouvelles‹ of 1528, from his later prints, from manuscripts, and from Marot's own authorized version, first printed in his ›Adolescence clémentine‹ in 1532[53] (see table). This list – it excludes arrangements – divides primary sources for the text of »Jouissance« into four sections: printed music, manuscripts, paintings, and purely poetic sources.[54] Grouping the texts of the chanson (as

50 Martin Bente, Neue Wege der Quellenkritik und die Biographie Ludwig Senfls (Wiesbaden 1968), pp. 261–269

51 See Edward E. Lowinsky, ›A music book for Anne Boleyn‹ in: Florilegium Historiale: Essays presented to Wallace K. Ferguson, ed. J. G. Rowe and W. H. Stockdale (Toronto 1971), pp. 160–235. For a different view of the origin and date of the main body of the manuscript, see Edward Nowacki, ›The Latin »Psalm Motet« 1500–1535‹, in: Renaissance-Studien. [Festschrift] Helmuth Osthoff zum 80. Geburtstag, ed. Ludwig Finscher (Tutzing 1979), pp. 164, 176, and 178.

52 These are Florence, Biblioteca Nazionale Centrale, MSS Magliabechi XIX, 111 and 112, from the Chansons nouvelles (1528), see Hamm and Kellman (footnote 30), pp. 224f.; and Munich, Bayerische Staatsbibliothek, Mus. Ms. 1501 (= Maier [footnote 48], no. 207), from ›37 chansons‹ (1532).

53 See Clément Marot, Œuvres Lyriques, ed. Claude Albert Mayer (London 1964), pp. 177f.

54 The list is derived from Rollin (footnote 2), pp. 190–192; Cazeaux, ›The Secular Music of Claudin de Sermisy‹ (footnote 2), pp. 209f., and idem, Sermisy, Opera omnia (footnote 37), p. xxii; Brown, Music in the French Secular Theater, 1400–1550 (Cambridge/Massachusetts 1963), pp. 244–246, no. 232; Heartz, Preludes, Chansons and Dances for Lute (footnote 32), p. LXXII, no. 32; and Courtney Adams, ›Some Aspects of the Chanson for Three Voices during the Sixteenth Century‹ in: Acta Musicologica 49 (1977), p. 243, no. 10.

A, B, C) is easier than it might first appear. Most texts in printed musical sources collapse into just one or two because they are re-editions. Six musical manuscripts and three inscriptions in paintings (Leningrad's and Meiningen's sheet and Courtrai's fragments) which have just a poetic incipit are included here only for the sake of completeness.

TABLE II

Sources for Claudin's »Jouissance vous donneray«

(excluding works modelled on one or more of its voices)

I	Prints	
A&B	Attaingnant:	›Chansons nouvelles‹ (1528): superius (B), tenor (A)
A&B		›37 chansons‹ (1529)
B		›Tres breve introduction‹ (1529), superius only (B)
B		›37 chansons‹ (1532)
B		›Premier livre‹ (1536)

II	Manuscripts	
	Basel, Universitätsbibliothek, F. IX, 59–62, no. 44: incipit only (after 1550)	
	Basel, Universitätsbibliothek, F. X, 17–20, no. 71: incipit only (after 1543)	
B&C	Cambrai, Bibliothèque Municipale, 125–128, fol. 138ᵛ (4th lower; 1542)	
C	Copenhagen, Det kongelige Bibliotek, 1848, p. 182, a3 (c. 1520–1525)	
A	Copenhagen, Det kongelige Bibliotek, 1848, p. 210, a3 (c. 1525) [A is altered to B]	
A	Gdańsk, Biblioteka Polskiej Akademii Nauk, 4003, II, no. 57 (c. 1554–1566)	
B	Florence, Biblioteca Nazionale Centrale, Magl. XIX, 111, fol. 1 (bass missing; c. 1530)	
A&B	Florence, Biblioteca Nazionale Centrale, Magl. XIX, 112, fol. 6: superius (B); tenor & contra (A)	
B	London, Royal College of Music, 1070, pp. 226–227 (chanson copied after 1528)	
	Munich, Bayerische Staatsbibliothek, 1501, no. 6 (incipit only; late 16th – early 17th century)	
	Munich, Bayerische Staatsbibliothek, 1516, no. 36 (incipit only; c. 1540)	
	Regensburg, Proske-Musikbibliothek, AR 940–41, no. 104 (incipit only; c. 1560)	
	Toruń, Książnica miejska, 102680/4. 29–32, App. no. 57 (1560)	
	Vienna, Österreichische Nationalbibliothek, 18810, no. 63 (incipit only; c. 1535)	

III	Paintings	
A?	Brazil, private collection: complete tenor; some text illegible	
	Courtrai, de Witte collection: incipit only of superius	
	Leningrad, Hermitage: incipit only of superius	
A?	Leningrad, Hermitage: tenor, lacking last line of music and text	
	Meiningen, Ducal collection: incipit only of superius	
A?	Meiningen, Ducal collection: tenor, lacking last line of music and text	
A	Rohrau, Harrach collection: complete superius	

IV	Text only	
C	Clément Marot, ›Adolescence clémentine‹ (1532; plus later editions), fol. 80	
C	›Sensuyvent plusieurs belles chansons‹ (1537), copied from Marot, ›Adolescence‹	
C?	Marguerite de Navarre, ›Mont de Marsan‹, farce (1547–1548), lines 708–709	

A

Joyssance vous donneray
Mon amy et sy[1] vous meneray
La ou pretend vostre esperance
Vivante ne[2] vous laisseray
Encore quand morte ie[3] seray
Sy vous auray ie[4] en souvenance.[5]

1 only in Danzig, Rohrau, Brazil
2 lacking in Copenhagen, p. 210
3 only in Attaingnant 1528–1529 and Florence 112
4 only in Copenhagen, p. 210
5 »L'esprit en aura souvenance« substituted in Copenhagen, p. 210

B

Jouissance vous donneray
Mon amy et[1] vous meneray
La ou pretend vostre esperance
Vivante ne vous laisseray
Encore quant morte ie[2] seray
L'esprit en aura[3] la[4] souvenance.

1 replaced by »si« in London, tenor only
2 only in Attaingnant 1528–1529 and in Florence 112
3 Hague facs. (s. footnote 62) gives »airs«
4 only in Florence 111, cantus and tenor

B (Cambrai, cantus and bassus)

Joijssance vous donneray
Mon amy et sy vous meneray
La ou pretent vostre esperance
Jamais ne vous oubliray
Encore quant morte seray
L'esprit en ara souvenance.

C

Jouyssance vous donneray
Mon amy et si meneray
A bonne fin vostre esperance
Vivante ne vous changeray[1]
Encores quant morte seray
L'esprit en aura souvenance.

1 laisseray in Marot

C (Cambrai, altus and tenor)

Joijssance vous donneray
Mon amy et sy vous meneray
A bonne fin vostre esperance
Jamais ne vous oubliray
Encore quand morte seray
L'esprit en ara souvenance.

The texts of »Jouissance« in the paintings presumably follow the same grouping as the paintings themselves, i.e., Rohrau-Brazil and Leningrad–Meiningen. Presumably, because many words in Brazil are illegible and because Leningrad–Meiningen entirely lacks the crucial closing line of the poem's first verse.

The closest readings of the poetic text to Rohrau (and perhaps by extension to Brazil, and to Leningrad–Meiningen) are those found under the rubric A. Of these, the earliest occurs in the Copenhagen version for three voices on p. 210, which, however, has text only for its cantus. Even though the texts in Copenhagen, pp. 210 and 182, differ, the copying of the text on p. 210 was done at the same time as that for the cantus of the other version à 3 on p. 182. This is revealed for example by the identical letter formation of the »J« of »Joyssance« in both cantus parts, the »y«

of which is replaced by »i« in the tenor and bass parts on p. 182. More importantly, the scribe – one otherwise unknown »Charneyron« – also employed a different color of ink when he later added the texts to the tenor and bass parts on p. 182, the same ink that he used to alter the final words in the superius of p. 210 above the words he had first written.[55] It is the earlier version of p. 210 which appears in Rohrau.

While this first version of Marot's chanson on p. 210 of the Copenhagen manuscript was thus undoubtedly known no later than c. 1525, whether Rohrau (or its prototype) was also this early remains uncertain because a virtually identical text also occurs solely in the tenors of Attaingnant's ›Chansons nouvelles‹ (1528) and in his ›Trente et sept chansons‹ (1529) and in all four voices in Danzig (Gdańsk).[56] There is a great likelihood, however, that Rohrau's version of the poem comes from a now unknown source predating those textual versions which became current and widespread with Attaingnant's revised printings in 1531 and 1536 and with Marot's own authorized version first printed in 1532.

Several other observations proceed from comparing versions A, B, and C. While Copenhagen, p. 182 (C), is the only early and fully-texted source to follow Marot at line three, already by c. 1525 it had corrupted his »laisseray« in line four to »changeray«. By 1542 a wondrous diversity of readings flourishes, even in a single source (compare Cambrai, versions B and C).

In the preface to his ›Adolescence clémentine‹, Marot speaks to these matters and hints about the age of the poems, including »Jouissance«, within: »Je ne sçay (mes très-chiers frères) qui m'a plus incité à mettre ces miennes petites jeunesses en lumière, ou voz continuelles prières, ou le desplaisir que j'ay eu d'en ouïr crier et publier par les rues une grande partie toute incorrecte, mal imprimée, et plus au proffit du libraire qu'à l'honneur de l'autheur.«[57] Because several poems in Marot's ›Adolescence‹ are no later than 1519 and may even hearken back to 1515,[58] »Jouissance« could also be an early work. Marot's statement certainly shows that by 1532 far too many corrupt texts were circulating for his taste.

If Copenhagen 1848, already textually corrupt in both its versions, is really from c. 1520–c. 1525, then Marot's »Jouissance« surely belongs to the early layers of his ›Adolescence‹. There is no telling when Claudin set it, but if Copenhagen's date proves accurate, by 1525 there were already circulating two different three-voiced versions of Claudin's setting. Perhaps Claudin brought his setting to Lyons, the probable place of origin for Copenhagen 1848.[59] He was there with the Royal Court from 1524 to February 1526.[60] The filler nature of the altus part as printed by Attaingnant from 1528 onwards supports an hypothesis that the original setting was for three voices.

For the redaction of this chanson at least, there never was that close relationship among Claudin, Marot, and Attaingnant, sometimes conjectured from their simultaneous presence in Paris at the time of publication of the ›Chansons nouvelles‹ and from the patronage of the three men by Francis I.[61] Claudin's and/or Attaingnant's ignorance of Marot's wishes for his poem

55 I wish to thank Peter Woetmann Christoffersen for sharing this information with me (letter of 5 April 1980).
56 Biblioteka Polskiej Akademii Nauk, Ms. 4003, Bk II, no. 57, copied between 1554 and 1563, see Hamm and Kellman (footnote 30), vol. 1, p. 248.
57 Marot, ›L'adolescence clémentine‹, ed. Verdun L. Saulnier (Paris 1958), p. 13.
58 Marot, Les Epitres, ed. Claude Albert Mayer (London 1958), pp. 7f., and Pauline M. Smith, Clément Marot: Poet of the French Renaissance (London 1970), pp. 5f. and 62f.
59 Hamm and Kellman (footnote 30), vol. 1, p. 164.
60 For the movements of the French court at this time see Pogue (footnote 34), p. 21.
61 Heartz, Pierre Attaingnant (Berkeley, Los Angeles 1969), pp. 102f., and Adams (footnote 54), p. 237.

seem proof enough. Moreover, substituting »airs« in the last line of The Hague's facsimile of a now otherwise unknown exemplar of the ›Chansons nouvelles‹[62] for »aura« hardly argues for Attaingnant consulting either Claudin or Marot.

Collaboration between Attaingnant and Claudin at this early period in respect to »Jouissance« seems doubtful for two other reasons. First, Claudin's name does not appear for this chanson either in 1528 or in 1529, although Attaingnant gave his name for other chansons in both these volumes.[63] Secondly, if collaboration existed, why the vestigial non-Marot final line in the tenor parts of 1528 and 1529, an error not corrected until 1532?[64]

Even though Attaingnant's shop on the Rue de la Harpe was not far from the Sainte-Chapelle and the Chapel Royal which employed Claudin, contact by either man with Marot before publication of the ›Chansons nouvelles‹ would have been difficult and perhaps even dangerous. Just then Marot was presumably little concerned about and certainly less than free to establish a chanson text for he was in and out of prison during much of 1526 and 1527 on charges of heresy, at first in Paris, then in Chartres, and again in Paris, until November 1, 1527.[65]

However pitifully meager the chronological and uncertain the stylistic evidence for the paintings by the Master of the Female Half-Lengths may be, the evidence afforded by the chanson inscribed in them and the instruments depicted therein suggests that if the paintings do all relate to a prototype, it was not painted before c. 1520–c. 1525. And as little as any of the preceding circumstantial evidence might hold up in a court of law, taken in toto it points to »Jouissance« as one of the earlier chansons of Marot, set to music by Claudin possibly 1520–1522.[66] Like no other chanson by Claudin or, for that matter, by any other composer in the sixteenth century, »Jouissance« evidently captured the literary, the terpsichorean, and the pictorial fancy of its contemporaries.

62 See Heartz, Pierre Attaingnant, pp. 210–212, no. 2, and ill. 15.
63 Ibidem, p. 211, no. 2 and pp. 219f., no. 9.
64 Ibidem, p. 245, no. 32.
65 Smith (footnote 58), pp. 7–13.
66 This is the personal opinion of Mr. Christoffersen. It is based on the evidence furnished by the watermarks and the repertoire of the two series, each containing six three-voiced chansons, which include the two versions of »Jouissance« (letter of 5 April 1980).

Hands, Music, and Meaning in Some
Seventeenth-Century Dutch Paintings*

Jane R. Stevens

List of Illustrations

Fig. 1: Jan Molenaer (1609/10–1668), ›Allegory of Fidelity in Marriage‹ (1633). Richmond/Virginia, Virginia Museum. – Photo: Museum

Fig. 2: Hendrick Terbrugghen (1588–1629), ›Lute Player and Singer‹. Paris, Louvre. – Photo: Paris, Musées Nationaux

Fig. 3: Budapest, National Széchényi Library, Ms. lat. 424. Gradual of King Corvinus, fol. 41 (Northern France, ca. 1480–1490). – Photo: after Robert Haas, Aufführungspraxis der Musik, Potsdam 1931, pl. VII

Fig. 4: Johannes Sadeler (after Jos van Winghe), ›David, Playing the Harp‹ (Frankfurt, ca. 1587–1590). – Photo: Amsterdam, Rijksmuseum-Stichting

Fig. 5: Pieter Lastman (1583–1633), ›David in the Temple‹ (1618), Braunschweig, Herzog Anton Ulrich-Museum. – Photo: Museum (B. P. Keiser)

Fig. 6: Hendrick Terbrugghen (1588–1629), ›Boy Singing‹ (1627). Boston, Museum of Fine Arts. – Photo: Museum

Fig. 7: Christofle de Savigny, Tableaux accomplis de tous les arts liberaux, Paris 1619 (first edition 1578), fol. P »Musique«. – Photo: Beinecke Rare Book and Manuscript Library, Yale University

Fig. 8: Marin Mersenne, Harmonie universelle, vol. 2, Paris 1636, p. 350 »main harmonique« with tetrachord divisions. – Photo: Author

Fig. 9: Horatio Scaletta, Scala di Musica molto necessaria Per Principianti, Como 1595, p. 1. – Photo: New York Public Library

Fig. 10: Benozzo Gozzoli (1420–1497), Detail of the ›Paradise‹ (late 1459?). Florence, chapel of the Medici palace (Palazzo Riccardi). – Photo: Alinari, Florence

Fig. 11: Gerard van Honthorst (1590–1656), ›The Concert‹. Paris, Louvre. – Photo: Paris, Musées Nationaux

Fig. 12: Paolo Veronese (1528–1588), ›The Mystical Marriage of St. Catherine‹ (1575). Venice, Galleria dell'Accademia. – Photo: after Terisio Pignatti, Veronese, Venice 1976, Alfieri Edizioni d'Arte

Fig. 13: Antiveduto Gramatica? (1571–1626), ›St. Cecilia‹. Wien, Kunsthistorisches Museum. – Photo: Museum

Fig. 14: Dirck van Baburen (1590–1624), ›Singer‹ (1622). Halberstadt, Das Gleimhaus.

Fig. 15: Gerard Terborch (1617–1681), ›Musical Entertainment‹. London, National Gallery. – Photo: London, National Gallery

Fig. 16: John Bulwer, Chirologia: or the Natural Language of the Hand and Chironomia: or the Art of Manual Rhetoric, London 1644, p. [151]. – Photo: Yale Medical Library

Reproductions with the kind permission of the owners

* * *

One of the bodies of works most enticing to musical iconographers seeking to document performance practices of the past is the large group of seventeenth-century Dutch genre paintings that show performances of chamber music. Because of their strikingly realistic style, which sometimes gives them the effect of a modern candid photograph, these paintings seem to offer an

* Much of the substance of this article was presented to the New England Chapter of the American Musicological Society in February 1978.

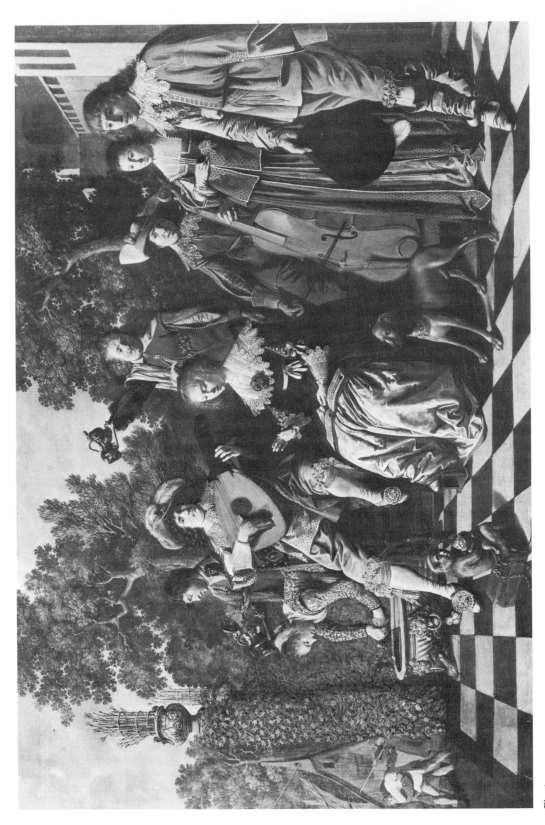

Fig. 1

accurate and objective record of contemporaneous instruments and performances. Little systematic work has been done on the interpretation of these performances, which include as many as five or six players and sometimes singers. Nevertheless, annotated collections of reproductions, such as Walter Salmen's extensive volume of ›Haus- und Kammermusik‹ in the series ›Musikgeschichte in Bildern‹, have offered tentative conclusions about the performance practices apparently documented in paintings and prints.[1] These unassuming, apparently straightforward compositions have so far attracted little attention from students of musical thought. Yet surely an awareness of the dangers of using paintings as accurate records of physical reality, together with the desirability of prefacing any conclusions with a larger understanding of the entire work, are as relevant here as in the Middle Ages and Renaissance.[2]

The precise relationship of these paintings to »reality« has in fact been a subject of particular interest to art historians over the past quarter century. They have come increasingly to understand these apparent records of everyday life as complex compositions of layered meanings and iconographic associations. In a highly influential study of still-life paintings, Ingvar Bergström explored the iconographic significance of lifeless objects, focusing attention particularly on motifs intended to suggest the transience of earthly life. Flowers (whether already faded or merely embodying that inevitability), soap bubbles (beautiful but strikingly ephemeral objects), even tools of the arts and sciences (symbols of specifically human, and thus earthly, activity), must all now be regarded as representative of the impermanent and vain world of this earth as opposed to the eternal life of the spirit.[3] The subsequent use of this analytic approach in the study of genre painting, informed by an understanding that human actions can also have iconographic as well as (or instead of) narrative significance, was set forth in useful articles by Seymour Slive in 1962 and by E. de Jongh in 1971.[4] As these studies have progressed, scholars have become aware of the complexities inherent in much seventeenth-century genre painting. Most recently, the interpretive complications presented by the discrepancy between what has been understood as overwhelmingly moralistic painting content and the material affluence of seventeenth-century Dutch purchasers have been discussed by de Jongh and by Simon Schama.[5]

1 Vol. 4, fascicle 3 of the series, ed. Werner Bachmann (Leipzig 1969). See, e.g., pl. 26, which Salmen takes as evidence of continued a cappella performance of vocal music into the late 17th century, at least in the north; see also footnote 75.

2 A model warning to all who would try to extract musical information from works of art was voiced nearly 30 years ago by Reinhold Hammerstein. In the tradition of earlier work most notably by Wilibald Gurlitt, he criticized music historians for treating works of art as nothing more than » . . . Darstellungen realer, praktischer Musik . . ., ohne daß nach dem eigentlichen Bildinhalt, nach Sinn und Bedeutung der Bildwerke gefragt wird« (›Die Musik am Freiburger Münster. Ein Beitrag zur musikalischen Ikonographie‹, in: Archiv für Musikwissenschaft 9 [1952], p. 204). More recently, the same point has been made in more detail by Emanuel Winternitz (›The Visual Arts as a Source for the Historian of Music‹, in: Report of the Eighth Congress of the International Musicological Society [New York 1961], vol. 1, pp. 109–120; repr. in: Musical Instruments and Their Symbolism in Western Art [New Haven 1979], pp. 25–42) and by Albert P. de Mirimonde (›Remarques sur l'iconographie musicale‹, in: Revue de musicologie 51 [1965], pp. 3–18), who includes some specific remarks on post-Renaissance art works.

3 Ingvar Bergström, Dutch Still-Life Painting in the Seventeenth Century, trans. Christina Hedström and Gerald Taylor (London 1956; original Swedish, 1947). Bergström is careful to distinguish between motifs suggesting the transience of human life in general and the more rigorous combination of elements into a so-called »Vanitas composition«, which has a specifically moralizing function.

4 Seymour Slive, ›Realism and Symbolism in Seventeenth-Century Dutch Painting‹, in: Daedalus 91 (1962), pp. 469–500. – E. de Jongh, ›Réalisme et réalisme apparent dans la peinture hollandaise du 17e siècle‹, in: Rembrandt et son temps (Brussels 1971, Palais des Beaux-Arts de Bruxelles), pp. 143–198. See also the introductory essays by de Jongh, Lothar Dittrich, and Konrad Renger, in: Die Sprache der Bilder. Realität und Bedeutung in der niederländischen Malerei des 17. Jahrhunderts (Braunschweig 1978, Herzog Anton Ulrich-Museum).

5 Simon Schama, ›The Unruly Realm: Appetite and Restraint in Seventeenth Century Holland‹, in: Daedalus 108, no. 3 (1979), pp. 103–123; de Jongh, Introduction to: Tot Lering en Vermaak. Betekenissen van Hollandse genrevoorstellingen uit de zeventiende eeuw (Amsterdam 1976, Rijksmuseum).

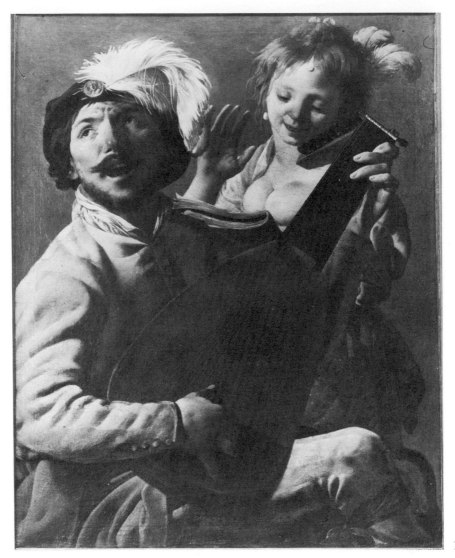

Fig. 2

Given a painting which shows a musical performance, then, the art historian asks not, »What musical event is the subject of this work?« but rather, »For what purpose did the artist include ›music‹ in his painting, and what meanings is it intended to bring to the painting as a whole?«

A particularly extended analysis by Pieter J. J. van Thiel of a painting by Jan Molenaer (1609/ 10–1668) provides a useful example of the sorts of meanings that now appear to be conveyed by seemingly naturalistic genre paintings (*fig. 1*).[6] According to van Thiel's very persuasive argument, the man in the center of the painting is watering (i.e., diluting) his wine, an action often used to signify temperance, or moderation, in sixteenth-century emblem books;[7] stringed

6 Pieter J. J. van Thiel, ›Marriage Symbolism in a Musical Party by Jan Miense Molenaer‹, in: Simiolus 2 (1967/68), pp. 90–99. The painting, now in the Virginia Museum in Richmond/Virginia, is dated 1633.

7 On emblem books, see especially Arthur Henkel and Albrecht Schöne, Emblemata. Handbuch zur Sinnbildkunst des XVI. und XVII. Jahrhunderts (Stuttgart 1967); and E. de Jongh, Zinne- en minnebeelden in de schilderkunst van de zeventiende eeuw (s. l. 1967), which demonstrates some ways in which emblems served as sources for 17th-century paintings. In 17th-century Holland the most well-known books of emblems, which combine a picture with a brief explanatory text, were those of Jacob Cats (1577–1660).

instruments, furthermore, foremost among them the lute, are also a symbol of temperance. The central content here, then, is not an afternoon musical party but a representation of Temperance, one of the four cardinal virtues. That representation is emphasized and strengthened by the contrasting figures of the two fighting men at the lower left (anger) and the boy who looks into the pitcher to see if any wine remains (a »kannekijker«, or »soak«, symbol of gluttony). The deeper significance of the painting is revealed by the man and woman on the right, apparently a portrait of the couple who commissioned the painting. A variety of other symbols, including the ubiquitous dog (fidelity) and the vine climbing on the wall (marriage, interdependence) help van Thiel to conclude that this painting is a marriage portrait, »a Mirror of Virtue holding up to husband and wife the virtue of Temperance, the key to an harmonious married life«.[8]

Ideas like these have had their effect on the study of musical iconography of the seventeenth century. Richard Leppert has analyzed a variety of nonliteral implications in a single painting depicting »amateur chamber music«.[9] The present study grows out of a belief that the symbolic meanings so convincingly demonstrated by art historians do indeed underlie musical as well as other activities in these paintings, and that our comprehension of the intended significance of these musical performances must be extended considerably if they are to contribute either to our practical knowledge of the time or to a larger understanding of the paintings themselves. I am concerned here not with more musical information which may be embedded in these paintings, but with the question of overall meaning. I have concentrated on a particular detail found in many »music paintings«, in the belief that such details are the only sure way to an eventual understanding of the whole, but also in the hope that its ramifications will have some more general significance for music and art historians alike.

The investigation centers on a particular type of Dutch music painting of the early seventeenth century in which a musical performance seems to occupy the central place. Fig. 2 shows a typical music-making painting by one of the greatest Dutch painters of the beginning of the century, Hendrick Terbrugghen (1588–1629). The scene appears to be perfectly naturalistic, in fact to place an absorption in musical performance at the very core of its content. In this painting of few figures and a relatively small number of objects, the girl's upraised hand gains the attention of the viewer almost immediately. The question to be addressed with regard to this and similar paintings is twofold. What is this gesture of the raised hand intended to convey to the viewer? And what implications can we therefore draw from this painting, and others like it, for the history of musical performance and thought?

Art historians have interpreted this gesture in two different, if related, ways. In the older view, the hand fulfills simply a narrative role, depicting the beating of time; since the act of beating is assumed to be a technical facet of performing, it is often taken to incorporate the function of conducting if more than one performer is present. Contemporaneous musical pedagogical works do in fact support the idea that a performer might beat time as he sang. Thomas Morley, for instance, discusses rhythm in terms of the »stroke«, quite clearly a tactus, which he first defines as »a successive motion of the hand, directing the quantity of every note and rest in the song with equal measure«.[10] And a little later, in 1618, the Saxon Daniel Friderici gives an even more

8 Van Thiel (footnote 6), p. 99.

9 ›Concert in a House: Musical Iconography and Musical Thought‹, in: Early Music 7 (1979), pp. 3–17. See also R. Leppert, The Theme of Music in Flemish Paintings of the Seventeenth Century, 2 vols. (Munich and Salzburg 1977), especially vol. 1, pp. 39–53.

10 Thomas Morley, A Plaine and Easie Introduction to Practicall Musicke (London 1597; facs. ed. Edmund H. Fellowes, London 1937), p. 9.

specific description, though perhaps of a slightly different system: »A tactus or Schlag [clearly Morley's ›stroke‹] is the time and space between the striking down and the rising up, thus divided there [›so da . . . geschicht‹] with the hand.«[11]

Documents (particularly illuminations and prints) from the Renaissance and even the late Middle Ages provide occasional representations of a hand which appears to be marking a tactus in this way.[12] Investigations of the history of choral performance have typically drawn evidence from the relatively large number of pictures that show church performances by a small group of singers grouped before a music book on a lectern. A figure at the front of the group who raises or extends a hand has commonly been assumed to be »conducting«, that is, indicating the beat for the entire group. When the level of detail permits, however, several figures may show gestures suggestive of conducting, casting doubt on the leadership of a single conductor. In a frequently reproduced miniature from a French manuscript now dated to the late fifteenth century, three figures gesture in the air, the »director« with both hands (*fig. 3*).[13] A less complicated but similarly ambiguous example appears in another French manuscript from the same period in which the »time-beating« hand of the singer at the lectern is repeated, but from a different vantage point, in the (nonmusical) figure of a mourner.[14] It is likely, moreover, that hand gestures having nothing to do with beating time would have been appropriate either to the act of group singing or to the work of art itself. Michel Huglo believes that the practice of cheironomy, the indication of melodic patterns by means of hand gestures, continued at least through the fifteenth century and probably well into the sixteenth.[15] And since pictures lack the specific content that would be provided by a text, artists used hand gestures as a primary means of imparting verbal meaning to their pictorial representations. Singers' hands may thus be marking a tactus for either the group or the individual, or may be directing a melody, or may be intended to signify something about the content or the purpose of the singing.[16]

During the sixteenth century there seems to be an increase in the number of pictures of musical performances, chiefly in prints, and an increase as well in the frequency with which

11 »Ein Tactus oder Schlag ist die Zeit und Raum zwischen dem nieder schlagen und auffheben, so da mit der Handt geschicht« (Daniel Friderici, Musica figuralis [Rostock 1649; 1st ed. 1618], ed. Ernst Langeliitje [Berlin 1901], p. 12). Friderici exhorts the Cantor, however, to teach his boys to avoid »unhöfflichen Sitten« such as »mit tactiren« (ibid., p. 41).
12 Early accessible examples may be seen in a late 15th-century tapestry showing the court of Maximilian and Mary of Burgundy (ill. in: Heinrich Besseler, ›Die Besetzung der Chansons im 15. Jahrhundert‹, Kongreßbericht Internationale Gesellschaft für Musikwissenschaft Utrecht 1952 [Kassel s. a., pp. 65–72], pl. 8; and in clearer detail in his ›Umgangsmusik und Darbietungsmusik im 16. Jahrhundert‹, in: Archiv für Musikwissenschaft 16 [1959], pp. 21–43, pl. 2) and in illustrations in: Die Musik in Geschichte und Gegenwart, vol. 2 (Kassel 1952), col. 1334 (three men singing the motet »Presidentes«), and vol. 9 (1961), pl. 117 (Ockeghem with his choir).
13 Budapest, National Széchényi Library, Ms. lat. 424, fol. 41; ill. in: Edmund A. Bowles, Musikleben im 15. Jahrhundert (= Musikgeschichte in Bildern, vol. 3, fascicle 8 [Leipzig 1977]), fig. 98; Jack Westrup, article ›Conducting‹, in: The New Grove Dictionary of Music and Musicians (London 1980), vol. 4, p. 642; Hans-Joachim Moser, article ›Dirigieren‹, in: Die Musik in Geschichte und Gegenwart, vol. 3 (Kassel 1954), col. 541; Robert Haas, Aufführungspraxis der Musik (Potsdam 1931), pl. VII (complete, in color).
14 London, British Library, Ms. Add. 18192, fol. 110; ill. in: Bowles (footnote 13), fig. 108.
15 Michel Huglo, ›La chironomie médiévale‹, in: Revue de musicologie 49 (1963), p. 169. This view stands in contrast to Edith Gerson-Kiwi's apparent assumption that the practice of cheironomy totally ceased with advent of precise musical notation (article ›Cheironomy‹, in: The New Grove Dictionary of Music and Musicians, vol. 4, p. 195).
16 A careful scanning of any of several picture collections, such as fascicles 3 and 8 of vol. 3 of ›Musikgeschichte in Bildern‹, will reveal the obvious pitfalls attendant upon an arbitrary interpretation of hand positions. Bowles (footnote 13), for instance, wisely reserves an interpretation of time-beating for figures who stand at the front of a group of singers, holding a staff in one hand and gesturing towards the music book with the other (e.g., p. 108). This approach is supported by Jack Westrup (footnote 13), p. 641, who finds evidence that by the 16th century a stick was preferred to the hand for beating time.

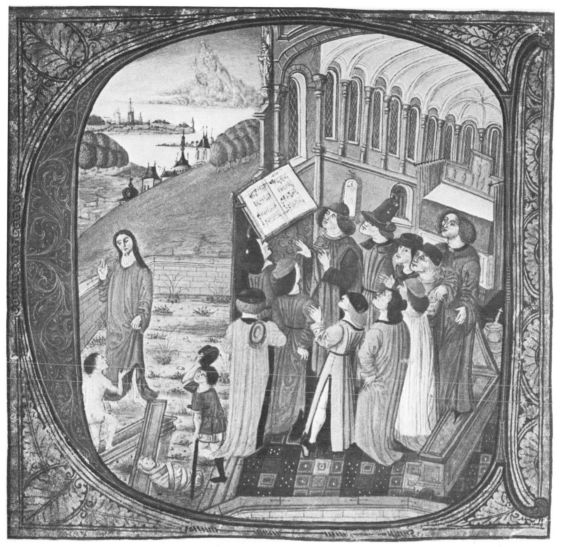

Fig. 3

singing is accompanied by a raised hand, most commonly in depictions of church singers around a lectern and in scenes of social gatherings which include small groups performing from music books. Even more than in earlier examples, these gestures merely provide background detail, and appear to elaborate on the representation of singing. In an engraving from the late 1580's by Jan Sadeler after a painting by Jos van Winghe, for instance, a group of singers reading from a music stand forms part of a rather complex composition depicting David singing psalms to the Lord (*fig. 4*).[17] Of the five figures, representing four generations, one of the youngest appears to be beating time against the lectern, and the next to the oldest gestures with both hands as if to lead

17 Johannes Sadeler I, no. 126, in: Hollstein's Dutch and Flemish Etchings, Engravings and Woodcuts ca. 1450–1700, vols. 21, p. 100 (text, compiled by Dieuwke de Hoop Scheffer, ed. Karel G. Boon) and 22, p. 113 (Amsterdam 1980); ill. in: Pieter Fischer, Music in Paintings of the Low Countries in the 16th and 17th Centuries (Amsterdam 1975), p. 21.

the singers. A painting of the same subject by Pieter Lastman, the teacher of Rembrandt, expands the number of gesturing members to three, one of whom now faces us so that we see his palm and fingers (*fig. 5*).[18]

While these examples are particularly clear, they are not unusual. By around 1600 hand gestures such as these are not uncommon in connection with singing. They seem intended to clarify the singing, either by conveying something about its circumstances and content or by imitating the behavior of real singers. But in Holland in the early seventeenth century, a gesture of this kind suddenly appears in a large proportion of music paintings; furthermore, the time-beating hand is often given prominence in the composition. Perhaps the most famous work using hand gesture in this way is the so-called ›Boy Singing‹ by Terbrugghen, dated 1627 (*fig. 6*). While failing to see any content in this painting (and other similar ones) beyond that implied by the present title, Benedict Nicolson, author of the standard catalogue of Terbrugghen's works, feels some intimation of a broader significance: »For these musicians are presented with all the solemnity of martyrs, as though their role were to bring spiritual enlightenment, not a jolly tune«.[19]

With the growing awareness of the importance of iconography in Dutch paintings of this period, in fact, the act of beating time has come to be interpreted in a less literal way. The just measuring of time in music is now identified with moderation and true proportion in human life. In the Molenaer painting shown in *fig. 1* (formerly known as ›Musical Party‹, retitled by van Thiel, ›Allegory of Fidelity in Marriage‹) the woman in the center who sings and beats time thus joins with the three men around her to complete the principal emblem of Moderation, or Temperance.[20] A similarly nonliteral interpretation may now be given for the »single musician« paintings exemplified by the Terbrugghen painting in *fig. 6*: in a confirmation of Nicolson's intuition of some wider meaning, the boy is now thought to represent not a characteristic individual, but an allegory of hearing.[21] Within such interpretations of music-making, the boy's raised hand might be a sign of the good proportion of his singing, or of his own temperate life.

Yet the image of a palm with fingers fully extended recalls a similar image intimately associated with the art of singing, namely the hand of Guido. That Terbrugghen's painting is not a depiction of a choirboy singing with the aid of the Guidonian hand is obvious: the hand we see is the right, rather than the left, and the boy is not even looking at it. It seems equally clear, however, that this hand, with its spread and almost stretched-out fingers, is not a terribly naturalistic record of the act of beating time.[22] The painter seems to be exploiting the image of the hand, making it one of the most prominent forms in the painting, not to emphasize naturalistic detail but to convey some kind of significance. An association with the Guidonian hand, like the act of beating time, would not make sense, then, unless it could be understood to bring some extra meaning to the painting.

18 Dated 1618; ill. in: Rembrandt und sein Kreis (Braunschweig 1973), pl. 3; and Walther Bernt, Die niederländischen Maler des 17. Jahrhunderts (Munich ³1969), vol. 2, pl. 664.
19 Benedict Nicolson, Hendrick Terbrugghen (London 1958), p. 16. The painting is now in the Boston Museum of Fine Arts.
20 Van Thiel (footnote 6), p. 91.
21 Allegories of the senses, either singly or in sets, are common subjects in the 17th century. For a series of paintings of the Five Senses by Jan Molenaer, see Slive (footnote 4), pp. 492f. This set together with sets by other artists are shown in Slive, Frans Hals, 3 vols. (London 1970), vol. 1, pp. 78f.
22 Describing a painting by Dirck van Baburen very similar to this one (fig. 14), Leonard Slatkes observes that the fingers of the raised hand are »spread apart as if reaching for a high note« (Dirck van Baburen [c. 1595–1624]. A Dutch Painter in Utrecht and Rome [Utrecht 1965], p. 98).

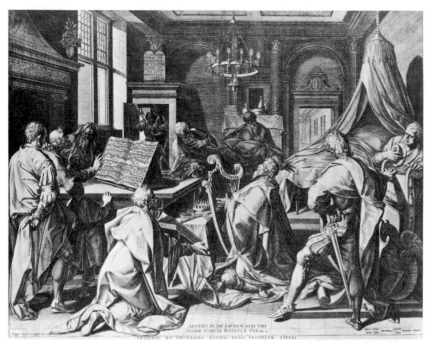

Fig. 4

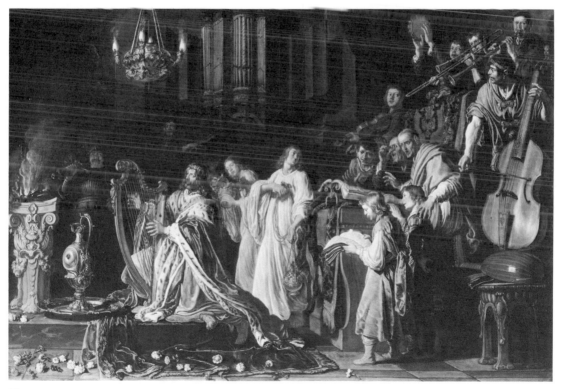

Fig. 5

Indeed, even to propose such an association, however tentatively, would require the prior establishment of two principles. First, it must be shown that the Guidonian hand was used widely enough in the early seventeenth century so that it would be familiar to both the painter and his audience: a widespread association of the palm and fingers with singing and solmization would make it possible for this image to serve as a viable iconographic motif when used within a context of music-making. Second, the motif of the upraised hand must be demonstrated to be a conscious and purposeful device of the painter, and not simply an accident of the visual narrative. If it is to be interpreted as a conscious device, furthermore, the motif must be understood to bring some kind of plausible significance to the paintings in which it appears.

It is generally accepted that solmization, and the Guidonian hand by which it was taught, were at the basis of singing instruction through the sixteenth and at least well into the seventeenth century.[23] Moreover, historians who have investigated schooling in Germany and Holland agree that during the latter part of the sixteenth and most of the seventeenth centuries singing was taught in *all* schools, both Latin schools and regular lower schools.[24] A knowledge of singing from notated music can therefore be presumed to have been relatively widespread during this period; and if – as most music historians assume – solmization continued to be taught with the hand, the association of the palm and fingers with singing would be equally widespread. Documentation for this assumption, however, is sparse indeed. Most elementary music books of the sixteenth and seventeenth centuries explain solmization very succinctly, by means of a simple hexachord chart, and make no mention of singing from a hand. But rather than reflecting a discontinuation of the use of the hand, this omission seems to arise from a total identification of the Guidonian hand with solmization itself.[25] In the Middle Ages and Renaissance, of course,

23 See, e.g., Martin Ruhnke, article ›Solmisation‹, in: Die Musik in Geschichte und Gegenwart, vol. 12 (1965), cols. 843–852.

24 Eberhard Preußner speaks of the 16th and 17th centuries as »die Blütezeit der Schulmusik«; the school music teacher, who was often the local town Kantor and thus a professional musician, had the aim of making each pupil a »wahren Kenner der Musik«. The principal means to this end, he asserts, was the use of solmization as the basis of school singing (›Solmisationsmethoden im Schulunterricht des 16. und 17. Jahrhunderts‹, in: Festschrift Fritz Stein zum 60. Geburtstag, eds. Hans Hoffmann and Franz Rühlmann [Braunschweig 1939], pp. 112, 115). A Dutch handbook for schoolteachers, entitled ›Een Reghel der Duytsche Schoolmeesters‹, written by Dirrick Adriaenz Valcooch and published in Amsterdam in 1597, provides a standard hexachord chart (with full explanations) for the teaching of singing (ed. Pieter Antonie de Planque, diss. Utrecht [Groningen 1926], p. 231, or facs. of the 1597 edition [Amsterdam 1973], p. 61). Speaking of the Netherlands, where Calvinism was of course strong, Gilles Dionysius Jacobus Schotel finds that whereas the church was opposed to dancing, and to the use of the organ in church, it did not oppose musical instruction. Singing instruction was given in all schools during special hours set aside for the purpose, and lessons began and ended with the singing of psalms. (Het oud-hollandsch Huisgezin der zeventiende eeuw [Haarlem 1867], p. 99; cf. Rule 12 of the General schoolorder for schoolmasters and sextons in the rural area of the parish of Tiel, drafted by the E-class on Sept. 8th, 1628, printed as Supplement A of de Planque's edition of Valcooch, p. 458.) See also Frederick W. Sternfeld, ›Music in the Schools of the Reformation‹, in: Musica Disciplina 2 (1948), pp. 99–122, for a discussion of the importance attached to music in both Lutheran and Reformed church schools in the 16th century.

25 Since the hand was employed largely as a pedagogical device for teaching beginning children, and most books were intended either for older boys or for the teacher himself, there would have been no need to explain it. Furthermore, as Georg Schünemann has emphasized, practical pedagogical books were not »methods« in our sense: the teacher taught notation, syllables, etc., and the book was used only as a source for memorization (Geschichte der deutschen Schulmusik [Leipzig 1928], p. 105; see also Schünemann's edition of Nicolaus Listenius' Musica of 1549 [Berlin 1927], p. XXII). Carl Parrish's conclusion that the failure of Georg Rhau to mention the Guidonian hand represents some kind of »deliberate« rejection of it seems unjustified in view of the similar omission in the majority of other 16th- and 17th-century manuals, and in light of Rhau's own parenthetical comment about Guido's »Introductorium [i.e., gamut] (quod vulgo manum vel Monochordum appellamus)« (Enchiridion utriusque musicae practicae, vol. 1, Wittenberg ⁷1538, facs. ed. Hans Albrecht [= Documenta musicologica series 1, vol. 1, Kassel 1951], fol. A viii. Cf. Parrish, ›A Renaissance Music Manual for Choirboys‹, in: Aspects of Medieval and Renaissance Music, ed. Jan LaRue [New York 1966], p. 652).

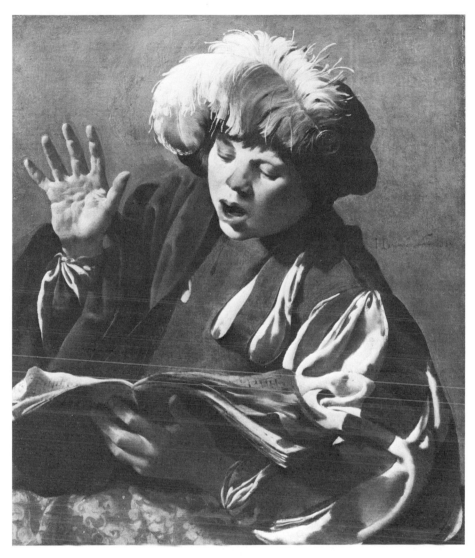

Fig. 6

altered tones outside the normal hexachord were explicitly labeled »extra manum«.[26] But even in the later sixteenth and seventeenth centuries there is scattered but convincing evidence of a continuing identification of the hand with solmization.

One of the earliest documents in what was to be a long and bitter fight over the merits of solmization is Loys Bourgeois's ›Le droict chemin de musique avec la maniere de chanter les Psaumes‹, published in Geneva in 1550. Bourgeois was a half century ahead of his time in his attack on the indispensability of the Guidonian gamut to the teaching of singing:

26 Cf. M. Ruhnke (footnote 23), col. 845. Opinion as to whether the hand was actually conceived as an aid for solmization by Guido himself may be coming full circle: after well over a century of skepticism, at least one scholar has suggested that both the hand and the system of mutation were attributed to Guido so soon after his lifetime, and grew so directly out of his ideas, that they probably did in fact originate with him (Joseph Smits van Waesberghe, ›Guido von Arezzo als Musikerzieher und Musiktheoretiker‹, in: Dia-pason de omnibus. Ausgewählte Aufsätze von Joseph Smits van Waesberghe, Festgabe zu seinem 75. Geburtstag, ed. C. J. Maas and M. U. Schouten-Glass [Buren 1976], p. 93; first published in: Kongreßbericht Bamberg 1953 [Kassel 1954], pp. 44–47).

»Attendu que par cy devãt il faloit employer la plusgrand' partie de son tẽps pour acquerir l'art de Musique en apprenant la Gamme, ie me suis efforcé de tout mon pouvoir, à trouver le chemin plus aisé & plus court, par lequel (aydant Dieu) en brief on y pourra parvenir. . . . On pourra pẽser que ie vueil le obsurcir la Musique quand ie parle d'abolir la Gamme, mais quand tout sera bien consideré, on cognoistra que ce que i'ẽ fay est pour l'esclarcir: & que la Gãme (veu l'obscurité fascheuse qui y est) est un retardement & empéchement à ceux qui desireroint auoir bien tost la cognoissance dudict art. Car ie scay que plusieurs gens de bon esprit ont laissé d'apprendre á chanter de peur de la Gãme. Mais, puis que naturellement on contemple mieulx les choses qu'on voit à l'œil, que celles, qu'il faut ymaginer en la phantaisie (comme on faict en apprenãt la Gamme)²⁷ & aussi que souuentesfois il aduiẽt que ceux qui ont grand' affectiõ en Musique desfaillent en quelques doigtz de la main, lesquelz seroint priués dudict art: qui m'accusera de presumption ou temerité si ie dy qu'on peut apprendre les commencementz de Musique en papier aussi bien que les autres sciences? Aussi ne les à [sic] on point ainsi apprins en la main (y contẽplãt les rongnes & cyrons) que depuis le Compot,²⁸ & depuis qu'aucuns les y ont tant recõmandés, disantz qu'en vain on pensoit apprendre à chãter sans la main«.²⁹

It is important to notice here that Bourgeois never mentions the Guidonian hand per se, but that »the hand« is used as a synonym for »the [Guidonian] scale« (as in the last sentence of this excerpt from the introduction). He rejects the gamut as a system of overlapping hexachords defining musical space, together with the hand with which it is totally identified. As his entire

27 Because one imagines the syllables in specific positions on the hand, in a system surely devised by analogy with the memory technique using loci that originated with the Greeks but was taught throughout the Middle Ages and was still assiduously cultivated in Bourgeois's own time. For an extended treatment of the history of this ars memoriae, see Frances A. Yates, The Art of Memory (London 1966). The loci in which imagined objects were placed, then to be associated with the items to be remembered, were in familiar buildings; in an ›Ars Memoriae‹ published in Frankfurt in 1602, however, numbered symbols are to be imagined on the edges of the palms and the finger joints of both hands, in a system the author considers to be a most useful innovation (Hieronymus Marafiotus, Ars Memoriae, Seu potius Reminiscentiae. Nova, eaque maxime perspicua methodo, per loca et imagines, ac per notas et figuras, in manibus positas, tradita & explicata [Frankfurt 1602, Joachim Bratheringius]). – Since the completion of this article, I have had the opportunity to read an unpublished paper (presented in part to the New England Chapter of the American Musicological Society in February, 1981) by Professor Karol Berger, of Stanford University, on ›The [Guidonian] Hand and the Art of Memory‹. Berger has marshalled an impressive amount of evidence to demonstrate that the medieval evolution and later practice of the Hand were in fact based on the larger theory and practice of memory, particularly as a division of rhetoric.

28 »Le Compot«, i. e., computus, computation of the (ecclesiastical) calendar. Berger (footnote 27) has shown the close connections in the Middle Ages between the mnemonic hand of computus and the Guidonian hand (pp. 34–42). Two hands used for calendar computation are reproduced in Joseph Smits van Waesberghe, Musikerziehung. Lehre und Theorie der Musik im Mittelalter (= Musikgeschichte in Bildern, vol. 3, fascicle 3 [Leipzig 1969]), pls. 57 and 58. Two of the four passages quoted in the definition of compot (= comput) in Edmond Huguet, Dictionnaire de la langue française du seizième siècle, still involve figuring on the fingers (Paris 1932), vol. 2, p. 396.

29 Loys Bourgeois, Le droict chemin de musique, fol. A2–A2ᵛ; facs. ed. P. André Gaillard (= Documenta Musicologica, series 1, vol. 6 [Kassel 1954]). »Considering that until now it was necessary to employ the largest part of one's time to acquire the art of music in learning the scale [›Gamme‹], I have endeavored with all my power to find the easiest and shortest way by which (God helping) one will be able to arrive at it quickly. . . . One might think that I want to obscure music when I speak of abolishing the scale, but when all is well considered, one will recognize that what I have done is for illumination, and that the scale (seeing the tiresome obscurity that is in it) is a retardment and impediment to those who wish to understand this art [of music] quickly. For I know that several intelligent people have left off learning to sing from fear of the scale. But since one naturally contemplates things one sees with one's eyes better than those that must be imagined in fantasy (as one does in learning the scale); and since furthermore it often happens that those who have a great affection for music are lacking several fingers of the hand, and these would be deprived of this art; who will accuse me of presumption or temerity if I say that one can learn the beginnings of music on paper as well as the other sciences? So they did not learn it this way on the hand (contemplating there the itch and the mites) except by the example of computation, and after some people recommended it to them, saying that in vain would one think to learn how to sing without the hand«.

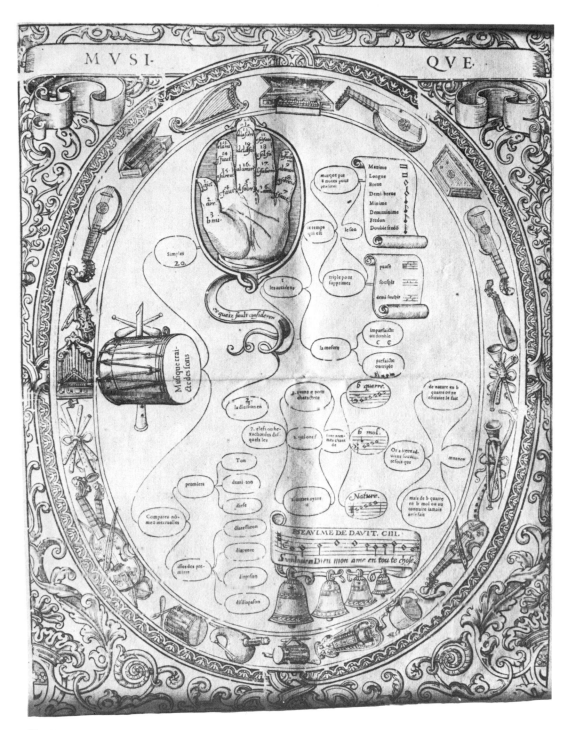

Fig. 7

introduction makes clear, this innovation was contrary to all established practice, and had probably already met significant opposition.[30]

Bourgeois's attempt to simplify solmization by separating it from the Guidonian hexachord system (and hand) seems not to have attracted many immediate followers; it is not even clear how widely it was known.[31] Solmization syllables and the hand continue to be identified with each other. In 1611 another teacher, Seth Calvisius, complained of the difficulties of teaching singing by solmization. The modern style fit so badly with traditional solmization that his boys were required to learn 62 notes and syllables – which, he mentions in passing, they reckoned on their fingers.[32] The assumption that solmization syllables are inseparable from the hand on which they are represented is still echoed in 1690 by Wolfgang Caspar Printz. Describing the origins of the scale, he says:

> »Nachdem Guido diese Voces denen Clavibus appliciret/ hat er sie hernach/ damit sie die Knaben desto leichter fassen möchten/ in Gestalt einer Hand vorgestellet/ und gewollt dass man im Γ allezeit *ut*, im *C*, nach Unterscheid des Gesanges/ oder in Ansehung des Auff- und Absteigens/ bald *sol*, bald *ut*, bald *F* singen sollte: und so ferner von andern; welches weil es fast jedermann bekandt, keiner fernern Erklärung von nöthen hat«.[33]

By this time, of course, solmization was under severe attack both as a theoretical basis for understanding music and as a pedagogical device. The complications of which Calvisius was already complaining in 1611 became increasingly unbearable toward the middle of the century, and more and more teachers turned to alternate methods.[34] Especially in light of Printz's observation, however, it seems safe to conclude that Johann Joseph Fux still used the Guidonian hand in his teaching, since it was based on six-syllable solmization. In a letter of 1718 to Johann Mattheson, arguing in favor of that system, Fux – like Printz – helps to explain the paucity of theoretical evidence regarding elementary music teaching: »All the boys here from the ages of nine and ten can sing the most difficult pieces *all' improviso*. . . . I have never had any reason to doubt the usefulness of this invention [i.e., solmization], and have never thought to write about it.«[35]

Thus despite the fact that very few writers of the late sixteenth and seventeenth centuries explicitly mention the Guidonian hand, the assumption that it was used as an indispensable tool

30 Notwithstanding the fact that he retains the syllables of solmization, ranged over the entire (great) staff, and organized according to soft, neutral, and hard hexachords, a systematization which he calls »l'eschelle« (see facs. of his table in Martin Ruhnke, article ›Hexachord‹, in: Die Musik in Geschichte und Gegenwart, vol. 6 [Kassel 1957], col. 355). Bourgeois was not unfamiliar with controversy, but attracted opposition in many areas of his life (see Frank Dobbins, article ›Bourgeois, Loys‹, in: The New Grove Dictionary of Music and Musicians [London 1980], vol. 3, pp. 111–113).

31 Only three copies still survive (two in Paris and one in Halle; see Ecrits imprimés concernant la musique (= Répertoire International des Sources Musicales, series B VI [München–Duisburg 1971], vol. 1, p. 173). According to Gaillard, the first historian of music theory to have read Bourgeois was François-Joseph Fétis (Nachwort to facs. ed. of Bourgeois, see footnote 29).

32 Preußner (footnote 24), p. 123.

33 Wolfgang Caspar Printz, Historische Beschreibung der edlen Sing- und Kling-Kunst (Dresden 1690), p. 107. »After Guido applied these syllables to the letter names, he represented them – so that the boys would learn them more easily – in the shape of a hand, and desired that one should sing on Γ always *ut*, on *C* . . . now *sol*, now *ut*, now *fa*: and so forth with the others, which needs no further explanation because it is known to almost everyone.«

34 See Preußner (footnote 24) for a discussion of this crisis in pedagogy. Joel Lester's ›The Recognition of Major and Minor Keys in German Theory: 1680–1730‹, in: Journal of Music Theory 22 (1978), pp. 65–103, includes (pp. 87ff.) a discussion of the early 18th-century controversy over solmization.

35 Letter of 12 January 1718, published by Mattheson in: Criticae Musicae Tomus Secundus (Hamburg 1725); trans. Joel Lester, ›The Fux-Mattheson Correspondence: An Annotated Translation‹, in: Current Musicology, no. 24 (1977), p. 51.

for the teaching of solmization seems justified. Painters of this period, however, tend to take their compositions not from real life but from other two-dimensional images. Although an element in a seventeenth-century painting may have significance because of real-life associations, and its details may be portrayed with painstaking and impressive verisimilitude, its source is nearly always to be found in earlier visual representations.[36] In order to argue that the hand which beats time in Dutch paintings has any connection to a Guidonian hand, one must therefore produce appropriate images which could have been available to the artist. It should not be surprising, in light of the preceding discussion, that such images are rare; but it is significant that each one I have so far discovered offers compelling evidence for the view that the Guidonian hand was at least as familiar to the average educated citizen in the early seventeenth century as it is to the music historian today.

In a large folio volume first published in 1578 in Paris, Christofle de Savigny presented ›Tableaux accomplis de tous les arts liberaux contenant brievement et clerement par singuliere methode de doctrine, une generale et sommaire partition des dicts arts, amassez et reduicts en ordre pour le soulacement et profit de la jeunesse‹.[37] This work, which was published in at least one more edition in 1619, contains 17 tables demonstrating the classification and organization of each of the liberal arts, each accompanied by a page of explanatory text. Fol. P, shown in *fig. 7*, sets forth all the young reader needs to know about »Musique«. On the page accompanying this table, de Savigny defines music as »the art of singing well, that which treats sounds«.[38] The *tableau* of music is unique in its use of pictures: all the other tables in the volume – including those on the visual arts – use words to set forth the elements of their respective arts. Perhaps the symbolic nature of musical notation prompted the use of nonverbal images here; but even more important may be the by now unsurprising inseparability of Guido's scale from his hand. »Il y a vingt sons nommez simples, qui sont mentionnez par les Musiciens, depuis *g ut* iusques a *e la*, & tous contenus en la game, qu'on appelle communément l'eschiele, ou la main, inuentée autrefois par vn nommé Guido Aretin Italien de nation, & moine jadis de Cluny, pour apprendre facilement à bien chanter.«[39] There seems no question that de Savigny is simply imparting a standard tradition in a straightforward way, since his book makes no claim for its originality of content (rather the opposite) but only for its novelty of tabular presentation. It is important to notice that with the exception of the somewhat ambiguous group to the far right, all the elements included in this musical table emanate originally from »musique traicte des sons«. In his page of introduction, in fact, de Savigny had already explained that »the sense of sight created Optics or Perspective; that of hearing, Music«.[40] The musical knowledge now necessary for the young student of the liberal arts, then, concerns not the mathematically harmonious music of the spheres, but earthly concords produced by human singers (and, to judge from the border illustrations, players as well).

36 Cf. the above discussion of Molenaer's ›Allegory of Fidelity in Marriage‹ (*fig. 1*), in which a composition apparently narrating an actual (or probable) event has in fact been produced from a combination of many separate elements, each with its own two-dimensional visual source.

37 The 1619 edition used for this study was »reuue, corrigé, & augmenté de nouveau«. I am grateful for this reference to Craig Monson of Yale University, whose enthusiasm for Hands has rivalled even my own.

38 »Musique est l'Art de bien chanter, laquelle traicte des sons« (fol. Q).

39 Ibid. Note that de Savigny does not see any substantive difference between »gamme« and »eschiele«. (»There are 20 sounds called simplex, which are mentioned by musicians, from *g ut* to *e la*, and all contained in the scale, that is commonly called ›l'eschiele‹, or the hand, invented earlier by one named Guido Aretin . . . to learn easily how to sing well.«)

40 »Le sens de la veüe a crée Perspectiue, celuy de l'ouye la Musique« (fol. B).

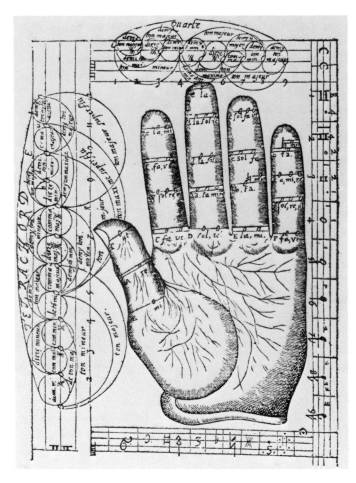

Fig. 8

De Savigny's ›Tableaux accomplis‹ is especially significant for the present investigation because of the evidence it provides of a widespread recognition among educated people of the close association between the Guidonian hand and good singing. In 1636 another French-speaking author writing not for musicians alone but for a wider educated public explained the hand at greater length. Marin Mersenne, in his ›Harmonie universelle‹, twice shows a Guidonian hand, which he calls the »main harmonique«. His first hand is »the ordinary harmonic hand of the practitioners, in which you see all the syllables [›dictions‹] which one uses for teaching children, although some reduce it now to the eight *dictions* which form the octave of *C sol ut fa* in order to abbreviate the method: but whatever ingenuity one brings to it, it all comes back to the same thing«.[41] Later Mersenne uses a Guidonian hand as a means of summarizing his theoretical

41 Marin Mersenne, Harmonie universelle (Paris 1636), facs. ed. François Lesure (Paris 1963). »Or ie mets icy la main Harmonique ordinaire des Praticiens, dans laquelle on void toutes les dictions dont on se sert pour enseigner les enfans, quoy que plusieurs la reduisent maintenant aux huit dictions qui font l'Octaue de *C sol ut fa*, afin d'abreger la methode: mais quelque industrie que l'on y apporte, tout reuient à vne mesme chose« (vol. 2, pp. 144 f.). Mersenne reveals the identity between scale and hand in the preceding paragraph, on the relationship of tetrachords to hexachords: »Secondement que les demitons des Hexachordes respondent aux demitons des Tetrachordes des Anciens, dont les trois conjoints sont à main gauche de la Gamme de Guy Aretin, & le disjoint, ou separé est á main droite avec le cinquiesme, auquel il es conjoint« (ibid.). The only other reference I have encountered to a system being

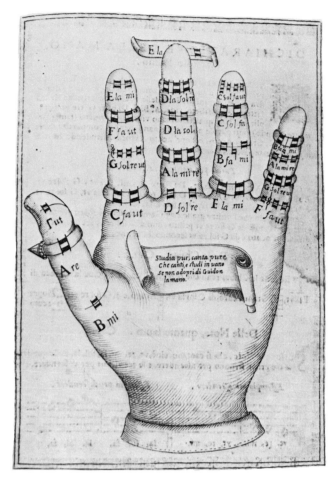

Fig. 9

discussion of scale patterns, establishing at the same time a visual association with the even more »theoretical« system of tetrachords (*fig. 8*).[42] Mersenne, like de Savigny, thus seems to use the image of the Guidonian hand as an economical and directly comprehensible device for conveying both a theoretical and a practical system.

Although my last three examples of Guidonian hands published in the late sixteenth and seventeenth centuries were intended for a more specialized audience than either de Savigny's or Mersenne's, it seems likely that they reached a larger number of people. In Como, Italy, in 1595, Horatio [Orazio] Scaletta published a small handbook entitled ›Scala di Musica molto necessaria Per Principianti‹; four years earlier, in 1591, Adam Gumpelzhaimer published in Augsburg a German translation of Heinrich Faber's ›Compendiolum musicae‹, which had first appeared in Braunschweig in 1548;[43] and three quarters of a century later, in 1672, a three-volume work

continued on the right hand is Smits van Waesberghe's citation of an »exceptional« 12th-century Ms. (Paris, Bibliothèque Nationale, lat. 7203; article ›Handzeichen‹, in: Die Musik in Geschichte und Gegenwart, vol. 5 [Kassel 1956], col. 1453).

42 Vol. 2, pp. 349f.

43 This is only one of four German translations of this 19-folio book that appeared between 1572 and 1605; see ›Ecrits imprimés‹ (footnote 31), vol. 1, p. 305. Faber's work was printed 46 times in all, most often in Nürnberg but also in Leipzig, Augsburg, etc., with a final issue in Frankfurt in 1617.

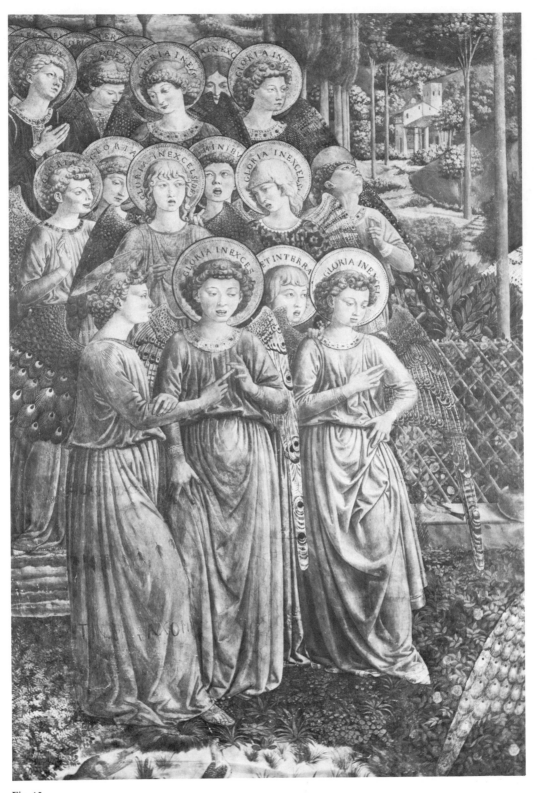

Fig. 10

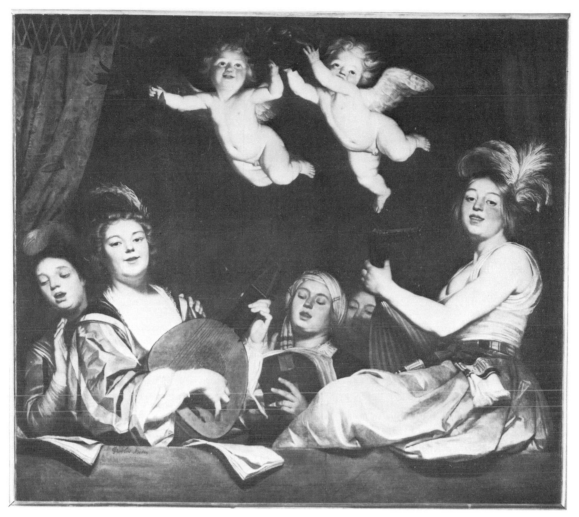

Fig. 11

appeared in Bologna entitled, ›Li primi albori musicali‹, by F. Lorenzo Penna. All three of these little books must have filled a widespread need, for each went through a series of frequent reprintings extending nearly to the end of the seventeenth century.[44] All three (but especially Scaletta and Gumpelzhaimer) consist less of textbook explanations than of collections of information that must be memorized by the young student.[45] And all three present at the very beginning of their instruction a Guidonian hand, together with exhortations about its importance as the basis of all musical study. *Fig. 9* shows Scaletta's page 1, a hand inscribed with this piece of advice: »Studia pur, canta pure/ Che canti, e studi in vano/ Se non adopri di Guidon la mano.«[46]

44 The Scaletta editions, which extend over a century to 1698, are listed in ›Ecrits imprimés‹ (footnote 31), vol. 2, pp. 756–759; the Gumpelzhaimer (from 1591 to 1681), ibid., vol. 1, pp. 387f.; and the Penna, ibid., vol. 2, pp. 642f. I am grateful to Stephen Hefling for the reference to Penna.

45 Cf. footnote 25.

46 Adam Gumpelzhaimer (Compendium musicae [Augsburg 1591], fol. 4v) also provides a verse with his hand: »Disce manu tantum, si vis benè discere cantum,/ Absque manu frustra, disces per plurima lustra«; like the hand itself, these

Especially when we remember that all schoolchildren in Germany and Holland (where schooling is believed to have been widespread[47]) learned singing, the available documents – although few and scattered – do indeed seem to justify an affirmative reply to our first question: the Guidonian hand, as a means to good singing, would probably have been a meaningful visual motif to the painters and their middle-class audience of early seventeenth-century Holland. Yet the question remains whether any painters intended an association of a time-beating hand with this motif. Two Italian works from the second half of the fifteenth century suggest that at least two painters of that earlier period were familiar with the use of the hand in singing, and thought it appropriate for inclusion in a depiction of angelic singing. In Benozzo Gozzoli's ›Paradise‹ in the chapel of the Medici palace in Florence (probably from late 1459), one member of an angel chorus holds up a left hand as another points to an upper joint of one finger (*fig. 10*).[48] And in a ›Coronation of the Virgin‹ painted in 1474 by Zanobi Machiavelli, a disciple of Gozzoli, the singer in the foreground musical ensemble appears to be using the thumb of the right hand to touch an appropriate finger joint on the same hand.[49]

This particular narrative function of a singer's hand was not absorbed into the common vocabulary of gestures, however. As has already been observed, gesturing hands in musical scenes of the fifteenth and sixteenth centuries, while usually difficult to interpret precisely, are typically consistent with the action of beating time. Some Dutch painters of the early seventeenth century merely continue the late sixteenth-century usage of more or less naturalistic time-beating by singers, who usually also read from music. In a painting by Gerard van Honthorst, for instance, a nearly exact contemporary of Terbrugghen from the same city – Utrecht – in the central Netherlands, the hand which appears to beat time makes no visual reference to the image of a Guidonian hand (*fig. 11*). But a small number of painters, during a brief period, depicted this time-beating with the same image seen in Terbrugghen's ›Boy Singing‹, that is, a fully raised hand, the palm clearly visible and the fingers fairly straight, often forming one of the central motifs of the composition. Furthermore, the figure who beats time in this way always sings from a book, that is, from notated music. There are few precedents in sixteenth-century paintings for this motif of palm and extended fingers. In about 1575 Paolo Veronese (1528–1588) included in his painting of ›The Mystical Marriage of St. Catherine‹ a pair of singers reading from a book; one of these singers raises his left hand so that the palm is visible above the music book (*fig. 12*).[50]

lines have a long tradition, for they appear in a 14th-century manuscript by Johannes Hollandrinus von Löwen (see Smits van Waesberghe, footnote 41, col. 1454). The picture of the hand is one of Gumpelzhaimer's helpful additions to Faber's text, which includes no explanation of it. Faber's omission of it is again not to be taken as a rejection, since nearly a half century later Gumpelzhaimer – who shows no signs of any disagreement with Faber – adds it to support the pedagogical usefulness of his manual.

47 J. L. Price, for instance, states that »there is evidence to suggest« that the Dutch population »was unusually literate by the standards of the time«, although »the evidence available is very limited, crude and of uncertain significance« (Culture and Society in the Dutch Republic During the 17th Century [London 1974], p. 110).

48 Ill. in: Heinrich Besseler, Die Musik des Mittelalters und der Renaissance (Potsdam 1931), pl. opposite p. 216.

49 Dijon, Museum; ill. in: Winternitz (footnote 2), pl. 68. Cf. Tinctoris, in his Expositio manus: ». . . some people most aptly indicate the places on the thumb of the left hand with the index finger of the same hand and the places on the other fingers similarly by the thumb of the same hand« (trans. Albert Seay, ›The Expositio manus of Johannes Tinctoris‹, in: Journal of Music Theory 9 [1965], p. 200).

50 For the painting see Terisio Pignatti, Veronese. Testo e Cataloghi, Tavole, 2 vols. (Venice 1976), no. 183, fig. 475. – A similar hand appears nearly 150 years earlier on a carved stone relief by Luca della Robbia, intended for the balustrade of the organ loft in the cathedral at Florence. A side panel shows seven singers reading from a book; the palm side of an upraised hand, with a somewhat ambiguous anatomical connection to a singer, is visible at the front of the group (Florence, Museo dell'Opera del Duomo); ill. in: Reinhold Hammerstein, Die Musik der Engel. Untersuchungen zur Musikanschauung des Mittelalters [Bern 1962], pl. 135 and pp. 251 f.)

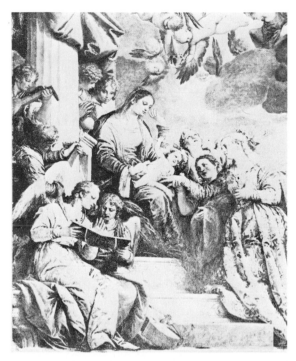

Fig. 12

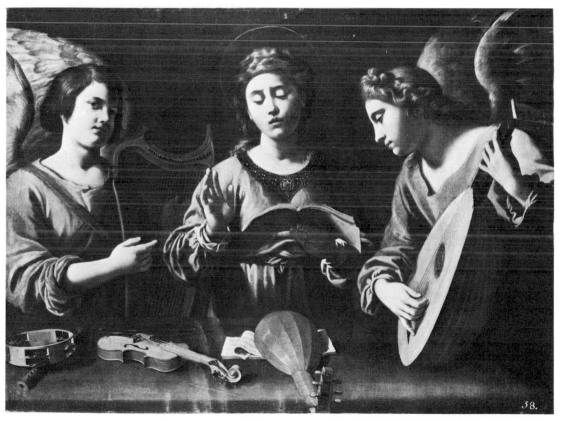

Fig. 13

A slightly later painting now attributed to Antiveduto Gramatica (1571–1626) depicts St. Cecilia in a pose very similar to that of the ›Boy Singing‹ (*fig. 6*); holding a book in her left hand, she raises her right, palm and fingers prominently displayed, as she sings (*fig. 13*).[51] This isolated example seems to have had no followers in Italy, however, and one can only speculate on the relationship it might have to Netherlandish music paintings.

The first Dutch painter to use this pose was apparently Dirck van Baburen (1590–1624), the third member of the »Utrecht school«, in a work now called ›Singer‹ (1622) (*fig. 14*) which appears to be the compositional source of the Terbrugghen singer of 1626 shown in *fig. 6*.[52] Baburen used the hand motif consistently in every music painting in which a singer reads from a book.[53] With only two exceptions – one in which the singers are probably angelic, and the other of a singing girl – the same is true of Terbrugghen.[54] Frans Hals (1584–1666), a Haarlem painter who appears to have had some connections with Utrecht early in his life, used a hand in this way in all but one of his paintings of singers.[55] Molenaer painted at least one other music-making group, in addition to the one shown in *fig. 1*, with a raised hand nearly at its center.[56] The blatancy with which the motif is used in the 1620's and early 1630's, the very earliest stage of the so-called »Golden Age« of Dutch painting and one dominated by the Utrecht painters, is thrown into relief by its subsequent modification. After the mid-1630's these exaggeratedly upraised hands become infrequent in Dutch painting. Singers who read from written music nevertheless continue to raise their hands, if anything even more consistently than ever. But these hands are now shown in much more naturalistic positions, most often in the diagonal pose seen in Terborch's ›Musical Entertainment‹ (*fig. 15*).[57] The obvious visual association with a Guidonian hand is missing here. Yet since the palm is easily visible and the gesture centrally placed, an association with a well-established meaning cannot be ruled out. The very consistency with which a singer in a Dutch painting of the middle and late seventeenth century who reads from a book also raises a hand, suggests that some such meaning may still be intended.[58]

Even given the tentative conclusion that an upraised hand seen from the palm side is used as a conscious device at least for a brief period, we are still left with the more important question of *why* it was used, what meaning it could bring to a work that would cause a painter to use it as a

51 Ill. in: Albert P. de Mirimonde, Sainte-Cécile. Métamorphoses d'un thème musical (Geneva 1974), pl. 98 (where the painting is attributed to Pellegrino Tibaldi). The appearance of a right rather than a left hand may seem to discredit a Guidonian hand interpretation; but the active exchange between painting and engraving (in which images are often reversed) during the sixteenth and seventeenth centuries led to an apparently easy acceptance of mirror images.

52 The source of the Utrecht musician paintings (a single half-length figure, or a very small group, engaged in musical performance) is generally taken to be the similar works (some musical, some not) of Michelangelo da Caravaggio (1573–1610), the Italian artist who most clearly influenced the Utrecht painters (cf., e.g., J. M. Nash, The Age of Rembrandt and Vermeer [New York 1972], p. 32). The upraised-hand motif never appears in Caravaggio, however.

53 Slatkes (footnote 22), catalogue nos. A14, B2, B4, and D9 (unauthentic, modelled on A14).

54 Nicolson, (footnote 19), catalogue nos. A27, A32, A37, A56, and pl. 36b (by an imitator of Terbrugghen).

55 Slive (footnote 21), catalogue nos. 23, 25, 54, D29 (doubtful), and L12 (engraving after a lost painting).

56 Reproduced in Nash (footnote 52). pl. 50.

57 London, National Gallery; Sturla J. Gudlaugsson, Katalog der Gemälde Gerard TerBorchs, 2 vols. (The Hague 1960), no. 220.

58 Two later works, well known to many music historians, further suggest that the hand motif continued to carry significance in the eighteenth and even the nineteenth century. The discordant singers of William Hogarth's ›A Chorus of Singers‹ of 1732 are depicted under an upraised hand that seems not to influence them (Ronald Paulson, Hogarth's Graphic Works, 2 vols. [New Haven 1965], no. 127). And an 1804 portrait of Beethoven shows this young giant of musical art as the true bearer of the highest tradition of serious music: flanked by Classical columns, he holds a lyre in his left hand and shows with the right a full palm and outstretched fingers (portrait by Willibrord Joseph Mähler [Vienna, Historisches Museum]; reproduced in, e.g., Hans Conrad Fischer and Erich Kock, Ludwig van Beethoven. A Study in Text and Pictures [New York 1972], facing p. 36).

Fig. 14

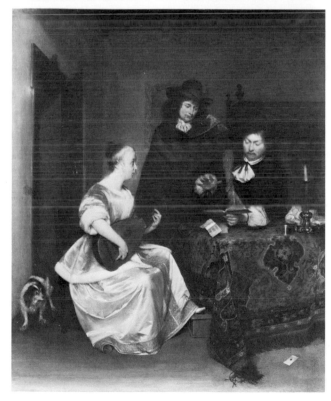

Fig. 15

center of focus. The discussion of this question will be measurably aided by some understanding of the role of hand gestures in Renaissance and Baroque art, and also of the meaning of music in general in northern painting. It has already been mentioned that artists of the Middle Ages and Renaissance used hand gestures as a means of imparting specific content in a nonverbal medium. Although we lack systematic studies of the use and meanings of gesture in post-classical Western art, there is general acceptance of its importance, together with an assumption that the vocabulary of gesture was closely connected with the study of oratory and rhetoric, which were central to humanistic education. Rhetoric continued to be a basic part of education through the seventeenth century, when – as is well known – it played a central role in the development of the theory of the passions in both music and art. In recent years, furthermore, music historians have begun to investigate the ways in which rhetorical treatises may have influenced not only these elaborative devices, but also more basic principles of musical structure.[59]

Within its five main divisions, rhetoric encompassed not only the literary composition of a discourse, but also its memorization and delivery, including both the pronunciation of the words and the accompanying facial and body gestures. We may tend to regard the meanings of everyday gestures to be both vague and universal. That they are neither can be forcibly demonstrated by the comparative study of gesture in different cultures in our own time.[60] We are in any case fortunate to have two books from the seventeenth century which show the specificity with which it was then possible to define the meanings of hand gestures. In Venice, in 1616, Giovanni Bonifaccio published ›L'Arte de' cenni / con la quale formandosi / favella visibile, / si tratta della muta eloquenza, / che non è altro che un facondo silentio‹.[61] The first part of this long treatise consists of a descriptive list of gestures, progressing from those of the head to the feet, heels, and finally the clothing; it includes nearly seventy pages describing and defining the meaning of eighty-one hand gestures. In the second part, the author expounds on the usefulness of a knowledge of gesture to the study of twenty-one disciplines of learning, including for instance metaphysics, music, and agriculture, with copious references to classical authorities. A similar approach is taken by John Bulwer in his ›Chirologia: or the Natural Language of the Hand and Chironomia: or the Art of Manual Rhetoric‹, published in London in 1644.[62] Bulwer's distinction between »natural« gesture,[63] used in everyday discourse, and more artful and decorous rhetorical gesture, implies that hand gesture can impart not only particular meaning, but information about the occasion or the character of the gesturing speaker. His book is both unusual and especially useful because it includes engraved plates illustrating many of the gestures he describes (*fig. 16*). Bulwer is particularly eloquent in his introductory praise of the communicative powers of gesture. »The motions« of the body, he observes, »disclose the present humor and state of the mind and will; for as the tongue speaketh to the ear, so gesture speaketh

59 Gregory G. Butler, ›Fugue and Rhetoric‹, in: Journal of Music Theory 21 (1977), pp. 49–109; Warren Kirkendale, ›Ciceronians versus Aristotelians on the Ricercar as Exordium, from Bembo to Bach‹, in: Journal of the American Musicological Society 32 (1979), pp. 1–44; and Ursula Kirkendale, ›The Source for Bach's Musical Offering: The Institutio oratoria of Quintilian‹, in: Journal of the American Musicological Society 33 (1980), pp. 88–141. For a bibliography of earlier studies of the interrelationship of music and rhetoric, see George J. Buelow, ›Music, Rhetoric, and the Concept of the Affections: A Selective Bibliography‹, in: Notes 30 (1973), pp. 250–259.

60 See the illuminating study by Robert L. Saitz and Edward J. Cervenka, Handbook of Gestures. Colombia and the United States (The Hague 1972).

61 The Art of Gestures: with which may be formed visible speech; treating of mute eloquence which is none other than an eloquent silence. It should perhaps be pointed out that the most popular text on rhetoric in this period, Quintilian's Institutio oratoria, is the only one of the classical sources to deal extensively with gesture.

62 Modern edition James W. Cleary (Carbondale/ Illinois 1974).

63 Ibid., p. xix.

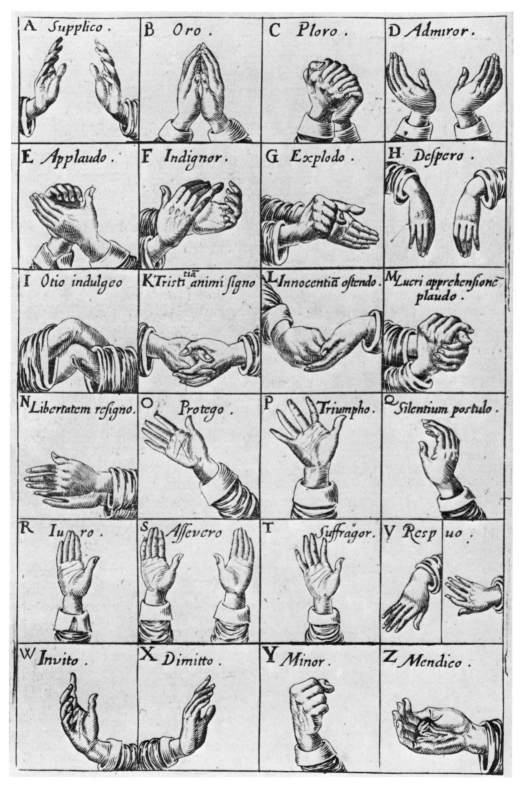

Fig. 16

to the eye«.[64] And of all the devices of bodily gesture, »the hand, that busy instrument, is most talkative, whose language is as easily perceived and understood as if man had another mouth or fountain of discourse in his hand«. Furthermore, »all these motions and habits of the hand are purely natural«; the hand »speaks all languages, and as an universal character of reason, is generally understood and known by all nations among the formal differences of their tongue«.[65]

The ability of hand gestures to »speak« would have made them an obvious resource for painters. During the sixteenth and early seventeenth centuries, possibly because of the very centrality of oratory and rhetoric, the silence of paintings seems to have been considered by some to be one of their leading deficiencies.[66] Gesture, the intimate corollary of public speech, could help to impart the same kind of explicit content afforded by the repertoire of iconographic symbols, so many of which were derived from engraved emblems with explanatory texts. And at least for that class of works now called »genre« paintings, an important aim of the Dutch artist of the seventeenth century was apparently the communication of a complex of ideas and associations which might otherwise have been expressed in words.[67]

Hand gestures, then, are not ornamental parts of artistic compositions during the early seventeenth century, nor can they be automatically dismissed as mere narrative details. Whether or not their meaning is still clear to us, they are intended to aid in conveying the meaning of the work as a whole. Similarly, »music« is included in a painting in order to add particular content, even if in this case as well we cannot always be sure just what that content is.[68] Although the significance of musical activity often seems ambiguous, and has not been thoroughly investigated by art historians, it is possible to see an important distinction in northern Renaissance painting between two kinds of music. The first is some kind of heavenly music, perhaps a visual analogue of the music of the spheres, typically performed by angels. Earthly, human music, on the other hand, while not necessarily sinful, is a symbol of earthly pleasure (thus vain and transient), and can lead to sinful dissipation.[69] This distinction becomes more difficult to interpret in the seventeenth century, with its strong emphasis on the appearances of everyday human life and on

64 Ibid., p. 5.

65 Ibid., pp. 15 f.

66 See Jan Ameling Emmens, ›Ay Rembrant, Maal Cornelis stem, in: Nederlands Kunsthistorisch Jaarboek 7 (1956), pp. 133–165, for a discussion of this point. Emmens's starting point is a poem by Joost van den Vondel about a portrait which Rembrandt painted in 1641 of a preacher, Cornelis Claesz. Anslo: »Ay Rembrant, maal Cornelis stem./ Het zichtbre deel is't minst van hem / t'Onzichbre kent men slechts door d'ooren / Wie Anslo zien wil, moet hem hooren.« (ibid., p. 133).

67 Although geographically outside the scope of this study, the painter who can most clearly be identified with the rhetorical tradition is Nicolas Poussin (1594–1665); some of his ideas about the meaning of his paintings, which were recorded by himself and by others during his lifetime, are summarized, e.g., by John Rupert Martin in: Baroque (New York 1977), pp. 86–88.

68 The most comprehensive discussion of the meaning of music in Netherlandish art of this period is found in Fischer (footnote 17). He approaches many of the questions suggested here and attempts to establish geographical and chronological boundaries for »good« and »bad« music, but without always establishing very specific criteria for interpreting the music in a given painting. The subject of musical iconography in 16th- and 17-century painting is an enormous one within which few clear conclusions have yet been established. The present essay can do no more than point out some of the issues that must be considered in interpreting music paintings.

69 Cf. Fischer (footnote 17), pp. 7–12. Leppert (footnote 9) includes an extensive discussion of the »bad« connotations of music as exemplified in several northern paintings. On the other hand, music-making continues to be a metaphor for heavenly harmony, in literary as well as in visual works. Cf., e.g., the passage quoted by Warren Kirkendale, in his study of some relationships between rhetoric and musical practice, from ›La ricreatione del savio‹ (1659) by Daniello Bartoli, who compares »the world to a well tuned harp«: »Thus God composed the world, tuned it, and holds it in his hand, continually tries it out, and lets the music be heard from it« (footnote 59, p. 9). A wide range of such metaphorical meanings of music is discussed by John Hollander in: The Untuning of the Sky: Ideas of Music in English Poetry, 1500–1700 (Princeton/New Jersey 1961); see especially Chapter II.

genre painting in particular. Paintings that appear to mirror typical middle-class life may, for instance, have allegorical content (as in allegories of hearing), or may portray an earthly reflection of the heavenly harmony of the spheres. In some cases the association of music with a sinful life remains perfectly clear: music continues to be a common element in scenes of bordellos, for example, in which music-making is only part of a larger scene illustrating a sinful, sensual world.[70] In other paintings of similar portent music-making can be associated with drinking parties or with low-class street singers. The »performers« in these paintings may either sing or play instruments; but they do not read from notated music, an activity which would presume both prior education and a kind of intellectualization opposed to the sensuality of the scene. In the small group of paintings in which the upraised hand is so prominent, on the other hand, the hand always belongs to a singer who reads music – one who is thus not a low-class street singer or drunken carouser – and signs of bordellos, wild parties, etc., are absent.[71] Whatever this hand may signify, then, it seems to be associated with some kind of elevated, intellectualized music that is associated with rational understanding rather than simply with sensuous enjoyment. The hand motif may thus be used as one of several a signs that the music which constitutes the principal surface content of the painting is nonsinful. This meaning would further reinforce van Thiel's contention that the beating hand introduces the idea of proportion, and thus of moderation and temperance.

If it were true that the painter intended some association with Guidonian solmization, however, the hand motif could assume a variety of added meanings. First of all, as the outstanding symbol of skillful and well-educated singing, the hand would intensify the idea that this singing is based on the education of the intelligence. Further, the Guidonian hand is of course a device to insure the singing of precisely correct pitches, those that will as a result be in tune, that is, produce true harmony. In group pictures such as Molenaer's ›Allegory of Fidelity in Marriage‹ (*fig. 1*), then, the upraised hand would suggest Harmony as well as Moderation as ideals for the newly married couple.[72] This harmony, while completely free from suggestions of sinful dissipation, is not the angelic, celestial harmony of the Middle Ages and Renaissance but a truly human harmony of beautiful sounds.

The human, sounded quality of the harmony suggested by this hand may even constitute its most important meaning. If many – or most – paintings of one or two musicians are actually allegories of hearing, the hand would play a meaningful part in the iconography of these works. The role of solmization as a tool for rendering perfect, abstract harmony sensible is explained in a school motto of the sixteenth century: »Der Buchstabe allein ist noch kein Ton, er wird erst zum Klang durch das Tonwort *ut, re, mi, fa, sol, la*,«[73] De Savigny also brings a Guidonian hand,

70 Bergström emphasizes the importance of musical instruments within the tradition of *Vanitas*-paintings: »musical instruments were not regarded only as symbols of an art [and thus of human vanity; cf. p. 77 above], but primarily as a warning against a lazy and sinful life. Even before this period lutes, violins [viols?], and wind instruments occurred in almost every representation of the parable of the Prodigal Son. In Vanitas-allegories, music is often performed by the person representing lust« (footnote 3, p. 156). Cf. the anonymous Flemish ›Prodigal Son‹ of ca. 1540 reproduced in: Robert Wangermée, La musique flamande dans la société des xvᵉ et xviᵉ siècles (Brussels ²1966; English trans. New York 1968), p. 184 (color plate).

71 Time-beating hands are rare in the absence of notated music, and thus in scenes of »low« music; they never occur in such scenes by the three painters who exploit the hand motif.

72 The conflict illustrated by the fighting pair at the left side of the painting would constitute a clear antithesis to this motif of harmony. The hand in Hogarth's ›A Chorus of Singers‹ (footnote 58) becomes an important key to the satire if understood as a reference to skillful and especially to harmonious singing.

73 Quoted by Georg Schünemann (footnote 25), p. 105. Recall also the use of the Latin term vox (with its vernacular equivalents) for »solmization syllable«.

together with musical notation symbols, into a *tableau* explicitly devoted to »music treated as sounds«.[74]

What, then, are the implications of these conclusions for the historian studying musical practice of the seventeenth century? If the music-making in paintings has a largely symbolic purpose, can it be trusted as a realistic reflection of actual performance practice? The answer must, I think, be both yes and no. First of all, these Netherlandish genre paintings can, and probably should, be read on several simultaneous levels: a single painting can convey a naturalistic scene with the charming realism of a candid photograph and a delight in rendering the appearances of a three-dimensional world on a flat surface, while at the same time it provides a record of an important event, and even goes on to moralize about the higher truths that may vitiate the worldly vanity that dominates the surface content. Because of the strong tradition in the Netherlands of precise naturalism of detail, a tradition which continues throughout the seventeenth century, depictions of musical instruments – and even the manner in which they are played – are probably as accurate as their painters could make them. The similarly strong tradition of imparting content through rhetorical gesture, however, makes any conclusions about hand movements – such as those that appear to »conduct« – much more tenuous. And finally, the specific combination of figures and objects in a painting is much less likely to be governed by naturalistic considerations than by iconographic ones.[75] Seventeenth-century Dutch paintings may in fact tell us less about specific musical practice than about the nature and place of music in the intellectual system of their time.

74 In paintings and especially in engravings, music often seems to be used emblematically to represent sweet, harmonious sound, in contrast to disordered or unpleasant noise. When in 1625 Cornelis Bloemart engraved a Baburen painting of a man holding a flute, he added an explanatory inscription: »De fluijt gaet soet, tgeluijt is eel. / Maer heer, hoe klinckt een out wijfs keel« (The flute pays sweetly, the sound is noble. / But Lord, what a noise an old wife's throat makes; see Slatkes, footnote 22, fig. 39). The engraving by Hogarth titled ›The Enraged Musician‹ (see Paulson, footnote 58, no. 158) demonstrates the contrast between noise and harmonious music by representing the former rather than the latter, the distressed violinist serving both to make that opposition explicit and to clarify the nature of all the other sounds in the picture.

75 For instance, Terbrugghen's ›Lute Player and Singer‹, with which this discussion began (*fig. 2*), would not have been thought to have any value in 1628 (when it was painted) if it had been understood to represent nothing more than an elegant tavern entertainment or an after-dinner amusement. (For one set of possible interpretations of this work, see E. de Jongh [footnote 5], pp. 58–61.) A similar example, of the sort that has proved most tempting to music historians, is offered by an engraving after a painting by Paul Decker the Elder (1677–1713) of a »musical party« (ill. Salmen [footnote 1], fig. 35). The scene depicted here, which Salmen describes as the performance of a chamber cantata by a mixed ensemble, includes two singers (one female and male), two string players (again one high [violin] and one low [cello]), three wind players (two recorders [soft] and one oboe [loud]) and a director who stands before an archway open to the sky, his rolled paper held high. This »performance« is fully explained by the verses that the engraver has added: »Man singt, man pfeifft, man geigt u. stimmt doch alles ein / Es bringt die Harmonie ein himmlisches entzücken. . . .« This group thus owes less to 17th-century cantata performance than to the angel ensembles discussed by Winternitz, ›On Angel Concerts in the 15th Century: A Critical Approach to Realism and Symbolism in Sacred Painting‹, in: The Musical Quarterly 49 (1963), reprinted in: Musical Instruments and Their Symbolism (footnote 2), especially pp. 140f. Essential to the significance of the painting – if puzzling to us today – are the figures of the boy and young woman who stand at the side, he in some kind of fancy dress, with a bird on his shoulder, and she with her right hand held up, palm outward and fingers outstretched.

Portrait of a Court Musician: Gaetano Pugnani of Turin*

Daniel Heartz

List of Illustrations

Color Plate: School of Turin (ca. 1755–1760), Portrait of Gaetano Pugnani; London, Royal College of Music. – Photo: Royal College

Fig. 1: Title page of Pugnani's ›Sei triò‹, Paris 1754. Alderman Library, University of Virginia. – Photo: University of Virginia Library

Fig. 2: Detail of color plate. – Photo: A. C. Cooper Ltd., London

Fig. 3: From the same print as figure 1. – Photo: University of Virginia Library

Fig. 4: Pier Leone Ghezzi, Caricature (I) of Pugnani (1749); London, British Library, Department of Prints and Drawings. – Photo: British Library

Fig. 5: Ghezzi, Caricature (II) of Pugnani (ca. 1750?); formerly in the collection of the Duke of Wellington, present whereabouts unknown. – Photo: courtesy of Alan Curtis

Fig. 6: Caricature (III), see fig. 5.

Reproductions 1–4 with the kind permission of the owners

* * *

A great violinist, like a great singer, lingers on in the collective musical memory. Since the advent of sound recordings during the last century they linger in a literal sense, more or less well served by the technologies of their time. For earlier centuries pictures help to restore some sense of a once commanding artistic presence, supplementing the evidence of notes on the page and verbal descriptions of performance. The later twentieth century has come to take pictures of musicians and music-making more seriously than was the case before World War II, as will be demonstrated in the case of Gaetano Pugnani, the greatest musical son of Turin when that city was the flourishing capital of the Duchies of Savoy and Piedmont and of the Kingdom of Sardinia. In 1939 Elsa Margherita von Zschinsky-Troxler brought out a study of Pugnani that was intended to be definitive, with a thematic catalogue and an attempt at iconographic coverage as well.[1] She reproduced as her second plate a handsome engraving of Pugnani, signed and dated »Bellicard Fecit 1749«. As her third plate she reproduced, without caption, William Hogarth's famous engraving entitled ›The Enraged Musician‹, which she dated between 1767 and 1769 in her concluding »Iconographie«. Pugnani was in London from 1767 to 1769. His identity as the violinist in the window of Hogarth's engraving is offered not as a conjecture but as a fact: »Im Fenster der Geiger Gaetano Pugnani.« Hogarth's violinist does have a large nose, as did Pugnani, but the engraving in question is clearly dated 1741 on the caption! Hogarth died in 1765. No depiction of Pugnani presented in this study figures in Zschinsky-Troxler's »Iconographie«.

The musical heroes most revered in fashionable circles during the mid-eighteenth century were male singers with unnaturally high voices and their closest instrumental parallels, the virtuosi of the violin. A soprano castrato was called in Italian »il musico«, pure and simple, as if

* This article is an enlarged version of a paper given at the Ninth International Conference on Musical Iconography, Musikwissenschaftliches Institut der Johannes Gutenberg-Universität Mainz, 27–28 August 1982.

1 Gaetano Pugnani 1731–1798. Ein Beitrag zur Stilerfassung italienischer Vorklassik. Mit thematischem Verzeichnis, 180 Notenbeispielen, graphischen Tabellen, 4 Faksimiles und 9 Abbildungen (Berlin 1939).

there were no other categories of musician quite worthy of the name. The tessitura of galant music tends to be higher than earlier or later styles, and there is little doubt that the worship of high-pitched soloists, vocal or instrumental, had something to do with the triumph of a simple, melodious, treble-dominated style, a style that by no means precluded elaborate solistic ornamentation. It is no coincidence that the best musicians' portraits from the galant age are precisely those of castrati and of violinists. Carlo Broschi Farinelli was portrayed by two of the finest Italian painters who flourished between 1720 and 1750, Jacopo Amigoni and Bartolomeo Nazari, both portraits containing the incipits of arias in musical notation, presumably from rôles sung by Farinelli.[2] An even more revealing portrait is that of the castrato Carlo Scalzi by Charles-Joseph Flipart, who depicts the singer in his elaborate stage costume, with bustle, train and, laid to one side, his feathered and bejewelled headdress, next to a page of music from Nicola Porpora's opera ›Rosbale‹ (Venice, 1737/38), to which Scalzi points.[3] Stage costume at this time had reached such a point of elegant affectation that it invited caricature and often received it. The leading Italian caricaturists, Anton Maria Zanetti and Pier Leone Ghezzi, took particular delight in depicting singers and instrumentalists. Scalzi was the object of one of Zanetti's caricatures.[4] Farinelli received attention from both Zanetti and Ghezzi,[5] who has also left us precious sketches of Pugnani that will be introduced below.

Pugnani was born at Turin on 27 November 1731, a scant four months before the birth of Joseph Haydn. He was a violin pupil of the renowned Giovanni Battista Somis (1686–1763), whose progenitors had served in the ducal chapel at Turin for generations. At the age of ten, on 15 December 1741, Pugnani was admitted to the last chair of the second violins of the Teatro Regio, a splendid new theater built in 1738.[6] The orchestra was under the leadership of Somis. On 19 April 1748 Pugnani was named »Suonatore di violino della nostra Cappella e Camera« by the Duke of Savoy and King of Sardinia, Carlo Emanuele III. The same prince gave Pugnani a stipend to study composition in Rome. He left Turin in May 1749. Similarly, Somis had been sent as a young man in 1703 to Rome in order to study with Arcangelo Corelli. Pugnani astounded his composition teacher, Vincenzo Ciampi, by the rapidity of his progress. He completed a two-year course of contrapuntal study in three months and a half, during which time he wrote four trio sonatas and eight violin sonatas. He was called back to Turin by April 1750 in order to play during the festivities surrounding the wedding of Vittorio Amadeo, heir to the throne, with a Spanish princess. He planned to return to Rome but the plan was not carried out. On his return he ranked tenth among the violinists of the royal chapel, and three years later he ranked seventh. His first tour as a violin virtuoso occurred the following year and took him first to Paris. Although away from Turin he was regularly paid during his year's absence.

2 Amigoni's portrait of Farinelli is preserved in Stuttgart, Staatsgalerie (inv. 3163). It is reproduced in color in the catalogue ›Le Portrait en Italie au Siècle de Tiepolo‹ (Paris, Musée du Petit Palais, 1982), pl. 22. Nazari's portrait, conserved in the Royal College of Music, London, is reproduced in the article by Robert Freeman, ›Farinelli‹, in: The New Grove (London 1980), vol. 6, p. 397.

3 Conserved in the Wadsworth Atheneum, Hartford, Connecticut. It is reproduced in the article by Winton Dean, ›Scalzi‹, in: The New Grove, vol. 16, p. 546.

4 Alessandro Bettagno, Caricature di Anton Maria Zanetti. Catalogo della mostra (Venice 1969), no. 321, pp. 105f.

5 Ibid., nos. 52, 196 and 205. Ghezzi's caricature of Farinelli singing a female rôle at Rome in 1724 exists in the collection of Janos Scholz, New York, and reproduced in Ralph Kirkpatrick, Domenico Scarlatti (Princeton 1953), fig. 30, alongside another portrait of Farinelli by Amigoni, engraved by Joseph Wagner (fig. 31).

6 The three fundamental studies on Pugnani, from which all our biographical data come, are Zschinsky-Troxler (footnote 1), S. Cordero di Pamparato, Gaetano Pugnani, violinista torinese (Turin 1930), and Albert Müry, Die Instrumentalwerke Gaetano Pugnanis. Ein Beitrag zur Erforschung der frühklassischen Instrumentalmusik in Italien (Basel 1941) which corrects a number of points in Zschinsky-Troxler on pp. 85–89.

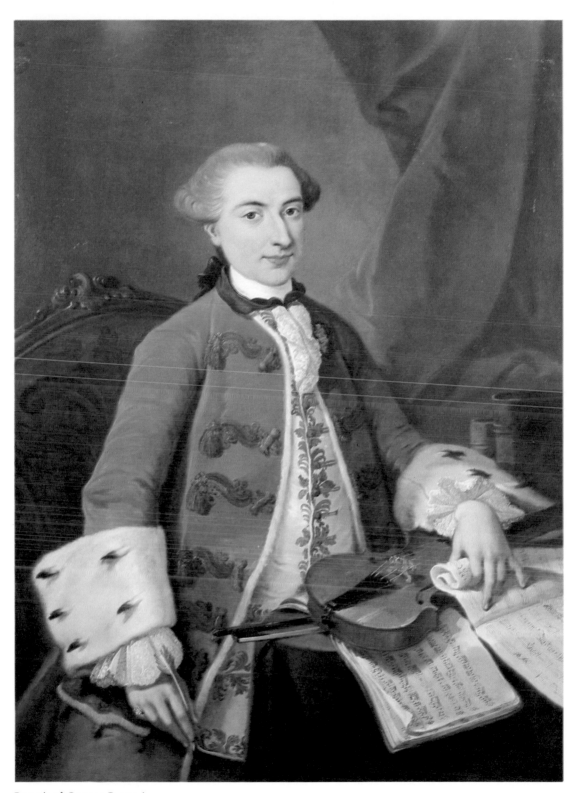

Portrait of Gaetano Pugnani

For generations Piedmontese violinists had crossed the mountains and sought their fortunes in France. They are documented at Paris as early as ›Le Balet comique de la Royne‹ of 1581. French musicians likewise visited Turin regularly. The fame of Somis brought him pupils of the calibre of Jean-Marie Leclair and Louis-Gabriel Guillemain, in addition to Jean-Pierre Guignon (a native of Turin who made his career at the French court). With so many ties between the musical establishments of the Bourbon and Savoy courts, it is hardly surprising that Somis journeyed in 1733 to Paris, where he was acclaimed for playing sonatas and concertos at the Concert Spirituel the same year.[7] Two Parisian publications of his violin sonatas coïncided with this visit. His daughter Christine, a fine soprano, married Carle van Loo, »premier peintre du roy«. Their official apartment in the Louvre served as a haven for Italian musicians visiting Paris. As the teacher of Marie Fel, Christine van Loo became an important force in the Italianization of French opera.

Pugnani arrived in Paris on 8 January 1754. He executed the violin solo in a concerto of his composition at the Concert Spirituel on 2 February. Notice was taken of the event in the ›Mercure de France‹ for the following month: »Monsieur Pugnani, Ordinaire de la Musique du Roi de Sardaigne, joua un concerto de violon de sa composition. Les connoisseurs qui étoient au Concert, prétendent qu'ils n'ont point entendu de violon supérieur à ce virtuose«.[8] Pugnani played a concerto again on 25 March and on the Feast of the Ascension, 23 May. During the same year the Parisian publisher La Chevardière brought out ›Sei triò a due violini, e basso dedicati a sua Altezza Reale Il Sig.nor Duca di Savoia da Gaetano Pugnani. Opera prima‹ (*fig. 1*). Pugnani's dedication does not rise above the self-demeaning flattery typical of the genre but it does confirm that these are his first works (» . . . queste prime produzioni del mio debole ingegno . . .«). And it is written in correct Italian, ostensibly the composer's own, no mean feat during a period when most musicians were so inept verbally that even a seasoned veteran like Nicola Porpora did not trust himself to the extent of being able to write a good preface on his own.[9]

The Concert Spirituel, a series founded in 1725 and located in the top floor of the large middle pavilion of the Tuileries Palace, was a magnet for the best musical talents from everywhere. It paid composers and performers well. Appearance at its concerts led to publication by the ever-voracious music-printing industry at Paris. Critical acclaim in the French press was one key to invitations to appear elsewhere. Pugnani is rumored to have been in London, Holland, and Vienna subsequently to Paris during his year's leave. Competition was intense at the Concert Spirituel. During the year 1754 alone there were three other violinists with European reputations who competed for the public's favor: Giuseppe Tartini's pupil Domenico Ferrari – who had already conquered the imperial court of Vienna with his playing; Pierre van Maldere, »maître de concert« to the court of Charles of Lorraine in Brussels; and Johann Stamitz, »maestro di concerto« of the Palatine Elector Carl Theodore at Mannheim. Moreover the violinists had to reckon with some formidable singers on the same programs. Paris did not forego the enchantments of the castrato voice just because such pleasures were banned at the Opéra. On the

7 Constant Pierre, Histoire du Concert Spirituel 1725–1790 (= Publications de la Sociéte française de musicologie, 3e série, vol. 3, Paris 1975), p. 89.

8 Müry (footnote 6), p. 3.

9 Porpora got Pietro Metastasio to write the dedication of his twelve violin sonatas to the Saxon Princess, Maria Antonia Walpurgis, printed at Vienna in 1754. The dedication is interesting because Porpora claims to have united the old style (i.e. Corelli's) with the new, and moreover the French style with the Italian. See Akio Mayeda, ›Nicola Antonio Porpora und der junge Haydn‹, in: Der junge Haydn, ed. Vera Schwarz (Graz 1972), p. 46; Mayeda identified a manuscript copy of the dedication, dated October 1754, as being in Metastasio's hand.

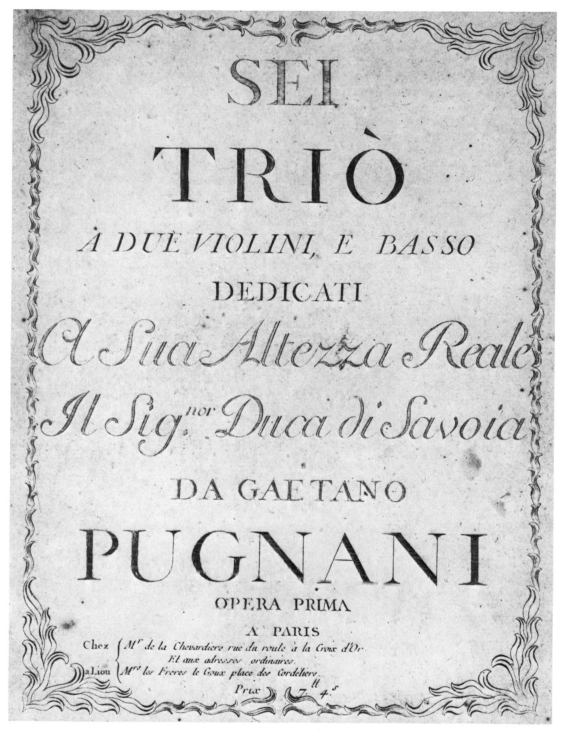

Fig. 1

same program at which Pugnani made his public début in Paris the soprano Egidio Albanese sang two Italian arias.[10] Mlle. Fel participated in the March concert at which Pugnani played. Throughout the Lenten season the great success, to judge from the number of repetitions, was Giovanni Battista Pergolesi's ›Stabat Mater‹, with choruses added by Joseph-Nicolas-Pancrace Royer, the solo parts sung by Albanese and the contralto Gaetano Guadagni. Guadagni, having sung for George Frederic Handel in London, would later turn up in Vienna, where he created the part of Orpheus in Christoph Willibald Gluck's ›Orfeo ed Euridice‹ (1762), and several other leading rôles. Pugnani too went on from Parisian successes to Vienna. A generation later he would escort his prize pupil Giovanni Battista Viotti on a similar European tour. It is worth dwelling on Pugnani's early visits to Vienna, since they have escaped his biographers to date.

Pugnani appeared as a soloist in the Academies of the Burgtheater, Vienna's answer to the Concert Spirituel, at some time before 1757, possibly in late 1754. His name stands first among the list of visiting virtuosi in the ›Répertoire des théâtres de la ville de Vienne depuis l'année 1752 jusque à l'année 1757‹ (Vienna, Ghelen, 1757).[11] It stands foremost in artistic eminence as well, the other instrumental musicians mentioned being of considerably lesser stature. In his ›Lebensbeschreibung‹ Carl Ditters von Dittersdorf mentions Pugnani as a rival violin virtuoso playing at the concerts of Prince von Hildburghausen; the context does not preclude a date of late 1754:

> »Whenever any virtuoso, singer, or player came to Vienna, and deservedly succeeded in winning the applause of the public, [Giuseppe] Bonno was ordered to arrange the terms, and to secure him for the Prince. The result was, that we had Gabrieli, Guarducci, Mansoli, as singers; Pugnani, and Van Maldere, on the violin; Besozzi [from Turin] on the oboe; Le Claire on the flute; Stamitz and Leutgeb as soloists on the horn; and other eminent players.«[12]

The »applause of the [Viennese] public« evidently refers to concert or operatic performances in the Burgtheater.

More about Pugnani's playing in the Burgtheater is known when he returned to Vienna in 1762, thanks to manuscript chronicles of theatrical events made by Philipp Gumpenhuber, assistant director of the French troupe's ballet.[13] Under date of 28 February 1762 Gumpenhuber writes: »La 1.re Accademie de Musique dans la Quareme dans la quelle ont chanté La D.lle Teiber[,] Le S.r Giardini[,] Le S.r Fribert [;] Le S.r Pagnani [sic] a joué un Solo sur le Violon. Le S.r Schmidt a joué un Concert sur la [sic] Hautbois[.] On a aussi executé un grand Chœur de la Composition du S.r Porpora . . . Les Airs ont été entremelées [sic] des nouvelles Simphonies. Outre autres on en a produit une avec des Seules des plusieurs Instrumens [i.e. a sinfonia concertante].« Two days later of the second Academy he writes: »Concerts ont joué Le S.r Pugnani sur le Violon de sa composition [et] Le S.r Leitgeb sur le Cor de Chasse.« Pugnani was heard again in a »Concert« on 7 March, and at the sixth Academy on 11 March, »Le S.r Pugnani a joué un Seul sur le Violon«, apparently meaning a solo sonata, and allowing us to interpret Gumpenhuber's »Concert« as a solo concerto with orchestra. Pugnani played subsequently on 14, 28 and 29 March. On 11 April he played at a »Service à Table« in the imperial palace. When Pietro Nardini went to Vienna in 1760 to play at the imperial wedding festivities he likewise appeared as a soloist on many

10 Constant Pierre (footnote 7), pp. 266–268, gives programs for all the concerts of 1754.
11 Robert Haas, Gluck und Durazzo im Burgtheater (Vienna 1925), p. 28.
12 The Autobiography of Karl von Dittersdorf dictated to his son, trans. A. D. Coleridge (London 1896), pp. 47f.
13 ›Repertoire de tous les spectacles qui ont été donné [sic] au theatre près de la cour . . . depuis le I.r Janvier jusqu'au 31 Dec. 1762 . . .‹, Wien, Österreichische Nationalbibliothek, Musik Hs. 34580/b. Gerhard Croll is in the process of editing all the extant Gumpenhuber chronicles.

occasions, but unlike Pugnani he also served as concertmaster in the Burgtheater. Gumpenhuber's ›État present de l'Orchestre qui a servi pour tous les Spectacles‹ shows that the concertmaster continued to be Joseph Trani, whose pupil, young Carl Ditters, is listed as the seventh and last of the first violins, while two other Ditters, Joseph and Alexander, are listed as fifth and seventh among the second violins. On 10 May there was an Academy for the court, assembled at Laxenburg palace, at which Pugnani played. The ›Wienerisches Diarium‹ reports, finally: »Vienna, 15 May 1762 ... in the usual attendance of our Cardinals and the Papal Monsignor Nuncio, was an excellent Tafel-music, at which the famous violinist Herr Pugnani was heard; and there was a public banquet.«[14] Pugnani's name disappears from Viennese records at this time and he presumably returned to Turin.

Between Pugnani's first and second sojourns in Vienna, that is to say following the publication of his trio sonatas in 1754, he was accorded one of the higher honors that could be bestowed on a musician. His portrait was painted probably by one of the court artists at Turin (see *colored plate*). This stunning portrait came to public attention in 1977 when it was put on sale by Christie's and eventually acquired by the Royal College of Music.[15] Pugnani's countenance wears a grave yet alert expression. The artist has done his best to flatter, given his subject's disproportionately large nose. Pugnani, quill in hand, wears the official gala dress of a court musician serving the house of Savoy: light blue coat with wide ermine cuffs, and a white waistcoat edged with blue lace. A red carnation near the neckerchief lends a note of vivacity and warmth to the coolness of the prevailing blue tones. There can be no doubt about the identity of subject, whose violin sits rather precariously on his bow, which lies on a music manuscript showing the violino primo part of the first movement of Pugnani's trio sonata op. 1 no. 3 in C.

It is tempting to speculate that this manuscript represents Pugnani's autograph, which was given to La Chevardière in Paris for the purpose of the print, then reclaimed and taken back to Turin by the composer. In the great portrait of François Couperin le Grand by André Bouÿs, surviving only as an engraving made by Jean Jacques Flipart in 1735, the composer's left hand rests on a piece of music paper bearing the inscription »Les Idées Heureuses« followed by the incipit of this piece from the »seconde ordre« of Couperin's ›Pièces de clavecin ... premier livre‹ (Paris 1713). In this case it has been suggested[16] that the artist counterfeited Couperin's hand. A close inspection and comparison of the Parisian print of Pugnani's third trio with its counterpart in the painting shows that they are very close indeed (*figs. 2 and 3*). The clefs, the spacing, the beaming of the notes, the accidentals – everything testifies to one source being directly copied from the other. Alas the music writing does not resemble at all the autograph of Pugnani's cantata ›La Scomessa‹.[17] It does look like other works professionally engraved at Paris. We conclude

14 H. C. Robbins Landon, Haydn. The Early Years 1732–1765 (= Haydn chronicle and works, vol. 1, Bloomington and London 1980), pp. 369f. The author was not aware of Gumpenhuber's chronicles.

15 Christie's sale catalogue for Friday, 2 December 1977 describes the painting as »The Property of a Lady. School of Turin, circa 1755–1760 ... An attribution to Andrea Soldi has been suggested.« Soldi was in England from 1735 and died there in 1771 making it unlikely that he was the painter; see John Ingamells, ›Andrea Soldi‹, in: The Connoisseur 185 (1974), pp. 192–200, and 186 (1975), pp. 178–186. The catalogue properly identifies the music from Pugnani's op. 1, no. 3 and gives the measurements of the painting as 119.5 × 87.7 cm. I am indebted to Margaret Christian of Christie's for sending me a copy of the catalogue entry and for answering my queries. I am indebted as well to Oliver Davies, Keeper of Portraits at the Royal College of Music who kindly informs me that the portrait was bought at Christie's by Richard Feigen in 1977 and acquired by the Royal College in 1978, and that it was loaned by George Hart in 1904 to the Music Loan Exhibition in Fishmongers' Hall. I am most indebted of all to Professor H. Colin Slim who called my attention to the portrait in the first place and brought me photographs of it from London.

16 By my colleague Professor Alan Curtis whom I thank for pointing out the source of »Les Idées Heureuses«. The portrait is reproduced in Edward Higginbottom, ›(4) François Couperin (ii)‹, in: The New Grove, vol. 4, p. 862.

17 Zschinsky-Troxler (footnote 1), p. 185, gives a facsimile of the first page of the score.

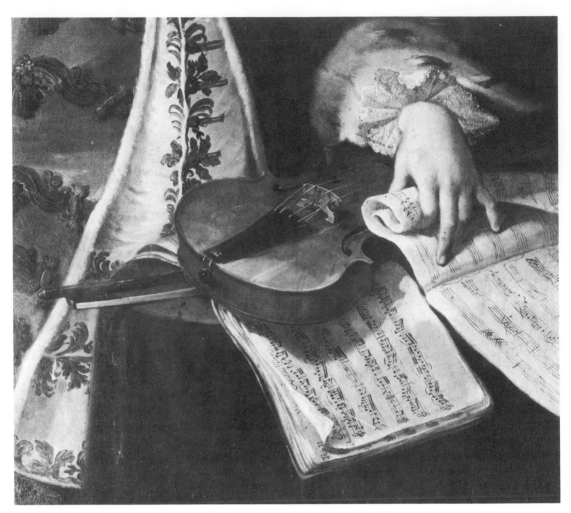

Fig. 2

Fig. 3

therefore that Pugnani gave the painter a copy of his printed trios and told him which page to incorporate. The painter (or more likely, a young assistant) did a remarkable job of counterfeiting with his brush what he saw on the printed page. He begins by taking account of the music that disappears under the violin, but later forgets to do so. Pugnani's left hand grasps another sheet, a double music page, which is upside down with respect to the violino primo part. It contains a sketch, with crossings out, on what looks like the same six-stave paper. The sketch is for a piece a 3. Here, in this freer and more cursive hand, we presumably have an artist's rendition of Pugnani's own handwriting.

Composers' sketches furnish a tantalizing subject for study whenever they are preserved, and very few survive from the mid-eighteenth century. Examining the painting itself, graciously made available by the Portrait Collection in its small quarters in one of the towers of the Royal College of Music, I was able to decipher the following from the main part of the sketched sheet: [*musical example 1*]. The passage should belong, by virtue of its key signature of two sharps, to the second theme area in the dominant of a trio in *D*. There is no trio in *D* among Pugnani's six published in 1754, the keys of which are *G, E, C, B* flat, *A* and *C*. Pugnani did not put much store by independent second themes, furthermore. The closest he came to one in this set is found in the trio no. 5 in *A*: [*musical example 2*]. And in this case he did not choose to repeat his »second

Ex. 1

Ex. 2

subject« in the tonic when it came time to do so in the reprise. The sketch cannot be related to the six trios of the print. Perhaps it relates to works that Pugnani was composing in the later 1750s, at the time of the painting. La Chevardière brought out another set of Pugnani's trio sonatas about ten years after the first, ›Sei sonate a due violini e basso ... Opera seconda‹. The keys of these trios are *B* flat, *C, A, E* flat, *B* flat and *c* minor.

Assuming that the composer himself picked the Andante of his op. 1 no. 3 to form the main musical »emblem« in his portrait, we are obliged to try to explain why he did so. It is not the most brilliant of the trios – that would be no. 5 in *A*, just quoted. It is not the most learned either. This distinction goes to no. 6 in *C*. The last trio, which with its four movements and its fugal second movement in the tonic minor, stands the closest to the old sonata da chiesa of Corellian stamp. The characteristic place to make a bow to the learned tradition of Italian chamber music during the mid-century galant phase was in fact the last work of a set. Pugnani probably picked

Fig. 4

Fig. 5

Fig. 6

the first of the two trios in *C* for his portrait because, if it was neither the most brilliant nor learned of the set, it was the most up-to-date in style, the most sentimental, and of a winning charm (*musical example 3*). The violino primo sings so ardently, and yet so delicately, that it does not take a very vivid imagination to hear the composer-violinist himself entoning this part. The violino secondo accompanies in thirds, sixths or tenths much of the time. The basso, which is lightly figured, provides the fundament for their warbling duets. After the half cadence in bar 9, there is a second idea over a dominant pedal and a new texture, but it can scarcely be called a second theme. The double bar with repeat sign is followed by a restatement of the initial material in the dominant, leading quickly to a restatement of the same in the tonic. This is standard operating procedure for the 1750s and Haydn follows it more often than not in his earliest sonata-form works, which may well reflect some inspiration from the Italian violinist-composers called to Vienna to grace the Burgtheater concerts. Pugnani veers away from tonic major, substituting tonic minor, then making his bass descend chromatically, while the second violin adds rhythmic excitement with its syncopated figure. The dynamic climax arrives with the double stops marked forte in the following bars. In the course of this passage tonic *C* major begins to reëstablish itself. There is no need for a double return (of initial theme and tonic simultaneously). In fact composers mostly avoided a double return if they had already sounded the main theme in the dominant then the tonic after the double bar. The pedal section, now in the tonic, returns and furnishes a clear recollection of the first half's conclusion, if not a clear second theme. Pugnani's inexperience shows most clearly in bar 27, after he has returned to the *G* pedal and nothing happens in either line or texture – the harpsichord would have supplied the missing third here but even so Pugnani took more care elsewhere to make the three parts euphonious and complete unto themselves without the necessity of continuo harmonization. The movement ends nicely with a reference to the chromatic descent from the opening melody.

Pugnani's Andante offers a veritable catalogue of galant mannerisms, beginning with the melodic »sdrucciolo« by which the violino primo slides up to *G*. Triplets, sextuplets, dotted rhythms, echoes in another register, graces of various kinds, forte-versus-piano contrasts – all belong to the stock in trade of the up-to-date composer around 1750. The surface ornamentation lends a rather frilly effect overall, but this is only in keeping with the fashion of the times, like the frilly neckerchief and sleeves worn by Pugnani in the painting. Underneath the frills and furbelows of the music the structure is solid, and aside from one difficult moment, mentioned above, the craft is strong.

The painting demonstrates more mastery than young Pugnani's Andante even so. If we look beyond its flounces to see what the artist is saying about Pugnani his message is strong and clear. Pugnani was a proper courtier, and proud to be so, at an opulent and art-loving court. He was more. With his quill in one hand and, quite extraordinarily for the genre of musicians' portraits, a sketch sheet in the other hand, he embodies the creative artist, not just the virtuoso violinist. Deep admiration for the art and craft of music emerge from the portrait. Even the learned-looking tomes used on the right to balance the chair on the left convey an aura of respect for what Pugnani represents. The loving detail with which the music, violin and bow are rendered intensify this aspect. Surely the instrument represents Pugnani's favorite violin, made in Cremona by Giuseppe (»del Gesù«) Guarnieri (1698–1744), the last and greatest member of a dynasty of violin makers.[18]

18 David D. Boyden, The History of Violin Playing from its Origins to 1761 (London 1965), p. 318: »Pugnani was the first important violinist to use del Gesù's violins . . .«

A certain appropriateness attaches to the acquisition of the Pugnani portrait by a royal institution in London. Pugnani succeeded Felice Giardini as leader of the Italian opera orchestra in the King's Theatre in the Haymarket in 1767. Paris, the scene of Pugnani's first international successes as a performer and composer also would have been appropriate, but Paris had so many musical sons of her own, and so many brilliant portraits of them, it could afford to cede Pugnani to London. But the most appropriate place of all for this painting is the city it never should have left: Turin. The greatest musical sons of Turin are precisely the triumvirate of Somis, Pugnani and Viotti, a progeny less vast than most other capitals. Were there any poetic justice Pugnani's portrait would hang in honored prominence in the halls of Turin's Conservatory so as to inspire latter-day Torinesi with a love for the history and traditions of their city. It was to Turin, after all, that Pugnani returned in 1770, giving up London. Back in his native city he achieved his lifelong ambition to become first violinist of the King's band, »Primo violino della Cappella e Camera«, the post long held by Somis, which entailed serving as »maestro di concerto« in the Teatro Regio. Pugnani acquired still further titles and the salaries that went with them – »Direttore generale della musica instrumentale« in 1776, and »Direttore della musica militare« in 1786. He died on 15 July 1798 and was entombed in the Royal Chapel. The posthumous inventory of his possessions is maddeningly vague about his instruments and paintings; it is possible that our portrait figured among the latter as »Un quadro con ritratto grande«.[19]

While Pugnani still lived he was the subject of a telling éloge by Giovanni Battista Rangoni in his ›Essai sur le goût de la musique avec le caractère des trois célèbres joueurs de violon[,] Messieurs Nardini, Lolli, & Pugnani‹, published by Tommaso Masi in both French and Italian at Livorno and Lyons in 1790. Of Nardini Rangoni says that one has to hear his music, and that of his teacher Tartini, played by someone from their school, else all is wrong. Antonio Lolli he calls a showman who gave up the sublime for the execution of difficulties. His appreciation of Pugnani is worth quoting at length for the light it throws on the violinist's music.

> »Fra' violini del primo ordine, io distinguo il Pugnani, per quella viva eloquenza e nervosa, onde la sua melodia è ripiena. Questo grande autore di sonate, che tanto dee all'incanto della sua musica appassionata, che a quello della sua maniera d'eseguirla, sacrifica, come fa il Rousseau nella sua Giulia, se è permesso di paragonare un momento la melodia alla prosa, l'eleganza dello stile al sentimento, da cui è vivamente commosso, e non di rado l'anima rapisce co' prestigi dell' immaginazione. Tale è il potere dell' eloquenza nelle scienze, in cui il sentimento ha tutta la forza e l'imperio. Da ciò deriva che, con tutte l'eccezioni che alcuni critici pretendono di dare alla sua maniera, egli si è fatto così padrone del cuore de' suoi uditori, che impossibil sarebbe di rovinare il partito [i.e. the favorable party or partisans], che si è fatto in alcune parti, e massime nel suo paese.
>
> La sua musica non dipende nè dall' arte dell' arco, nè dalla difficoltà della mano, che egli tiene affatto subordinata all' espressione del sentimento, ed ella non può mettersi con quella di tanti altri autori moderni che senza carattere e senza significato, solo agli orecchie si fa sentire: ma ella penetra tosto fino all' anima, perchè le sue modulazioni son chiare, precise, ed energiche, come le frasi d'un filosofo eloquente, e d'un oratore. Libera, come ella è, d'accenti inutili, esprime i soli sentimenti; e le idee succedendosi con ordine, non s'allontanano mai dal primo motivo. Infine questo valente musico riduce le sue composizioni a quella unità precisa che de' vari soggetti che la compongono, forma un tutto indivisibile.«

In his final paragraph on Pugnani Rangoni elaborates on his orchestral leading, which was done, typically for Italian practice, mainly by the players watching his bow. It helps also to know that the »maestro di concerto« often sat or stood on a higher platform than the other players.

> »In oltre egli signoreggia da gran maestro nell' orchestra come un bravo comandante fra' suoi soldati. Animato dal fuoco divoratore dell' ingegno che gode, e pieno del suo principale oggetto, che è l'unione

19 A. Bertolotti, Gaetano Pugnani e altri musici alla corte di Torino nel secolo XVIII (Milan 1892), p. 24.

generale, ora con uno sguardo, ora con un segno soggetta tutti i membri dell' orchestra a' minimi moti del suo volere. Il suo arco è il bastone di comando, a cui ciascuno obbedisce colla maggiore esattezza. Con una sola arcata, data a tempo, ei rinforza l'orchestra, la rallenta e la rianima a suo talento, egli addita agli attori i minimi degradamenti, e tutti richiama a quella perfetta unità, che è l'anima d'un' accademia [»l'ame d'un concert«].«

The French critic François Fayolle had a few original things to say about Pugnani in his ›Notices sur Corelli, Tartini, Gaviniés, Pugnani et Viotti‹ (Paris 1810), although most of his information is taken from Rangoni. According to Fayolle Pugnani was able to pass his art of orchestral-leading on to his pupils, of whom Viotti was the most famous. The source of the following should be evident, but Fayolle extends the observation with a precise reference:

»Une éloquence vive et nerveuse règne dans sa mélodie. Les idées s'y succèdent par ordre, sans jamais s'écarter du motif! Quelques-uns de ses trios ont même le grandiose du concerto, entr'autres, celui où Viotti a pris le motif d'un de ses plus beaux concertos. (Voyez le 1er trio de l'œuvre X en *mi* bémol.)«

Fayolle commented, finally, on Pugnani's sumptuous dress and great dignity, qualities that are confirmed by the Turin portrait of him as a fastidious young artist. An engraving by Lambert showing Pugnani in profile, with an enormously protuberant nose, accompanied the text.[20]

»Peu d'artistes ont su mériter comme Pugnani l'admiration pour leur talent, et l'estime pour leur personne. Quand il paroissoit en public, il étoit somptueusement paré, et conservoit dans son maintien beaucoup de dignité. Le grandiose de son exécution répondoit parfaitement à cet exterieur qui frappoit tous les yeux. D'après la gravure de son portrait, fait sur le dessin original, on voit que Lavater l'auroit rangé dans la classe de l'aigle.«

Lambert's engraving was not intended to be a caricature but it has the effect of one. Pugnani could hardly have escaped the attention of the true caricaturists. With his great talent, habits of dress and remarkable physiognomy, he invited their attention. One of the most paradoxical but endearing qualities of the settecento was its ability to caricature the very values it revered the most, an ability that reached its zenith in the art of Hogarth, Ghezzi, and Zanetti. Pier Leone Ghezzi was well along in his seventies when young Pugnani visited Rome in 1749/50. He had been sketching noteworthy figures from all walks of life, but especially musicians, for over fifty years. His caricatures of Pugnani[21] (*figs. 4–6*) are in their own way a tribute to an extraordinary musical talent quite as touching as the elegant Turin oil portrait.

20 It is reproduced in Boris Schwarz, ›Pugnani‹, in: Die Musik in Geschichte und Gegenwart, vol. 10 (Kassel etc. 1962), col. 1745.

21 Figure 4 is preserved in the Department of Prints and Drawings of the British Library, London under the call number 197 d. 4. 1859. 8. 6. 138 and measures 10×13,8 cm. The caption reads: »Gaetano Pugniano Turinese mandato dal Rè di Sardegnia in Roma per studiare il Contrapunto dal S.r Ciampi Maestro di Capella in S. Giacomo de' Spagnioli & il S.r Gaetano è nell' età di Anni 19 fatto dà Me Cav.l Ghezzi Li 24 Luglio 1749.« Figures 5–6 stem from the former collection of the Duke of Wellington and are believed to be in private hands in America now. The photographs come from the collection of Alan Curtis, whom I thank again for his help.

Max Klingers Verhältnis zur Musik*

Hellmuth Christian Wolff

Verzeichnis der Abbildungen

Wo nicht anders angegeben, stammen die Reproduktionsvorlagen aus dem Museum der bildenden Künste Leipzig (Photograph Herbert Zschunke). Die Graphiktitel und -Werknummern fußen auf: Hans Wolfgang Singer, Max Klingers Radierungen, Stiche und Steindrucke. Wissenschaftliches Verzeichnis (Berlin 1909, Reprint New York 1978; = S.-V.).

Graphik

Aus ›Sauvetages des sacrifices d'Ovide‹ / Aus ›Rettungen Ovidischer Opfer‹, Radierungen, S.-V. 25–42

Fig. 1 ›Narziß und Echo I‹, S.-V. 31
Fig. 2 ›Pyramus und Thisbe‹, S.-V. 39'IV

Illustrationen zu Johannes Brahms: Vier Lieder, op. 96
Fig. 3 Entwurf zum äußeren Titelblatt ›Im Grase‹ (= ›Feldeinsamkeit‹), Federzeichnung (später lithographiert, siehe S.-V. 319)
Fig. 4 ›Arion‹, inneres Titelblatt, Lithographie, S.-V. 320

Aus ›Brahms-Phantasie‹, Radierungen, S.-V. 183–229
Fig. 5 ›Accorde‹, S.-V. 183
Fig. 6 ›Evocation‹, S.-V. 201'V
Fig. 7 ›Im Grase‹, Illustration zum Lied ›Feldeinsamkeit‹, S.-V. 198
Fig. 8 ›Nackte Frau am Baum (Die Ferngeliebte)‹, Illustration zu ›Böhmisches Volkslied‹, S.-V. 190
Fig. 9 Zu ›Alte Liebe‹, obere Randleiste am Anfang des Liedes, S.-V. 184
Fig. 10 Zu ›Alte Liebe‹, seitliche Randleiste am Schluß des Liedes, S.-V. 189
Fig. 11 ›Homer‹, Titelillustration zum ›Schicksalslied‹, S.-V. 208
Fig. 12 ›Zierleiste mit der nackten Frau und grünem Schleier‹,
›Zierleiste mit nackter Frau und zwei Adlern‹,
Illustrationen zum ›Schicksalslied‹, S.-V. 210/211
Fig. 13 ›Die Schönheit (Aphrodite)‹, Illustration zum ›Schicksalslied‹, S.-V. 213
Fig. 14 ›Zierleiste mit den Kletternden‹, Illustration zum ›Schicksalslied‹, S.-V. 215
Fig. 15 ›Zierleiste mit dem Bergsturz‹ I und II, Illustrationen zum ›Schicksalslied‹, S.-V. 218/219
Fig. 16 ›Nacht‹, S.-V. 203
Fig. 17 ›Fest (Reigen)‹, S.-V. 205
Fig. 18 ›Der befreite Prometheus‹, S.-V. 223
Fig. 19 ›Der Bauer dessen Saat in Unheil aufgeht‹, S.-V. 222

Aus ›Vom Tode Erster Teil‹, Radierungen, S.-V. 171–182
Fig. 20 ›Der Tod als Heiland‹, S.-V. 180

Plastik

Fig. 21 Beethoven-Denkmal (Vorderansicht). Leipzig, Museum der bildenden Künste
Fig. 22 Beethoven-Denkmal (Rückansicht des Throns). ibidem
Fig. 23 Kopf Wagners, Entwurf zum Wagner-Denkmal. ibidem
Fig. 24 Wagner-Denkmal (zweiter Entwurf). ibidem
Fig. 25 Wagner-Denkmal, Sockel, heutiger Zustand. Leipzig, Klinger-Hain
Fig. 26 Brahms-Denkmal. Hamburg, Kunsthalle. – Photo: Archiv für Denkmalswesen der Stadt Hamburg

* Der Aufsatz basiert auf einem am 8. September 1970 in Leipzig gehaltenen Vortrag.

Fig. 27 Entwurf zu einem Brahms-Denkmal für Wien. Photo aus Ludwig Hevesie in: Zeitschrift für bildende Kunst, Neue Folge 38 (1902), pp. 236–238.

Fig. 28 Liszt-Büste. Leipzig, Hochschule für Musik. – Photo: Ludwig Daume, Leipzig, Hochschule für Graphik

Fig. 29 ›Max Reger auf dem Totenbett‹, Kreidezeichnung. Leipzig, Museum der bildenden Künste

Fig. 30 Richard Strauss-Büste. Leipzig, Museum der bildenden Künste

Reproduktionen mit freundlicher Genehmigung der Besitzer der Vorlagen

* * *

Die Beurteilung Max Klingers war in den letzten Jahrzehnten den stärksten Wandlungen unterworfen. Die Kunst des Kubismus und des Expressionismus konnte mit ihm überhaupt nichts anfangen. Man erkannte zwar seine formale Kunstfertigkeit an, auch seine ethische Haltung, glaubte aber, daß die naturalistische Darstellung vieler seiner symbolischen Gedanken stilwidrig gewesen sei. So bezeichnete Hans Hildebrandt im Jahre 1924 Klinger als am Naturalismus gescheitert[1]. 1932 liest man in Richard Hamanns ›Geschichte der Kunst‹: »Vollends gescheitert ist die für ihre Zeit so bedeutungsvolle, uns heute nicht nur fremde, sondern auch unzeitgemäß erscheinende Kunst von Max Klinger«[2]. Bald danach setzte jedoch eine allgemeine Aufwertung des Jugendstils ein; Klinger wurde nun als Vorgänger des Jugendstils und als »einer der wirksamsten Anreger im deutschen Raum« bezeichnet[3]. Seine Darstellungen der »Leiden der Welt«, sozialer Probleme und Nöte wurden wieder beachtet, etwa sein Einfluß auf Käthe Kollwitz. Schließlich wurde seine utopische Wunschwelt und naturferne Phantastik wieder positiv beurteilt und seine Bedeutung für den Symbolismus und Surrealismus anerkannt[4]. Hierbei kommt der engen Beziehung Klingers zur Musik eine nicht geringe Rolle zu, oft waren die Anregungen, die er durch Musik erhielt, sogar entscheidend für sein Schaffen. Hier sollen einige der wichtigsten genannt werden.

Das Leben Max Klingers (1857–1920) war von Anfang an eng mit Musik verbunden, er erhielt frühzeitig Klavierunterricht, und das Klavierspiel begleitete sein ganzes Schaffen. Klingers Vater war ein aus dem sächsischen Voigtland nach Leipzig übersiedelter, sehr wohlhabender Seifenfabrikant, der selbst künstlerische Interessen hatte und gemalt hat. Die Beschäftigung mit der Kunst wurde nicht als Luxus, sondern als Lebensnotwendigkeit angesehen. Vater Klinger ermöglichte seinem Sohn das Studium der bildenden Kunst an den ersten Kunstschulen seiner Zeit, so in Karlsruhe, Berlin, dann in Paris und Brüssel. Bereits in seiner Karlsruher Studentenzeit trat Max Klinger in Feiern der Kunstschule als Solist am Klavier auf, er begleitete z. B. eine geistliche Arie von J. S. Bach. In ausführlichen Briefen hat Klinger seinen Eltern

1 Hans Hildebrandt, Die Kunst des 19. und 20. Jahrhunderts (Potsdam 1924), p. 334.

2 Richard Hamann, Geschichte der Kunst von der altchristlichen Zeit bis zur Gegenwart (Berlin 1932), vol. 2, p. 861, ebenso in der Auflage von 1955.

3 Hans H. Hofstätter, Geschichte der europäischen Jugendstilmalerei (Köln 1963), p. 168; ferner idem, Symbolismus und die Kunst der Jahrhundertwende (Köln 1965), passim.

4 J. Kirk T. Varnedoe, Graphic Works of Max Klinger (New York 1977), pp. xiii–xxv. Varnedoes Bibliographie (p. 99) und eine Anzahl von Ausstellungen in den letzten zehn Jahren spiegeln das wiedererwachte Interesse an Klinger. Direkt auf das Thema unseres Beitrags bezogen ist die Dissertation von Karen Mayer-Pasinski, Max Klingers Brahmsphantasie (Göttingen 1979). Im allgemeinen sind jene Arbeiten, die die Symbolismus-Bewegung von der literaturhistorischen Seite aus angehen, jenen aus den Schwesterdisziplinen überlegen. Aus der erstgenannten Kategorie ist die beste Studie Anna Balakian, The Symbolist Movement. A Critical Appraisal (New York 1976), mit ausgezeichneter Bibliographie (pp. 199–203). Eine gut illustrierte Übersicht über den Symbolismus in der bildenden Kunst bietet Philippe Jullian, The Symbolists (London 1973). Was den Surrealismus angeht, sei verwiesen auf Maurice Nadeau, Histoire du Surréalisme (Paris 1945).

Fig. 1

hierüber berichtet, über sein Musizieren mit einem Geiger, über vierhändiges Klavierspiel usw. Er hatte privat ein Klavier zur Verfügung und »abonnierte« die Noten in einer Musikalienhandlung, wie dies damals üblich war[5]. Klinger sang in Karlsruhe auch in komischen Quartetten mit und war besonders als Frauendarsteller für die pantomimischen Darstellungen berühmter Gemälde beliebt. Auch später hatte Klinger immer einen Flügel in seinem Atelier, wie zuletzt in Leipzig – ein Photo des heute noch erhaltenen Ateliers gibt davon Kunde (abgebildet in dem Katalog der Max Klinger-Ausstellung des Museums der bildenden Künste in Leipzig 1970, p. 19). Klinger war mit vielen Musikern bekannt oder befreundet, so mit Max Reger in Leipzig und mit dem bekannten Cellisten Julius Klengel. Richard Strauss besuchte Klinger 1910 und nochmals 1915, wo Klinger eine Bildnisbüste von ihm schuf. Besonders bedeutsam waren Klingers Beziehungen zu Johannes Brahms, die leider erst zu einem späten Zeitpunkt erfolgten und die durch den Tod von Brahms abgebrochen wurden.

Schon in der ersten Schaffenszeit erhielt Klinger Anregungen durch musikalische Werke, so widmete er den 1879 in Brüssel entstandenen graphischen Zyklus ›Sauvetages des sacrifices d'Ovide‹ dem Gedächtnis Robert Schumanns. In diesen ›Rettungen Ovidischer Opfer‹ änderte Klinger die tragischen Schlüsse einiger der bekanntesten Metamorphosen des Ovid, damit Liebespaare wie Echo und Narciss nicht getrennt, sondern vereinigt werden und damit die »Verwandlung« unterbleiben konnte (*Fig. 1*). Klinger war hierzu offenbar durch literarische Vorbilder Gotthold Ephraim Lessings angeregt worden, vielleicht aber auch durch graphische

5 Hans Wolfgang Singer (ed.), Briefe von Max Klinger aus den Jahren 1874 bis 1919 (Leipzig 1924), Brief Klingers an seine Eltern vom 22. Mai 1874.

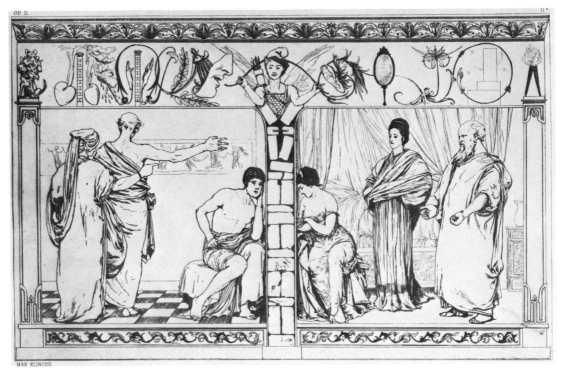

Fig. 2

Zyklen der ›Fliegenden Blätter‹, für die damals erste Künstler wie Moritz von Schwind arbeiteten. Jedenfalls zeigt sich bereits hier eine bemerkenswerte Tendenz zur Verfremdung und eine ironische Haltung gegenüber dem klassischen Bildungserbe. Der Verleger Leo Liepmannssohn fragte Klinger nach dem Grund seiner Widmung der ›Rettungen‹ an Schumann. Klinger antwortete in einem Brief: »Ich liebe die schumannsche Musik außerordentlich und behaupte und glaube von seiner Compositionsweise viel beeinflußt zu sein«, jedoch könne er keine Einzelheiten darüber angeben[6]. Man kann also nur den Einfluß des romantisch-phantastischen Charakters von Schumanns Musik im allgemeinen in Klingers frühen graphischen Werken suchen. Aber es wird nicht nur die Kompositionsweise gewesen sein, die Klinger zu dieser Widmung veranlaßte, sondern auch seine Affinität zum zyklischen Gedanken, der bei Schumann sein Vorbild hat[7]. Wenn Klinger die Klaviermusik Schumanns schätzte, so kannte er sicher dessen zyklische Werke wie ›Carnaval‹ (1837), ›Phantasiestücke‹ (1838) und ›Kinderszenen‹ (1839). Als weiteres Beispiel aus den ›Rettungen‹ Klingers sei das Blatt aus ›Pyramus und Thisbe‹ erwähnt, in dem das klassische Liebespaar in teilweise moderner Kleidung zu sehen ist (*Fig. 2*), die Wand zwischen sich, in der oberen Randleiste benutzt Amor seinen Bogen als eine Art von Telephon zwischen dem Mund eines Liebenden und dem Ohr des anderen – im Zeitalter der großen Historienmalerei läßt sich hier ein unakademischer und moderner Charakter erkennen (das

6 ibidem, Brief Klingers an seine Eltern vom 16. Januar 1880.
7 Elsa Asenijeff, ›Das Musikalische in Max Klingers Schaffen‹, in: Musikalisches Wochenblatt 36/15 (13. April 1905), p. 313; Asenijeff war die langjährige Lebensgefährtin Klingers und Mutter seiner Tochter Désirée. Ferner wies Felix Zimmermann in ›Beethoven und Klinger‹ (Dresden 1906), pp. 13–51, auf die vielen Beziehungen Klingers zur Musik hin.

Telephon wurde seit 1877 in der Praxis der Postanstalten eingeführt). Klinger trat auch theoretisch für eine Wiederbelebung der alten graphischen Künste, der »Griffelkunst«, ein (in der Schrift ›Malerei und Zeichnung‹ [Leipzig 1891]), so daß man nun sogar von einer »Griffelmusik« seiner Zeichnungen sprach[8].

Klinger schätzte ganz besonders die Kompositionen von Johannes Brahms. Durch dessen Berliner Verleger Simrock wurde Klinger im Jahre 1886 gebeten, Titelblätter für die zwei herauszugebenden Liederzyklen von Brahms op. 96 und op. 97 zu entwerfen. Skizzen Klingers wurden an Brahms in Wien geschickt, der sich zunächst beifällig äußerte, von den fertigen Titelzeichnungen jedoch nicht begeistert war, weil diese teilweise für andere Werke von ihm gedacht waren[9]. Klinger hat je zwei verschiedene Titelblätter für den äußeren und inneren Umschlag der Lieder geschaffen (zu op. 96 ›Im Grase‹ und ›Arion‹ [*Fig. 3* und *4*] und zu op. 97 ›Satyr mit Dryade‹ und ›Entführung einer Frau durch einen Ritter‹, offenbar den Heiligen Georg darstellend, der in einer Randleiste erscheint). Brahms schob in einem Brief an Klinger die Schuld an dem Versagen dem Verleger zu, der die Bilder zu schnell veröffentlicht habe. Diese Kritik wurmte Klinger so sehr, daß er beschloß, ohne Auftrag seiner Verehrung für die Musik von Brahms durch einen umfassenden, neuen Graphik-Zyklus Ausdruck zu geben[10]. In etwa fünfjähriger Arbeit entstand so die ›Brahms-Phantasie‹, in welcher Klinger sechs vollständige Kompositionen von Brahms in Noten stach, mit Illustrationen versah und diese dann im Selbstverlag in 150 Exemplaren veröffentlichte (*Fig. 5–19*). Vorher sandte Klinger die Blätter einzeln an Brahms bis er ihm 1893 den vollendeten Zyklus vorlegen konnte. Brahms bedankte sich und schrieb an Klinger: »Ich sehe die Musik, die schönen Worte dazu – und nun tragen mich ganz unvermerkt Ihre herrlichen Zeichnungen weiter; sie ansehend, ist es, als ob die Musik ins Unendliche weitertöne und alles aussprächle, was ich hätte sagen mögen, deutlicher, als Musik es vermag, und dennoch ebenso geheimnisreich und ahnungsvoll. Manchmal möchte ich Sie beneiden, daß Sie mit dem Stift deutlicher sein können, manchmal mich freuen, daß ich es nicht zu sein brauche. Schließlich aber muß ich denken, alle Kunst ist dieselbe und spricht die gleiche Sprache«[11]. Dies waren Gedanken von der Gemeinsamkeit aller Künste, wie sie seit der Romantik besonders beliebt waren. Sie fanden am Ende des 19. und am Beginn des 20. Jahrhunderts eine weite Verbreitung, die zu einer engeren Verbindung von Malerei und Musik führte. Die Symbolisten behandelten diese Kunstformen als Metaphern (»ut pictura musica«); für James Whistler, Paul Gauguin, Odilon Redon, Wassily Kandinsky und Paul Klee ist Musik in diesem Sinne ein fundamentales Anliegen. Klingers Haltung möchte man dagegen am ehesten als allegorisch bezeichnen, da für ihn Musik und Malerei komplementär sind mit der Literatur als Mittlerin zwischen ihnen. Allegorische Kunst ist im wesentlichen erzählerisch, was sich in Klingers Vorliebe für zyklische Formen widerspiegelt. Sie erstreckt sich über das ganze 19. Jahrhundert von Johann Heinrich Füßli und William Blake über Eugène Delacroix (mit den Hamlet- und Faust-Illustrationen), Schwind, Alfred Rethel und Charles Meryon bis zu Klingers Zeitgenossen und Nachfolgern Gustave Moreau, Gustave Doré, Fernand Khnopff, Gustav Klimt und James Ensor[12].

8 Über die Anwendung dieses Terminus auf Klinger siehe Georg Treu, Max Klinger als Bildhauer (= Sonderabdruck aus der Zeitschrift Pan [Leipzig und Berlin 1900], pp. 7/8).

9 Kurt W. Richter, Brahms und Klinger. Drei unveröffentlichte Briefe von Max Klinger an Johannes Brahms aus dem Brahmsarchiv (= Mitteilungen der Brahms-Gesellschaft Hamburg [April 1973], p. 3).

10 Max Kalbeck, Johannes Brahms (Berlin 1904–1914), vol. 4/2, pp. 329 ff.

11 ibidem, vol. 2/2, p. 361.

12 Andrew George Lehmann, The Symbolist Aesthetic in France 1885–1895 (Oxford ²1968), pp. 215–237, und Hendrik Roelof Rookmaaker, Synthetist Art Theories; Genesis and Nature of the Ideas on Art of Gauguin and his Circle

Fig. 4

Fig. 3

Für Klinger war die Musik mehr eine Anregung für inhaltlich-literarische Darstellungen, denen er allerdings genügend »Geheimnisreiches und Ahnungsvolles« beizugeben wußte, wie Brahms es formuliert hatte. Hierdurch blieb er nicht im rein Illustrativen stecken, sondern ging weit darüber hinaus in die Bezirke des Surrealismus. Dies zeigt auch seine ›Brahms-Phantasie‹.

Dieser Zyklus besteht aus 41 Stichen, Radierungen und Lithographien, welche als Randleisten oder auch als ganzseitige Blätter die erwähnten sechs Liedkompositionen von Brahms illustrieren und erläutern. Das ganze Werk besteht aus zwei Teilen, im ersten sind fünf bekannte Sololieder mit Klavierbegleitung in Noten mit Randleisten versehen, während der zweite Teil aus dem ›Schicksalslied‹ für Chor und Orchester auf den Text von Friedrich Hölderlin besteht, in einer Fassung mit Klavierauszug mitgeteilt und ähnlich illustriert. Dem ›Schicksalslied‹ fügte Klinger jedoch einen Zyklus über Prometheus hinzu, der aus sieben ganzseitigen Blättern besteht. Die Randleisten wurden diesem gewaltigen Werk allein nicht gerecht. Man versteht dies nur, wenn man die Musik dazu beachtet. Beiden Teilen ist jeweils ein gesondertes Einleitungsblatt vorangestellt: ›Accorde‹[13] und ›Evocation‹. Auf diesen Blättern sitzt ein Pianist am Meer oder an einem See. In ›Accorde‹ (*Fig. 5*) heben Triton und Nereiden eine Harfe aus dem Wasser, im Hintergrund ist eine italienische Seen- und Berglandschaft, auf dem Wasser ein Segelboot, welche die Großartigkeit und Schönheit der Natur andeuten. Auf dem anderen Blatt, ›Evocation‹ (*Fig. 6*), ist es eine Frau, welche die Harfe spielt, der Künstler am Flügel wartet wie ein Solist im Konzert auf den Einsatz. Die Verbindung der Musik mit der Natur und mit einer Harfe ist altes romantisches Erbe: Ludwig Tieck schrieb 1798 in seinem Roman ›Franz Sternbalds Wanderungen‹: »Ich höre, ich vernehme, wie der ewige Weltgeist mit meisterndem Finger die furchtbare Harfe mit allen ihren Klängen greift«[14]. Klinger erhielt die Anregung für diese Harfen zweifellos aus dem Text Hölderlins, in dem die seligen Götter beschrieben sind:

> Ihr wandelt droben im Licht
> Auf weichem Boden, selige Genien!
> Glänzende Götterlüfte
> Rühren Euch leicht,
> Wie die Finger der Künstlerin
> Heilige Saiten.

(Amsterdam 1969), pp. 210–220, erörtern die weitverzweigten Beziehungen zwischen der Symbolismusbewegung und Musik. Siehe ferner Ursula Kersten, ›Klinger und die Musik‹, in: Max Klinger, Kunsthalle Bielefeld, 10. Oktober–11. November 1976 (Bielefeld 1976), pp. 227–233, sowie unter etwas allgemeinerem Gesichtspunkt Hellmuth Christian Wolff, ›Das Musikalische in der modernen Malerei‹ in: Jahrbuch für Aesthetik und allgemeine Kunstwissenschaft 7 (1962), pp. 48–66.

13 Die Radierung ›Accorde‹ erinnert an Richard Wagners ausführliche Metapher in ›Das Kunstwerk der Zukunft‹. Dort schreibt er unter Nr. II/4 ›Tonkunst‹: »Noch dürfen wir das Bild des Meeres für das Wesen der Tonkunst nicht aufgeben. Sind Rhythmus und Melodie die Ufer, an denen die Tonkunst die beiden Kontinente der ihr urverwandten Künste erfaßt und befruchtend berührt, so ist der Ton selbst ihr flüssiges ureigenes Element, die unermeßliche Ausdehnung dieser Flüssigkeit aber das Meer der Harmonie. Das Auge erkennt nur die Oberfläche dieses Meeres: nur die Tiefe des Herzens erfaßt seine Tiefe. Aus seinem nächtlichen Grunde herauf dehnt es sich zum sonnighellen Meeresspiegel aus: von dem einen Ufer kreisen auf ihm die weiter und weiter gezogenen Ringe des Rhythmus; aus den schattigen Thälern des anderen Ufers erhebt sich der sehnsuchtsvolle Lufthauch, der diese ruhige Fläche zu den anmuthig steigenden und sinkenden Wellen der Melodie aufregt.« Die Vermutung dürfte nicht abwegig sein, daß Klingers Radierung vielleicht auf diese Passage zurückgeht; dies legt zumindest der Titel ›Accorde‹ und Wagners Metapher »Meer« für »Harmonie« nahe. Wir verdanken übrigens Giorgio De Chirico eine ungewöhnliche Beschreibung der ›Accorde‹, in der die surrealistischen Aspekte hervorgehoben werden, siehe Massimo Carrà (ed.), Metaphysical Art (New York–Washington 1971), pp. 99/100.

14 Ludwig Tieck, Franz Sternbalds Wanderungen (Berlin 1798), vol. 2/1, Kapitel 5.

Fig. 5

Fig. 6

Fig. 7 Fig. 8 Fig. 10

Fig. 9

Klinger läßt aber nicht nur »glänzende Götterlüfte«, sondern viel dramatischer die Gewalt des Meeres sowie den Kampf der Giganten am Himmel erscheinen, der im Hintergrund der ›Evocation‹ in wolkenartigen Gebilden angedeutet ist. Während bei Tieck die Natur als Ahnung des Göttlichen, als »Hieroglyphe« Gottes bezeichnet wurde, brachte Klinger den Kampf des Irdischen mit dem Göttlichen hinzu, den Hölderlin im Text seines ›Schicksalsliedes‹ angedeutet hat.

Man kann die Illustrationen Klingers in drei verschiedene Gruppen gliedern: Reine Textillustrationen, erläuternde Illustrationen und freie Ergänzungen. Der Textillustration dienen meist die Randleisten des ersten Teiles, so in dem Lied ›Feldeinsamkeit‹ (op. 86,2), wo die Worte von Almers in Zeichnungen umgesetzt werden (*Fig. 7*):

> Ich ruhe still im hohen grünen Gras
> und sende lange meinen Blick nach oben

Hier knüpfte Klinger an eines seiner ersten Titelblätter für Brahms an (*Fig. 3*). Eine rechts seitlich angebrachte Satyr- oder Faunsgestalt ist bereits erläuternde Illustration, sie deutet auf das Elementare der Natur im allgemeinen hin, während die auf der zweiten Seite dieses Liedes erscheinenden Köpfe zweier Liebenden im Dunkel bereits freie Ergänzung zum Thema »Einsamkeit« darstellen. In ›Böhmisches Volkslied‹ (op. 49,3) »Hinter jenen dichten Wäldern weilst du meine Süßgeliebte weit« wird das Bild der Geliebten mit Wald illustrierend dargestellt (*Fig. 8*), während das Schlußbild freie Ergänzung ist: Der Liebhaber sitzt am Boden zu Füßen der Braut, ein sehr realistischer Wunschtraum, der aus dem Text dieses auch als ›Sehnsucht‹ betitelten Liedes nicht direkt hervorgeht. Die Verzweiflung eines betrogenen Liebhabers (in ›Am Sonntag Morgen‹ op. 49,1) wird von dem Dichter Paul Heyse durch das Ringen der Hände zum Ausdruck gebracht. Klinger steigerte dies, indem er ihn als Ertrinkenden darstellt, der sich an einen Blumenstrauß klammert. In ›Alte Liebe‹ (op. 72,1) wird der Text des Candidus durch Klinger frei interpretiert: Die Erinnerungen an den »alten Liebesharm« und an den »alten Traum« realisierte Klinger, indem er einen am Boden seines Balkons liegenden Pianisten in alten Liebesbriefen wühlen läßt, die ihm der geflügelte Amor als etwas ältlicher Knabe offenbar in einem Kästchen gebracht hat – im Hintergrund ist die Stadtsilhouette von Rom zu sehen, wo Klinger mehrfach gewesen ist (*Fig. 9*). Im Text heißt es:

> Es ist, als ob mich leise
> wer auf die Schulter schlug,
> als ob ich säuseln hörte
> wie einer Taube Flug.

Daraus wurde bei Klinger die Gestalt Amors, der übrige Text wird nicht illustriert, lediglich am Schluß sieht man die »dunklen Schwalben« aus den Noten heraus um einen alten Turm fliegen, an die Anfangsworte des Liedes anknüpfend:

> Es kehrt die dunkle Schwalbe
> aus fernem Land zurück. (*Fig. 10*)

Der zweite Teil der ›Brahms-Phantasie‹ ist der gewichtigere, Klinger gab hier außer Randleisten zum Text des ›Schicksalsliedes‹, wie erwähnt, die Prometheussage wieder.

Auf dem einleitenden Blatt (*Fig. 11*) ist der Text des ›Schicksalsliedes‹ vollständig mitgeteilt, auf der links daneben befindlichen halbseitigen Abbildung sieht man einen alten Mann, der von

Fig. 11

Singer als Homer bezeichnet ist[15], vor einem riesengroßen leidenden menschlichen Kopf stehen, im Hintergrund sind die Leichen Ertrunkener im Meer zu sehen. Klinger brachte durch die Gestalt Homers die Verbindung Hölderlins mit der Antike zum Ausdruck. Oben in den Wolken sind Zeus und Hera als die »seligen Genien« angedeutet. Ähnliche Genien werden außerdem in Randleisten als jugendliche Gestalten in luftiger Höhe über dunklen Gebäuden gezeigt (im Original farbig; *Fig. 12*). Zu dem Beginn des zweiten Teiles der Komposition, einem dramatischen Allegro gab Klinger die Gestalt der Schönheit, die sich über dem Grauen ertrunkener Menschen erhebt (*Fig. 13*). Man kann diese Illustrationen also nicht nur als Wiedergabe der jeweiligen Text- oder Musikteile auffassen, es handelt sich auch um ergänzende und freiere Zugaben. Wörtliche Illustration ist die Zeichnung von den auf Klippen sitzenden Menschen (*Fig. 14* rechts) sowie eines ins Wasser gezogenen Mannes, den ein Polyp erfaßt hat (*Fig. 14* links). In weiteren Randleisten sieht man einen in der Wüste verdursteten Mann mit seinem Hund (oder einer Hyäne) sowie einen Bergsturz, den ein Mann aufrecht gefaßt entgegen nimmt, während eine alte Frau betend daneben sitzt (*Fig. 15*).

Es heißt bei Hölderlin:

Es schwinden, es fallen Wie Wasser von Klippe
Die leidenden Menschen Zu Klippe geworfen,
Blindlings von einer Jahrlang ins Ungewisse hinab.
Stunde zur andern,

15 Hans Wolfgang Singer, Max Klingers Radierungen, Stiche und Steindrucke. Wissenschaftliches Verzeichnis (Berlin 1905 und 1909), p. 82.

Fig. 12

Fig. 13

Fig. 14

Fig. 15

Fig. 19

Fig. 16

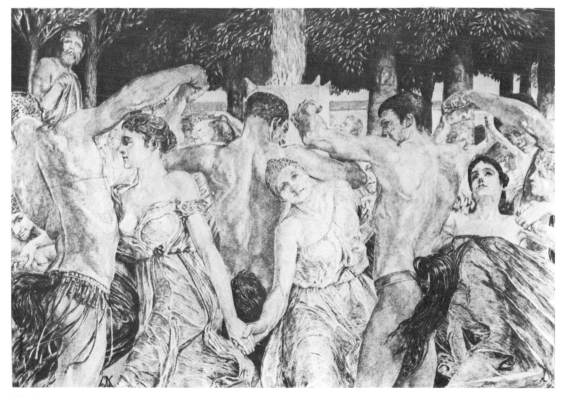

Fig. 17

Aus dem Gegensatz der glücklichen Genien oder Götter zu den leidenden Menschen kam Klinger auf den Prometheus-Zyklus, in dem der Kampf der Giganten oder Titanen gegen die Götter gezeigt wird, Apollo und Artemis schießen mit ihren Bogen gegen die Steine und Felsen schleudernden Giganten, welche auf dem zweiten Blatt zerschmettert nachts am Boden liegen (*Fig. 16*). Es ist wohl das bedeutendste Blatt des ganzen Zyklus, mit ›Nacht‹ betitelt. Prometheus ist oben am Himmel als junger Mann dargestellt, wo ihm Hera oder die »Sage« von der Not der Menschen berichtet. Darauf raubt er den Göttern das Licht und bringt es in das Dunkel der Nacht, es folgen ein Freudenfest mit tanzenden Männern und Frauen (*Fig. 17*), die Entführung des Prometheus zur Strafe, ein Opfer primitiver Menschen an Zeus, die für Prometheus beten, zuletzt die Befreiung des Prometheus durch Herakles (*Fig. 18*). Prometheus ist nach der jahrelangen Gefangenschaft, die ihn angekettet an einem Felsen hielt, wo ihm der Adler des Zeus immer wieder die Leber aufhackte, so erschüttert, daß er in Tränen ausbricht. Unten sieht man Meeresgötter singen. Mit diesem befreienden und hoffnungsvollen Abschluß knüpfte Klinger unmittelbar an die Komposition von Brahms an, der sein ›Schicksalslied‹ nicht mit der Verzweiflung der Menschen schließen ließ wie Hölderlin, sondern mit einem Ausblick auf eine Besserung, mit der Hoffnung. Brahms gab ihr in Form eines Orchesternachspiels Ausdruck, welches an den Anfang des Werkes, das Orchestervorspiel, anknüpfte, in dem die »seligen Genien« musikalisch nachgezeichnet wurden. Brahms brachte durch das sehr ähnliche Nachspiel zum Ausdruck, daß auch die Menschen zu »seligen Genien« werden können[16]. Der Widerstreit von Tragik und Hoffnung war das Thema vieler Kompositionen von Brahms, zuvor auch von Beethoven, der von Klinger ebenfalls sehr verehrt wurde, vor allem der Beethoven der Neunten Sinfonie. Als Abschluß des ›Schicksalsliedes‹ brachte Klinger aber eine weniger optimistische Zierleiste an, auf welcher aus den Furchen eines pflügenden Bauern Schwerter wachsen, oben reißt eine Faust die Wage der Gerechtigkeit aus ihrem Lot – so dämpfte er den Optimismus durch eine scharfe kritische Zeichnung, die an Krieg und Ungerechtigkeit erinnert (*Fig. 19*).

Im Jahre 1914 machte man in Wien den Versuch, die ganze ›Brahms-Phantasie‹ Klingers in Lichtbildern zusammen mit den Kompositionen auf- und vorzuführen. Der damalige Wiener Kunstwissenschaftler Josef Strzygowski hat hierüber eingehend berichtet[17] und auf die glückliche Ergänzung der »weicheren« Kompositionen von Brahms durch die »herben« Zeichnungen Klingers hingewiesen. Das ›Schicksalslied‹ kam dabei besonders günstig zur Wirkung, während die fünf Solo-Lieder durch ein Zuviel der Zeichnungen beeinträchtigt wurden. Als musikalische Ergänzung zu dem Prometheus-Zyklus verwendete man damals die ›Tragische Ouvertüre‹ von Brahms, deren Verlauf sich hierfür besonders eignete. Bei dieser Gelegenheit sei ein anderes Lieblingsstück Klingers erwähnt, das Adagio affettuoso der zweiten Sonate für Cello und Klavier (op. 99), das sich als musikalische Ergänzung für diese Blätter ebenfalls gut eignen würde, z. B. zur ›Nacht‹ (Nr. 16) oder ›Befreiung‹ (Nr. 18)[18]. Es sind die Elemente der Klage, des titanischen Ringens wie der tröstenden Hoffnung, die sich auch in diesem Satz von Brahms finden.

Brahms war so begeistert von der ihm gewidmeten Phantasie, daß er Klinger in Leipzig besuchte, was Klinger durch einen Gegenbesuch in Wien 1894 beantwortete. Brahms hatte schlechte Erinnerungen an Leipzig, wo sein erstes Klavierkonzert 1859 im Gewandhaus durchgefallen war und wo Brahms auch später schlechte Kritiken erhielt, auch mit den

16 Siegfried Kross, Die Chorwerke von Johannes Brahms (Berlin 1958), pp. 313/314.

17 Josef Strzygowski, ›Klingers Brahmsphantasie in öffentlicher Vorführung‹, in: Die Kunst für Alle 31 (1916), pp. 214–223.

18 Kalbeck (Fußnote 10), vol. 4/1, p. 34.

Musikverlegern scheint er schlechte Erfahrungen gemacht zu haben. Jedenfalls schrieb Brahms an Klinger, als dieser ihn zu einem erneuten Besuch in Leipzig-Plagwitz aufforderte, er würde ja gern in Klingers Atelier in die Karl Heinestraße 6 kommen, »wenn nur Leipzig nicht gar so ein schlimmes Anhängsel an Plagwitz wäre« (Brief vom 18. Oktober 1894)[19]. Durch Klingers Werke erhielt Brahms offenbar Anregungen für seine vorletzte Komposition ›Vier ernste Gesänge‹ (op. 121), die er Klinger gewidmet hat. Brahms schrieb in einem Begleitbrief an Klinger: »Ich habe Ihrer oft dabei gedacht und wie tief Sie die großen, gedankenschweren Worte ergreifen möchten. Auch wenn Sie ein Bibelleser sind, werden sie Ihnen wohl unerwartet kommen, mit Musik aber jedenfalls« (23. Juni 1896)[20]. Die krasse Realistik in der Darstellung des Todes, wie sie in den ersten beiden dieser Lieder zum Ausdruck kommt, entsprach manchen Darstellungen Klingers in seiner ersten Folge ›Vom Tode‹ (1889). Hier erscheint jedoch auch ›Der Tod als Heiland‹ (*Fig. 20*)[21], wie er in dem Zyklus von Brahms geschildert wird. Klinger stützte sich auf einen Text von Moses Mendelssohn (aus dessen Schrift ›Phädon‹), den er zitierte: »Wir fliehn die Form des Todes, nicht den Tod.« Der Tod erscheint hier wie ein Engel mit einem Palmzweig und wird von einem knienden Menschen verehrt, während die anderen vor ihm flüchten. Bald danach starb Brahms im Jahre 1897, und nun schuf Klinger eine zweite Folge ›Vom Tode‹, die 1898 erschien – hier sind bekannte Blätter wie ›Krieg‹, ›Pest‹, ›Elend‹ zu finden. In dem verworfenen Blatt ›Genie‹ sitzt ein Künstler vor einem Flügel und hält einer vor ihm liegenden sterbenden Frau, die wohl den »Erfolg« symbolisiert, die Augen zu – rechts seitlich sieht man Prometheus, den der Adler des Zeus zerfleischt; weiter befindet sich hier auch das optimistische Blatt ›Und doch‹[22]. Damit knüpfte Klinger an die Bejahung des Todes bei Brahms an, wie sie z. B. in den letzten beiden der ›Vier ernsten Gesänge‹ zum Ausdruck kommt: »O Tod, wie wohl bist du« und »Wenn ich mit Menschen- und mit Engelszungen redete und hätte der Liebe nicht«. Man darf fast mit Sicherheit annehmen, daß hier eine mehrfache Wechselwirkung zwischen Komponist und bildendem Künstler stattgefunden hat, wie sie in der Musik- und auch in der Kunstgeschichte nicht häufig zu finden ist.

Außer den Graphiken ist eine Reihe von Plastiken Klingers zu nennen, die musikalischen Persönlichkeiten gewidmet sind. Am bekanntesten ist sein ›Beethoven‹, dessen erster Entwurf in Paris 1885 entstand und Klinger »am Klavier« kam (*Fig. 21*). In Paris wirkte gleichzeitig Auguste Rodin, mit dem Klinger später bekannt war, es liegt nahe, dessen Einfluß hier schon anzunehmen, wenn Klinger diesen für seinen ›Beethoven‹ auch abstritt, indem er behauptete, das in Betracht kommende Werk Rodins ›Der Denker‹ habe 1885 noch gar nicht existiert. Tatsächlich hatte Rodin aber bereits 1880 den ersten Entwurf dazu fertig, der in französischen Kunstzeitschriften auch veröffentlicht wurde. Auf beiden Werken ist der in Gedanken versunkene geistige Mensch als nackte Männergestalt dargestellt, Rodin hatte anfangs ein Porträt Dantes gegeben, der an einem Höllentor über die Grausamkeiten des Lebens grübelt. Die gespannte Energie eines vornübergebeugten Mannes ist bei beiden zu finden, wenn Rodin den Körper desselben auch viel mehr durcharbeitete, die gespannten Muskeln lassen die Anstrengung dieses Denkens erkennen. Klinger legte mehr Wert auf die Ausführung durch verschiedenfarbigen Marmor sowie auf die Beigabe eines Adlers, des Symbols der Macht des antiken Zeus und einen Thron, auf dem weitere

19 Brahms. Briefe an Max Klinger (Leipzig 1924), p. 9.
20 Kalbeck (Fußnote 10), vol. 4/2, p. 443.
21 Singer (Fußnote 15), Nr. 180.
22 Singer (Fußnote 15), Nr. 245 und 237.

Darstellungen zu finden sind[23]. Klinger gab das Bild des großen schöpferischen Künstlers nach dem Vorbild einer nur durch Beschreibungen bekannten antiken Zeus-Statue des Phidias[24]. Klinger zeigte hier einen Künstler wie einen Gott, den göttlichen Künstler – eine typisch romantische Anschauung. Besonders Beethoven wurde bereits im 19. Jahrhundert nicht nur als Naturkind und als Revolutionär, sondern auch als Zauberer und Priester aufgefaßt, Richard Wagner betonte dagegen das Heldische[25]. Diese Auffassungen wurden von Klinger aufgegriffen, er wollte diesen Beethoven wie ein Kultbild in einem besonderen Raum aufgestellt wissen, was ihm dann auch in Leipzig, im ehemaligen Museum, gelang. Neuartig war der Verzicht auf Musikinstrumente und musizierende Engel, Klinger gab nur die Gestalt des Komponisten, einige kleine Engelsköpfe im Hintergrund.

Durch die Verwendung verschiedenfarbigen Marmors erzielte Klinger die Wirkung der farbigen Bemalung der Plastik, wie sie von Archäologen bei antiken Bildwerken nachgewiesen wurde. Auch der Thron, auf dem Beethoven sitzt, ist aus verschiedenen Metallen zusammengesetzt – dieser Thron wurde bei einer der wenigen Firmen, die damals so etwas technisch in einem einzigen Guß herstellen konnten, in Paris 1901 in einer einzigen Nacht gegossen. Klinger hatte dies jedoch dort im Laufe eines halben Jahres vorbereitet und eine Wachsform geschaffen, welche beim Guß verbrennen mußte – es war das alte Verfahren der verlorenen Form. Elsa Asenijeff hat dies in allen Einzelheiten in ihrem Buch ›Max Klingers Beethoven‹ (Leipzig 1902) beschrieben und vieles abgebildet. Daß durch dieses Verfahren manche Einzelheiten verschiedenartig herauskamen, beweisen die verschiedenen Abbildungen etwa der Rückseite dieses Throns, auf dem oben die Kreuzigung Christi und unten die Geburt der Venus dargestellt sind – dazwischen die Figur des Johannes, der auf die Venus zeigt, die hier wohl als die Schuldige oder Rettende (?) dargestellt wird (*Fig. 22*). Auf den Seitenteilen des Throns ist der Sündenfall wiedergegeben. Diese Szenen haben eigentlich nichts direkt mit Beethoven zu tun, Klinger gab hier elementare Gegebenheiten, die er in der Musik Beethovens zu finden glaubte. Das Werk wurde nach einer Ausstellung in Wien[26] von Klinger für 250 000 Mark an die Stadt Leipzig verkauft. Klinger stellte

23 Werner Hofmann, Art in the Nineteenth Century (London 1960), pp. 251/252, geht kurz auf den Effekt von Klingers ursprünglich verwendeten Materialien in dieser Skulptur ein und hebt die Bedeutung des ursprünglichen Ausstellungsraums für das Werk selbst hervor (siehe pp. 251f.). Gert von der Osten, Plastik des 19. Jahrhunderts in Deutschland, Österreich und der Schweiz (Königstein i. T. 1961), p. 16, weist auf die Analogie der Verwendung verschiedenfarbigen Marmors und Metalls zu der klassizistischen Praxis der Skulpturbemalung hin und erwähnt als Beispiele Klinger und Arthur Volkmann. Für eine ausführliche Diskussion von Klingers Anwendung der beiden Techniken siehe Georg Treu, Max Klinger als Bildhauer (Leipzig – Berlin 1900), pp. 8ff.

24 Direkte Frontalansichten von thronenden Gottheiten oder Königen sind auch vor Klinger eine typische (neoklassische) Erscheinung. Nach Agnes Mongan, ›Ingres and the Antique‹, in: Journal of the Warburg and Courtauld Institutes 10 (1947), pp. 1-13, wurde das Bild von John Flaxman nach Anne-Claude-Philippe De Caylus, Recueil d'Antiquités (1752ff.) kopiert. Ingres erfuhr davon durch Flaxman und benützte den Typus in seinen Werken ›Jupiter und Thetis‹, ›Die Apotheose Homers‹ und ›Napoleon I auf seinem kaiserlichen Thron‹. Dieselbe Idee findet sich auch in Horatio Greenoughs Statue von George Washington (1832–1841), siehe Robert Rosenblum, Jean-Auguste-Dominique Ingres (New York s. d.), p. 68.

25 Arnold Schmitz, Das romantische Beethovenbild (Berlin – Bonn 1927), pp. 1–14.

26 Im Jahre 1902 veranstaltete die Wiener Sezession eine Ausstellung mit Klingers ›Beethoven‹ im Zentrum der Galerie. Alma Mahler-Werfel beschreibt das Ereignis folgendermaßen (Gustav Mahler, Erinnerungen und Briefe [Amsterdam 1940] p. 49): »Im Mai 1902 rüstete man in der Sezession zu einer intimen Feier für Max Klinger. Die Maler der Sezession hatten in der selbstlosesten Weise Fresken an die Wand gemalt, von denen nur die von Gustav Klimt gerettet wurden. Man hat sie mit ungeheuren Kosten von der Wand abgelöst. Alle Wände waren also geschmückt mit allegorischen Fresken, die sich auf Beethoven bezogen, und in der Mitte sollte zum ersten Mal das Beethoven-Denkmal von Max Klinger zur Auf- und Ausstellung gelangen. Da kam Moll mit der Bitte zu Mahler, bei dieser Eröffnung zu dirigieren, und er hat diese Idee liebevoll ausgeführt. Er setzte den Chor aus der Neunten: ›Ihr stürzt nieder Millionen? . . .‹ für Bläser allein, studierte es mit den Bläsern der Hofoper ein und dirigierte den Chor, der, auf

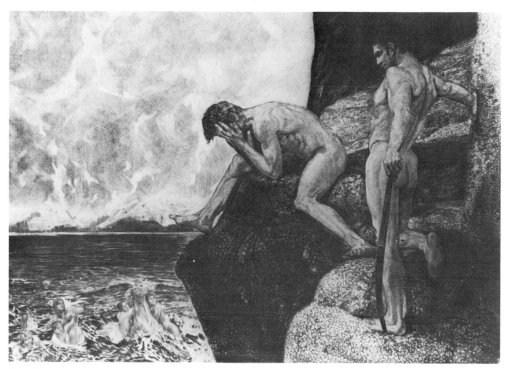

Fig. 18

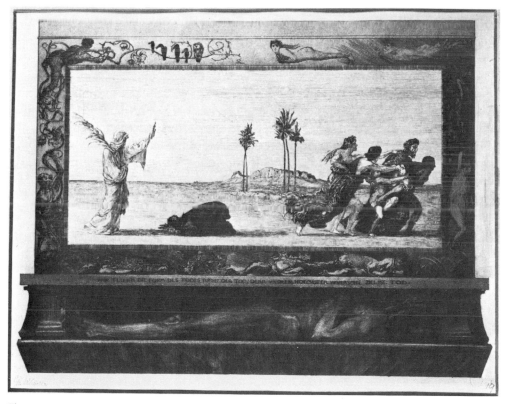

Fig. 20

davon 50000 Mark für den Bau eines neuen Seitenflügels des Museums zur Verfügung, in dem sein ›Beethoven‹ und andere seiner Werke aufgestellt wurden. Dieser Bau wurde im Kriege zerstört; der ›Beethoven‹ ist jedoch erhalten und befindet sich im heutigen Gebäude des Museums der bildenden Künste am Dimitroff-Platz zu Leipzig. Etwa gleichzeitig mit Klinger schuf der französische Bildhauer Emile-Antoine Bourdelle mehrere Beethoven-Plastiken, die schlichter gehalten sind und den Einfluß Rodins noch deutlicher erkennen lassen. In Deutschland wurde Klingers ›Beethoven‹ aber kaum übertroffen, auch später nicht von Georg Kolbe 1927[27].

Zuletzt seien die Denkmäler Klingers für Richard Wagner und für Johannes Brahms erwähnt. Das Wagner-Denkmal war im Jahre 1904 in Auftrag für Leipzig gegeben worden, es wurde jedoch nie vollständig aufgestellt. Die Geschichte dieses Wagner-Denkmals ist kein Ruhmesblatt für Leipzig, denn Klinger hatte seine Entwürfe fertig und diese mehrfach umgeändert (*Fig. 23*; vgl. den Bericht von Johannes Hartmann vom Jahre 1928 im Anhang I). Der erste Entwurf zeigte Wagner »ohne theatralische Pose«, wie Elsa Asenijeff schrieb[28], auf einem einfachen Podest mit wenigen großen Stufen, Wagner in einen Mantel gehüllt in ganzer Gestalt. Das Schwergewicht war auf den Kopf gelegt worden. In einem zweiten Entwurf (*Fig. 24*) wurde diese Figur Wagners auf ein hohes Postament gestellt, dessen Seiten mit Szenen aus Wagners Opern versehen wurden: Siegfried mit dem getöteten Drachen und mit dem Kopf und Händen Mimes, die aus dem Marmor herausragen – eine sehr originelle Lösung, sowie den zusammengesunkenen Parsifal mit Kundry. Auf der Vorderseite sind »Die drei Künste« dargestellt (*Fig. 25*). Es handelt sich um einen weit über 2 m hohen Marmorblock, dessen Beschaffung aus Italien durch den Ersten Weltkrieg verzögert wurde. 1920 starb Klinger, so daß dieses Postament erst 1924 in Leipzig in dem ihm gewidmeten »Klingerhain« ohne die Figur Wagners aufgestellt werden konnte, wo er sich heute noch befindet (leider ohne jede Bezeichnung)[29]. Klinger war kein Verehrer Wagners, was sich zweifellos ebenfalls hinderlich auswirkte. Klinger schrieb anläßlich der Einhundert-Jahrfeier von Wagners Geburtstag am 23. Mai 1913 an seinen Leipziger Freund Hirzel über eine ›Meistersinger‹-Aufführung in der Leipziger Oper: »Die letzte Stunde habe ich mich gewunden mit innerlichen und äußerlichen Schmerzen. Du kennst ja das. Man ist völlig an Aufnahmefähigkeit erschöpft und dann rinnt es noch eine Stunde an einem runter wie bei einer Regentonne – da helfen nur einige Glas Bier und das so schöne Schimpfen.« Klinger verglich dann die ›Meistersinger‹ mit einem »modernen Renaissance-Bierpalast«[30].

Klinger stand mehr auf der Seite der geistigen Ideale Beethovens und von Brahms. Deswegen kam die Ausführung eines bestellten Brahms-Denkmals für Hamburg Klinger mehr entgegen, es wurde 1909 dort aufgestellt und ist heute noch erhalten (*Fig. 26*). Brahms wird hier wie Wagner in ganzer Gestalt in einen Mantel gehüllt gezeigt, neben ihm eine Muse, darunter lauschende Menschen, die sich um ihn schlingen. Als Vorbild kommt die Balzac-Statue Rodins aus dem Jahre 1897 in Betracht, deren Neuartigkeit und elementare Einfachheit allerdings von Klinger nicht erreicht wurde. Während Rodins Statue wegen mangelnder Porträtähnlichkeit in Frankreich sogar von dem Verband der Künstler abgelehnt wurde, ist Klingers Brahms absolut

solche Art uminstrumentiert, granitstark klang. Der scheue Klinger betrat den Saal. Wie angewurzelt blieb er stehen, als von oben her diese Klänge einsetzten. Er konnte sich vor Rührung nicht halten, und Tränen rannen ihm langsam über das Gesicht herab.« Klimts Fresken sind jetzt im neuen UNO-Stadtteil bei Wien zu sehen.

27 Adolf Schmoll gen. Eisenwerth, ›Zur Geschichte des Beethoven-Denkmals‹, in: Festschrift Joseph Müller-Blattau (Kassel 1966), p. 258.

28 Asenijeff (Fußnote 7), p. 314, wo die erste Fassung dieses Wagner-Denkmals abgebildet ist.

29 Cf. Susanne Heiland in: Max Klinger 1857–1920. Ausstellungskatalog. Leipzig, Museum der bildenden Künste (1970), pp. 59–61.

30 Singer (Fußnote 5), p. 199.

Fig. 21

Fig. 22

porträtähnlich, offenbar nach Photos gemacht, wie auch auf einem zweiten – nicht ausgeführten – Brahms-Denkmal für Wien (*Fig. 27*), auf dem Brahms in einem kleinen antiken Tempel sitzt[31].

Ergänzend seien Klingers Porträt-Plastiken von Liszt (*Fig. 28*) und Wagner für eine Ausstellung in Saint Louis erwähnt, ferner eine Kreidezeichnung von Max Reger auf dem Totenbett (*Fig. 29*) sowie der Porträtkopf von Richard Strauss (*Fig. 30*). Dieser war zweimal im Atelier von Klinger, 1910 und 1915, wobei er ihm »zwei Akte aus seiner neuen Oper« (›Die Frau ohne Schatten‹?) vorspielte. Klinger hat berichtet, daß der Gesichtsausdruck von Strauss sich beim Klavierspiel völlig veränderte, seine sonst etwas nüchtern-sachliche Miene wich einem heiter-verklärten, fast spöttischen Lächeln, Ausdruck des schöpferischen Menschen. Diesen hat Klinger großartig getroffen. So ist dieses Porträt von Richard Strauss eines der wertvollsten Komponisten-Porträts neuerer Zeit, ein Dokument, das nach dem Leben gestaltet wurde (vgl. Anhang II). Die Einflüsse der Musik auf Klinger beschränkten sich auf die Graphik und auf die Plastik, die Anwendung musikalischer Wirkungen durch die Farbe blieb Klinger versagt. Sie spielte in der Entwicklung der neueren Malerei jedoch ebenfalls eine entscheidende Rolle, die zu Klingers Zeit von Whistler, Gauguin, dem litauischen Maler Mikalojus Konstantinas Čiurlionis und dem in Paris lebenden Tschechen František Kupka, auch von Luigi Russolo 1911 (›La Musica‹) und von Kandinsky um 1910 weitergeführt wurde und der abstrakten Malerei

31 Ludwig Hevesi, ›Max Klingers Entwurf zu einem Brahmsdenkmal‹, in: Zeitschrift für bildende Kunst Neue Folge 38 (1927), pp. 236–238; ferner A. (= Ferdinand Avenarius), ›Klingers Brahmsdenkmal‹, in: Kunstwart 22/2 (1909), pp. 355–357 und p. 374.

Fig. 23

wesentliche Wege wies[32]. Die Fülle des historischen Wissens, der klassischen Bildung wurde für Klinger vielleicht manchmal zur Fessel. Klinger blieb auf dem Boden des Naturalismus und Symbolismus des späten 19. Jahrhunderts. Die aktive und enge Beziehung, die er zur Musik hatte, läßt ihn jedoch als einen universell gebildeten, vielseitigen Künstler erscheinen, der als Ausdruck des gebildeten Bürgertums seiner Zeit zu gelten hat[33]. Klinger suchte die Ideale der Romantik mit denen eines geschärften Realismus zu verbinden, was zum Surrealismus führte. Es

32 Eingehende Nachweise hierfür gebe ich in dem noch unveröffentlichten Buch ›Das Musikalische in der Malerei des 19. und 20. Jahrhunderts‹, das im Manuskript abgeschlossen ist.

33 Cf. Maria Hogrebe, Max Klinger im Urteil seiner Zeit (Phil. Diss. Münster 1952). Hier wird eine gute Übersicht der Urteile über Klinger von seinen Zeitgenossen gegeben. Auch wird auf die Abwendung Klingers vom reinen Naturalismus, etwa von Adolph von Menzel, sowie auf seine Verbindung zum Bildungsgut der damaligen gebildeten Schichten in Deutschland hingewiesen. Wie neuartig manche Bilder auf die Zeitgenossen wirkten, mag man daraus ersehen, daß seine ›Urteil des Paris‹ und ›Die große Kreuzigung‹ bei ihrer ersten Ausstellung in München Empörung auslösten, die unbekleidete Figur Christi mußte mit einem Vorhang zugedeckt werden. Die von Klinger dargestellten Personen waren Menschen seiner eigenen Gegenwart und nicht historisierend gezeichnet, was damals völlig neuartig wirkte. In den Darstellungen von kontrastierendem Licht und Dunkel ging Klinger teilweise auf Illustrationen von Gustave Doré zu Dantes ›Göttlicher Komödie‹ zurück (etwa dessen ›Fegefeuer‹, XXV. Gesang); siehe Konrad Farner, Gustave Doré der industrialisierte Romantiker (Dresden 1963), vol. 2, Tafel 83. Das heroische Pathos des Doré wurde dabei von Klinger durch größeren Realismus ersetzt. Wegen der von Klinger dargestellten Nachtseiten des Lebens wurde er von dem Münchner Kunstkritiker Friedrich Pecht mit »Höllenbruegel« verglichen. Mehrfach wurde von der damaligen Kritik auf die geistige Unabhängigkeit Klingers hingewiesen, der ein eigenes Weltbild gestaltete, in dem trotz der Anerkennung von Schmerz und Leid immer wieder auch die Schönheiten der Welt zur Darstellung kamen. Der bekannte Dichter Christian Morgenstern hat ein Gedicht auf einen Studienkopf Klingers verfaßt, das beginnt:
 Du willst, o Welt, nicht, daß man dich verachte,
 nachdem man sich an dir zu Tod gehärmt.

waren nicht nur Antike und Christentum, sondern auch Symbolismus und Gesellschaftskritik, die er miteinander zu vereinigen wußte. Hierbei kam ihm die Abkehr von der äußerlichen Historienmalerei seiner Zeit wie von einem formalen Klassizismus zustatten. Durch die Musik wurde er zu einer geistigen und verinnerlichten Auffassung der Kunst geführt, die auch für unsere Zeit vielleicht manche wertvolle Anregung vermitteln kann.

Anhang I

Die Geschichte des Leipziger Richard Wagner-Denkmals

Zum 75. Geburtstage Max Klingers von Prof. Johannes Hartmann, Leipzig

Aus: Leipziger Neueste Nachrichten (18. Februar 1928).

Die Geschichte des Leipziger Richard Wagner-Denkmals umfaßt einen Zeitraum von 45 Jahren. Die Vorgänge dieser Angelegenheit in einem Zeitungsartikel zu schildern, würde einen sehr großen Raum beanspruchen, ich beschränke mich deshalb darauf, nur die einzelnen Daten in Form eines Grundrisses aufzuführen.

1883. Richard Wagner stirbt. In Leipzig bildet sich ein Ausschuß zur Errichtung eines Richard Wagner-Denkmals, der in mühevoller Sammeltätigkeit 85000 Mark zusammenbringt.

1890. Verschiedene Denkmalsentwürfe deutscher Künstler werden dem Ausschuß vorgelegt, aber als nicht geeignet abgelehnt.

1903. Der verstorbene Oberbürgermeister Dr. Tröndlin kommt auf die glänzende Idee, dem größten in Leipzig geborenen Tonkünstler Richard Wagner durch den größten in Leipzig geborenen bildenden Künstler Max Klinger ein Denkmal errichten zu lassen.

1904. Der Denkmalsausschuß beauftragt Max Klinger mit der Herstellung des Denkmals.

1904–05. Max Klinger fertigt die Wagnerstatue, die eine Größe von 4 1/2 m erhalten soll, in halber Größe an. Er will die Figur auf einen bühnenartig wirkenden niedrigen Sockel stellen, zu dem drei Stufen hinaufführen. Das Denkmal soll am Alten Theater, in der Nähe von Wagners Geburtshause, aufgestellt werden. Der Entwurf wird vom Ausschuß genehmigt und Klinger bestellt den dazu nötigen Marmor in Laas (Italien).

1905. Der Marmor wird im Bruch gewonnen. Bei einer genauen Besichtigung des Blockes durch Klinger wird der Stein verworfen, weil er mehrere Fehler aufweist.

1906–07. Klinger revidiert seinen Denkmalsplan und findet, daß der in Aussicht genommene Platz ihm nicht mehr gefällt. Er sucht nach anderen Plätzen und kommt auf den Gedanken, sein Denkmal am Matthäikirchhofe in Verbindung mit einer Treppe aufzubauen. Er legt dem Ausschuß seine neuen Pläne vor. Klinger projektierte auf der Treppe einen Riesensockel, der mit drei Reliefs geschmückt wird. Auf der Vorderseite sollten die »Drei Künste« dargestellt werden, für die beiden Seiten waren »Parsifal und Kundry« und »Siegfried mit dem Drachen und Mime« gedacht. Die Wagnerfigur sollte statt 4 1/2 m 5,30 hoch werden, also 15 cm höher wie der berühmte David des Michelangelo. Trotzdem die Kosten für das Denkmal mehr als das Doppelte des ersten Entwurfes betrugen, geht der verständnisvolle Ausschuß in Verbindung mit dem Rat der Stadt auf den neuen Plan ein.

1908/09. Klinger arbeitet am Aulabild für die Universität und kommt infolgedessen für zwei Jahre nicht dazu, sich mit dem Denkmal zu beschäftigen.

1910–11. Klinger wartet mit den Arbeiten, weil ihm bis dahin keine Garantien gegeben wurden wegen der Deckung der Herstellungskosten.

1912. Unter Hinweis auf den 100. Geburtstag Wagners wird Klinger gebeten, die Denkmalsarbeiten unverzüglich in Angriff zu nehmen. Es wird ihm versprochen, das fehlende Geld aus städtischen Mitteln zu beschaffen! Klinger bestellt neue Marmorblöcke in Laas und beginnt mit der Ausführung der schönen Sockelreliefs.

Fig. 24 Fig. 25

1913. Feierliche Grundsteinlegung an der inzwischen vom Rate gebauten Treppenanlage am Matthäikirch-hof. Bald darauf Abtransport der Modelle zum Sockel nach Laas. Unterdessen fertigt Klinger die Kopfstudie zur Wagnerfigur an. Ein von der Witwe Klingers gestifteter Bronzeabguß befindet sich im Städtischen Museum (*Fig. 23*). In derselben Zeit erfolgt die Ausführung der endgültigen Wagnerfigur im Maßstab 1:5, die nur wenige Abänderungen zeigt im Vergleiche zu der im Jahre 1904–05 geschaffenen großen Statue.

1914. Sämtliche Modelle zum Denkmal sind fertig, bis auf die Wagnerfigur, die noch in einem endgültigen großen Modell in halber Größe wiederholt werden soll. Die Punktierarbeiten in Laas sind beendet und der Abtransport soll beginnen. Klinger, der jetzt erst die Arbeiten voll und ganz überschaut, reicht seinen Kostenanschlag ein, der eine Summe von 175 000 M vorsieht, ohne Aufstellung, Transporte usw. Der Denkmalsausschuß bittet den Rat, die Weiterarbeit an dem Denkmale zu übernehmen und die noch entstehenden Kosten im Betrage von 110 000 Mark aus städtischen Mitteln zu bewilligen.

1914–18. Weltkrieg. Der Sockel kann nicht abtransportiert werden. Alle Arbeiten am Denkmal ruhen. Es kommt auch zu keinem Vertrag zwischen dem Ausschuß und dem Künstler.

1918–20. Nachkriegszeit, Revolution. Es wird alles aufgeschoben bis zur Konsolidierung Deutschlands. Am 4. Juli 1920 erfolgt der Tod Klingers.

1922–23. Der Marmorlieferant in Laas, der von Klinger schon erhebliche Zahlungen erhalten hatte, bedrängt die Rechtsnachfolger Klingers um Bezahlung der Restsumme, bis er schließlich im Sommer 1923 mit Pfändung droht. Der um Zahlung gebetene Denkmalsausschuß erklärt, daß er sein Geld durch die Inflation verloren habe und nicht zahlen könne. Schließlich erfolgt die übereinstimmende Erklärung von Ausschuß und Stadt, daß das ganze Unternehmen infolge der Inflation zusammenbrechen müsse, und daß der Sockel zerschnitten werden solle, um aus dem Erlös des wertvollen Materials die Ansprüche des Gläubigers zu befriedigen.

1924. Die Rechtsnachfolger Klingers sind mit einer Zerstörung des schönen Werkes keinesfalls einverstanden und zahlen schließlich, um das Werk zu retten, die auf Lire gestellte Rechnung. Der 720 Zentner schwere Sockelblock lag in Laas auf einem inzwischen gekündigten Werkplatze, der geräumt werden mußte. Hilfsbereit sprang hier der Rat der Stadt ein und übernahm in dankenswerter Weise die Kosten für den Transport. Ende August 1924 traf der Sockel in Leipzig ein und wurde auf Anordnung des Rates im Klingerhain des Palmengartens aufgestellt. Dieser Gedanke war nicht glücklich, weil man Marmordenkmä-

142

ler nicht in Anlagen mit großen Bäumen der Feuchtigkeit wegen placieren darf. Viel richtiger und billiger wäre es gewesen, wenn der Sockel provisorisch vor der Treppenanlage des Denkmalsplatzes am Matthäikirchhofe Aufstellung gefunden hätte.

1927. Die Rechtsnachfolger Klingers erhalten von Geheimrat Wrba in Dresden ein Gutachten über die Klingerschen Leistungen am Denkmal, auf Grund dessen sie den Rat der Stadt ersuchen, den Sockel aus dem Nachlasse Klingers zu übernehmen. Verlangt wurde ein Teil des Klinger zustehenden Honorars für seine jahrelange Arbeit, nebst dem von den Rechtsnachfolgern verlegten (sic) Gelde für die Schlußrechnung des Marmorlieferanten.

1928. Völlig ablehnender Bescheid des Rates. Der Rat erklärt, Rechtsnachfolger des ehemaligen Denkmalsausschusses zu sein. Als solcher sei er berechtigt, die an Klinger bezahlten Vorschüsse zurückzufordern, und beschlagnahmt deshalb den Sockel solange, bis die à-Konto-Zahlungen von den Rechtsnachfolgern Klingers an den Rat zurückgezahlt seien. Dann könne der Sockel abgeholt werden. Im übrigen verwies der Rat auf den Klageweg.

1928, am 18. Februar, dem 71. Geburtstage Max Klingers, teilen die Rechtsnachfolger Klingers dem Rate der Stadt mit, daß sie es mit ihrem Empfinden nicht vereinbaren können, wenn der schöne, obgleich unvollendete Sockel schließlich anderen Zwecken zugeführt würde, als dem von Klinger bestimmten, d. h. wenn er in Zeitungen zum Verkauf ausgeboten werden müßte, und dann entweder als wertvolles Material zerschnitten oder von einer kunstsinnigeren anderen Stadtverwaltung des In- oder Auslandes übernommen und aufgestellt würde! Der seit Jahren im Palmengarten liegende Stein muß endlich entfernt werden, wenn er nicht größeren Schaden durch die Nässe der vielen umstehenden Bäume erleiden soll.

Ein Prozeß gegen den Rat würde zirka 2 Jahre dauern, während dieser Zeit kann der Sockel schon erheblich gelitten haben. Aus Sorge hierfür und im Interesse des Leipziger Richard Wagner-Denkmals geben die Rechtsnachfolger Klingers den Sockel frei mit der ausdrücklichen Bemerkung, daß, weil Klinger für seine jahrelangen Bemühungen keinerlei Honorar bekommen habe, sämtliche Modelle zum Denkmal Klingersches Eigentum, auch über die gesetzliche Schutzfrist hinaus, bleiben.

Da der Rat als Rechtsnachfolger des Denkmalsausschusses auch einige Geldmittel übernommen hat, so ist zu hoffen, daß der Sockel nunmehr bald aus dem Palmengarten entfernt wird.

Wenn man den Sockel der fehlenden Wagnerfigur wegen nicht auf der bestehenden Treppe anbringen will, so wäre zu erwägen, denselben in die Mitte des davor befindlichen Rondells zu placieren. Etwa in der Art wie das schöne Bürgermeister-Müller-Denkmal am Hauptbahnhofe.

(Sperrungen original)

Anhang II

Als Ergänzung sei hier angeführt, was Stefan Zweig über Richard Strauss geschrieben hat, mit welchem er anläßlich der Abfassung seines Textes zur Oper ›Die schweigsame Frau‹ oft zusammen war (›Die Welt von Gestern‹ [Stockholm ²1944], pp. 420–422):

Dieses »Arbeiten« ist bei Strauss ein ganz merkwürdiger Prozeß. Nichts vom Dämonischen, nichts von dem »Raptus« des Künstlers, nichts von jenen Depressionen und Desperationen, wie man sie aus Beethovens, aus Wagners Lebensbeschreibungen kennt. Strauss arbeitet sachlich und kühl, er komponiert – wie Johann Sebastian Bach, wie alle diese sublimen Handwerker ihrer Kunst – ruhig und regelmäßig. Um neun Uhr morgens setzt er sich an seinen Tisch und führt genau an der Stelle die Arbeit fort, wo er gestern zu komponieren aufgehört, regelmäßig mit Bleistift die erste Skizze schreibend, mit Tinte die Klavierpartitur, und so pausenlos weiter bis zwölf oder ein Uhr. Nachmittags spielt er Skat, überträgt zwei, drei Seiten in die Partitur und dirigiert allenfalls abends im Theater. Jede Art von Nervosität ist ihm fremd, bei Tag und bei Nacht ist sein Kunstintellekt immer gleich hell und klar. Wenn der Diener an die Tür klopft, um ihm den Frack zu bringen zum Dirigieren, steht er auf von der Arbeit, fährt ins Theater und dirigiert mit der gleichen Sicherheit und der gleichen Ruhe, wie er nachmittags Skat spielt, und die Inspiration setzt am nächsten Morgen genau an der gleichen Stelle wieder ein. Denn Strauss »kommandiert« nach Goethes Wort seine Einfälle; Kunst heißt für ihn Können und sogar Alles-Können, wie sein lustiges Wort bezeugt: »Was ein richtiger Musiker sein will, der muß auch eine Speiskarte komponieren können.« Schwierigkeiten

Fig. 26 Fig. 27

erschrecken ihn nicht, sondern machen seiner formenden Meisterschaft nur Spaß. Ich erinnere mich mit Vergnügen, wie seine kleinen blauen Augen funkelten, als er mir bei einer Stelle triumphierend sagte: »Da habe ich der Sängerin etwas aufzulösen gegeben! Die soll sich nur verflucht plagen, bis sie das herausbringt.« In solchen seltenen Sekunden, wo sein Auge auffunkelt, spürt man, daß etwas Dämonisches in diesem merkwürdigen Menschen tief verborgen liegt, der zuerst durch das Pünktliche, das Methodische, das Solide, das Handwerkliche, das scheinbar Nervenlose seiner Arbeitsweise einen ein wenig mißtrauisch macht, wie ja auch sein Gesicht zuerst eher banal wirkt mit seinen dicken kindlichen Wangen, der etwas gewöhnlichen Rundlichkeit der Züge und der nur zögernd zurückgewölbten Stirn. Aber ein Blick in seine Augen, diese hellen, blauen, stark strahlenden Augen, und sofort spürt man irgend eine besondere magische Kraft hinter dieser bürgerlichen Maske. Es sind vielleicht die wachsten Augen, die ich je bei einem Musiker gesehen, nicht dämonische, aber irgendwie hellsichtige, die Augen eines Mannes, der seine Aufgabe bis zum letzten Grunde erkannt.

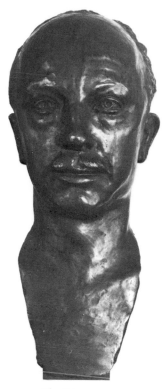

Fig. 28

Fig. 30

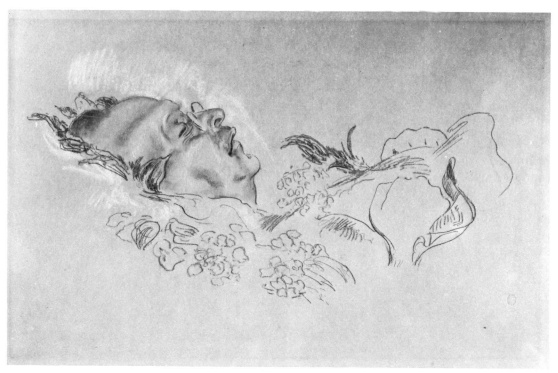

Fig. 29

The Cylinder Kithara in Etruria, Greece, and Anatolia*

Bo Lawergren

List of Illustrations

(Abbreviations: MMA = Metropolitan Museum of Art, New York; BM = British Museum, London; M. A. K. = Antikensammlungen, Munich; BF = Attic black-figure vase; RF = Attic red-figure vase; WG = Attic white-ground vase; CVA = Corpus Vasorum Antiquorum)

Fig. 1: Kithara patterned on a vase painting (red on black; made 1915 by H. Kent). See Schlesinger (footnote 1). – Photo: after Schlesinger

Fig. 2: Stone statuette (height of lyre: 28 cm.; Cypro-Egyptian, 570–540 B.C.). MMA. – Photo: Stewart Pollens

Fig. 3: Roman bronze statuette (height: 15 cm.). Hanover (Germany), Kestner Museum, inv. 3405. – Photo: Museum

Fig. 4: Roman marble statue ›Apollo of Cyrene‹. BM. – Photo: Author

Fig. 5: RF amphora (Berlin painter, 490 B.C.) MMA, 56.171.38. – Photo: Museum

Fig. 6: WF lekythos (Achilles painter, 460 B.C.). Stockholm National Museum, G 2107. – Photo: Author [see also fig. 15, A3]

Fig. 7: WF lekythos (Achilles painter, 460 B.C.). M. A. K. ex Schoen 80. – Photo: Author [see also fig. 15, A4]

Fig. 8: Relief on Cippus (height of lyre: 4 cm.; 480–475 B.C.). Chiusi, Museo Civico. – Photo: Author [see also fig. 15, C3]

Fig. 9: Stone sphinx (height of lyre: 10 cm.; 555–550 B.C.). Copenhagen, Ny Carlsbergs Glyptotek. See Poulsen (footnote 12). – Photo: Museum [see also fig. 15, C2]

Fig. 10: Terracotta tile from Aquarossa, Italy (height of lyre: 6 cm.). – Photo: after Arvid Andrén, Osservazioni sulle terracotte architettoniche Etrusco-Italiche (= Opuscula Romana 8 [1974]), pp. 1–16, fig. 53.

Fig. 11: Terracotta tile from Aquarossa. – Photo: after Andrén (as in fig. 10), fig. 54.

Fig. 12: RF fragment (ca. 390 B.C.). Tübingen, Archäologisches Institut der Universität, inv. 5485. – Photo: Museum

Fig. 13: Etruscan sarcophagus from Cerveteri (mid 5th century). The Vatican, Museo Etrusco Gregoriano. – Photo: Author

Fig. 14: Relief from Karatepe, Anatolia (ca. 700 B.C.). – Photo: after Kinsky (footnote 25)

Fig. 15: A 1: RF (bilingual) amphora (520–510 B.C.). Bologna, Museo Civico, Pell 151 (CVA 5 III, 1, pls. 95,1 and 96,5)

 A 2: BF amphora (510 B.C.). Oxford, Ashmolean Museum, 212 (CVA 2 III H, pl. 8,5)

 A 3: WF lekythos [same source as fig. 6]

 A 4: WF lekythos [same source as fig. 7]

 B 1: RF pelike (430 B.C.). M. A. K., 2363 (CVA 2, pls. 76,3 and 78,1)

 B 2: RF hydria. Naples, Museo Nazionale, 3232 inv. 81398. See Adolf Furtwängler and Karl Reichhold, Griechische Vasenmalerei, fig. 171 and p. 320, fig. 151.

 B 3: RF hydria. Berlin, F 2388. See Wilhelm Heinrich Roscher, Lexicon der griechischen und römischen Mythologie, vol. 2/2, fig. 2a.

 B 4: Wall painting. Tarquinia, Tomba dei Leopardi (490–470 B.C.)

 C 1: Wall painting. Tarquinia, Tomba della Nave (mid-5th century B.C.)

 C 2: Stone sphinx [same source as fig. 9]

 C 3: Relief on Cippus [same source as fig. 8]

* This study was made possible by a Clawson-Mills Fellowship at the Metropolitan Museum of Art, New York. Many valuable comments, in diverse fields, have been provided by Drs. Larissa Bonfante, Machteld I. Mellink, Lawrence E. R. Picken, Anthony M. Snodgrass, A. Dale Trendall, and Emanuel Winternitz.

C 4: Frieze on sarcophagus from Vulci, Italy (early 5th century B.C.). Boston, Museum of Fine Arts [see also figs. 16 and 17]

D 1: RF neck-amphora (Peleus painter, 440 B.C.). BM, E 271 (CVA 4 III Ic, pl. 11,1a and b) [see also fig. 19]

D 2: RF calyx-krater (Christie painter, 440–430 B.C.). Würzburg, Martin von Wagner Museum, 521. See Max Wegner, Griechenland (= Musikgeschichte in Bildern, vol. 2, fascicle 4 [Leipzig s. a.]), pl. 13, and Ernst Langlotz, Catalog, pl. 130

D 3: RF stamnos (Christie painter, 440–430 B.C.). Fogg Art Museum, Harvard University, 1925. 30. 42 (CVA Hoppin collection, pl. 16,3)

D 4: WG lekythos. Paris, Louvre, CA 612 [see also fig. 31]

E 1: RF skypos (475 B.C.). Schwerin, Landesmuseum, 708. See Wegner (as in fig. 15, D 2), pl. 16a, and CVA, pl. 26

E 2: WG pyxis (Hesiod painter, 460–450 B.C.). Boston, Museum of Fine Arts, 98. 887. See Wegner (as in fig. 15, D 2), pl. 56

E 3: A different lyre on fig. 15, E 2

F 1: BF vase. Orvieto, Museo Civico, 2670

F 2: RF oenochoe (Goluchow painter, 510 B.C.). M. A. K., 2446 (CVA 2, pl. 84,1)

F 3: BF amphora (Leagros group, 510 B.C.). M. A. K., 1416 (CVA 1, pl. 50)

F 4: RF vase (510–500 B.C.). M. A. K., 8935/8945

G 1: BF vase (late 6th century). Rhodes, Museo civico, 12.200 (CVA, pl. 19)

G 2: RF cup. BM, E 38. Epiktetos. See Furtwängler (as in fig. 15, B 2), pl. 73,2

G 3: RF column-krater (490–480 B.C.). Lecce, Museo Provinziale, 572 (CVA 1 III Ic, pl. 3)

G 4: RF cup fragment (480 B.C.). Oxford, Ashmolean museum (CVA 1 III I, pl. 14,10)

H 1: WG cup (Hesiod painter, 450 B.C.). Paris, Louvre, CA 482

H 2: RF pelike (Painter of Munich 2335, 430 B.C.). M. A. K., 2362 (CVA 2, pl. 76,3)

Figs. 16 and 17: Frieze on sarcophagus from Vulci [same source as fig. 15, C4]. – Photo: Boston, Museum of Fine Arts

Fig. 18: Cylinder kithara patterned on the instrument in fig. 15, A3; reconstruction by the author [see also fig. 29]. – Photo: Author

Fig. 19: Cylinder kithara patterned on the instrument in fig. 15, D1; reconstruction by the author. – Photo: Author

Fig. 20: Sudanese Kissar. MMA. – Photo: Author

Fig. 21: Burmese harp. MMA 271. – Photo: Author

Fig. 22: Gambian Kora. MMA. – Photo: Author

Fig. 23: Ethiopian Baganna. New York, Museum of Natural History [see also fig. 27]. – Photo: Author

Fig. 24: Lyra patterned on a fragmentary extant instrument in BM. – Photo: after Quennell (footnote 16)

Figs. 25 and 26: Egyptian lyre. – Photo: after William C. Hayes, Scepter of Egypt, vol. 2 (New York 1959), p. 24, fig. 9

Fig. 27: Ethiopian Baganna [same source as fig. 23]. – Photo: Author

Fig. 28: Chinese P'i-p'a. MMA. – Photo: Author

Fig. 29: Cylinder kithara (same model as fig. 18). – Photo: Author

Fig. 30: Hinge motion of arms

Fig. 31: WG lekythos [same source as fig. 15, D4]. – Photo: Paris, Louvre

Reproductions with the kind permission of the owners

* * *

This article will examine lyres that existed primarily between 600 and 400 B.C. in Greece and in some neighboring regions. From the evidence now available the three-dimensional shapes of the instruments in question and the functions of their parts can be evaluated. Earlier work on lyres has generally taken the opposite view: drawn spirals, notches, circles, and other designs

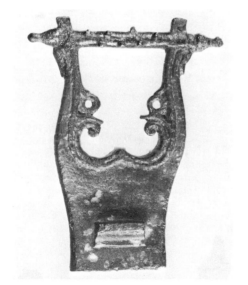

Fig. 1

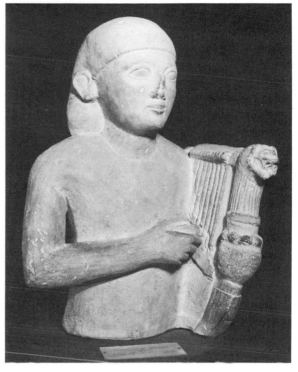

Fig. 2

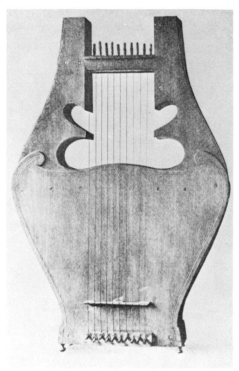

Fig. 3

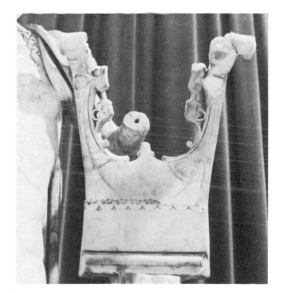

Fig. 4

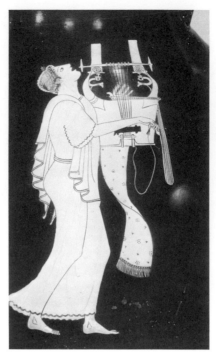

Fig. 5

seem to have been considered, a priori, to be merely decorations on the body (*fig. 1*).[1] We will here assume that these parts have acoustic functions; only when no function can be found for them will the parts be considered ornamental. Moreover, illustrations of instruments appearing on vase paintings from classical Greece show structures that are more complex than the plucked stringed instruments we are familiar with in concerts, in museums, or in iconographic evidence produced during the Christian era. Drawn details suggest hinges, springs, and other movable parts. Such movable instruments stand in strong contrast to our rigid instruments (lyres, violins, guitars, for example). In the absence of surviving specimens[2] I shall resort to reconstructions

1 Kathleen Schlesinger, The Greek Aulos (London 1939), pl. 15. As regards organological terminology we use the following definitions: lyre is a generic term for all types of instruments with a body, two arms and a yoke where the strings stretch between the yoke and the body in a plane parallel to the front of the body; kithara is a large lyre with straight arms and a large wooden body; lyra is a lyre with a body usually made of a tortoise carapace covered with skin and with horn-shaped arms, see Sibyl Marcuse, A Survey of Musical Instruments (New York 1975), pp. 358–365.

2 Fragments of two instruments (both lyras) have survived. The best preserved, in the British Museum, is very similar to paintings and reliefs (the so-called »Boston Throne«, see William J. Young and Bernard Ashmole, ›The Boston relief and the Ludovici Throne‹, in: Bulletin of the Fine Arts Museum, Boston 66 [1968], pp. 124–166). Judging from the heavy construction seen in vase paintings, lyras were rigid instruments. The BM instrument confirms this. The very fact that few string instruments have survived shows, of course, that the major parts were made of perishable materials (under normal soil conditions). When these instruments were made thin metal strings were unavailable and strings had to be made from animal or vegetable matter. Vibrating strings, regardless of their constitution, make little sound on their own. Early man would have discovered that louder sounds were produced if the string somehow was put in contact with larger (but light) objects such as wood plates, gourds, stretched hides. It would have been evident that heavy objects such as stone and metal are poor sound amplifiers. For this reason it is prudent to remain skeptical when stone objects are claimed to be string instruments; at best such objects may be likenesses of string instruments. This point is illustrated by a hypothetical reconstruction in the drawing of a lyre in the Archeological Museum of Heraclion by Nikolaos Platon reported by Stylianos Alexiou in: Guide to the Archaeological Museum of Heraclion (Athens 1974), pp. 53 f.; see also Bernhard Aign, Die Geschichte der Musikinstrumente des ägäischen Raumes bis um 700 vor Christus (Phil. Diss. Universität Frankfurt am Main 1963), p. 82.

Fig. 7

Fig. 6

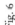

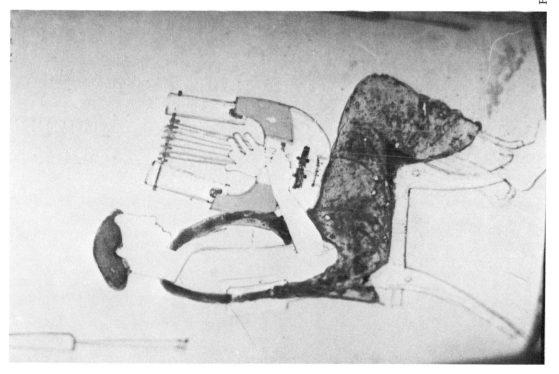

based on the most detailed vase paintings and the few reliefs available to us in order to explain the functions of these movable parts.

During the period of this study (600–400 B.C.) vase paintings, large reliefs, coins, seal rings, and other artifacts provide rich details which, on the whole, recur consistently. This is not the case prior to 600 B.C., where the few dozen surviving vase paintings of stringed instruments are quite rudimentary by comparison and the shapes vary markedly from picture to picture. After 400 B.C. and especially in the Hellenistic world instruments underwent change; some of the features that were originally functional now became nonfunctional and decorative. Given the character of the evidence for the early period, it is hazardous to extract from it such specific information as the shape or even the existence of a bridge, sound holes, dimensions, and any idiosyncratic details; and while it is possible to observe such general features as the flat shape of the lower end of the sound box, it is inadvisable to base theories about the origins of these very early instruments on evidence that does not offer enough specific detail to rule out plurigenesis.

Recent finds of ivory fragments of actual lyre arms and a sculpture in the Metropolitan Museum show more intricate structures in archaic instruments than were previously suspected on the evidence drawn from vase paintings. First Ohly and later Greifenhagen identified ivory statuettes as parts of the arms of lyres from about 650 B.C.[3] These identifications appeared rather tentative at the time, especially since they could not point to any pictures or sculptures of instruments that showed such elaborately sculpted arms. A sculpture from Cyprus, however, dated ca. 550 B.C. (*fig. 2*) has a lyre with at least one arm shaped like a lion with a deeply carved head near the yoke.[4] These examples seem sufficient proof for the existence of instruments adorned with figurines in the arms. Yet the fact that vase paintings in the Geometric and Protoattic style do not show such features further undermines our confidence in the evidence they provide.[5]

During the two centuries following 600 B.C. first the black-figure and then the red-figure Attic vases were perfected, and the draftsmanship became highly realistic,[6] detailed, and reliable. The plastic arts also gained in realism but unfortunately no free-standing Greek sculpture containing a lyre has come down to us. Many Roman copies of statues of Apollo have survived but they are useless to us as a source of information on Greek lyres. Evidently by the time the Roman copies were made the old lyres had died out and a new, simplified instrument had replaced them. The copyists apparently substituted the new instruments as shown in *figs. 3 and 4*.

> Such instruments have little in common with the Greek kitharas show in vase paintings and in reliefs. However, some of the peculiarities of the Greek kitharas such as the spring-, spiral-, and hinge-like features have been retained, greatly distorted and placed in odd positions. The surrealistic effect is further heightened by the decorative approach. It is possible that these instruments had already become mere symbols for the »classical« music.

3 Dieter Ohly, ›Zur Rekonstruktion des samischen Geräts mit dem Elfenbeinjüngling‹, in: Mitteilungen des Deutschen Archäologischen Instituts, Athenische Abteilung 74 (1959), pp. 48–55; Adolf Greifenhagen, ›Ein ostgriechisches Elfenbein‹, in: Jahrbuch der Berliner Museen, Neue Folge 7 (1965), pp. 125–155.

4 This instrument is evidently round-bottomed. Further conclusions must be drawn cautiously since many of the details are carved inconsistently. For example, the pegs above the strings on the yoke do not show on the back. The asymmetric back is unusual. If it is taken at face value, we must conclude that the ivory statuettes described by Ohly and Greifenhagen (footnote 3) may not necessarily have counterparts on the other lyre arm. Their suggested reconstructions may thus be wrong.

5 The zig-zag lines in Aign (footnote 2), pp. 62f., figs. 28 and 29, may provide a primitive attempt to render sculpted arms.

6 Still, accuracy varies from case to case. Most lyre pictures also show the player. The amount of realism in the depiction of human forms gives an idea about the accuracy in the lyre drawings.

Fig. 8

Fig. 9

Fig. 10

Fig. 11

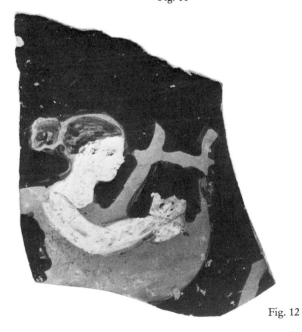

Fig. 12

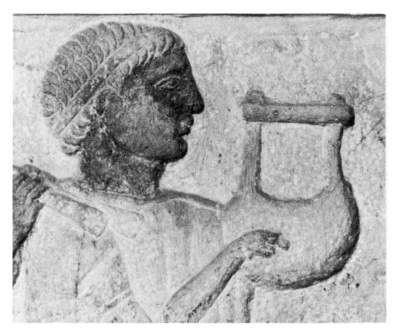

Fig. 13

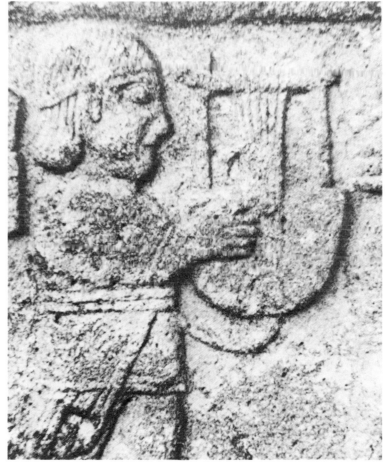

Fig. 14

Some reliefs have survived, however, and they give invaluable information on the three-dimensional structure of the instruments (little depth information can be obtained from vases; they mostly show the instruments en face). Seal rings and coins also carry valuable information about the topology of the instruments.

We shall examine here a kithara type which I should like to call the cylinder kithara. This instrument possesses a fairly elaborate structure. As it turns out, this structure seems to be nonfunctional. This is in contrast to the arm structure in concert kitharas (*fig. 5*), which is functional as will be described elsewhere.

The cylinder kithara

In gross outline all round-bottomed kitharas consist of more or less sickle-shaped bodies with long, straight arms protruding nearly parallel to each other at the points of the sickle and with a yoke across the distal ends of the arms.[7] Wegner named such an instrument a »Wiegenkithara«.[8] Closer study of the available pictorial material shows that this definition is too broad: two distinct groups of instruments are discernible. First, there is the instrument which will be called the cylinder kithara since it will be shown to have quasi-cylindrical structures, or parts thereof, located at the junctions of the arms and the body (*figs. 6–9*).

Figs. 8, 9, and 17 have accompanying line drawings to clarify the instruments. The parts are labeled 1=cylinders; 2=yoke; 3=body; 4=arms; 5=bridge; 6=left hand; 7=right hand; 8=string holder; 9=ribbon for left arm support of the instrument.

About two dozen vase paintings and a dozen reliefs of this instrument are known.[9] Second, there is an instrument, especially favored on (but not confined to) the Italian peninsula. It lacks the »cylinders« and, accordingly, the arms are smoothly and stiffly joined to the body. About half a dozen representations of that instrument are known and some are shown in *figs. 10–14*.

Fig. 15 shows most of the cylinder kitharas pictured by vases, reliefs, and wall paintings.[10]

In order to make the comparison meaningful, all instruments have been made the same height and redrawn. They have been »cleaned up« in the sense that obvious cracks, specks, and other damage to the pots have not been included. Lines that are likely to be straight and smooth, judging from the free-hand drawing, have been drawn straight and smooth by means of ruler and French curves. Asymmetries have been retained. Parts obscured by the player or by damage have been left out. Instruments C 2, C 3, and C 4 are taken from reliefs. The cross hatchings indicate elevation of the surface:

very high

high

low

very low

7 On the other hand, the concert kithara consisted of a more or less rectangular body with two long arms protruding and with the yoke crossing the arms near their junction to the body (*fig. 5*).
8 Max Wegner, Das Musikleben der Griechen (Berlin 1949), pp. 30–32. Wegner pointed out that the round-bottomed kithara was a fairly frequent subject on Attic vases and he named it the »Wiegenkithara«. He listed 26 vases and argued that the instrument was different from the earlier (6th and 7th centuries) round-bottomed phorminx because the »Wiegenkithara« had more strings than the phorminx. Such argument may be slight, but nevertheless it is prudent to abstain from generalizations based on vases painted before the Attic black-figure vases. In common with the only other writer on the subject, Maas (footnote 9), he believed that the »Wiegenkithara« was a local Attic phenomenon or, at least, only shown on Attic ware. Our table shows that this is a mistake.
9 For listings, see Wegner (footnote 8), p. 206 or Martha Maas, ›The Phorminx in Classical Greece‹, in: Journal of the American Musical Instrument Society 2 (1976), p. 54, see also our List of Illustrations at the beginning of this article.
10 Most of the Greek instruments were taken from Wegner (footnote 8).

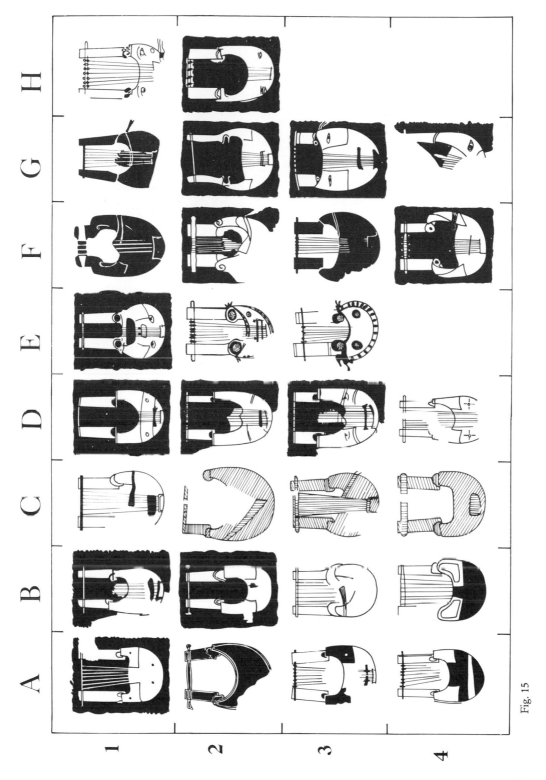

Fig. 15

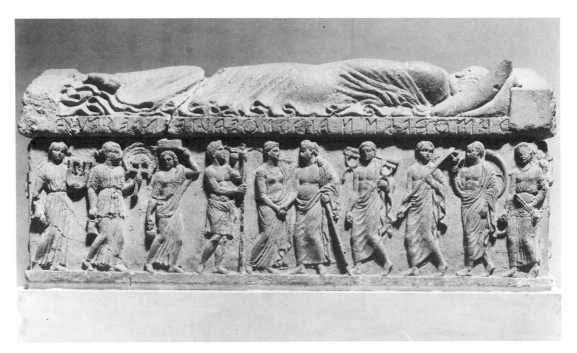

Fig. 16

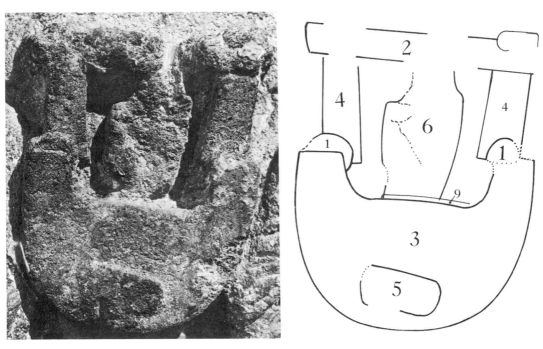

Fig. 17

The dotted fields in E 2 and E 3 indicate elevated surfaces produced by thick paint.

Each column contains cylinder kitharas with common features and the more common types are shown in the left columns. Vase pictures are kept together as are wall paintings and reliefs. The numbering system follows chronological sequences.

Since earlier studies [11] of this instrument relied only on the two-dimensional information on vase paintings, the (parts of) circles drawn at the shoulders could be interpreted either as indentations, protrusions, or merely as ornamental incisions in a smooth surface. Here crucial sculptural evidence is useful: a large number of relief sculptures have been found on Etruscan »cippi« (e.g. *fig. 8*) and on a sarcophagus from Vulci (*figs. 16, 17*); and a cylinder kithara is found on a free-standing sphinx from Anatolia shown in *fig. 9*.[12] The height of the relief is consistently shown as decreasing step-wise as one proceeds from the sickle-shaped body to the »circles« (one step down) and to the arms (two steps down). The height of the steps varies somewhat from relief to relief. The »circular« feature is thus an object with a nearly circular cross section. Its bluntly cut side protrudes above the level of the arm but may not quite reach the level of the body. For lack of a better word, the feature will henceforth be called a cylinder.

Typical reliefs are shown in the third column (C 2–4) of *fig. 15*. The details of the reliefs are so similar to those of the vases in the first and second columns (A 1–4, B 1–4) and the Etruscan wall paintings (B 4, C 1) that there can be no doubt that they represent one and the same instrument with the same idiosyncratic features at the shoulders. The slight differences in outline between the instruments in columns A, B, and C can probably be expected from hand-made instruments (and hand-painted vases). Of course, there is no proof that the morphology is the same for the flat pictures and for the reliefs but for reasons of scientific parsimony other interpretations are ruled out until indications of an alternative structure are found. As it turns out, most of the instruments in *fig. 15* can easily be interpreted as possessing such cylinders. (Cols. F, G, and H may or may not have such cylinders, however.)

Within the class of cylinder kitharas one can distinguish between several groups. In *fig. 15* the three left-most columns show instruments with complete circular cylinders which are partly covered by the sound box to allow attachment of the arms to the body. (Such an instrument is shown reconstructed in *fig. 18*). Col. D contains instruments where the cylinders have been halved along a diameter. The vase paintings show a narrow strip between the flat part of the half cylinder and the top of the sound box. Most likely this represents a shelf for the half cylinder as shown in the reconstruction in *fig. 19*. Col. E contains instruments with an unobstructed full circle. Instruments E 2–3 come from a white ground pyxis. The pictures of the lyres are minuscule (15 mm. high) but one clearly sees that the circles have been filled with unusually thick daubs of paint that protrude above the surface of the vase. In itself this protrusion does not prove that the circles are cylinders but the daubs look suspiciously like confirmations of the sculpted evidence. The right-most columns contain instruments where the simple, easily recognizable cylinder has been varied or disguised. The deviations are considerable in some cases but the general scheme with the arms joined to the body via rounded joints is nevertheless clear. Instruments F 4, G 3, and those of col. E resemble the instrument in Maas [13] (footnote 9, *fig. 7*) having very prominent cylinders.

Let us discuss the details of the instrument from top to bottom.

11 Wegner (footnote 8) and Maas (footnote 9).

12 Ekrem Akurgal, Die Kunst Anatoliens von Homer bis Alexander (Berlin 1961), pls. 226 and 228; Frederik Poulsen, ›Neuerworbene Griechische Grabdenkmäler in der Ny Carlsbergs Glyptotek‹, in: Acta Archaelogica (Copenhagen) 5 (1934), pp. 49–64, figs. 1–2, pl. I.

13 Maas (footnote 9), p. 34.

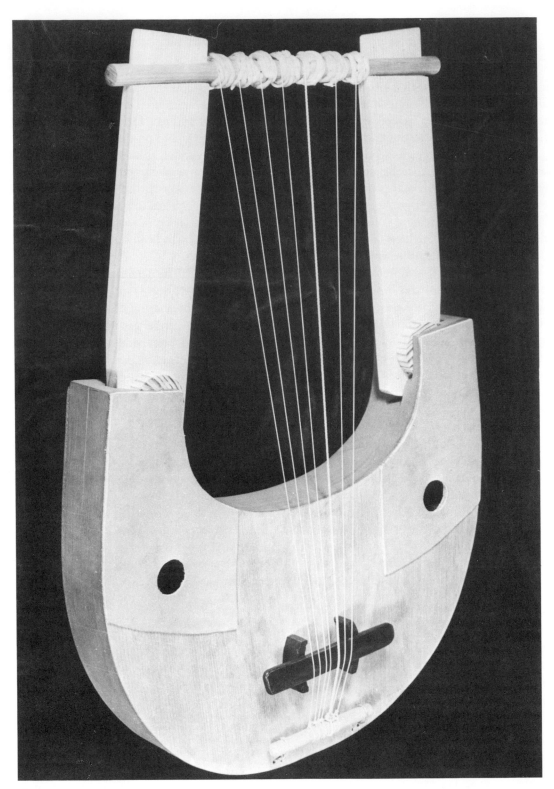

Fig. 18

Yoke and tuning collars

The string attachment at the yoke is of the same type as seen in the concert kithara: collars are wound around the yoke and a string is attached to each collar. The string is stretched by suitable rotation of the collar around the yoke. Since such tuning collars still exist in some contemporary instruments[14] (Burmese harps, Sudanese lyres, Gambian Koras, *figs. 20–22*), we know that this mechanism works. The yoke must have a circular cross section at the location of the collars, but it need not be circular everywhere: on the Baganna, an Ethiopian lyre tuned with modified collars (*fig. 23*), the yoke is square on either side of the locations of the collars.[15] In fact the few lyres surviving from antiquity all have circular yokes (*figs. 24–26*).[16]

> The collars on the cylinder kithara were probably most similar to the Kora's and the Kissar's. Tuning was probably accomplished by twisting the collar (as on the Kissar) and not through a sideways slide of the collar (as in the Kora). The Baganna has pegs inserted into the collars. There is no evidence for the use of pegs in cylinder kitharas. Later, during Roman times, pegs became popular on kitharas.

The larger the diameter of the yoke, the greater string tensions can be used since a large diameter gives a large surface that can exert (static) friction on the collar. A large collar is also easier to control in the tuning process since it provides a good grip for the hand. The interpretation of the iconographic evidence is supported by a passage in one of Aristotle's ›Mechanical Problems‹[17] which refers to this very mechanism: the tuning collars and the yoke.

The yoke must not, itself, be rotatable. On the lyra in the British Museum the yoke is fixed by having (i) two rectangular holes cut through the yoke, (ii) the arms shaped with the same rectangular cross section above the level where the yoke rests, and (iii) the arms inserted in the two holes of the yoke (*fig. 24*). While the picture correctly shows the arms and yoke of the extant lyre in the British Museum, the museum lyre lacks the front of the sound box and the drawing in the figure is certainly incorrect with regard to this front, the bridge and the tail piece.

A similar idea can be seen a thousand years earlier: in Egyptian lyres dowel pins were inserted into the yoke. (In *figs. 25* and *26*, the yoke has been separated from the body to show the construction.) The close-up picture (*fig. 26*) shows the dowels that prevent the yoke from turning. The pictures of the cylinder kithara seem to indicate that the arms and the yoke were joined through slots as seen in the reconstructions (*figs. 18–19*). Again, a sturdy construction (i.e., large yoke diameter) would allow high string tension.

Many of the instruments have seemingly narrow yokes (the exceptions are mainly the Etruscan instruments; *fig. 15*, B 4, C 3, C 4, and F 1, F 2 marred by comparatively poor draftsmanship) as compared to the majority of illustrated concert kitharas. This, if significant, suggests that the string tension was lower in the cylinder kithara than in the concert kithara.

14 First noticed by Karl von Jan, Die griechischen Saiteninstrumente (Leipzig 1882), p. 15, and later stressed by Curt Sachs in: The History of Musical Instruments (New York 1940), p. 130.

15 The sticks inserted into the collars can also be seen in lyres found at Ur, see Joan Rimmer, Ancient Musical Instruments of Western Asia . . . in the British Museum (London 1969), cover frontispiece and pls. I and II, and on Roman Kitharas, see Emanuel Winternitz, Musical Instruments and their Symbolism in Western Art (New Haven ²1979, Yale University Press), pls. 77b and 88a, b.

16 Marjorie and C. H. B. Quennell, Everyday Things in Archaic Greece (London 1931), fig. 62. The Metropolitan Museum of Art's Egyptian Art Department, Dr. Christine Lilyquist, private communication. Young and Ashmole (footnote 2), p. 124.

17 Aristotle, Mechanical Problems No. 13 (= Loeb Classical Library, Minor Works vol. 1 [1936]), pp. 366 and 368, gives: Διὰ τί ῥᾷον κινοῦνται περὶ τὸ αὐτὸ ζυγὸν οἱ μείζους τῶν ἐλαττόνων κόλλοπες (Why are larger collars [kollopes] easier to rotate round the yoke [zygon] than smaller ones?).

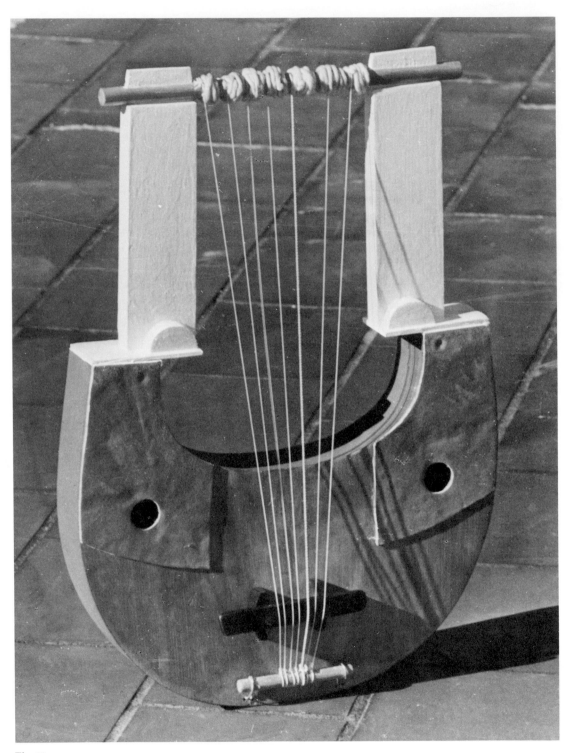

Fig. 19

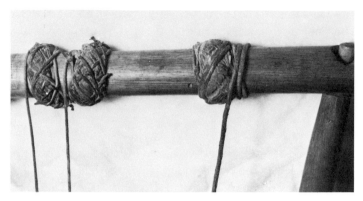

Fig. 20

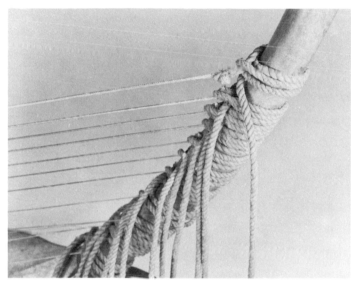

Fig. 21

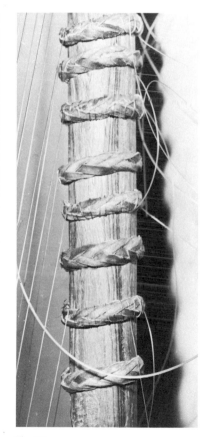

Fig. 22

Arms

Judging from the numerous cylinder kitharas on Etruscan »cippi« (*fig. 8*) and a sarcophagus (*figs. 16–17*) the arms were thin.[18] The tall, nearly rectangular shape was similar to the arms of the concert kithara. The yoke was attached at the upper end of the arms whereas in the concert kithara the yoke was attached at the lower end of the arms. This results in a different balance of forces in the two instruments. The joint between the arms and the body (i.e., the shoulder) must be strong enough to withstand the warping effect of the string tension.[19]

Shoulders

The shape of the »cylinders« varies somewhat from instrument to instrument; *fig. 15* speaks for itself on this matter. Whether the cross section is circular, ellipsoidal, egg-shaped, or some other shape is, of course, of secondary importance at this stage. The main point is that the Etruscan and the Anatolian reliefs show that the rounded form seen at the shoulder is, in fact, a massive object nearly cylindrical in shape and with bluntly cut sides.

To see how ambiguous the vase paintings can be, consider the two nearly identical instruments A 3/A 4. We notice that the same painter (the Achilles painter) could resort to inverted color schemes: in A 3 the circular form is left uncolored, thus suggesting a hole in the arm while in A 4 the circular form is filled in with red paint suggesting a nontransparent object (the background is white). Since it is hardly likely that such a consistently recurring feature on the kitharas could either be a hole or a protrusion, we can only conclude that the color scheme is an unreliable clue to the topography of the instrument in these white-ground lekythoi.

This insight helps us understand some troublesome vase pictures. For example, D 1 from a British Museum vase looks structurally unsound at a first glance: the semicircular black fields at the shoulders appear to be holes in the arms since the background is also black. In that case only two narrow points would have touched the body and this would have made for a flimsy structure at a junction which needs to be strong. The instrument, however, looks instead like that of *fig. 19* and here the required strength can easily be provided.

Another hitherto puzzling instrument[20] is E 1. The attachment of the arms to the body resembles that of E 2: the cylinders are stuck through large holes in the body and the arms.[21]

The instruments in cols. F, G, and H are drawn in such an ornamental or unclear way in the original vase painting that further examination is hardly warranted.

The implications of the elaborate shoulder construction will be examined later in this article.

18 The reliefs are cut so that the heights of adjacent surfaces can be judged unambiguously only near the borders between the surfaces. Away from the vicinity of the borders the surfaces tend to move up to a common level, namely the height of the uncut surface. This makes it difficult to estimate precisely the thickness of the arms but, certainly, they were thinner than the shoulders which, in turn, were thinner than the body.

19 To argue, as Maas (footnote 9), p. 44 does, that the instrument was bent forward at the shoulders is hazardous since it would require extremely strong joints at the shoulders in order to withstand the tension from the strings. The iconographic evidence does not show particularly massive shoulders, however.

20 This instrument is shown in an erroneous line drawing in Wegner (footnote 8, p. 30, fig. 2). The error makes the construction of the instrument unintelligible. Maas (footnote 9, p. 44) writes: »...the majority show(s) half or full circles at this point which may indicate openings ...«. The erroneous conclusion is caused by unfamiliarity with non-Attic iconography.

21 The central black field just above the bridge is still ambiguous. It could be a hole (which would make the upper contour of the body rounded similarly to instruments A 3 and A 4) with a unique narrow rib across the indented edge or it could be interpreted as a plate (maybe to protect the body from being scratched by the plectrum) which would make the upper contour of the body more flat similarly to instrument A 1.

Body

The outline of the body is sufficiently invariable in the instruments shown in *fig. 15* to make it reasonable to consider all the instruments as being of one and the same type (family). Yet within this family there is a fairly large amount of variation: the sixteen instruments in the left half of the figure (and possibly F 3, G 1, and H 2), which are quite similar, constitute the main type. The three instruments in col. E (especially E 2 and E 3) seem to form a distinct subgroup as do instruments F1 and F2. The sample of instruments in *fig. 15* is possibly too small to allow valid analysis but it seems that the main group by no means dominates the family. Perhaps as much as 30 percent of the sample consists of instruments with quite large deviations from the main type, which is in contrast to the concert kithara family where there are few deviants. (Instruments like Wegner's [footnote 8, p. 45] »Thamyris Kithara« can hardly be considered a variation of the concert kithara. It is an instrument in its own right. Whatever way it is viewed, there are few known Thamyris kitharas whereas there are thousands of concert kitharas on Attic vases.)

The vase paintings give us no clue about the vaulting of the back or the front surfaces of the body just as they give little hint that human forms are not flat. Luckily, we have relief sculptures of both the front and the back (*figs. 8 and 9*). The front appears to be flat (given the uncertainty of interpreting the Etruscan relief technique) while the back is slightly vaulted. (The curvature of the Anatolian relief is also difficult to interpret exactly since the instrument is held against the strongly curved chest of the sphinx and seemingly bends around the chest.) The curved back was adopted in the reconstruction of *fig. 18*.

Occasionally these instruments are decorated with pairs of eyes, but they can hardly be considered a characteristic trait,[22] since only six of the twenty-nine instruments in *fig. 15* have eyes. More common are the flaps (e.g., the black fields on A 3); but these, of course, are also a feature of the concert kithara. Because of the large-sized flaps on some of the instruments (B 2, D 1, D 2, D 3, and G 3), it is unlikely that these fields indicate solid parts (e.g., shoulder supports). Otherwise the sound boards would have abnormally small areas available for vibration and sound amplification. (In the reconstructions [*figs. 18 and 19*] the flaps were made of leather.)

Most of the instruments are held to the player's body by means of a sling attached to the arms (player's and instrument's). Generally, these slings have been omitted from *fig. 15*.

Bridge

None of the Etruscan reliefs datable before ca. 490 B.C. show bridges. This is exemplified in *figs.* 8 and 15, C 3. Likewise, the wall painting in the Tomba dei Leopardi (490–470 B.C.) seems to lack a bridge (*fig. 15*, B 4). Yet most of the other details (including the prominent string holder/tail piece) are shown faithfully. The bridge may be concealed by the strings. One should be careful not to take the existence of a bridge for granted at this time and place, however. Later (end of the fourth century) the instrument on the Etruscan sarcophagus (*figs. 15*, C 4 and *16, 17*) was outfitted with a bridge, as was the wall painting (*fig. 15*, C 1) from the Tomba della Nave from ca. 450 B. C.

All of the vase paintings showing unobstructed front views have bridges. These bridges are generally narrow (*fig. 15*, E 1 and E 2 might be exceptions) and nearly all lack left-right symmetry, although the instruments are quite symmetric in other respects. More strongly asymmetric bridges were used on concert kitharas where the bridges were also significantly wider.

22 Wegner (footnote 8), p. 31, seems to consider a pair of eyes to be a characteristic of cradle kitharas.

String-holder (tail-piece)

In most cases the string-holder is drawn as an unfilled rectangle. It can thus be of two shapes: either a narrow rigid stick attached with two straps to the bottom edge of the body (as in *fig. 27*) or a rigid rectangular piece (as in *fig. 28*). Instrument G3 is definitely of the latter type while the others could be either.

Strings

Some 65 percent of our examples have seven strings, 25 percent have six or eight, while five or nine strings are less frequent.

Geographical and historical spread of the cylinder kithara

The known cylinder kitharas are distributed as shown in the table below.

Provenance	Medium	Date/Period	Type of Cylinder Kithara on fig. 15	Number of items
Athens, Greece	vases	520–430 B.C.	all types	ca. 35
Chiusi, Etruria (Italy)	cippi, reliefs	480–475 B.C.	main type	ca. 6
Vulci, Etruria	sarcophagus (relief)	300–280 B.C.	main type (C 4)	1
Tarquinia, Etruria[23]	tomb paintings	550–390 B.C.	main type (B 4 and C 1)	ca. 6
Cyzicus, Anatolia (Turkey)	relief on sphinx sculpted in the round	ca. 540 B.C.	main type (C 2)	1

That no example is found prior to the mid-sixth century does not mean that the instrument was »invented« at that time. The scarcity of samples is just as likely to be due to the state of representational art at this date. It is also probably not significant that one or two examples of full-fledged concert kitharas are known from the seventh century. On the other hand, the vast geographical spread of the cylinder kithara is significantly different from the concert kithara's, which is rarely found outside mainland Greece.[24]

In Anatolia a variety of other lyre types have been found.[25] They date from before 500 B.C. None have the attributes of the concert kithara of *fig. 5* (i. e., there are no complex arrangements

23 Mario Moretti, New Monuments of Etruscan Painting (Pennsylvania State University Press, 1970), no. 3242 (pp. 291–297), no. 3226 (pp. 206–213, especially 208), no. 578 (pp. 175–184), no. 809 (pp. 93–102), no. 238 (pp. 195–203, especially 208) and in the Tomba dei Leopardi.

24 There are hundreds of Attic vase paintings of the concert kithara and many reliefs from mainland Greece. On the other hand, there are few concert kitharas from outside Greece: the metope from Selinus, Sicily discussed later and a small plaque from Gortyn, Crete (Heraklion Archaeological Museum, inv. No. 11417). Both objects have early dates (580 and 625 B.C. respectively).

25 See, for example, A History of Music in Pictures, ed. Georg Kinsky (New York 1951), p. 2, fig. 3; or Ekrem Akurgal, The Art of Greece, Its Origins in the Mediterranean and Near East (New York 1968), p. 211, pl. 32.

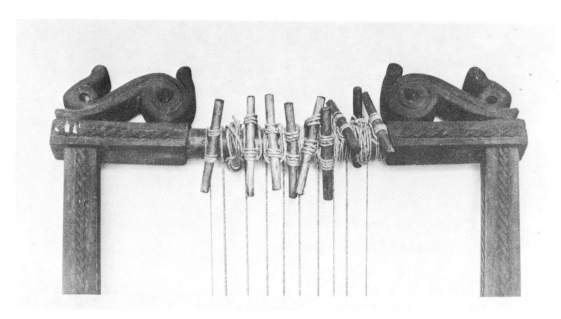

Fig. 23

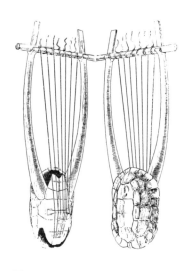

Fig. 24

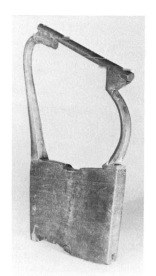

Fig. 25

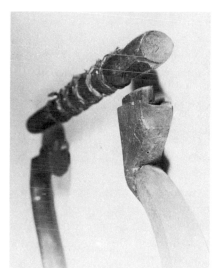

Fig. 26

Fig. 27 Fig. 28

of springs, spirals, and hinges located at the shoulder).[26] Generally, these lyres are of simple construction without any idiosyncratic structure at the shoulders. They are reminiscent of the Sumerian lyres from 2600 B.C. and the Egyptian from 1500 B.C. (*figs. 25–26*). The Cyzicus instrument is a fully developed cylinder kithara, however.

Ionian origin of the cylinder kithara

There is much evidence that East Greek craftsmen worked in Etruria at this time (about 600–450 B.C.),[27] and recent archeological finds in Anatolia also support this view. Painted tombs have been found in Lydia (central Anatolia)[28] and in Lycia (southwestern Anatolia)[29] which strongly resemble Etruscan tombs.[30] Both these Anatolian sites were under Ionian artistic influence at this time (sixth century). Likewise, clothing fashion in Etruria corresponds to that which existed in Ionian cities and spread to Athens during the period 550–450 B.C.[31] Our sample of cylinder kitharas is small but, significantly, the find from Anatolia comes from the Ionian settlement Cyzicus (northern Anatolia).[32] The geographical distribution of the cylinder kithara thus fits well into the pattern established in other artistic fields. With the present evidence it is

26 An instrument shown in fig. 86 in Akurgal (footnote 12) has some (decorative?) device at the shoulders but it bears no resemblance to the well-known combination of springs, spirals, hinges etc. that is the hallmark of the concert kithara.
27 Massimo Pallottino, The Etruscans (Pelican Books, 1978) pp. 156f. In this edition the Italian »cetra« suffers a mistranslation and becomes »zither« instead of »kithara«. D. H. Lawrence (in: Etruscan Places, p. 45, published as ›David Herbert Lawrence and Italy‹ by Viking Press, 1972) commits the same error. Temptation was provided by the Italian tongue which has but one word for »kithara«, »zither«, and »cittern« (cf. Winternitz, footnote 15, pp. 30 and 57).
28 Rodney S. Young, ›The Campaign of 1955 at Gordion: Preliminary Report‹, in: American Journal of Archaeology (= AJA) 60 (1956), pp. 255f.
29 Machteld J. Mellink, ›The Painted Tomb near Elmalı‹, in: AJA 74 (1970), pp. 251–253; id., ›Excavations at Karataş-Semayük and Elmalı, Lycia, 1971‹, in: AJA 76 (1972), pp. 257–269; id., ›Excavations at Karataş-Semayük and Elmalı, Lycia, 1973‹, in: AJA 78 (1974), pp. 351–359.
30 Otto J. Brendel, Etruscan Art (= The Pelican History of Art; Penguin Books, 1978), pp. 170 and 191.
31 Larissa Bonfante, Etruscan Dress (Baltimore and London 1975), p. 38.
32 John Boardman, The Greeks Overseas (Penguin Books, 1968), p. 247.

reasonable to assume common migration patterns for such diverse fields as the fine arts, dress, and the cylinder kithara. Summarizing the evidence for painting and sculpture, Brendel wrote:

>»Since direct connections between these widely distant monuments can hardly be assumed, the existing similarities are best explained as the symptoms of an international style which from a Greek Ionian center radiated to northern Asia Minor in the east, Italy in the west. While the original center as yet cannot be identified, the evidence being too fragmentary, it still does not seem unlikely that this rather erratic appearance of related stylistic and perhaps cultural traditions in outlying provinces of the ancient Mediterranean came to pass in the wake of enforced migrations such as the evacuation of Phocaea earlier in the century«.[33]

The origins of the cylinder kithara should, therefore, be sought in Anatolia.

Etruscan kitharas

The Cyzicus kithara is of the main type in *fig. 15* (those in cols. A, B, and C) but one cannot, on this evidence, rule out the possibility that the other types of cylinder kithara also existed in Anatolia. If the variants had existed, one would have expected them to be transferred by the East Greek craftsmen that migrated to Etruria, but the Etruscan sample of a dozen cylinder kitharas are all of the main type, too. This can most easily be explained by assuming that there was only one type in East Greece at the time of the transfer (before the middle of the sixth century, for example) to Etruria and Athens. Local conditions in Athens could have been conducive to the development of the variants while conditions in Etruria favored stability. (The very late find on the Vulci sarcophagus [see our table] at a date when the Attic cylinder kithara had not been depicted since, at least, one hundred years, also tends to argue for a musically conservative society.) Vase paintings reveal that the Attic variants existed already by 510 B.C. (*fig. 15*, F 2–4). Since some time is required before the variants would arise, the transfer probably occurred well before 510 B.C. From studies of the commercial activities of the Ionian Greeks,[34] it is known that Etruria imported luxury goods as early as 675 B.C. and musical instruments might well have been among these.

At any rate, three unique features characterized the cylinder kithara in Etruria: (I) It was the stringed instrument represented most often in art.[35] (II) It lacked variants. (III) It lasted longer than elsewhere.

Such features imply that it was a kind of »national« instrument[36] just as the concert kithara was the stringed instrument par préférence in Athens.

33 Brendel (footnote 30), p. 170.

34 Mauro Cristofani, L'arte degli Etruschi. Produzione e consumo (Turin 1978), pp. 42, 43, and 81.

35 Oddly enough, a musical scene in the Tomb of the Leopard has become very well-known, being reproduced in many books on Etruscan art (e.g., W. Dräyer, M. Hürlimann, and M. Pallottino, Art of the Etruscans (New York 1955), pl. 11). Atypically, the selected scene shows a lyra. However, in the same tomb a cylinder kithara is also painted but it has been ignored, as a rule, by the art books. D. H. Lawrence (footnote 27, p. 39), visiting the tomb in 1927, paid little attention to the cylinder kithara. Turning the other way he wrote: »The ›subolo‹ plays the double flute [it is, of course, a ›diaulos‹] the Etruscans loved so much, touching the stops with big, exaggerated hands, the man behind him touches the seven-stringed lyre, the man in front turns around . . .«.

36 To complete this account of Etruscan lyres, one should point out that several other types of round-bottomed instruments existed although they were rare judging from the few pictures that have come down to us. In all of these lyres the arms were smoothly joined to the body making a stiff joint. Already mentioned was the large horseshoe kithara of fig. 6 depicted twice at Aquarossa. Similar, smaller, instruments are shown in Günter Fleischhauer, Etrurien und Rom (= Musikgeschichte in Bildern, vol. 2, fascicle 5; Leipzig s. a.), pp. 38–41, figs. 13 and 15. Both lyre bodies have the shape of a letter D (rotated 90 degrees clockwise) and their arms are narrow. There is a striking

Fig. 29

Fig. 30

As already mentioned, there is another remarkable facet of Etruscan organology: the absence of the concert kithara. This instrument is never shown on native Etruscan artifacts although it is found often enough on the imported Attic vases and may have existed elsewhere in Italy: there is evidence that a Greek colony in Sicily possessed concert kitharas; for a metope from Temple Y at Selinus shows an instrument from about 580 B.C. that is similar, though not exactly identical, to the concert kithara.[37] With the large quantity of utilitarian Attic vases available in Etruria, a rather curious situation existed: pictures of concert kitharas must have graced many an Etruscan drinking party, kitchen, and tomb but their sound would have been less familiar. This, then, is another example of self-imposed »cultural deprivation« discussed by Winternitz[38] in another musical context. This notion goes against the generally accepted view as expressed by Boardman: »The Etruscans accepted all they were offered, without discrimination. They copied or paid Greek and perhaps immigrant easterners to copy – with little understanding of the forms and the subjects which served as model«.[39]

similarity between this Etruscan D-kithara and an instrument known to have existed in Anatolia around 700 B.C., see Akurgal (footnote 12), fig. 18. A large lyre with a combined flat and round bottom existed around 575 B.C., see Jocelyn Penny Small, ›The Banquet Frieze from Poggio Civitate (Murlo)‹, in: Studi Etruschi 39 (1971), pp. 25–61, pl. 14. Barbitons and lyras are also found. For a recent inventory of Etruscan lyres, see Jean René Jannot, ›La Lyre et la Cithare: Les Instruments à Cordes de la Musique Étrusque‹, in: L'Antiquité Classique 47 (1978), pp. 469–507.

37 Georges and Valentine de Miré, Sicile Grecque (Paris 1955), pl. 85. Luca Giuliani, Die archaischen Metopen von Selinunt (Mainz 1979), pp. 58 ff., pl. 14.

38 Communicated by Emanuel Winternitz in a lecture ›Further evidence of Open Strings in Classical Greek Music, 5th and 4th centuries B.C.‹, given at the Fourth International Conference on Musical Iconography (1976); cf. RIdIM-RCMI Newsletter 2 (1976), pp. 5 f.

39 Boardman (footnote 32), p. 210.

Purpose of the cylinders

So far we have analyzed the instrument seen in pictures and sculpture as to form and shape. Now let us try to go beyond that stage and inquire into the purpose of the described details. For most of these details the purpose is self-evident; the function of the cylinders is less clear. The position of the cylinders at the junction of two functionally and dimensionally distinct parts is suggestive: they may be (1) reinforcements or they may be (2) hinges resulting in rigid and movable joints respectively; or they may simply be decorations. Because of the absence of examples, our replica (*fig. 18*) was furnished with hinges to see if flexibility would be of practical value for a performer of the instrument. Each hinge consisted of a wooden rod (1 cm. diameter) stuck through a hole drilled through the three layers: body/cylinder/body. This is shown in *fig. 29*. The rectangular slots in the yoke had to be wide enough to permit movement of the arms. Sidewise motion of the arms (in the plane of the sound board) caused pitch changes in the strings, which is explained in *fig. 30*.

> Position A shows the »normal« instrument (the yoke is shown with vertical hatched lines). If the arms are pushed sideways to the position marked B, the yoke (shown with horizontal hatchings) becomes higher on the right side and lower on the left because the yoke will rest on different parts of the ledge which has been cut into the top of the arms. The string tensions change accordingly and the string pitches become sharp and flat for the left- and right-hand strings, respectively.

The iconographic material shows that the pitch changes could not have been performed while the instrument was being played: it is necessary to push one of the arms with the left hand but the hand is always shown behind the strings and not in contact with an arm. The only exception is the vase in the Louvre shown in *fig. 31*. Judging from his posture, the player is tuning his instrument. From numerous scenes on sixth and fifth century vases it seems certain that the concert kithara was tuned in this way: the player's right hand gripped the collar while the left hand plucked the tuned string. (The apparent great ease with which the right hand turned the collar is frequently shown by letting the little-, the ring-, and the middle-fingers point straight up, not taking part in the grip.) Equally clear, but unusual, is the method involved: the musician is not turning the collar of the string he is tuning. Two interpretations come to mind: (1) he is actually tuning one of the right-most strings but happens at the moment of the drawing to be testing it against the left-most string or (2) he is tuning the left-most string and adjusting it by pushing the arm/yoke sideways to achieve fine tuning in the above manner. To complicate the issue further, one notices that the instrument in the figure has the type of shoulder joint where a semi-cylinder is resting on a thin plate (as in *fig. 19*). Such a joint, probably, had a natural tendency to return to its position of equilibrium.

> In summary, the purpose of the cylinder is ambiguous. Regrettably, there is little hope that new evidence can throw light on this question unless extant instruments (or relevant parts thereof) are found.

Discussion of previous work on the cylinder kithara

The article by Martha Maas (footnote 9) is extensive and specific but of uncertain value since it is mistaken in its underlying premises and sometimes in its observations.

> Maas tried to prove that the round-bottomed lyres shown on eighth and seventh century vases were the same as the round-bottomed instrument found on sixth and fifth century vases and that the latter lyre should be designated by the term »phorminx«, the Homeric name for the earlier lyre. It is, however,

logically impossible to prove this thesis since, as we have seen, there were several different types of round-bottomed lyres in the sixth and fifth centuries: (A) the cylinder kithara (which, in turn, had several distinct variants) and (B) the types with smooth shoulders (*figs. 10–14*). The very fact that there is no »unique« round-bottomed lyre in the classical period invalidates the reasoning. To try to save the argument by ignoring the distinctions between types (A) and (B) is rather like pretending that violins and guitars are the same and that both, furthermore, are identical to the crwth (all are round-bottomed) and ought to be so called. Having »proved« that the round-bottomed lyres had not changed between the eighth and fifth centuries, Maas further asserts that »the continued existence of such an instrument-form suggests, moreover, that the art of music was not subject to any fundamental reconstruction in the course of the seventh century«. This is rather like arguing that Western music has not undergone any fundamental change since 1550 A.D. because the violin has not.[40]

The sound of the cylinder kithara

The reconstruction of the instrument seen in *figs. 18* and *19* has been achieved with much certainty as to three-dimensional shape and structure. On the other hand, conclusions about the materials, the thickness of the walls, and the inside structure (ribbings, sound posts, and other details) cannot be drawn from the iconographic evidence. These quantities have a large influence on the sound intensity and timbre and in order to recreate the sound we have to resort to some (informed) guessing. The two major determinants of the sound are the sound board (i.e., the surface underneath the bridge) and the strings.

(1) The sound board was probably made of wood worked as thin as possible since it only needs to withstand the string force acting down on the board via the bridge. That force is moderate since the tension obtainable with the kollopes is considerably less than in modern instruments with peg tuning. One of the few ancient instruments that has survived with an intact sound board, the Egyptian lyre from ca. 1500 B.C. in the Rijksmuseum van Oudheden in Leiden, does indeed have an extremely thin top plate (2 mm.). Obviously, this lyre does not prove that the cylinder kithara also had a thin sound board but it is plausible to assume that Greek instrument-makers were aware of thin boards (and their role in good sound production) since there was much other transfer of craft techniques between mid-second millenium Egypt and archaic Greece (e.g., monumental sculpture, temple building, and scarab chiseling).

(2) The highest pitched string was probably tuned up close to its breaking point. Using the so-called Mersenne string formula, one can easily show[41] that the highest pitch a string can attain does not depend on its thickness but only on the material (and the processing of the material) and its length. Because pitches and lengths of the (open) strings are known for many European

40 Some details in Maas' (footnote 9) account are incorrect or misleading. The trouble spots will be listed here to remove possible ambiguities in our understanding of the kithara. (1) p. 44 reads: »There is some reason to think that the half circles shown with inset arms may curve, not directly toward one another, but somewhat forward as well«. Maas gives no hint of a proof (or picture) of the forward curving arms. I have failed to see any indication of forward curving arms. (In the Cyzicus sculpture, as explained earlier, the curving simply follows the body of the sphinx. The sculptor probably wanted to avoid the technical difficulty involved in rendering projections straight outwards, as well as the resulting fragility of the stone.) (2) p. 45, footnote 24, states that kollopes (tuning collars) may have had a pin stuck through them in classical-period lyres. Again, Maas cites no evidence for her observations. The present author has seen no such evidence and believes these pins (as in fig. 23) did not occur until the Roman period (2nd century B.C.) when they became standard.

41 Djilda Abbott and Ephraim Segerman, ›Strings in the 16th and 17th centuries‹, in: The Galpin Society Journal 27 (1974), pp. 48–73; id., ›Historical background to the strings used by catgut-scrapers‹, in: The Catgut Acoustical Society Newsletter 25 (1976), pp. 24–26.

Fig. 31

stringed instruments since the Renaissance, one can show that most of these instruments had the top string tuned a small interval (approximately a third) below the breaking point. (To verify this principle, it is not necessary to have surviving string specimens as long as one knows the material, mostly gut.)

Of course, we are unlikely ever to find ancient sources on the absolute pitch of Greek or Egyptian lyres since there were no frequency standards in antiquity. Some small knowledge may perhaps be gained from an acoustical study of the Egyptian shoulder harp (from ca. 1500 B.C.) which proved [42] the instruments to be very soft in sound especially if the top string is not tuned as high as possible. The Egyptian »ladle harp« seems to have been a louder instrument, provided its top string was tuned high. Another indication that Greek lyre strings were tuned close to the breaking point is the familiar account of strings snapping at a competitive musical event. [43]

There is good reason to believe that the cylinder kithara strings were made from gut: (1) gut is an easily accessible material and (2) the Homeric ›Hymn to Hermes‹ (dated as late as the sixth century [44] describes lyra strings made of ox-gut. The breaking point for chemically untreated gut strings of 35 cm. length (as in this reconstruction) is approximately *c* above middle-*c*.

If the cylinder kithara had the thin sound-board and the stringing we have suggested, its top string would have sounded somewhat like a gut *A*-string of a contemporary viola plucked with a massive plectrum.

42 Bo Lawergren, ›Acoustics and evolution of arched harps‹, in: The Galpin Society Journal No. 34 (1981), pp. 110–129.
43 In a musical contest between Eunomus and Ariston a string broke on Eunomus' kithara. Luckily, a cricket passed by and sang the missing note (see Solon Michaelides, The Music of Ancient Greece; an Encyclopaedia [London 1978], s. v. »adein«).
44 Albin Lesky, A History of Greek Literature (New York 1966), p. 87.

Summary

It has been shown that the cylinder kithara constituted a distinct instrument form during the archaic and classical period in Greece and Etruria with an odd example in Anatolia. There are about fifty known examples found on Attic vases (the majority), Etruscan cippi, and tomb paintings. We have attempted a reconstruction taking into account all the evidence from this large corpus of sources. Even then some details have to be conjectured but it is doubtful if further archeological discoveries will greatly change the situation.

Historically, we have seen that a remarkable situation arose in Etruria where the cylinder kithara became the principal lyre, while the concert kithara, the principal lyre of Greece, was completely absent. There are reasons to believe that the cylinder kithara was imported to Etruria from Anatolia prior to 550 B.C.

Padmasaṃbhava's Paradise
Iconographical and Organological Remarks
on a Tibetan Ritual Painting

Arnold Perris

List of Illustrations

Fig. 1: ›Padmasaṃbhava's Paradise‹ (19th century). St. Louis/Missouri, George Hibbard Collec-
(Frontispiece) tion. – Photo: A. Perris
Fig. 2: Detail of fig. 1, »Ḍākinī (»Kandroma«), celestial messengers. – Photo: A. Perris
Fig. 3: The »Chod« (»gCod«) Goddess with skull drum and handbell (gilt bronze, 15 cm.;
 possibly 18th century). St. Louis/Missouri, George Hibbard Collection. – Photo: A. Perris
Fig. 4: »Yang Can Ma« (»dByangs-can-ma«), the Melodious Goddess (woodblock). From The
 Three Hundred Icons, originally published in Peking (late 18th century). – Photo: after
 Blanche Olschak, Mystic Art of Ancient Tibet (London and New York 1973, George
 Allen & Unwin), p. 153, no. 157.
Fig. 5: Detail of fig. 1, »Dhṛtarāṣṭra«, Guardian of the East, with his lute. – Photo: A. Perris
Fig. 6: Detail of fig. 1, The temple scene with the monks' orchestra. – Photo: A. Perris
Fig. 7: »Dril-bu« (handbell). Author's collection. – Photo: A. Perris
Fig. 8: ›The Paradise of Padmasaṃbhavam‹ (62 × 42,5 cm.; early 19th century). The Philadelphia
 Museum of Art, 60-131-6. – Photo: Museum

Reproductions with the kind permission of the owners

* * *

The esoteric form of Buddhism immanent in Tibetan religious painting requires approaches different from those applied to European art. Indeed, the Western viewer may have some preconceptions to set aside before proceeding very far. To understand iconography, we begin with the relevant religious canons and practices. When we compare the purpose of Christian icons with the purpose – and significance – of a Tibetan »thanka« (»thang-ka«),[1] an extraordinary difference must be admitted. In Christianity the worshipper is little accustomed to utilizing art for ritual purposes. There are to be sure many art forms which are employed in parts of the liturgies: the crucifix or cross, the stations of the cross, images of saints which are carried in Eastern Orthodox, Italian, and Spanish rites, and so on. In the West images may serve as a reminder of a religious canon or as an impetus to prayer. Reverence for religious art, even

1 The Romanization of Tibetan names and terms is an obstacle to all but the most persistent readers of the literature. The difficulty is that the orthography was fixed more than a thousand years ago and differs widely from modern pronunciation, which in turn varies from one Tibetan region to another. Words rendered in transcription must therefore include a host of mute or modifying consonants which bewilder the uninformed eye. Some writers employ a capital letter to indicate the true radical (as »rDo-rje«, pronounced dorjay – scepter, »vajra« in Sanskrit), but this method scarcely eliminates all the problems. There are five systems of transcription in use. I have endeavored to bring my Tibetan citations into the system of Turrell V. Wylie, ›A Standard System of Tibetan Transcription‹, in: Harvard Journal of Asiatic Studies 22 (1959), pp. 261–267. Historically the teaching came from India, hence many terms in Western literature are commonly given in Sanskrit transliteration. Such spellings are apt to be more familiar, and following precedent, I have often used some here, as »dharma« (doctrine or law), rather than the Tibetan »chos«. A few Tibetan terms have come into English usage, as lama (Tibetan »bla-ma«), not to mention thanka or tanka.

veneration, is a traditional act of piety, but this is not a required step in daily practice. Ignatius of Loyola asked his readers to visualize a religious scene or event and see themselves participating in it (»composicion viendo el lugar«),[2] as a means for improving meditation, but this is not a practice familiar to the average Catholic. A religious painting is a tangible visualization of such a scene or event. Beholding the work of art, the faithful (not only in Christian but also in Jewish and Islamic faiths) – clergy and laity – stand outside the subject matter depicted, and doctrine does not instruct them to become the divinity represented. Here is the main contrast of attitude, or purpose, with Tibetan Buddhist iconography that must be accepted before analyzing the work at hand.

Tibetan sacred art expresses »the vision of tantric Buddhism«,[3] »Vajrayāna«, a method of Mahāyāna Buddhism founded in north India and developed after the ninth century with enormous scriptural and iconographical complexity in Tibet, Sikkim, Nepal, and adjacent regions. The art, principally painted banners termed »thankas«, is used for meditation by every monk or lama. A thanka is usually viewed hung on a wall. When not in use, it is covered with a light veil fixed to the top board, or it is rolled up on a pole from the bottom.[4] It » . . . aims at making visible religious, meditational, purely spiritual and visionary contents so that the initiated may in turn re-live them«.[5] The devotee must think of himself as identical with the deity depicted, and render honor and devotion to himself as himself. The artist before drawing the image is expected to evoke the sacred forms by first visualizing them. Every artist, however, must know the instructions for each subject to be illustrated.[6] Traditions prescribe the great number of deities, saints, and other beings with their specific design, color, garments, postures and attributes.[7] So profound is this doctrine that many pictures contain several levels of meaning, which the practitioner realizes only during repeated contemplation. (Giuseppe Tucci discourses for some five pages on the meanings of the lotus.[8]) Despite the prescriptions there is some room

2 The Spiritual Exercises of St. Ignatius, trans. and ed. David L. Fleming, S. J. (St. Louis 1978), nos. 47, 103, 111–117.

3 Chögyam Trungpa, Rinpoche, Visual Dharma. The Buddhist Art of Tibet (Berkeley 1975), p. 18. The term »tantric« comes from »tantra(s)«, secret writings which evolved from Hinayāna and Mahāyāna Buddhism, and including esoteric rites and symbols. See Detlef Ingo Lauf, Tibetan Sacred Art; The Heritage of Tantra (Berkeley 1972), pp. 20–23.

4 Giuseppe Tucci, Tibetan Painted Scrolls, 3 vol. (Rome 1949), vol. 1, p. 267, translates thanka as »something rolled up«. In a recent book a lama now living in the West derives the meaning from »thang-yig«, meaning »a written record« (Chögyam Trungpa [footnote 3], p. 16). John C. Huntington sees both of these explanations as philologically wrong: »Thang-ka is specifically the term for painting. Its root, ›thang‹, means 1) flat plain, or 2) clear, even or flat.« (Personal communication, 27 February 1981.)

5 Lauf (footnote 3), p. 46; see also Chögyam Trungpa, ›The Tibetan Heritage of Buddhist Art‹, in: The Tibetan Journal vol. 1, fasc. 2 (1976), pp. 5–9. »To appreciate Tibetan art one must appreciate himself, the fact of his being, the quality of his awareness and all that is manifested therein«, see Tarthang Tulku, Sacred Art of Tibet (Berkeley 1972), ›Introduction to Tibetan Sacred Art‹ (a chapter, not paginated).

6 The act of painting is itself a sacred rite according to Tucci (footnote 4), vol. 1, pp. 268 f. and 289–291; vol. 2, p. 604, item 7. For descriptions of the techniques and customs see also Antoinette K. Gordon, Tibetan Religious Art (New York 1963, a reprint of the 1952 ed. with new introduction by Thubten Jigmo Norbu), pp. 13 f.; Lauf (footnote 3), pp. 50 f.; Rolf A. Stein, Tibetan Civilization (Palo Alto 1972), pp. 281–286; and Chögyam Trungpa (footnote 3), p. 17. Tucci's is the most extensive study and the model for all which followed. The recent publications by other scholars, often with lavish color plates, are now indispensable for their reproductive detail and added sources, such as Lauf and other authors frequently cited here.

7 Tucci (footnote 4), vol. 1, pp. 267–325; Mary Connors Angetsang, ›The Thanka Paintings of Tibet, a Painter's View‹, in: The Tibet Society Bulletin 15 (June 1980), pp. 5–9 (based in part on her painting instruction from Jamyang Dakpa); Blanche Christine Olschak in collaboration with Geshé Thupten Wangyal, Mystic Art of Ancient Tibet (London and New York 1973), pp. 12–41, 132–197.

8 Tucci (footnote 4), vol. 1, pp. 300–304.

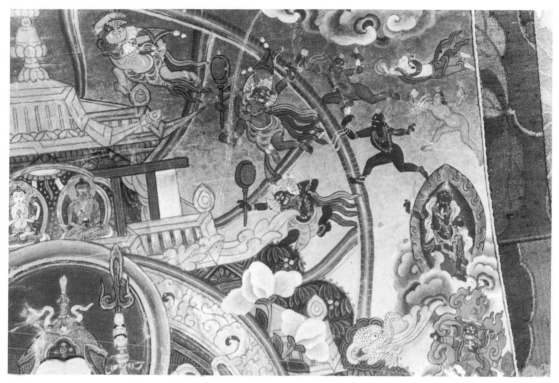

Fig. 2

for choice on the part of the artist; for example, in the appropriate insertion or rearrangement of secondary figures or scenes. Indeed, of some four hundred thankas I have examined, no two are exactly alike, even when their subjects are identical.[9]

Perhaps the reader must be wary of another bias: the contemporary habit of imputing a secular value to religious art. I do not mean here an extrinsic worth, though the latest prices often seem to demand preeminence in news of the art world. I suggest that viewers impose a secular status on art which overrides the inherent or original purpose. Consider Michelangelo's renowned ›Pietà‹. When it was damaged through an act of vandalism in 1974, the outpouring of dismay was inspired more by the possible loss of an historic art work than a sacred icon. To be sure, many were also offended at the implied attack on religious devotion. But in assessing the worth of the ›Pietà‹, aesthetic values have taken precedence. And this despite aesthetic contradictions, such as proportion. (The female figure is enormous next to the man's.) If the work's function were to make scripture »real«, where is the scriptural evidence that Mary held her dead son in her arms? Neither art lovers nor the pious reject the ›Pietà‹ (a late medieval theme) because of Michelangelo's liberties.

In Tibetan religious art the viewer should perceive carefully the context of ritual requirements. Further, to admire primarily the craft – the design, vivid colors, the »imagination« of the

9 The history of the thanka reveals changing styles and regional and foreign influences. Tucci's selection demonstrates some of these. Stephan Beyer, The Cult of Tārā, Magic and Ritual in Tibet (Berkeley 1973), p. xiii, refers to »iconographic fads and styles« in his research. His experiences with the venerable lay artist, Tendzin yongdü (p. xv), whom he engaged to illustrate ›The Cult of Tārā‹, offer insight into the potential for variation and individuality in artistic judgment. See the drawings throughout the book; compare them with the Three Hundred Icons (late eighteenth century woodblock prints, Peking) in Olschak (footnote 7), pp. 113–185, and the illustrations of Padmasaṃbhava's Eight Manifestations in a series of woodblocks made in Derge, East Tibet (an important center for printing), in Olschak, pp. 24–33; and also in: Crystal Mirror 2 (Berkeley 1972), pp. 37, 39 and elsewhere.

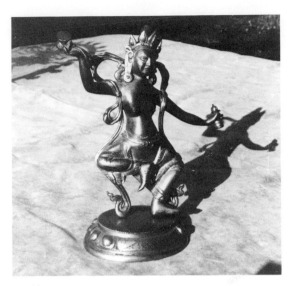

Fig. 3

painter's mind – is to miss the point of this art. Stein cautions that »The maṇḍalas, for instance, whose well-ordered symmetry would delight a town-planner, are likely to give the European beholder an impression of stylistic elegance or an aesthetic satisfaction that were not intended by the artist, and are not felt by a Tibetan audience«.[10] All the visual elements of a thanka are present by the commands of ritual. None of them is present as an aesthetic end in itself. Let us turn to the example illustrated here.

The painting I am concerned with is in a private collection and is thought to be from the nineteenth century (*fig. 1, frontispiece*). The subject is the mountain paradise of Padmasaṃbhava (Pad-ma-hbyung-gnas), also called Guru Rinpoche (Beloved Teacher), an Indian tantric master who was the eighth-century founder of Tibetan Buddhism.[11] It is a familiar theme and there are many variants extant. The painting is approximately 17 by 26 inches (43 × 64 cm.) with the customary border of brocade. It is painted with opaque mineral pigments in collagen binders on cotton cloth. This painting reveals seventy-one persons, as well as birds, animals, flowers, temples, and stūpas, all below, upon, or above the copper-colored mountain that rises from an island. Twenty-nine of the figures, gods or mortals, play a total of thirty-five musical instruments. In many thankas a solo musician, even a small group is present. In no other example to come to my attention are there so many players with so near a full complement of instruments which compose most monastery orchestras. None of them is imaginary or unidentifiable; they are instruments still in use.[12] As in contemporary Tibetan ensembles, the orchestral instruments appear in pairs (or more).[13]

10 Stein (footnote 6), p. 281.
11 A biographical article which provides considerable iconographical information is by the Lama Tarthang Tulku, ›The Life and Liberation of Padmasaṃbhava‹, in: Crystal Mirror 4 (Berkeley 1975), pp. 2–34. The author is of the Nyingma school (the »Old Ones«) which commenced with Padmasaṃbhava. There is also a traditional text by Yeshe Tsogyal with the same title, The Life and Liberation of Padmasaṃbhava, 2 vols., illustrated with thankas (Berkeley 1978), translated from the French edition of Gustave-Charles Toussaint, Le Dict de Padma, 2 vols. (Paris 1933).
12 Peter Crossley-Holland, ›Tibet‹, in: The New Grove 18 (1980), pp. 799–811.
13 Such instruments are also used outside the monastery for religious occasions. A narrative painting of the historic monastery of Drepung ('Bras-spungs) is an iconographical example. The foreground shows a single file of monks departing on a pilgrimage. Conspicuous among them (though the scale is small) are at least five playing trumpet, cymbals, bone trumpet, pole drum and »shawm« (»gyaling«, described elsewhere in this article). Lauf (footnote 3), pl. 5, p. 16, and explanatory notes p. 12.

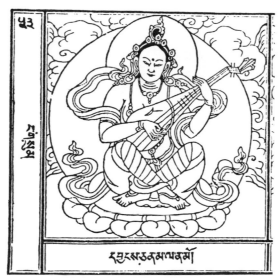

Fig. 4

According to traditional practice Padmasaṃbhava is seen in very large scale in the center, dominating the principal space. His Sanskrit name means »born of the lotus«, and he sits on a lotus throne.[14] Below him, right and left center, are his two female disciples, and his eight manifestations – peaceful or wrathful forms, with which he conquered the demons of Tibet (that is, the native Bön-po beliefs), and spread the teaching of tantric Buddhism. He holds three nonmusical ritual objects.[15]

Fourteen flying creatures surround him, inside and outside his great rainbow nimbus, and fill the space in the thanka, as it were, with musical sounds (*fig. 2*). These are minor deities, »dakinī« (Tibetan »mKha'-'gro'-ma«, meaning »walking in the sky«) on the outside of the rainbow, and six male counterparts, »daka« (»mKha'-'gro'po«) inside. They are yellow, dark red, and green. On the right three of them bear pole drums with green heads (»lag rnga«), which are struck with a beribboned[16] curved stick. A horizontal white figure, a »puja (offering) deva«, strikes a pair of cymbals (»sil synan«).[17] Three other musicians are equipped with two instruments each: one is a small hourglass-shaped drum, like the Indian wooden »damaru«. For use in meditation the drum is made of two skull caps (the cranium) covered with skinheads, joined back to back to make a double drum (»thod dam« or »thod rnga«). For musical use, especially today, they are made of

14 Tucci (footnote 4), vol. 1, pp. 300 ff.

15 He holds the »vajra« (Sanskrit) or »rDo-rje«, the »diamond« scepter (i.e., diamond-shaped at each end, and there is a conceptual meaning also), a trident (»khatvāṅga«), and a skull-bowl (»kapāla«) filled with the elixir of immortality (»amṛta«), symbols of his attainment. For these details see Chögyam Trungpa (footnote 3), pls. 19 and 20, and commentary on p. 64.

16 Not a decoration; ribbons are talismans, especially if imprinted. J. Deniker describes these as » . . . streamers of ribbon on the end of a stick which are imprinted with the sacred formulas. These ribbons are held to have the power of keeping evil spirits away from the convent. We have here a relic of ancient animism« (that is, of Bön-po, the indigenous religion); in Alice Getty, The Gods of Northern Buddhism (Oxford 1928; repr. Tokyo 1962), p. xlviii. See also René de Nebesky-Wojkowitz, Oracles and Demons of Tibet; The Cult and Iconography of the Tibetan Protective Deities (The Hague 1956), p. 346.

17 Two kinds of cymbals are used. The heavier type, with a thick center knob (boss), is called »rol-mo«; they are held flat, one above the other, and struck vertically. Lighter weight discs, »syl-synam«, are struck with a horizontal motion, as the celestial musician does here. In the temple scene discussed below, the monk next to the abbot is playing »rol-mo«. According to Nebesky-Wojkowitz (footnote 16), p. 398, there are two types of music, soft and loud, appropriate to »dharmapālas« or guardians. The »rol-mo« is loud and corresponds with the angry deities. (»Rol-mo«, pronounced »rö-mo«, is also the term for ritual music in general.)

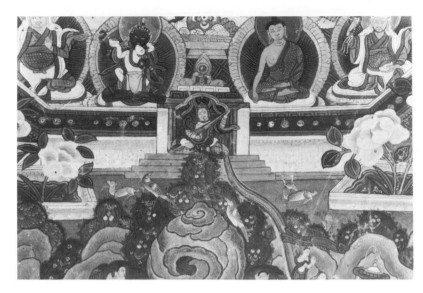

Fig. 5

wood. As the drum is rotated, two knotted leather strips tied to the waist alternately strike the two heads. In the opposite hand these flying musicians ring a handbell, »dril-bu«, the Indian »ghaṇṭā«.

On the left side in mirror image figures also play pole drums, skull drums, and handbells. A white »apsara« plays the white conch shell trumpet »dung« (»dung« means shell, and is also the generic name for the Tibetan trumpets; more properly it is »chos-dung«, »trumpet of the dharma«). This shell (»xancus pyrum«) is of wide significance in Asian religions. In Buddhism the conch shell horn is the gift of the Hindu god, Indra (Brgya-byin), to Buddha Śākamuni (the historical buddha) during the latter's enlightenment.[18] The conch thus became one of the eight auspicious symbols[19] to be found on the Buddhist altar, including the one depicted in this thanka (lower right). It represents sound, as the voice of the Buddha.[20]

Two of the guru's manifestations, wearing white turbans, also hold skull drums, ornamented with a tassel (a talisman): the Guru, »Lotus King« (»Pad-ma Gyal-po«) and the Guru, »Wisdom King« (»bLo-ldan mChog-sred«) at the right and left corners respectively, inside the palace wall.[21] Like the conch, the double drum has many meanings. The Wisdom King raises the »ḍamaru«, »from which the eternal sound of the dharma (doctrine) rhythm emerges and pervades the universe«.[22] *Fig. 3* shows in bronze the graceful yet intense dance of the goddess of the »gCod« doctrine. She is »the One Mother, the Lamp of Speech« (»Ma-gcig labs-sgron-ma«).[23]

18 Indra is pictured with the shell as Icon no. 277 in Olschak (footnote 7), p. 179.

19 See Olschak (footnote 7), pp. 44, 86, 184f. (Icon no. 294); and Gordon (footnote 6), p. 81.

20 »Lha-mo« (Sanskrit »Śrī Devi«), the important, fierce goddess who rides a mule (in some forms), is as her name implies – Lha-mo dung skyongs-ma – the protector of the conch shell, since it represents the teaching, see Nebesky-Wojkowitz (footnote 16), p. 32. In the iconography as shown in Icon no. 246, Olschak (footnote 7), p. 171, she does not actually hold a conch shell, rather a sword and the mongoose which spits up jewels (that is, wealth).

21 Anagarika Govinda, ›The Eight Forms of Guru Padmasaṃbhava‹, in: Gesar/Buddhist Perspectives 5, no. 4 (Berkeley 1979), pp. 15f. See also Crystal Mirror (footnote 9), pp. 36–39.

22 Govinda (footnote 21), p. 15.

23 Rinjing Dorje and Ter Ellingson, ›Explanation of the Secret Gcod Ḍa Ma Ru; An Exploration of Musical Instrument Symbolism‹, in: Asian Music 10/2 (New York 1979), pp. 63–91. She is shown in Icon no. 35, Olschak (footnote 7), p. 121, her guru Phadampa, also bearing drum and bell, in no. 34. The teaching also describes other female deities, the eight or nine animal-headed »ma mo« (»Ma-mo mched-dgu«), ferocious beings, each of whom holds a unique drum of precious material, crystal, coral, turquoise, etc., see Nebesky-Wojkowitz (footnote 16), p. 271.

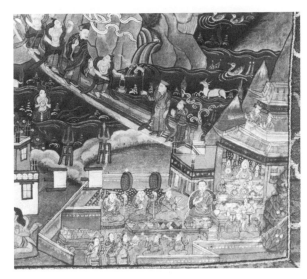

Fig. 6

Poised in the »bow and arrow« position, she also shakes the drum and the handbell.

Returning to the paradise scene, we find in each upper corner a trio of attendants. In both groups the middle figure plays an instrument; on the left, a long transverse flute, on the right, a pear-shaped lute. As far as can be discerned in this small scale, the lute has but one string, possibly an artistic convention. This and the fact that no tuning peg can be seen are clearly musical anomalies. Perhaps a peg is to be imagined underneath the fingerboard like some latter-day Caucasian fiddles. Perhaps also we should assume that tuning chores are irrelevant in paradise, or that an instrument may be present as an identifying object, an attribute, not a functional thing. Still, closer to reality, the neck of this lute is bent back, a feature found on the Tibetan folk lute »damyan« (»sgra snyam«) and some other Asian lutes (*fig. 4*).[24] Another lute, with two strings and no pegs, is played by the Guardian of the East, identified below. Each of these players holds a gold plectrum. Almost any plucked string in this literature is called a »vīnā« (»pi-wang«), a generic term, but the instrument actually illustrated varies considerably. The vīnā is the instrument of Sarasvatī, goddess of learning and music to both Hindus and Buddhists. In the Tibetan pantheon she is Yang can ma (dByangs-can-ma), the Melodious Goddess. In the correct visualization of Yang can ma, as stated by the illustrious Lama Tsong-kha-pa, her lute has a thousand strings. As she plays, »she completely captivates the minds of every living creature

24 Crossley-Holland, who may hold the lead in recent writings on Tibetan instruments, uses the terms »sgra-snyam« (pronounced »dam-nyän«) for the long-necked lute, unfretted, often ornamented with a horsehead, six strings (three double courses), and also »snyan-gra«, see (footnote 12) p. 806 with fig. 4 (the picture shows an instrument for modern usage). The term »pi-wang« (and »hor-chin«) he reserves for a bowed lute with two (or four) strings, the strings passing between the bow, as in the Chinese »hu« family (p. 810). The relationships of the terms »vīnā«, »pi-wang«, »pipa« (and of course »biwa«) seem as close and yet as distant as the actual organological development. For a short, specialized study of these lutes, see Ganesh Hari Tarlekar and Nalini Tarlekar, Musical Instruments in Indian Sculpture (Pune/India 1972), chapter 1 (pp. 7–49). The lute is the only instrument depicted in this thanka which is not a ritual instrument and is thus not a part of the monastery orchestra. The remarks of a Tibetan musician are gratefully introduced here. Professor Ngawang Thondup Narkyid (Kalamazoo/Michigan) states that »lutes, as the sgra-snyan, are not considered to be religious musical instruments. I never saw this kind of lute [that is, the ›folk lute‹ with the name used here] used in an actual religious musical performance . . . but they do appear in religious texts and thankas . . . used by beings in offering music to a deity or a Buddha. [So] it is difficult to say they are not ›religious instruments‹.« (Personal communication, 17 May 1980.) See also Rakra Tethong, ›Conversations on Tibetan Musical Traditions‹, in: Asian Music 10/2 (1979), p. 10.

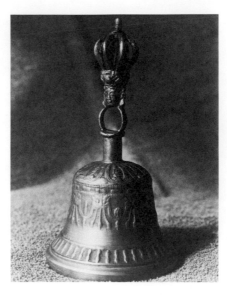

Fig. 7

from the gods and celestial musicians on down, rendering them helpless and without an independent will of their own.«[25]

Below the palace is the entrance for pilgrims. In the doorway sits Dhṛtarāṣṭra (Tibetan: Yul-'khor-srung), Guardian of the East, and one of the four »Lokapāla«, »world protectors« (*fig. 5*). He carries no weapon and utters no warning, but plays a lute – the source of his protecting force: music can control the minds of all who approach. At the left the Guardian of the South, Virūḍhaka ('Phags-skyes-po), holds an upraised sword. At the right, the Guardian of the North, Vaiśravaṇa (rNam-thos-sras), carries a round victory banner and a mongoose which spits out gems.

Dhṛtarāṣṭra seems to be exchanging apprehensive glances with a saucy bird. Has the bird presumed some comment on the divine lutenist? Has the anonymous painter allowed himself a touch of humor? It reminds us of the sly jests half hidden in European manuscript illumination. I have not found this bird in other presentations of Dhṛtarāṣṭra in this setting. Dhṛtarāṣṭra with his identifying lute is found in other subjects, such as the Assembly Field of the Gods (Tshogs-zhing), where he is always at the bottom with the three other guardian kings,[26] or in the great series of pictures depicting the Buddha, the sixteen »arhats« (saints) and two supporters of the faith.[27]

We now proceed to cataloging other instruments in the thanka.[28] Under the east gate, lamas

25 Tsong-kha-pa (1357–1419), ›Meditative Realization of the Melodious Goddess‹, trans. Ter Ellingson, in: Asian Music 10/2 (1979), p. 1; see frontispiece.

26 Examples are found in Olschak (footnote 7), pp. 70f.; also in Thangka Art (exhibition catalog), Doris Wiener Gallery (New York 1974), pl. O; John Lowry, Tibetan Art (London 1973), pl. 28. A small bronze of Dhṛtarāṣṭra holding a lute with many palpable strings – all wondrously fastened to one peg – is in the collection of the Victoria and Albert Museum in London; published in Lowry, pl. 9. Olschak, p. 75, shows a gilded bronze of the Guardian of the East with the lute missing. He is described as king of the heavenly musicians, the »ghandarvas« (»Dri-za«).

27 For example, in the portrait of Ho Shang (one of the supporters), in which the Guardian King of the East is in turn accompanied by a flute player. Tarthang Tulku (footnote 5), pls. 26 and 26b. There is also thanka no. IM 45-1910 in the Victoria and Albert Museum (Indian Collection), not published.

28 Below the east gate at the edge of the island rises a huge green form shaped like a conch shell. This is surely not musical iconography, but there is some purpose, perhaps its symbolism of the doctrine. I have to date found no comment on this form as it appears here, though it is found in some other versions of the paradise.

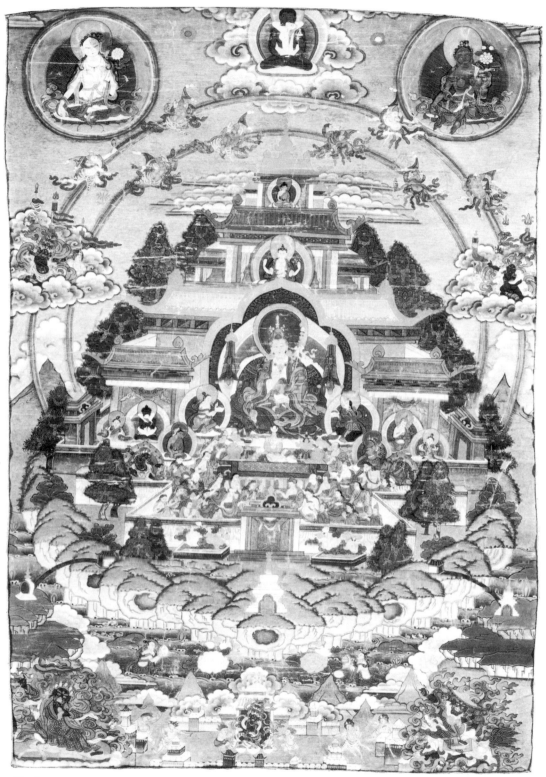

Fig. 8

meet on the rainbow bridge.[29] Below this another event is taking place. Here in a monastery or temple is a sharp-eyed abbot seated with musicians wearing ceremonial gold hats (»rgyag zhwa«) (*fig. 6*). His right hand grasps the lama's indispensable device, the »vajra«. It consists of four or eight closed prongs at each end around a center post. It is cast of gold, meteoric iron, or more commonly of bronze. (See Padmasaṃbhava's right hand and the similar ornament in his red cap.) In the lama's left hand is the handbell, »dril-bu«. Its handle resembles one half of the »vajra«, but with eight prongs resting on the head of Prajñā (wisdom depicted as a goddess; *fig. 7*). Both objects are ornamented with lotus petals, and tiny »vajras« rim the bell.[30] The ritual use of these two articles is of central importance in Vajrayāna Buddhism.[31]

They are presented to the yoga at his initiation. In one interpretation the »vajra« symbolizes method (the masculine aspect) and the bell wisdom (feminine). The combination of these aspects brings »mystic unity or gnosis«,[32] or »the union of bliss and emptiness«.[33] This is also the meaning of the frequent depictions of the male deity embracing his consort in father-mother (»yab-yum«) position.[34] And there is a direct verbal meaning of »female« in the Hindu name of the bell-bearing goddess Ghaṇṭā.[35]

In the temple scene seven monks form an orchestra. They play cymbals (held horizontally), two pole drums, and two pairs of thigh bone trumpets (»rkang dung«).[36] The two monks with

29 In another version, published in Doris Wiener's exhibition catalog (footnote 26), pl. L, there are rainbow paths right and left, and on the latter the great Fifth Dalai Lama is seen, preceded by monks playing trumpets or possibly gyaling.

30 Lauf (footnote 3), photographs of »vajra« and »ghaṇṭā« (»dril-bu«) are shown in pls. 38 and 39, with description on p. 100.

31 A photograph of a Gelugpa (dGe-lugs-pa) ritual in Lauf (footnote 3), pl. 50 with note on p. 124, shows each monk holding his scepter and bell.

32 Lauf (footnote 3), p. 91.

33 Chögyam Trungpa (footnote 3), pl. 34, commentary on p. 94.

34 See Olschak (footnote 7), pp. 126f.; Wiener (footnote 26), pl. K. The union of »yab yum« is seen in a »maṇḍala« for the Bardo, that state between one life and the next, in Francesca Fremantle and Chögyam Trungpa (trans. and eds.), The Tibetan Book of the Dead; The Great Liberation Through Hearing in the Bardo (Berkeley 1975), plate with the caption, ›The Host of the 42 Peaceful Deities‹. One of the fearful images which appears is the Great Heruka with six arms, clasping his indigo consort. Behind her back two of his hands hold the »vajra« and bell – the bell inverted like a cup, appearing as a receptacle for the scepter. Is the mystical union doubly expressed in such a painting? (Heruka also shakes a »damaru« in one right hand.) See also Chögyam Trungpa (footnote 3), pl. 37, Buddhasattva's bell; and Lauf (footnote 3), p. 75.

35 The Tibetan Book of the Dead (footnote 34), p. 23, states »If you try to frighten anybody by aggression and make your way out [of your karmic responsibility] on this day, the goddess with a very loud bell subdues your loud scream of aggression and your deep voice of anger.« The green goddess named Ghaṇṭā is the guardian of the north gate of the Bardo. And there is a male Ghaṇṭā. One of the eighty-four »mahāsiddhas« (saints and miracle workers) is Ghaṇṭāpā-da. In the Three Hundred Icons he is seen to hold the »dril-bu« in his left hand and flourish the »damaru« in his right. Olschak (footnote 7), p. 117, no. 14; see also Lowry (footnote 26), pp. 32f. Each of the five »Dhyani-Buddhas« (»rGyal-ba Rigs lNga«, meditation buddhas) requires the bell; see Olschak, p. 127, Icons 55–60; with them is the primordial Ādibuddha, Vajradhara (rDo-rje-hChang), no. 56, also bearing a bell. It must be clear that the iconography offers many examples of figures holding the bell and the drum. Instruments are familiar attributes and with each appearance is the intimation of the power of sound – whether or not the instrument is apparently being played. One of the meditation buddhas, Vajrasattva, carries a bell »in token of his vow of compassion not to abandon samsara [i.e., in simplest terms, the world, the unenlightened] and also portraying the seductive quality of the dharma«; Chögyam Trungpa (footnote 3), pls. 10 and 37, with note on p. 46.

36 The instrument, also called »rkang gling« (»thighbone flute«), is used in rituals of fierce deities, see Rinjing Dorje and Ellingson (footnote 23), pp. 66–72; and Giuseppe Tucci, The Religions of Tibet, trans. from the Italian (Berkeley 1980), pp. 89, 92, and 119f. The instrument also appears with the Mad Yogi of Bhutan, who rests a trumpet in his right hand on his lap. The trumpet indicates »he possesses the wisdom which sees samsara and nirvana as one«, see Chögyam Trungpa (footnote 3), p. 86, and pl. 30. Another reference, which emphasizes the Indian sources of Tibetan Buddhism, is in a thanka of the fearsome »mahākāla« with four heads and four arms, the Great Black One (Nag-po c'en-po). Below his main figure he appears again in small form »in a Brahman's aspect«, wearing a »dhoti«, sounding a

their backs to us, one hand concealed, the other in the air, like the two trumpeters seen in profile, are also probably playing trumpets, making two pairs.

The last instruments to be found are seen on the roof of the temple. Here two monks sound long trumpets with flaring bells, presumably of copper. They are not the spectacular giant instruments called »rag-dung« (or »dung-chen«, meaning great trumpet) to be seen in outdoor settings, but are »zangs-dung« (copper trumpet, approximately 75 cm. long, also called »dBang-dung«).[37] The shape of the instruments on the roof is typical. Tibetan metal trumpets with two or more telescoping sections are best described as terminating not in a bell but in a wide cylinder into which the upper sections slide when at rest. (Some trumpets, as the »dung-chen« or »rag-dung«, are as long as two meters or more, and must be specially supported when played.)

A few other examples, briefly examined, will demonstrate the uniqueness of this thanka among thankas on the same subject. In the Himalayan Collection of the Philadelphia Museum of Art is ›The Paradise of Padmasambhavam‹ (sic), which displays the basic iconography – the three-tiered palace on the island, the flying musicians above (*fig. 8*). But the accessory scenes which contain so many instruments in the thanka studied here are not included; for example, the two trios in the upper corners are replaced by two goddesses (the White and Green Tārās). The guru is flanked by his female disciples, his eight manifestations and also by his twenty-five disciples. There is no temple scene and no orchestra.

Two other variants with events not found in my model are in London museums, though not on public view at this writing and not published. The British Museum thanka no. 1906-5-25-5 includes the sky-going musicians, though fewer and without a cymbal player. A striking change at the right and left sides are groups of archers, each group with a trumpeter, possibly a reference to Padmasambhava's defense of his followers against heretics.[38] In the upper corner is a flutist rather than a lute player. The Guardian of the East plays his lute, though no bird distracts him (or us). There is no temple scene. The other example is in the Victoria and Albert Museum, no. 65-1965. Here are the basic elements with even more figures. An army with musicians also appears, on the left side a (Persian) timpani player, perhaps suggested by Mughal narrative painting.[39] On the right is a trumpet player (that is, a straight silver [?] instrument as are the two described above). Dhṛtarāṣṭra is seen below standing with a three-string lute.[40]

bone trumpet in his left hand and vigorously shaking a »damaru« with his right, see Tucci (footnote 4), vol. 3, pl. 201; commentary vol. 2, pp. 589f. Nebesky-Wojkowitz (footnote 16) states that loud music produced by instruments made of bones »is said to be pleasing to the angry guardians of the faith« (p. 398).

37 Cf. ›rGya-gLing Hymns of the Karma-Kagyu‹, in: Selected Reports in Ethnomusicology 1, no. 3 (Los Angeles 1970), pp. 80f. See the photograph in Valrae Reynolds, Tibet a Lost World (New York 1978), pp. 54f. For a time I assumed these were the double reed aerophone, »rGya gLing« (pronounced gyaling), also appropriate for outdoor performance, but gyaling are usually of dark wood with silver fittings and flaring bell, and characteristically provide the melody within an ensemble. Another aerophone, however, which is sounded from an upper story of a temple, is the »kar gLing«, a brass trumpet with a flat bell, also not what the artist has drawn. I confess my regret at not locating the reedy gyaling anywhere in this thanka for their appearance would all but complete a roster of monastery instruments. We may resist the temptation to assign them to the two monks with their backs to us because gyaling, unlike bone trumpets, have seven finger holes and require two hands to play! Tucci (footnote 36) pp. 117–121, illustrates and identifies thirteen instruments used in the liturgies of various sects.

38 Tucci (footnote 4), vol. 2, p. 605; Chögyam Trungpa (footnote 3), p. 64.

39 For example, ›Rejoicings on the Birth of Prince Salīm at Fathpur-Sikri in 1569‹, in: Anonymous, Indian Art (= Victoria and Albert Museum Large Picture Book no. 36; London 1969), pl. 30.

40 For other published examples of this paradise type, see Lauf (footnote 3), pl. 14, text, p. 52; Olschak (footnote 7), p. 82 (an exquisitely simple design, but one which, so far as I can make out, contains not one figure with an instrument), see also pp. 24f. Another source is the series of color prints of Dharma Publishing (Berkeley s. a.), no. 16. Some others in a noted American collection are published in Eleanor Olson, Catalog of the Tibetan Collections and other Lamaist Material in the Newark Museum (Newark/New Jersey 1971), vol. 3 ›Images and Molds – Painting‹, pls. 42 and 48.

It has been noted that the guru in his »primary form«, holding his staff, does not require any musical instrument. In the iconography of three of his eight manifestations, he holds a drum or a bell, and there may be attendant musicians. In the woodblock of Padma Gyalpo, the Lotus King (see footnote 9), the guru is shaking the »damaru« while two attendants ring bells and a standing female plays a lute. It is a lute with six pegs – and no strings! In a style that indefatigably supplies individual beads in a necklace and petals in every flower, such omission seems curious indeed. Apparently lute strings have no symbolical meaning here and are not a canonic necessity.

Padmasaṃbhava is the subject of many thankas, such as those depicting his lineage, his previous manifestations, or his disciples. These designs should be distinguished from the paradise of the copper-colored mountain discussed here, although a musical instrument is sometimes to be seen.[41] There are also other paradise scenes which include musicians, such as the Potala Heaven of Avalokiteśvara, the Buddha of Infinite Compassion.[42]

I must confess that I found one thanka, not a paradise scene, which includes more instruments than my subject, but in a strange context: no one is visible to play on them. The painting, oblong in shape, is ›The Banquet of the Dharmapālas‹, in the Philadelphia Museum.[43] A great assemblage of ritual objects is displayed on altars, racks, and the floor. Armor, skins, flowers, jewels, elixirs are offered to the Defenders.[44] Animal mounts – lions, tigers, goats, yaks, horses – posed right and left, impatiently await their celestial riders. Dozens of musical instruments of the kinds discussed here rest about the main altar, as well as a large hanging gong and a Chinese drum. But the instruments lie silent; there are no musicians. The »dharmapālas« likewise are not present. Their thrones remain vacant. Since the initiate is to visualize the deities (and himself?) in a living scene, the near motionless tableau projects an uncanny mood.[45] In many of the previous examples we can imagine the sounds of the vigorous musical performances depicted; they are »loud« pictures. In the ›Banquet‹ the effect is a suspenseful silence, the awesome tones of Tibetan music yet to be initiated. But does this scene take place in silence? It may be that these divine horns, drums, and cymbals are »deva-like« instruments which play the »sound of the dharma« continually, untouched by hands.[46]

The complex, arcane art of Tibet presents formidable challenges despite the recent publishing achievements of Western scholars and not a few expatriate Tibetans. All iconographical art demands the application of the relevant literary or traditional roots. In much Western religious art, especially in realistic styles, a general, even universal meaning may be extracted. However,

41 Compare Tucci (footnote 4), vol. 3, pls. 149 and 150, which include dancers with pole drums in the lower left; the commentary is in vol. 2, p. 548. See other examples in Tarthang Tulku (footnote 5), pls. 15, 16 and 17. A highly concentrated design painted in 1961 by Lama Chögyam Trungpa, ›Vision of Guru Rinpoche‹, should be examined also, in Fremantle and Chögyam Trungpa, The Tibetan Book of the Dead (footnote 34), facing p. 8; and in black and white reproduction in Chögyam Trungpa, Visual Dharma (footnote 3), p. 67.

42 Tucci (footnote 4), vol. 3, pl. 153, commentary, vol. 2, pp. 551–553; Doris Wiener catalog (footnote 26), pl. F; in the Victoria and Albert Museum, no. 61–1965 (unpublished).

43 Stella Kramrisch, ›The Art of Nepal and Tibet‹, in: Philadelphia Museum of Art Bulletin 55/265 (1960), pp. 30f., a photograph of the thanka; there is no discussion of it, however, in the accompanying article marking the then newly organized Gallery of Nepalese and Tibetan Art.

44 For the iconography of offerings to the »dharmapālas« read Nebesky-Wojkowitz (footnote 16), pp. 400–402.

45 See Nebesky-Wojkowitz (footnote 16), p. 20, on the level of reality of the court of the »dharmapālas«. Tucci (footnote 36), p. 117, states: »Here reality is transformed onto a plane of the imagination which is attributed by virtue of meditation a new, more real and more intense reality than normal everyday existence. An imaginary plane is reached, on which both the sacrificer and the whole feast (›mgron‹) to which the imagined divine guests are invited come together in an apotheosis transcending space and time.«

46 Suggested by John C. Huntington, personal correspondence, 27 February 1981.

Tibetan religious art cannot be reduced to simplistic messages about »ordinary« people. The reason is not because idealized or symbolic forms are used (since, on the contrary, the rendering of the figures is almost always highly realistic, if sometimes stylized), but rather because a generalization erases the distinctive identification of the subject and the only purpose for the painting.

Catalogus
A Corpus of Trecento Pictures
with Musical Subject Matter, Part I

Howard Mayer Brown

Introduction

The study of paintings, manuscript illuminations, sculpture, and so on, for what they can tell us about the music of the past – that is, the relatively young discipline of musical iconography – has been hampered by the fact that scholars have not had easy access to repertories of pictures created over a relatively short period of time in a particular country. Certain tentative conclusions about musical topoi, the place of music in society, the use of instruments, the history of their change over time, and about various other aspects of musical performance, can be made using whatever pictures come to hand from many centuries and a variety of countries. But systematic and careful study of pictures as musical evidence will ultimately depend on placing each object within a well-defined historical and artistic context. In order to understand fully what the artist intended, we must study individual pictures in relation to other pictures made by the same artist, by his contemporaries and immediate predecessors and successors. A number of recent studies have done just that.[1] In spite of such studies, though, we are still at the very beginning of the process of collecting material and preparing basic bibliographic studies, necessary preliminary steps before we can begin to evaluate the material in order to learn just what pictures can teach us about music. The collection of pictures from fourteenth-century Italy published here and in the next several issues of Imago Musicae, forms a repertory from a particular time and place that may prove useful to scholars in their attempts to discover not only what music sounded like six hundred years ago, but also what place it had in society and how its changing image in art revealed people's beliefs then. I myself have already attempted to assess and evaluate in a variety of ways some of the pictures listed here,[2] but the process of trying to understand the past is long and difficult and the effort will take many years. I hope that this corpus of trecento pictures can help historians of both music and art to approach the fourteenth century more easily as they confront problems of various kinds.

1 I think immediately of Genette Foster's 1977 dissertation for the City University of New York, ›The Iconology of Musical Instruments and Musical Performance in Thirteenth-Century French Manuscript Illuminations‹, Tilman Seebass, Musikdarstellung und Psalterillustration im früheren Mittelalter, 2 vols. (Bern 1973), Richard D. Leppert, The Theme of Music in Flemish Paintings of the Seventeenth Century, 2 vols. (München and Salzburg 1977), Leppert's Arcadia at Versailles (Amsterdam and Lisse 1978), and various works in progress, such as the dissertation for The University of Chicago on music in French and Flemish books of hours in the fifteenth century now being written by Margaret Boyer Owens. Other recent works that take account of the historical and artistic context of paintings, but without concentrating on a single country and period, include various studies by Reinhold Hammerstein, and especially his most recent book, Tanz und Musik des Todes: Die mittelalterlichen Totentänze und ihr Nachleben (Bern and München 1980), a number of essays by James McKinnon, and Hugo Steger, David Rex et Propheta (Nürnberg 1961).

2 See the following of my essays: ›Trecento Angels and the Instruments They Play‹, in: Modern Musical Scholarship, ed. Edward Olleson (Stocksfield 1978), pp. 112–140; ›Music in Trecento Wedding Processions‹, in: Acta scientifica: Musica antiqua V (Bydgoszcz 1978), pp. 467–482; ›The Trecento Harp‹, to be published in the Proceedings of the Conference on Performing Practice at New York University in October 1981; ›St. Augustine, Lady Music and the Gittern in Fourteenth-Century Italy‹, to be published in the Proceedings of the Conference on Music in Society at Bressanone, August 1982; and ›Ambivalent Trecento Attitudes Towards Music‹, to be published in a book of essays honoring Professor John Ward.

The reasons why I began to collect pictures from fourteenth-century Italy systematically are many, various, and doubtless not altogether conscious or rational. Trecento pictures constitute a well defined corpus of material. They are relatively well studied by art historians. They are easier of access than, say, late medieval French pictures, since Italian artists painted so many large altarpieces and other panel paintings originally displayed in public places and now collected for the most part in museums and churches, whereas French painters specialized in book illustrations that have not been so well studied, and are not as widely reproduced in art historical literature. Perhaps most important, as a scholar who has worked mostly in French and Italian music of the fifteenth and sixteenth centuries, I thought it advisable to begin a repertory study of pictures with the fourteenth century simply because so many artistic traditions that affect the depiction of music began then. Italian painters before the fourteenth century apparently limited their representations of musical instruments and musical performance largely to pictures of David in liturgical books, to angels blowing trumpets at the Last Judgment, and to a few other subjects that seem to derive from earlier medieval traditions and that are not apt to tell us directly very much about social reality. With the beginning of the fourteenth century, Italian artists began to include many more musicians in their paintings – largely angels, to be sure – and in many cases their pictures can be shown to have a direct relationship with social reality since artists often interpreted Biblical, hagiographic, or legendary stories in modern everyday terms, so that they would be more immediately relevant to their first viewers. In short, many of the artistic traditions relating to musica practica began for the first time in the fourteenth century, and it is therefore crucial to understand fourteenth-century conventions in studying fifteenth- or sixteenth-century pictures with musical subject matter. It seemed to me that a repertory of trecento pictures formed a collection of evidence relatively easily related to the life of the times, and at the same time revealed how musical conventions in Renaissance art began. Something of the same idea was doubtless in the minds of Sydney R. Charles and David D. Boyden when they prepared a mimeographed pamphlet, ›Musical Instruments in Paintings: An Index to Reproductions of Fourteenth-Century Italian Paintings showing Musical Instruments‹ at the University of California, Berkeley, in 1961. Their aims were more modest – they list 86 pictures in all, as opposed to the more than one thousand pictures that will eventually appear in this corpus – but theirs was a useful beginning that has served me in many ways as a model.

The Corpus of Trecento Pictures with musical subject matter will be divided into five parts:

(1) pictures (panel paintings, frescoes and mosaics) signed by or attributed to particular artists or their followers, arranged alphabetically by artist,

(2) pictures not attributable to a particular artist, arranged alphabetically by present location (with the »homeless« paintings at the end),

(3) sculpture, whether attributed or not, arranged alphabetically by present location,

(4) manuscript illuminations and drawings, whether attributed or not, arranged alphabetically by present location, and

(5) needlework, enamels, and other examples of the minor arts, whether attributed or not, arranged alphabetically by present location.

Each object is identified with a single number for ease of reference. Thus, Corpus no. 6 refers to the anonymous Virgin and Child on the Bevilacqua tomb in the Cappella Pellegrini of the Church of Sant'Anastasia in Verona, attributed to a follower of Altichiero, and Corpus no. 101 refers to the Coronation of the Virgin in Altenburg, Staatliches Lindenau-Museum, attributed to Bernardo Daddi.

I have tried, wherever possible, to supply the following information about each object: the name of the artist who signed the work or to whom the work is attributed, with the dates of his birth and death or the years during which he can be documented, and the principal city where he worked; a standardized title (such as ›Virgin and Child‹ or ›Virgin and Child, with saints and angels‹) along with some indication of the main subject matter if the picture with musical subject matter is part of a larger work (such as ›Life of the Virgin: Nativity‹, ›Life of Christ: Nativity‹, ›Polyptych with predella showing Feast of Herod‹); the date appearing on the picture, or an approximate date when the work may have been created; the museum, church, or collection where the picture is presently located, or where it was last known to have been located, and its inventory number, if known; the medium of the object; a brief summary of the musical objects or sort of musical performance depicted; the source of the photograph reproduced in the Corpus; and a highly selective bibliography, where more information about each work or its artist may be found.

In short, I have tried to keep each entry as brief and simple as I could, while identifying each object as precisely as possible, describing its musical content, and informing the reader where he can find more information. The format of each entry represents a simplification of the procedures described in H. M. Brown and Joan Lascelle, ›Musical Iconography: A Manual for Cataloguing Musical Subjects in Western Art Before 1800‹ (Cambridge/Massachusetts 1972).

Art historians spend much more time and energy debating questions of attribution and chronology than music historians do. Thus many of the attributions in the following list reflect current opinion and are subject to revision. Anonymous paintings thought by art historians to be influenced by a master, paintings thought to have been created in the workshop of a master, and those painted by a master's assistant or student are all grouped together at the end of each painter's more securely attributed œuvre. Paintings thought to be related to one another in style and thus to be the work of one man even though he cannot be definitely identified, are traditionally attributed by reference to his best known painting or to some stylistic trait, as the Master of the Arte della Lana, the Master of Bambino Vispo, and so on. These groups of paintings are listed together in the alphabetical ordering of Section One under »Master«, except in the rare case where an individual has been identified, such as the Master of the Fabriano Altarpiece, now tentatively known as Puccio di Simone, and therefore listed under Puccio in the alphabetical ordering. In an effort to help readers identify paintings attributed variously, I have included a good many cross references among the main entries, and more cross references will appear in later installments of this list. Readers will also find the topographical index that will appear at the end of each installment useful in finding paintings listed here with an attribution different from that found in one or another book or article.

Some paintings are signed and dated, and those facts have been noted in the following list. Most paintings, however, are not signed and dated, and I have added the approximate years when the painting was made only in those cases where art historians seem to agree on the chronology, or where recent studies have suggested an approximate chronology for the works of a particular artist or a particular work. Needless to say, these approximate dates are tentative and subject to revision. They do not reflect anything more than what I take to be the current state of opinion in art historical circles.

The name of the museum, church, or collection where each painting is presently located is included in the following list, or the collection where the painting was last known to be located, along with an inventory number, if that is known. Italian churches are listed simply by their dedicatory saint or a short form of their full title (for example, Verona, S. Anastasia, and Verona,

S. Fermo, rather than Chiesa di Sant'Anastasia and Chiesa di San Fermo), and cathedrals are listed as »Cathedral« (rather than »Duomo« or whatever) regardless of their geographical location. Not all the private collections identified in the following list still exist. In those cases where I have reason to believe that the collection is dispersed, I have indicated the painting as having been »formerly« there (as is the case, for example, with Corpus no. 36, the Coronation of the Virgin by Barnaba da Modena, formerly in the collection of Richard M. Hurd in New York, whose present whereabouts is unknown). I have adopted Bernard Berenson's terminology to identify those paintings whose present whereabouts are unknown as »homeless«. It has seemed advisable to publish such paintings for what additional information they give us and in the hope that some of them may be found as a result of their publication here.

The descriptions of the musical activity in the following list have been kept as brief and simple as possible. I have identified instruments by their generic names – fiddle, bagpipe, lute, and so on – without adding any information about the structural details or the playing technique depicted in a particular painting, in order to keep the list to a manageable size, and because in many cases questions of interpretation, requiring extensive explanation, would be involved in any more elaborate description.[3] Moreover, readers interested in a particular type of instrument need to be encouraged to examine carefully all the examples of the generic type.

The bibliography for each painting is short and highly selective. I have included references to the lists of Italian pictures prepared by Bernard Berenson (BerensonCN, BerensonF and BerensonV in the bibliography) wherever these mention a painting included here, to van Marle's ›Development of the Italian Schools of Painting‹, still the standard and most useful survey of the subject, to more recent catalogues of each artist's work, if such exist (such as the extensive catalogues of later Florentine painters in BoskovitsPF and the catalogues that appear in monographs on individual artists), to museum catalogues, monographs and periodical articles, especially those published within the past twenty-five years, and to regional studies. The bibliography is not intended to be comprehensive, but rather to help orient the reader to the art historical literature about particular works. Many of the bibliographical references are to studies where a more complete bibliography can be found.

The following indexes will appear at the end of each installment of the Corpus of Trecento Pictures: a bibliography spelling out the abbreviations found in the lists themselves, a topographical index of locations where the pictures are presently housed (helpful also in identifying works of uncertain or disputed authorship), an index of instruments shown in the pictures, an index of the principal subject matter of the pictures with music, and an index of photo sources. These indexes will be gathered together and re-published at the end of all the installments to furnish an easy way of access to the entire repertory of pictures.

Although the Corpus is said to contain trecento pictures, I have not been pedantically rigorous in following the chronological limits. Some thirteenth-century pictures appear in the lists, and some created during the first decades of the fifteenth century. In general, I have not systematically collected works by artists who died before 1300, and I have tried to exclude works

3 In most cases the kind of instruments depicted is clear and unambiguous. Wind instruments, on the other hand, tend to look alike, and readers may wish to challenge some of my decisions to label an instrument a shawm rather than a recorder or trumpet (the term »bowed gittern« in Corpus no. 77 is likewise open to challenge). I have called plucked stringed instruments with sickle-shaped pegboxes gitterns, and those with bent-back pegboxes lutes, regardless of the shapes of their bodies. And I have labeled as »unclear instruments« all those of which I was uncertain, because the photograph was insufficiently detailed, or because the work of art has deteriorated or the artist gave us insufficient information to enable us to reach a clear conclusion.

by artists who were born after about 1380. The selection of thirteenth- and early fifteenth-century pictures is more random and arbitrary than those created in the fourteenth century, but it seemed advisable to adopt a relaxed policy of inclusion rather than to follow the chronological limits strictly, simply for the sake of the additional information that could thus be gathered.

It should be self-evident that the Corpus does not include every picture created during the fourteenth century that still survives. The Corpus is not complete, nor could such a repertory ever be absolutely complete. In truth, the ideal of completeness is a kind of chimera that can easily lead us never to do anything, since we can never do everything. The hopelessness of ever gathering together everything from fourteenth-century Italy that has survived to the present day should be especially apparent in considering the problem of collecting manuscript illuminations. Illuminated liturgical manuscripts from fourteenth-century Italy survive in great numbers in many churches in Italy, and various sorts of trecento manuscripts can be found in every major library in the world. No one person can survey this vast material, and the list of manuscript illuminations and drawings, therefore, should be taken merely as a random sampling of what survives. The principal point of making this list is simply to assemble a sizable repertory of works of art created during a particular time in a particular country in order to begin to be able to make generalizations about conventions and regional differences based on a collection of information that is much more than a random sample of one or two bits of evidence, even if it is not absolutely complete. On the other hand, I shall very much welcome additions and corrections to the list.

The incompleteness of the Corpus is not its only shortcoming. Every art historian will challenge some of the attributions, or the approximate dating of the undated works, some of the present locations are vague or non-existent, and I have doubtless missed important recent studies of some works. In one sense, the corpus is merely a preliminary sorting out of a vast amount of material so that scholars can more easily identify those relatively few works of art that interest them for one reason or another. But with all its faults and shortcomings, the Corpus can nevertheless be enormously useful as the starting point for any number of studies evaluating the material listed here: studies of the conventions artists employed in using music as a subject, of regional differences, chronological changes, individual preferences and skills of artists, and of iconographic themes, as well as histories of particular instruments and even of combinations of instruments.

Indeed, in preparing these lists, I have tried to keep in mind that the Corpus will be used for a variety of purposes, not all of which I can foresee, and I have therefore tried to be as inclusive as possible. My first inclination, for example, was to omit from the lists all of the angels who blow trumpets at the Last Judgment and all of the soldiers playing the trumpet at Christ's Crucifixion, and the men who blow horns at the Mocking of Christ. It is improbable that such pictures will ever prove useful in the study of the history of polyphony in fourteenth-century Italy. But the study of polyphony is not the only subject worth attention. Trumpet-playing angels and mockers with horns may well tell us things we ought to know about the establishment of musical subjects in the history of art, or about the dissemination of images in western Europe at the time, or about something else that I cannot yet imagine, and therefore such pictures have been included in the Corpus. A survey of the King Davids in the Corpus, for example, reveals that he is normally shown in Italian pictures playing the psaltery – a conclusion that can be firmly documented only by examining a large, albeit incomplete collection of pictures such as the Corpus – and that fact may well have important implications for the way the Biblical word »cithara« was translated by Italians, and it can be used to help show French influence in Italy in those cases where David is

shown playing or tuning a harp, and so on. In short, however pedantic or tedious it may seem to document every instance of King David in trecento art, conclusions important for our understanding of the culture of the past may well depend on the retrieval of such information.

Nevertheless, some categories of musical subject matter in trecento art are perhaps underrepresented in the Corpus. It may be, for instance, that I have missed examples of angels playing trumpets at the Last Judgment, soldiers playing trumpets at the Crucifixion, and shepherds holding or playing bagpipes in scenes of the Nativity. Most important, I have not always included groups of angels adoring the Christ Child held by the Virgin Mary or shown at the Nativity (even when the angels hold a book that might well have been intended to suggest they are singing »Gloria in excelsis Deo«), or groups of clerics shown at funerals and in procession, all of whom may or may not be singing. In a metaphorical way, we can of course imagine that groups of angels are always intended to be singing for joy; their presence in a painting was surely intended to signify as much. But unless the angels or clerics have their mouths wide open, or a choirbook lies open at a lectern, it is by no means clear that all such groups were intended actually to be singing. In any case, most paintings depicting the Virgin and Child, and many showing the Nativity, portray such groups of angels. Including them in the Corpus would considerably extend the length of the lists without adding any new information.

Compiling the Corpus of Trecento Pictures would not have been possible without the help of many people and institutions. I am especially grateful to the Fototeca Berenson at Villa I Tatti, the Harvard University Center for Italian Renaissance Studies in Florence, where I began the task of systematically collecting trecento pictures, and to various other picture collections: the Max Epstein Archive at The University of Chicago, the Witt Collection at The Courtauld Institute in London, the Frick Art Reference Library in New York, and the Photographic Archive of The National Gallery of Art in Washington, D.C. Moreover, the curators and staff of many of the public institutions that own trecento works of art have been unfailingly kind and helpful in answering my enquiries and in sending me photographs. I am grateful to them all, and to the friends who from time to time have supplied me with information about particular pictures. I owe a special debt of gratitude to Gordon Bowie, photographer for The University of Chicago Hospitals, and to my research assistant, Margareth Boyer Owens, for service above and beyond the call of duty.

Bibliography

AntalFP	Frederick Antal, Florentine Painting and its Social Background (London 1948).
ArslanTA	Edoardo Arslan, ›Una tavola di Altichiero e un affresco di Turone‹, in: Commentari 11 (1960), pp. 103–106.
BattistiC	Eugenio Battisti, Cimabue (University Park, Pennsylvania, 1967).
BeenkenU	Hermann Beenken, ›Das Urbild der sienesischen Assuntadarstellungen im XIV. und XV. Jahrhundert‹, in: Zeitschrift für bildende Kunst 62 (1928/29), pp. 73–85.
BellosiDN	Luciano Bellosi, ›Due note per la pittura fiorentina di secondo trecento‹, in: Mitteilungen des kunsthistorischen Institutes in Florenz 17 (1973), pp. 179–194.
BenedictisPS	Cristina de Benedictis, La pittura senese 1330–1370 (Firenze 1979).
BerensonCN	Bernard Berenson, Italian Pictures of the Renaissance . . . Central Italian and North Italian Schools, 3 vols. (London 1968).
BerensonF	Bernard Berenson, Italian Pictures of the Renaissance . . . Florentine School, 2 vols. (London 1963).
BerensonH	Bernard Berenson, Homeless Paintings of the Renaissance, ed. Hanna Kiel (Bloomington, Indiana, and London 1969).
BerensonV	Bernard Berenson, Italian Pictures of the Renaissance . . . Venetian School, 2 vols. (London 1957).
BertauxSM	Emile Bertaux, Santa Maria di Donna Regina e l'arte senese a Napoli nel secolo XIV (Napoli 1899).
BertoliniPisaC	Livia Bertolini and Mario Bucci, Camposanto monumentale di Pisa (Pisa 1960).
BirminghamH	The University of Birmingham. Handbook of the Barber Institute of Fine Arts (Birmingham 1949).
BolognaPN(1979)	La pinacoteca nazionale di Bologna. Notizie storiche e Itinerario. Servizi didattici (Bologna 1979).
BoskovitsC	Miklòs Boskovits, ›Ein Vorläufer der spätgotischen Malerei in Florenz: Cenni di Francesco di Ser Cenni‹, in: Zeitschrift für Kunstgeschichte 31 (1968), pp. 273–292.
BoskovitsPF	Miklòs Boskovits, Pittura fiorentina alla vigilia del Rinascimento, 1370–1400 (Firenze 1975).
Boston MFA Cat	Summary Catalogue of European Paintings in Oil, Tempera and Pastel (Boston, Museum of Fine Arts, 1955).
Brigstocke Edinburgh Cat	Hugh Brigstocke, Italian and Spanish Paintings in the National Gallery of Scotland (Edinburgh 1978).
CarliBF	Enzo Carli, Bartolo di Fredi a Paganico (Firenze s. a.)
CarliDA	Enzo Carli, ›La data degli affreschi di Bartolo di Fredi a San Gimignano‹, in: Critica d'Arte 8 (1949), pp. 75f.
Carli Montalcino Cat	Enzo Carli, Montalcino, Museo civico, Museo diocesano d'arte sacra (Bologna 1972).
CarliPPT	Enzo Carli, Pittura pisana del trecento, 2 vols. (Milano 1961).
CecchiniSG	Giovanni Cecchini and Enzo Carli, San Gimignano (Milano 1962).
ColettiA	Luigi Coletti, Gli affreschi della Basilica di Assisi (Bergamo 1949).
ColettiP,3	Luigi Coletti, I primitivi, vol. 3: I Padani (Novara 1947).
Crowe/Cavalcaselle	J. A. Crowe and G. B. Cavalcaselle, A History of Painting in Italy, 3 vols. (London 1908–1909).
De BosqueAI	A. De Bosque, Artistes italiens en Espagne, du XIVe siècle aux rois catholiques (Paris 1965).
DeWaldMO	Ernest T. DeWald, ›The Master of the Ovile Madonna‹, in: Art Studies 1 (1923), pp. 45–54.
Emiliani BolognaPN	Andrea Emiliani, La pinacoteca nazionale di Bologna (Bologna 1967).
FaldiPV	Italo Faldi, Pittori viterbesi di cinque secoli (Roma 1970).

FilippiniAB Francesco Filippini, ›Andrea da Bologna miniatore e pittore del XIV secolo‹, in: Bollettino d'arte del Ministero della Pubblica Istruzione 5 (1911), pp. 50–62.

FogolariGF G. Fogolari, The Giorgio Franchetti Gallery in the Ca d'oro in Venice (Roma 1950).

FrancescoSA Francesco d'Assisi. Storia e arte (Milano 1982).

Fredericksen Getty Cat Burton B. Fredericksen, Catalogue of the Paintings in the J. Paul Getty Museum (Malibu 1972).

FremantleA Richard Fremantle, ›An Addition to Antonio Veneziano‹, in: Burlington Magazine 116 (1974), pp. 526–529.

FremantleFG Richard Fremantle, Florentine Gothic Painters from Giotto to Masaccio (London 1975).

GarrisonIRP E. B. Garrison, Italian Romanesque Panel Painting (Firenze 1949).

HammersteinME Reinhold Hammerstein, Die Musik der Engel (Bern and München 1962).

Heinemann Thyssen Cat Rudolf Heinemann (ed.), Catalogue of the Thyssen-Bornemisza Collection (Lugano–Castagnola 1969).

HetheringtonPC Paul Hetherington, Pietro Cavallini. A Study in the Art of Late Medieval Rome (London 1979).

IP Italian Primitives. The Collection of Richard M. Hurd, Esq. May 1937 (New York, Newhouse Galleries, 1937).

LangascoCF Cassiano da Langasco and Pasquale Rotondi, La ›Consortia deli Foresteri‹ a Genova, Una Madonna di Barnaba da Modena e uno statuto del trecento (Genova 1957).

London NG Cat Martin Davies, The Earlier Italian Schools, 2nd rev. ed. (London, National Gallery, 1961).

LonghiFM Roberto Longhi, ›Fatti di Masolino e di Masaccio‹, in: Critica d'arte 25/26 (1940), pp. 180ff.

LonghiMTB Roberto Longhi, ›La mostra del trecento Bolognese‹, in: Paragone 5 (1950), pp. 5–23.

van Marle Raimond van Marle, The Development of the Italian Schools of Painting, 19 vols. (Den Haag 1923–1938).

MatthiaePC Guglielmo Matthiae, Pietro Cavallini (Roma 1972).

MeissPF Millard Meiss, Painting in Florence and Siena after the Black Death (Princeton 1951).

MeissRA Millard Meiss, ›Reflections of Assisi: A Tabernacle and the Cesi Master‹, in: Scritti di storia dell'arte in onore di Mario Salmi, vol. 2 (Roma 1962), pp. 75–111.

MelliniA Gian Lorenzo Mellini, Altichiero e Jacopo Avanzi (Milano 1965).

Milan Cat AL Arte Lombarda dai Visconti agli Sforza, introduced by Roberto Longhi (Milano 1958).

Moscow Pushkin Cat (The Pushkin Fine Arts Museum Moscow) (Leningrad 1975).

New York Met Cat Katharine Baetjer, European Paintings in the Metropolitan Museum of Art by artists born in or before 1865, 3 vols. (New York 1980).

NicholsonC Alfred Nicholson, Cimabue, A Critical Study (Princeton etc. 1932).

Oertel Altenburg Cat Robert Oertel, Frühe italienische Malerei in Altenburg (Berlin 1961).

Offner Richard Offner, A Critical and Historical Corpus of Florentine Painting, 16 vols. (New York 1931–1981).

OffnerSF Richard Offner, Studies in Florentine Painting. The Fourteenth Century (New York 1927).

OffnerSuppl Richard Offner, Supplement to A Critical and Historical Corpus of Florentine Painting (New York 1981).

Oxford Ashmolean Cat A Catalogue of the Earlier Italian Paintings in the Ashmolean Museum, compiled by Christopher Lloyd (Oxford 1977).

PallucchiniPV Rodolfo Pallucchini, La pittura veneziana del trecento (Venezia and Roma 1964).

Paris Louvre Cat Catalogue sommaire illustré des peintures du Musée du Louvre, vol. 2: Italie, Espagne, Allemagne, Grande-Bretagne et divers, ed. Arnauld Brejon de Lavergnée and Dominique Thiébaut (Paris 1981).

Pasadena Simon SP Selected Paintings at the Norton Simon Museum, Pasadena, California, introduced by Frank Herrmann (London and New York 1980).

PettenellaA Plinia Pettenella, Altichiero e la pittura veronese del trecento (Verona 1961).

Pistoia Cat MC Museo civico di Pistoia. Catalogo delle collezioni, ed. M. C. Mazzi (Firenze 1982).

PrevitaliG Giovanni Previtali, Giotto e la sua bottega (Milano 1967).

ProcacciBC Ugo Procacci, ›Bonaccorso di Cino e gli affreschi della Chiesa del Tau a Pistoia‹, in: Atti del congresso internazionale per la celebrazione del VII centenario della nascità di Giotto (Roma 1971), pp. 349–359.

RicartPG José Gudiol Ricart, Pintura gótica, Ars Hispaniae, vol. 9 (Madrid 1955).

Richmond Cat European Art in the Virginia Museum of Fine Arts. A Catalogue (Richmond/ Virginia 1966).

RigatusoBF Lucia Rigatuso, ›Bartolo di Fredi‹, in: La Diana 9 (1934), pp. 214–267.

Rohoncz Cat Sammlung Schloß Rohoncz. Gemälde (München 1930).

RowleyAL George Rowley, Ambrogio Lorenzetti, 2 vols. (Princeton 1958).

SalmiS Mario Salmi, ›Spigolature d'arte toscana‹, in: L'Arte 16 (1913), pp. 208–227.

SalmiSPP Mario Salmi, ›Per la storia della pittura a Pistoia ed a Pisa‹, in: Rivista d'arte 13 (1931), pp. 451–476.

San Gimignano Guide Jole Vichi Imberciadori, San Gimignano of the Beautiful Towers (Terni [1982]).

Santi Perugia Cat Francesco Santi, Die Nationalgalerie von Umbrien in Perugia (Roma 1964).

SaxlHI Fritz Saxl, A Heritage of Images. A Selection of Lectures (Harmondsworth 1970).

Seymour Yale Cat Charles Seymour, Jr., Early Italian Paintings in the Yale University Art Gallery (New Haven and London 1970)

ShapleyPK Fern Rusk Shapley, Paintings from the Samuel H. Kress Collection. Italian Schools. XIII–XIV Century (London 1966).

Shapley Washington IP Fern Rusk Shapley, Catalogue of the Italian Paintings. National Gallery of Art, Washington, 2 vols. (Washington 1979).

Shaw Oxford Cat J. Byam Shaw, Paintings by Old Masters at Christ Church, Oxford (London 1967).

SienesePH Sienese Paintings in Holland . . . Groningen . . . 1969, Utrecht . . . 1969, ed. H. W. Van Os (Leiden 1969).

SimonA Robin Simon, ›Altichiero versus Avanzo‹, in: Papers of the British School at Rome 45 (1977), pp. 252–271.

SindonaC Enio Sindona, L'opera completa di Cimabue e il momento figurativo pregiottesco (Milano 1975).

SinibaldiPI Giulia Sinibaldi and Giulia Brunetti, Pittura italiana del duecento e trecento. Catalogo della mostra giottesca di Firenze del 1937 (Firenze 1943).

SupinoSFA I. B. Supino, La Basilica di San Francesco d'Assisi (Bologna 1924).

SymeonidesTB Sibilla Symeonides, Taddeo di Bartolo (Siena 1965).

Symeonides Venice Cat Sibilla Symeonides, Fourteenth and Fifteenth Century Paintings in the Accademia Gallery, Venice (Firenze 1977).

Toesca Pietro Toesca, Storia dell'arte italiana, vol. 2: Il trecento (Torino 1951).

ToescaPC Pietro Toesca, Pietro Cavallini (New York 1960).

TorritiPNS Piero Torriti, La pinacoteca nazionale di Siena, i dipinti dal XII al XV secolo (Genova 1980).

Uffizi Cat Gli Uffizi. Catalogo generale (Firenze 1979).

Vatican Pin Ennio Francia, Pinacoteca Vaticana (Milano 1960).

VavalàCD Evelyn Sandberg Vavalà, La croce dipinta italiana e l'iconografia della passione (Verona 1929).

VitaliniSC G. Vitalini Sacconi, Pittura marchigiana. La scuola Camerinese (Trieste 1968).

VolpePR	Carlo Volpe, La pittura riminese del trecento (Milano 1965).
WhiteD	John White, Duccio. Tuscan Art and the Medieval Workshop (London 1979).
Zeri Baltimore Cat	Federico Zeri, Italian Paintings in the Walters Art Gallery, 2 vols. (Baltimore/Maryland 1976).
ZoccaA	Emma Zocca, Catalogo delle cose d'arte e di antichità d'Italia: Assisi (Roma 1936).

Index of Places

Altenburg, Staatliches Lindenau-Kunstmuseum 101

Arezzo, Museo comunale 24

Assisi, S. Francesco 13, 83, 84

Baltimore, Walters Art Gallery 58

Berlin, Staatliche Museen Preußischer Kulturbesitz 59, 102

Birmingham, The Barber Institute of Fine Arts 37

Boston Museum of Fine Arts 41

Camerino, Monastero di S. Chiara 86

Chianciano, Collegiata di S. Giovanni Battista 56

Crespina (Pisa), S. Michele Arcangelo 91

Edinburgh, National Gallery of Scotland 103

Eindhoven, Philips-de Jong Collection 117

Florence, Accademia 104, 105

Florence, Acton Collection 92

Florence, Bellini Collection 75

Florence, Gallerie fiorentine 24, 76

Florence, S. Giovannino dei Cavalieri 60

Florence, S. Maria Novella 17, 18, 19, 20, 21

Florence, Uffizi 106

Florence, Ventura Collection 107

Hannover, Niedersachsisches Landesmuseum 25

London, National Gallery 34

London, Straus Collection 93

Longleat, Marquess of Bath Collection 94

Lucignano (Val di Chiana), S. Francesco 42

Lugano-Castagnola, Thyssen-Bornemisza Collection 77

Malibu, J. Paul Getty Museum 78

Milan, private collections 4, 85

Montalcino, Museo civico 43

Moscow, Pushkin Museum 95

Murcia, Cathedral 35

Naples, S. Maria di Donna Regina 71, 72, 73, 74

New Haven, Yale University Art Gallery 96

New York, Hurd Collection 36

New York, Metropolitan Museum of Art 38, 44

Offida (near Ascoli Piceno), S. Maria della Rocca 14, 15, 16

Oxford, Ashmolean Museum 5

Oxford, Christ Church 108

Padua, Basilica del Santo (S. Antonio) 1, 2

Padua, Oratorio di S. Giorgio 3

Paganico (Grosseto), S. Michele 45, 46

Paris, Louvre 109

Perugia, Galleria nazionale dell'Umbria 47

Pescia, Biblioteca capitolare 61

Pescia, S. Francesco 30

Pisa, Camposanto 22, 23, 26

Pisa, S. Tommaso 27

Pistoia, Baldi Papini Collection 79

Pistoia, Cathedral 33

Pistoia, Museo civico 97

Pistoia, S. Domenico 98

Pistoia, S. Francesco 31, 32

Pistoia, S. Giovanni Fuorcivitas 99

Portland (Oregon) Art Museum 110

Prague, National Gallery 111

Princeton, Princeton University, The Art Museum 80

Radensleben, Wilfried von Quast Collection 112

Richmond (Virginia), Virginia Museum 8

Rome, S. Cecilia in Trastevere 69

Rome, S. Maria in Trastevere 70

Rome, see also Vatican

St. Jean Cap Ferrat, Musée Ile de France 48

San Gimignano, Collegiata di S. Maria Assunta 49, 50

San Gimignano, Museo civico 90

San Gimignano, S. Agostino 51

San Gimignano, S. Lorenzo in Ponte 81, 82

Siena, Pinacoteca nazionale 9, 10, 52, 53, 63, 113

Signa, S. Martino a Gangalandi, Baptistery 62

Toledo, Cathedral 28, 29

Torrita (Val di Chiana), SS Flora e Lucilla 54

Turin, Sandri Collection 65

Vaduz, Schloß, Sammlungen des Fürsten von Liechtenstein 39

Valdagno, Marzotto Collection 40

Vallo di Nera (Perugia), S. Maria 87, 88, 89

Vatican Pinacoteca 55

Venice, Accademia 66, 67

Venice, Cà d'oro 11

Venice, Pinacoteca Querini-Stampalia 68

Verona, Museo del Castelvecchio 7

Verona, S. Anastasia 6

Vertine in Chianti, S. Bartolommeo 63

Vienna, Lanckoronski Collection 114

Washington, National Gallery of Art 115, 116

homeless: 12, 57, 64, 100

Index of Instruments
Singing and Dancing

Bagpipe 9, 18, 31, 34, 37, 44, 45, 55, 59, 60, 76, 80, 81, 94, 97, 103, 106, 107, 109, 113, 116

Cittern 84

Cymbals 8, 27, 48, 73, 81

Double recorder 8, 14, 16, 27, 34, 36, 41, 45, 81, 100, 110, 112

Fiddle 3, 6, 8, 12, 14, 15, 18, 21, 24, 27, 28, 31, 34, 42, 43, 46, 47, 48, 53, 56, 57, 61, 62, 66, 67, 68, 76, 77, 80, 81, 82, 84, 87, 91, 93, 95, 96, 99, 100, 101, 102, 105, 106, 108, 109, 110, 111, 112, 114, 115

Gittern 3, 6, 13, 28, 45, 57, 68, 110, 117

Gittern, bowed 77

Harp 3, 8, 10, 11, 12, 16, 24, 48, 62, 74, 75, 77, 78, 82, 96

Harp-psaltery 74

Horn 20, 70, 85, 90

Hurdy gurdy 31

Lute 3, 6, 10, 11, 12, 14, 15, 16, 21, 31, 34, 36, 41, 42, 47, 48, 52, 56, 57, 61, 62, 63, 64, 65, 66, 67, 68, 77, 80, 87, 89, 95, 106

Nakers 31, 34, 49

Organ, portative 3, 6, 12, 13, 14, 17, 27, 28, 34, 36, 43, 49, 52, 57, 62, 63, 64, 65, 66, 67, 68, 79, 80, 81, 82, 99, 100, 101, 102, 105, 106, 108, 112, 113, 115

Organ, positive 16

Psaltery 3, 8, 16, 17, 19, 21, 22, 25, 26, 27, 28, 31, 41, 46, 48, 57, 58, 62, 68, 75, 77, 78, 79, 80, 82, 88, 93, 94, 100, 101, 105, 106, 110, 112, 113, 115, 117

Rebec 16, 21, 57, 77, 91, 92, 97, 98

Recorder. See Double recorder.

Shawm 3, 8, 12, 30, 31, 34, 36, 41, 48, 56, 64, 75, 76, 77, 79, 80, 81, 82, 97, 98, 102, 106, 113, 115

Tambourine 18, 65, 75, 76, 80, 81, 93, 108, 112

Trumpet 1, 2, 3, 4, 7, 13, 19, 29, 31, 33, 34, 35, 39, 40, 49, 50, 62, 69, 71, 73, 74, 76, 81, 82, 83, 86, 98, 102, 104

Unclear instruments 30, 74, 82, 84, 102

Singing. See especially 5, 18, 23, 26, 32, 41, 44, 51, 52, 54, 72

Dancing 13, 18, 21, 22, 31, 45, 53

Index of Principal Subject Matter

Angel musicians (as principal subject matter) 16, 64, 89, 108

Apocalypse: Adoration of the Throne 84

Apocalypse. See also Last Judgment and Christ as Judge

Battles 2

Christ: Adoration of the Magi 46

Christ: Adoration of the Shepherds 44, 54. See also Christ: Nativity and Annunciation to the Shepherds.

Christ as Judge. See Last Judgment and Christ as Judge.

Christ: Ascension 21

Christ at the right hand of God. See Christ in Glory.

Christ: Crucifixion 1, 4, 7, 19, 29, 39, 86, 104

Christ: Descent into Limbo 19

Christ in Glory, or Christ and the Virgin in Glory 28, 62, 80, 81, 82

Christ, Mocking of 90

Christ: Nativity and Annunciation to the Shepherds 9, 37, 44, 45, 59, 60, 70, 76, 102, 103, 106, 107, 116. See also Christ: Adoration of the Shepherds.

Christ walking on the waves. See Navicella.

Christ: Way to Calvary 40

David, King 17, 19, 58, 88

Feast of Herod 53

Joachim and the Angel 55

Job, Story of 49, 50

Last Judgment and Christ as Judge 33, 35, 38, 69, 71, 72, 83, 85, 98

Music as a liberal art 17

Music as a worldly pleasure 13, 18

Navicella (Christ walking on the waves) 20

Salome. See Feast of Herod.

St. Agnes 73

St. Catherine 13

St. Eligius, Consecration of 5

St. Elisabeth of Hungary 74

St. Francis 31, 32
St. James 2
St. John Evangelist 99
St. Lucy 35, 96
St. Ranieri 22, 23, 26
St. Thomas Aquinas 17
Shepherds. See Christ: Adoration of the Shepherds and Christ: Nativity and Annunciation to the Shepherds.
Virgin and Child 6, 10, 12, 14, 25, 47, 57, 63, 75, 77, 91, 92, 95, 97, 106, 109, 110, 113, 114, 115
Virgin: Annunciation 58

Virgin: Assumption or Death and Assumption 8, 27, 41, 42, 48, 51, 52, 56, 87. See also Virgin handing girdle to St. Thomas.
Virgin: Coronation 3, 11, 15, 24, 30, 34, 36, 43, 61, 65, 66, 67, 68, 78, 79, 94, 100, 101, 102, 105, 111, 112, 117
Virgin, Death of. See Virgin: Assumption or Death and Assumption.
Virgin handing girdle to St. Thomas 93
Virgin in Glory. See Christ in Glory, or Christ and the Virgin in Glory.
Weddings 74

Index of Photo Sources

Alinari (Fratelli Alinari, S. p. A.) 2, 3, 6, 7, 9, 10, 22, 23, 24, 31, 32, 47, 55, 60, 73, 74, 81, 84, 90, 91, 99, 104, 105, 106
Altenburg, Staatliches Lindenau-Museum 101
Aurelio Amendola, Pistoia 97
Baltimore, Walters Art Gallery 58
Berenson Fototeca (Villa I Tatti, Florence) 14, 15, 16, 57, 65, 93, 100
BerensonCN 54, 71
BerensonF 27, 59, 92
BerensonH 12, 64
Berlin (West), Staatliche Museen 102
Bertolini Pisa C 26
Birmingham, The Barber Institute of Fine Arts 37
Osvaldo Böhm, Venice 11, 66, 67, 68
BoskovitsC 76, 79
BoskovitsPF 75
Boston Museum of Fine Arts 41
CarliBF 45, 46
CecchiniSG 49, 50
FremantleFG 98
Frick Art Reference Library, New York 56
Foto Grassi, Siena 43, 52, 53, 63, 113
Hannover, Niedersächsisches Landesmuseum 25
HetheringtonPC 69
IP 36
London, Courtauld Institute 94
London, National Gallery 34
Lugano-Castagnola, Thyssen-Bornemisza Collection 77
Malibu, J. Paul Getty Museum 78
MAS, Barcelona 28, 29, 35

MatthiaePC 70
MeissRA 48
MelliniA 1
Moscow Pushkin Cat 95
New Haven, Yale University Art Gallery 96
New York, Metropolitan Museum 38, 44
Offner 17, 18, 19, 20, 21, 107, 112, 114
Oxford, Ashmolean Museum 5
Oxford, Christ Church 108
Paris, Réunion des musées nationaux 109
PettenellaA 4
Portland (Oregon) Art Museum 110
Princeton University Art Museum 80
ProcacciBC 33
Richmond (Virginia), The Virginia Museum of Fine Arts 8
RigatusoBF 51
Fr. Gerhard Ruf, Sacro Convento di S. Francesco, Assisi 13, 83
SalmiS 61
San Gimignano Guide 82
Tom Scott, Edinburgh 103
SienesePII 117
SindonaC 85
Soprintendenza ai Beni Artistici e Storici di Napoli 72
Vaduz, Sammlungen des Fürsten von Liechtenstein 39
VitaliniSC 86, 87, 88, 89
VolpePR 40
Washington, National Gallery of Art 115, 116

A Corpus of Trecento Pictures with Musical Subject Matter
I. Pictures Signed by or Attributed to Particular Artists or Their Followers

Altichiero da Zevio (ca. 1330–1395), Verona

1. Crucifixion, 1377–1379
 Padua, Basilica del Santo (S. Antonio), Cappella di S. Felice (formerly Cappella di S. Giacomo), fresco
 One mounted soldier holds a trumpet.
 Photo: MelliniA
 Bibl.: BerensonCN, 1:2 (pl. 218); Crowe/Cavalcaselle, 3:226–230 (series attributed to Altichiero, Avanzi, and others); van Marle, 4:128–135; MelliniA, pp. 41–53 (fig. 64 and 72; series attributed to Altichiero and Avanzi); PettenellaA, p. 39 (figs. 18 and 19); and SimonA, pp. 252–258 (establishes date and attributes to Altichiero alone)

2. St. James appears during the battle of Clavigo and secures the victory of the Christians over the Moslems (as foretold in a dream of Ramirus, king of Oviedo), 1377–1379
 Padua, Basilica del Santo (S. Antonio), Cappella di S. Felice (formerly Cappella di S. Giacomo), fresco
 On the left (center), one mounted soldier plays a trumpet, and another holds a trumpet.
 Photo: Alinari
 Bibl.: BerensonCN, 1:2; Crowe/Cavalcaselle, 3:228 (Series attributed to Altichiero and Avanzi); van Marle, 4:131 (fig. 62); MelliniA, pp. 52f. (color pl. opposite p. 38, and figs. 107 and 111; series attributed to Altichiero and Avanzi); and SimonA, pp. 252–258 (establishes date and attributes to Altichiero alone)

3. Coronation of the Virgin, 1379–1384
 Padua, Oratorio di S. Giorgio, fresco
 Angels play on the left: one (or two) trumpets, two shawms, incurved demi-trapezoidal psaltery, lute, portative organ, and fiddle; and on the right: one (or two) trumpets, shawm, gittern, harp, incurved trapezoidal psaltery, portative organ, and shawm.
 Photo: Alinari
 Bibl.: BerensonCN, 1:2; Crowe/Cavalcaselle, 3:230–236 (series attributed to Altichiero and Avanzi); van Marle, 4:135 (fig. 65; series attributed to Altichiero and Avanzi); MelliniA, pp. 57–77 (color pl. opposite p. 88, and figs. 161, 163, 188, and 247–249; series attributed to Altichiero and Avanzi); PettenellaA, pp. 44f. (fig. 41); and SimonA, pp. 258–261 (establishes date and attributes to Altichiero alone)

Altichiero da Zevio, or a follower

4. Crucifixion
 Milan, private collection, panel painting
 One mounted soldier plays a trumpet.
 Photo: PettenellaA
 Bibl.: ArslanTA, pp. 103–106 (fig. 1); and PettenellaA, p. 56 (fig. 17)

Altichiero da Zevio, follower of

5. The Consecration of St. Eligius
 Oxford, Ashmolean, A 732, panel painting
 Three men and three boys on the left, and two men and one boy on the right appear to be singing.
 Photo: Museum
 Bibl.: Oxford Ashmolean Cat, pp. 1f. (pl. 1)

6. Virgin and Child, with saints and donor, ca. 1400
 Verona, S. Anastasia, Cappella Pellegrini, Bevilacqua tomb, fresco
 Angels play lute, portative organ, fiddle and gittern.
 Photo: Alinari
 Bibl.: Crowe/Cavalcaselle, 3:239 (attributed to follower of Altichiero or Jacopo da Verona); van Marle, 4:158 (fig. 81; attributed to evolved follower of Altichiero, possibly ca. 1400); and PettenellaA, p. 64 (fig. 50; attributed to Martino da Verona)

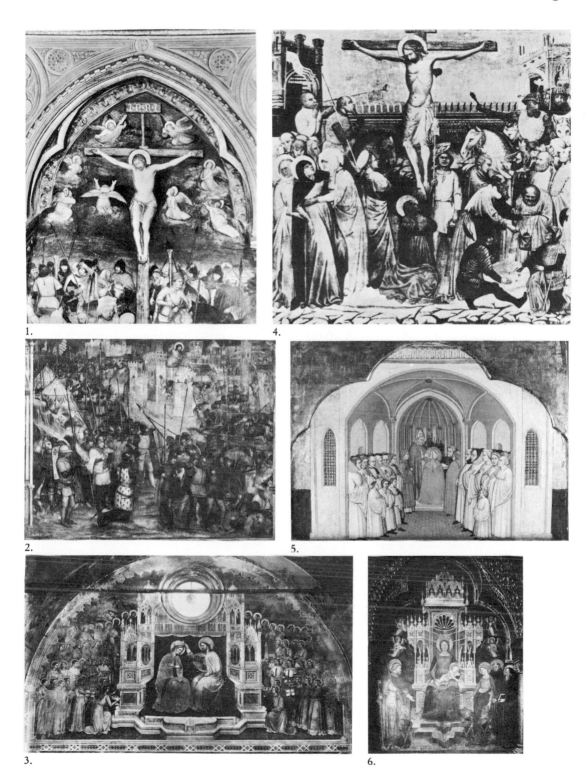

1.

4.

2.

5.

3.

6.

(Altichiero da Zevio, follower of)

7. Crucifixion
 Verona, Museo del Castelvecchio, no. 513, fresco detached from Convent of Santissima Trinità (fresco now destroyed)
 One mounted soldier plays a trumpet.
 Photo: Alinari
 Bibl.: van Marle, 4:155 (fig. 78)

Altichiero da Zevio. See also **Pietro da Rimini,** and, under MSS: Paris, BN, MS fonds lat. 6069F and 6069I.

Ambrogio di Baldese. See under anonymous paintings: New Haven, Yale University Art Gallery, and Roma, Pinacoteca Capitolina.

Andrea di Bartolo (active by 1389, died 1428), Siena

8. The Assumption of the Virgin, with two donors, early fifteenth century (signed »ANDREAS BARTOLO DE MAGISTRI FREDI DE SENIS PINXIT« with an inscription identifying the donor as Ser Palamedes of Urbino, who is shown with his son Matthew)
 Richmond, Virginia Museum, 54–113, panel painting
 Angels play harp, cymbals (?), double recorder, shawm, fiddle, and trapezoidal psaltery.
 Photo: Museum
 Bibl.: BeenkenU (ill. on p. 76); BerensonCN, 1:7 (p. 423); Crowe/Cavalcaselle, 3:135–136 (ill. facing p. 134); DeWaldMO (fig. 31); van Marle, 2:574; and Richmond Cat, p. 12 (ill.)

9. Nativity, with saints (central panel of a triptych)
 Siena, Pinacoteca nazionale, no. 133
 Above the manger, an angel announces the birth to two shepherds, one of whom holds a bagpipe.
 Photo: Alinari
 Bibl.: BerensonCN, 1:8; van Marle, 2:581; SymeonidesTB, pp. 243f.; and TorritiPNS, p. 203 (fig. 231)

10. Polyptych: Virgin and Child, with saints and angels, ca. 1397
 Siena, Pinacoteca nazionale, no. 220, panel painting
 Angels play lute and harp.
 Photo: Alinari
 Bibl.: BerensonCN, 1:8; van Marle, 2:577–578 (fig. 362); and TorritiPNS, p. 207 (fig. 236)

11. Coronation of the Virgin
 Venice, Cà d'oro, Franchetti Collection, panel painting
 Angels play lute and harp.
 Photo: Osvaldo Böhm
 Bibl.: BerensonCN, 1:8; FogolariGF, p. 15 (ill., p. 46); and van Marle, 2:579 (fig. 363)

12. Madonna of Humility, with angels
 Homeless, panel painting
 Angels play lute, fiddle, portative organ, shawm, and harp.
 Photo: BerensonH
 Bibl.: BerensonH, pp. 40f. (fig. 55)

Andrea di Bartolo. See also Bartolo di Fredi.

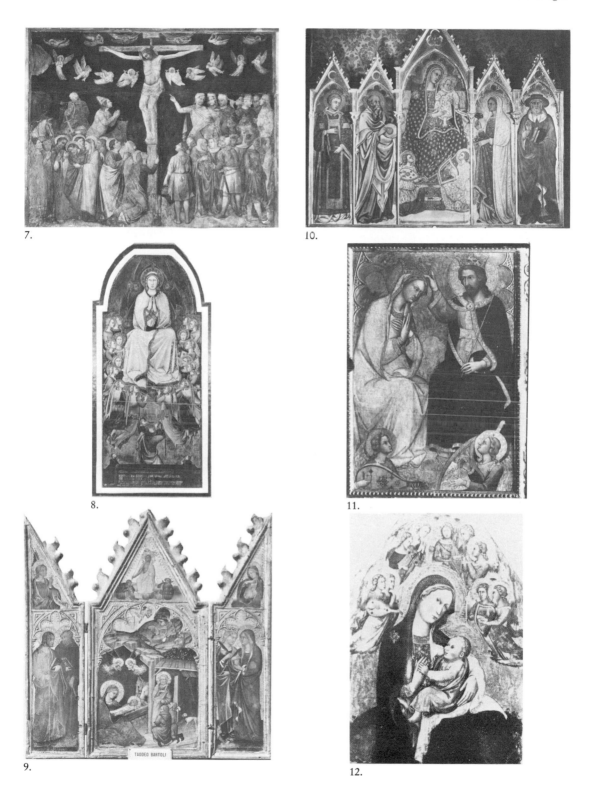

7.

10.

8.

11.

9.

TADDEO BARTOLI

12.

Andrea da Bologna (active between 1368 and 1372), Bolognese who worked in the Marches

13. Life of St. Catherine: St. Catherine before the Emperor Maxentius, commissioned 1368
Assisi, Basilica di S. Francesco, Lower Church, fresco
Two men play trumpets to the left of the saint and the emperor. In the lower right, five or six people dance in a circle, accompanied by a man playing a gittern, and a girl playing a portative organ.
Photo: Assisi, S. Francesco
Bibl.: BerensonCN, 1:9; ColettiA, pp. 67–69 (pls. 188–199); FilippiniAB; van Marle, 4:428–430; RowleyAL, 2:pl. 136; Toesca, p. 745; and ZoccaA, pp. 41–43

14. Virgin and Child, with angels
Offida (near Ascoli Piceno), S. Maria della Rocca, fresco
Angels play fiddle, lute, portative organ and double recorder.
Photo: Fototeca Berenson
Bibl.: BerensonCN, 1:9; and van Marle, 5:182–192 (as eclectic follower of Allegretto Nuzi)

15. Coronation of the Virgin
Offida (near Ascoli Piceno), S. Maria della Rocca, fresco
Angels play fiddle and lute.
Photo: Fototeca Berenson
Bibl.: BerensonCN, 1:9; and van Marle, 5:182–192 (as eclectic follower of Allegretto Nuzi)

16. Saints and musical angels
Offida (near Ascoli Piceno), S. Maria della Rocca, fresco
Angels play rebec held upright, lute, incurved demi-trapezoidal psaltery, positive organ, lute, rebec, double recorder, and harp.
Photo: Fototeca Berenson
Bibl.: BerensonCN, 1:9; and van Marle, 5:182–192 (as eclectic follower of Allegretto Nuzi)

Andrea da Bologna. See also under MSS: Chantilly, Musée Condé.

Andrea Bonaiuti, or **Andrea da Firenze** (active by 1346, died 1377), Florence

17. Triumph of St. Thomas Aquinas, ca. 1366–1368
Florence, S. Maria Novella, Spanish Chapel, fresco
St. Thomas is flanked by evangelists and prophets and kings from the Old Testament, including King David (upper row, left) playing an incurved trapezoidal psaltery. Below St. Thomas are personifications and representatives of the higher sciences and the seven liberal arts, including Lady Music (lower row, right) playing a portative organ and Tubal hammering on an anvil.
Photo: Offner
Bibl.: BerensonF, 1:5 (pls. 235 and 241); BoskovitsPF, pp. 32f. and 277; FremantleFG, p. 207 (figs. 413, 414 and 418); van Marle, 3:432–435 (fig. 249 and pl. opposite p. 432); MeissPF, pp. 94–105 (figs. 93 and 95); and Offner IV/VI, pp. 27–31 (pls. I, 1–26)

18. The Church Militant and Triumphant, ca. 1366–1368
Florence, S. Maria Novella, Spanish Chapel, fresco
On the right, among those enjoying the pleasures of the world are four people seated in a garden; one woman plays a fiddle. A man below her plays a bagpipe. Beside him, seven smaller women (or girls) dance while an eighth sings while accompanying herself on a tambourine.
Photo: Offner
Bibl.: BerensonF, 1:5 (pl. 236); BoskovitsPF, pp. 32f. and 277; FremantleFG, p. 205 (fig. 408); van Marle, 3:430–432 (fig. 245); MeissPF, pp. 94–105 (figs. 93 and 94); and Offner IV/VI, pp. 36–43 (pls. II, 1–32)

13.

16.

14.

17.

15.

18.

(Andrea Bonaiuti, or Andrea da Firenze)

19. Crucifixion, ca. 1366–1368
 Florence, S. Maria Novella, Spanish Chapel,
 fresco
 a) Crucifixion scene; one mounted soldier
 plays a trumpet.
 b) [not reproduced] Christ descends into Lim-
 bo; among the figures in Limbo is King David
 with a psaltery.
 Photo: Offner
 Bibl.: BerensonF, 1:5 (pl. 237); BoskovitsPF,
 pp. 32f. and 277; FremantleFG, p. 208 (figs.
 417 and 420); van Marle, 3:427–430 (fig. 243);
 MeissPF, pp. 94–105 (figs. 93, 96, and 98); and
 Offner IV/VI, pp. 46–49 (pls. III, 1–20;
 attributed to Andrea with assistants)

20. Navicella, ca. 1366–1368
 Florence, S. Maria Novella, Spanish Chapel,
 fresco
 Two wind gods blow through curved horns.
 Photo: Offner
 Bibl.: BerensonF, 1:5 (pl. 237); BoskovitsPF,
 pp. 32f. and 277; van Marle, 3:437–438 (fig.
 97); MeissPF, pp. 94–105; and Offner IV/VI,
 pp. 62f. (pls. VII, 1–7; attributed to Andrea
 with assistants)

21. Ascension, ca. 1366–1368
 Florence, S. Maria Novella, Spanish Chapel,
 fresco
 Angels play rebec, lute, trapezoidal psaltery,
 and fiddle. Below them, two groups of three
 angels each appear to be dancing.
 Photo: Offner
 Bibl.: BerensonF, 1:5; BoskovitsPF, pp. 32f.
 and 277; van Marle, 3:437–438; MeissPF, pp.
 94–105; and Offner IV/VI, pp. 70f. (pls. IX,
 1–7; attributed to Andrea with assistants)

22. Conversion of St. Ranieri, 1376/77
 Pisa, Camposanto, fresco
 While St. Ranieri plays a trapezoidal psaltery
 for a group of four girls dancing, a woman (his
 mother?) exhorts him to lead a better life.
 Photo: Alinari
 Bibl.: BerensonF, 1:5; Bertolini Pisa C, pp.
 69–73 (figs. 58 and 59); BoskovitsPF, p. 279;
 CarliPPT, pl. 30; FremantleFG, p. 210 (fig.
 425); and van Marle, 3:439 (fig. 252)

23. Temptation and Miracles of St. Ranieri, 1376/
 77
 Pisa, Camposanto, fresco
 In Nazareth, St. Ranieri attends rites in Mary's
 house (far left), transformed into a sanctuary.
 He kneels while six men, three on either side
 of a lectern on which choirbooks are apparent-
 ly resting, sing. The devil tries to distract him
 from his prayers.
 Photo: Alinari
 Bibl.: BerensonF, 1:5 (pl. 248); Bertolini Pisa
 C, pp. 75f. (fig. 65); BoskovitsPF, p. 279;
 CarliPPT, pl. 32; and van Marle, 3:439

Andrea Bonaiuti, or **Andrea da Firenze.** See also
Jacopo di Cione and Niccolò di Tommaso.

Andrea di Cione, called Orcagna. See **Orcagna.**

Antonio di Francesco, called **Antonio Veneziano**
(documented from 1369 to 1388), Venetian
active in Florence and Spain

24. Coronation of the Virgin
 Arezzo, Museo comunale (on loan from So-
 printendenza alle Gallerie fiorentine, Inv. no.
 4656), panel painting
 Angels play fiddle and harp.
 Photo: Alinari
 Bibl.: FremantleA, pp. 526–528 (fig. 24)

19.

22.

20.

23.

21.

24.

(Antonio di Francesco)

25. Virgin and Child, with angels, ca. 1385–1390
Hannover, Niedersächsisches Landesmuseum,
Landesgalerie, Inv. KM 86, panel painting
Angels play two psalteries.
Photo: Museum
Bibl.: BerensonF, 1:17; BoskovitsPF, pp. 153
and 281; FremantleFG, p. 238 (fig. 483); van
Marle, 3:451; and OffnerSF, pp. 67–81 (fig. 4)

26. Death of St. Ranieri, 1384–1386
Pisa, Camposanto, fresco
The fresco is almost completely illegible; the
engraving (reproduced here) was made in 1832
by Gian Paolo Lasinio and Giovanni Rossi
a) At least three clerics read or perhaps sing
from a book at the saint's bier. Clerics may
sing while carrying the dead saint to the
cathedral.
b) On the extreme right, in front of the
cathedral, some clerics kneeling; one of them
plays a demi-trapezoidal psaltery.
Photo: Bertolini Pisa C (after Lasinio and
Rossi)
Bibl.: BerensonF, 1:17 (pl. 256); Bertolini Pisa
C, pp. 77–83; BoskovitsPF, pp. 153f. and 282
(pl. 171 and fig. 296); and van Marle,
3:444–447 (fig. 254)

27. Assumption of the Virgin, ca. 1385–1390
Pisa, S. Tommaso
Angels play incurved trapezoidal psaltery,
cymbals, two pairs of double recorders, fiddle
and portative organ.
Photo: BerensonF
Bibl.: BerensonF, 1:17 (pl. 257); BoskovitsPF,
pp. 154 and 282 (fig. 292); FremantleA, p. 528
(fig. 28) van Marle, 5:248 (fig. 165; attributed
to Turino Vanni); and OffnerSF, pp. 67–81
(fig. 6)

28. Christ at the right hand of God, ca. 1395–1400
Toledo, Cathedral, Capilla di San Blas, fresco
Angels play portative organ, demi-trapezoidal
psaltery, gittern, and fiddle.
Photo: MAS, Barcelona
Bibl.: BoskovitsPF, pp. 155f. and 282f., with
information about Antonio's collaboration
with Rodriguez da Toledo and earlier attribu-
tion to Gherardo Starnina (pl. 169); De Bos-
queAI, pp. 89–99 (ill., p. 98); van Marle,
5:480; and RicartPG, pp. 205f. (pl. 177;
attributed to Starnina and Rodriguez)

29. Crucifixion, ca. 1395–1400
Toledo, Cathedral, Capilla di San Blas, fresco
One figure in the crowd plays a trumpet.
Photo: MAS, Barcelona
Bibl.: BoskovitsPF, pp. 155f. and 282f., with
information about Antonio's collaboration
with Rodriguez da Toledo and earlier attribu-
tion to Gherardo Starnina (fig. 300); De
BosqueAI, pp. 89–99 (ill., p. 94; attributed to
Starnina); and van Marle, 5:480

25.

28.

26.

27.

29.

Antonio di Vita, or **Antonio Vite** (active by 1379, died ca. 1407), Pistoia

30. Coronation of the Virgin, 1392 (signed, according to BoskovitsPF, p. 152: »HOC OPUS FIERI FECIT D. THOMAS D. DINI DE OBITIIS DE LUCA PRO RIMEDIO ANIMAE SUAE ET SUORUM DISCENDENTIUM A. D. 1392«)
Pescia, S. Francesco, Cappella maggiore, fresco
The badly damaged fresco shows four angels, playing two shawms and two unclear instruments.
Photo: None available
Bibl.: BoskovitsPF, pp. 151 and 283

31. St. Francis in Glory, ca. 1385–1390
Pistoia, S. Francesco, Sala del capitolo, fresco
Two groups of five angels each dance in circles on either side of the enthroned Francis. Below him, angels play on the left: two shawms, bagpipe, hurdy gurdy and incurved trapezoidal psaltery; and on the right: fiddle, lute, two trumpets, and nakers.
Photo: Alinari
Bibl.: BoskovitsPF, pp. 149 and 284 (fig. 546), including discussion of earlier attribution to Puccio Capanna; HammersteinME, p. 226 (fig. 68); van Marle, 5:308; and SalmiSPP, pp. 463–468 (fig. 10)

32. The Miracle at Greccio (scenes from the life of St. Francis), ca. 1385–1390
Pistoia, S. Francesco, Sala del capitolo, fresco
While Mass is being said, four clerics apparently sing from a choirbook.
Photo: Alinari
Bibl.: BoskovitsPF, pp. 149f. and 284, including discussion of earlier attribution to Puccio Capanna; and van Marle, 5:308

33. Angel from a Last Judgment, ca. 1380–1385
Pistoia, Cathedral, fresco (fragment)
Angel plays a trumpet.
Photo: ProcacciBC
Bibl.: BoskovitsPF, p. 284 (fig. 549); and ProcacciBC, p. 351 (figs. 5 and 6)

Avanzi, Jacopo. See **Altichiero da Zevio, Jacopino di Francesco,** and, under MSS: Dublin, Beatty Collection.

Balletta. See **Francesco d'Antonio Zacchi,** called **il Balletta**

Barnaba da Modena (documented 1361–1383), Modenese active in Piemont

34. Coronation of the Virgin (one of four panels also showing Trinity, Virgin and Child, and Crucifixion), signed and dated »barnabas. de mutina pinxit. 1374«
London, National Gallery, no. 2927, panel painting
Angels play on upper left: double recorder, shawm and bagpipe; on middle right: two trumpets; and below the central figures: fiddle, lute, portative organ, and nakers.
Photo: Museum
Bibl.: BerensonCN, 1:28; ColettiP, 3:xxxv-xxxvi (fig. 68); Crowe/Cavalcaselle, 3:210–211; LangascoCF, pp. 68–70 (fig. 11); London NG Cat, pp. 45f.; van Marle, 4:374–378 (fig. 191); and Toesca, p. 751

35. Retable of St. Lucy: Christ as Judge
Murcia, Cathedral, panel painting
To the right of Virgin and Child, upper panel: two angels play trumpets.
Photo: MAS, Barcelona
Bibl.: BerensonCN, 1:28

36. Coronation of the Virgin
Formerly in New York, R. M. Hurd collection, panel painting
Angels play shawm, portative organ, double recorder, and lute.
Photo: IP
Bibl.: BerensonCN, 1:28; and IP, no. 8

31.

32.

33.

34.

35.

36.

Barnaba da Modena. See also **Master of St. Ursula.**

Baronzio, Giovanni (active middle of the fourteenth century), Rimini

37. Left wing of a diptych, including the Nativity (the right wing survives in Urbino, Galleria nazionale delle Marche)
Birmingham, The Barber Institute of Fine Arts, The University of Birmingham, panel painting
A shepherd plays a bagpipe.
Photo: Museum
Bibl.: BerensonCN, 1:355 (attributed to Riminese trecento); and BirminghamH, p. 11

38. Scenes from the Life of Christ: Last Judgment
New York, Metropolitan Museum, 09.103 panel painting (lower right)
The two angels in the lower right panel who are sometimes thought to be playing trumpets are actually assisting the blessed to enter Heaven. Thus, there is no musical subject matter in this painting.
Photo: Museum
Bibl.: BerensonCN, 1:357 (attributed to Riminese trecento); van Marle, 4:341 (fig. 180; attributed to school of Baronzio); New York Met Cat, 1:95 (ill., 2:80; attributed to Riminese painter of the middle fourteenth century); and VolpePR, pp. 41–43 and 82f. (fig. 205)

39. Crucifixion with Adoration of the Magi above and seven saints below
Schloß Vaduz, Sammlungen des Fürsten von Liechtenstein, panel painting
One soldier plays a trumpet at the Crucifixion.
Photo: Museum
Bibl.: BerensonCN, 1:361 (attributed to Riminese trecento); van Marle, 4:341 (fig. 179); and VolpePR, pp. 41–43 and 83 (fig. 213)

Baronzio, Giovanni, follower of

40. Scenes from the Life of Christ, including (on the lower right) the Way to Calvary
Valdagno, Collection of Conte G. Marzotto (the left part of the »Corvisieri Dossal« in Rome, Galleria nazionale), panel painting
One man plays a trumpet while Christ carries the cross to Calvary.
Photo: VolpePR
Bibl.: BerensonCN, 1:361 (attributed to Riminese trecento); and VolpePR, pp. 41–43 and 83 (fig. 208)

Bartolo di Fredi Battilori (active by 1353, died 1410), Siena

41. Triptych: Death and Assumption of the Virgin, with saints, probably between about 1360 and 1380
Boston Museum of Fine Arts, 83, 175, panel painting
Angels around mandorla play shawm, trapezoidal psaltery, lute, and double recorder; some angels may sing.
Photo: Museum
Bibl.: BenedictisPS, p. 80; BerensonCN, 1:425 (attributed to Tegliacci); Boston MFA Cat, p. 2; van Marle, 2:493 (fig. 320); Offner III/VIII, p. 156; and RigatusoBF, pp. 239 and 262

42. Fragment of an Assumption of the Virgin (?)
Lucignano (Val di Chiana), S. Francesco, fresco
Angels play fiddle and lute.
Photo: None available
Bibl.: BenedictisPS, p. 80; BerensonCN, 1:29; and RigatusoBF, p. 266

37.

40.

38.

39.

41.

(Bartolo di Fredi Battilori)

43. Coronation of the Virgin (probably part of a triptych, another part of which is in Siena, see below no. 52; signed and dated 1388: »BARTHOLUS MAGISTRI FREDI DE SENIS ME PINSIT. ANNO DNI M. CCC. LXXXVIII.«)
 Montalcino, Museo civico (probably painted for Montalcino, S. Francesco), panel painting
 Angels play portative organ and fiddle.
 Photo: Foto Grassi
 Bibl.: BenedictisPS, p. 80; BerensonCN, 1:30; Carli Montalcino Cat, pp. 16f. (figs. 32–36); Crowe/Cavalcaselle, 3:124–125; van Marle, 2:495–499 (fig. 321); RigatusoBF, pp. 218, 222f., and 262; and Toesca, 2:599

44. Adoration of the Shepherds (formerly signed and dated 1374)
 New York, Metropolitan Museum, Cloisters, 25.120.288 (from the Convent of S. Domenico in San Gimignano), panel painting
 Above the manger are six angels, some or all of whom sing. On the right, an angel announces the birth to two shepherds, one of whom holds a bagpipe.
 Photo: Museum
 Bibl.: BenedictisPS, p. 81; and New York Met Cat, 1:7 (ill., 2:54)

45. Nativity, 1368
 Paganico (Grosseto), S. Michele, fresco
 In the foreground, a shepherd plays a bagpipe. In the background, on both sides angels dance in two rows while two play gittern (left) and double recorder (right).
 Photo: CarliBF
 Bibl.: BenedictisPS, p. 81; BerensonCN, 1:30; CarliBF, figs. 9, 14, and 15; van Marle, 2:507–508 (fig. 328); and RigatusoBF, p. 266

46. Adoration of the Magi, 1368
 Paganico (Grosseto), S. Michele, fresco
 Above the main scene, two angels play in-curved trapezoidal psaltery and fiddle.
 Photo: CarliBF
 Bibl.: BenedictisPS, p. 81; BerensonCN, 1:30; CarliBF, figs. 20 and 30; van Marle, 2:507–508; and RigatusoBF, p. 266

47. Triptych: Virgin and Child, with saints
 Perugia, Galleria nazionale dell'Umbria, no. 88 (from Perugia, S. Simeone del Carmine), panel painting
 Angels play lute (left) and fiddle (right)
 Photo: Alinari
 Bibl.: BenedictisPS, p. 81; BerensonCN, 1:30; van Marle, 2:493; RigatusoBF, p. 266; and Santi Perugia Cat, p. 14

48. Assumption of the Virgin
 St. Jean Cap Ferrat, Musée Ile de France, panel painting
 Angels play on the left: shawm, harp, cymbals, and shawm; and on the right: psaltery, lute, shawm, and fiddle.
 Photo: MeissRA
 Bibl.: BerensonCN, 1:30; and MeissRA, p. 77 (fig. 1)

43.

46.

44.

47.

45.

48.

(Bartolo di Fredi Battilori)

49. Scenes from the Old Testament: God allows the Devil to tempt Job, 1367
 San Gimignano, Collegiata di S. Maria Assunta, fresco
 On the right, four musicians entertain Job and his wife at dinner. The musicians play two trumpets, nakers and portative organ.
 Photo: CecchiniSG
 Bibl.: BenedictisPS, p. 81; BerensonCN, 1:30–31; CarliDA; CecchiniSG, p. 85 (pl. 43); Crowe/Cavalcaselle, 3:122 (dated 1356); van Marle, 2:486–487 (fig. 316); RigatusoBF, pp. 223–229 and 262 (fig. 3); and Toesca, 2:598

50. Story of Job: The Earthquake, 1367
 San Gimignano, Collegiata di S. Maria Assunta, fresco
 Above the destroyed building, an angel (or a demon) plays a trumpet.
 Photo: CecchiniSG
 Bibl.: BenedictisPS, p. 81; BerensonCN, 1:30–31; CarliDA; CecchiniSG, p. 85 (pl. 45); Crowe/Cavalcaselle, 3:22 (dated 1356); van Marle, 2:486–487; RigatusoBF, pp. 223–229 and 262; and Toesca, 2:598

51. Death of the Virgin
 San Gimignano, S. Agostino, fresco
 At least two women sing.
 Photo: RigatusoBF
 Bibl.: BenedictisPS, p. 81; BerensonCN, 1:30; CecchiniSG, p. 85 (pl. 83); van Marle, 2:499–501; and RigatusoBF, p. 263 (fig. 15)

52. Assumption of the Virgin (part of the triptych dated 1388 now in Montalcino; see above no. 43)
 Siena, Pinacoteca nazionale, no. 101, panel painting
 Angels play lute and portative organ; some may sing.
 Photo: Foto Grassi
 Bibl.: BenedictisPS, p. 81; BerensonCN, 1:31; Crowe/Cavalcaselle, 3:124; van Marle, 2:499 (fig. 324); RigatusoBF, pp. 240 and 262; and TorritiPNS, pp. 170–176 (fig. 193)

53. Feast of Herod (one panel of a predella in five sections)
 Siena, Pinacoteca nazionale, no. 103, panel painting
 Salome dances, accompanied by a man playing a fiddle.
 Photo: TorritiPNS
 Bibl.: BerensonCN, 1:31; Crowe/Cavalcaselle, 3:126; van Marle, 2:499 (dated ca. 1388); RigatusoBF, pp. 235–237 and 264; and TorritiPNS, pp. 168f. (fig. 182)

54. Triptych: Adoration of the Shepherds, with saints
 Torrita (Val di Chiana), SS. Flora e Lucilla, panel painting
 Eight angels hover over the manger. Some of them sing.
 Photo: BerensonCN
 Bibl.: BenedictisPS, p. 82; BerensonCN, 1:31 (fig. 410); van Marle, 2:493–494; and RigatusoBF, pp. 241f. and 264 (fig. 12)

49.

52.

50.

53.

51.

54.

(Bartolo di Fredi Battilori)

55. Joachim and the angel
Vatican Pinacoteca, no. 153, panel painting
A shepherd plays a bagpipe.
Photo: Alinari
Bibl.: BerensonCN, 1:30; van Marle, 2:573–574 (attributed to Andrea di Bartolo); and RigatusoBF, p. 267; Vatican Pin, fig. 69

Bartolo di Fredi Battilori, follower of

56. Assumption of the Virgin
Chianciano, Collegiata di S. Giovanni Battista, panel painting
Angels play lute, two shawms, and fiddle.
Photo: Courtesy of the Art Reference Library Frick (as Sienese school, fifteenth century)
Bibl.: van Marle, 2:508

57. Virgin and Child, with angels
Homeless, panel painting
Angels play on the left: lute, portative organ, and fiddle; and on the right: triangular psaltery, gittern and rebec held upright. (The form of the instruments suggests that the attribution to Bartolo di Fredi is incorrect.)
Photo: Fototeca Berenson (Attributed to Bartolo? or to an anonymous Catalan)

Bartolo di Fredi Battilori. See also **Andrea di Bartolo, Bernardo Falconi,** and **Niccolo di Ser Sozzo Tegliacci.**

Bicci di Lorenzo (1373–1452), Florence

58. The Annunciation, ca. 1430 (assisted by Stefano d'Antonio)
Baltimore, Walters Art Gallery, Inv. no. 37.448, panel painting
On the frame, King David (in a spandrel) plays an incurved trapezoidal psaltery.
Photo: Museum
Bibl.: BerensonF, 1:27; and Zeri Baltimore Cat, 1:32–34 (pl. 14)

59. Nativity (central panel of predella), dated 1423
Berlin, Staatliche Museen, no. 1046A (destroyed in 1945), panel painting
A shepherd holds a bagpipe.
Photo: BerensonF
Bibl.: BerensonF, 1:27 (fig. 499); FremantleFG, p. 473 (fig. 980); and van Marle, 9:10

60. Nativity (predella panel), dated 1435
Florence, S. Giovannino dei Cavalieri, panel painting
A shepherd plays a bagpipe.
Photo: Alinari
Bibl.: AntalFP, pp. 331f. (fig. 127b); BerensonF, 1:29 (fig. 509); FremantleFG, p. 482 (fig. 1003); and van Marle, 9:20 (fig. 12)

55.

58.

56.

59.

57.

60.

(Bicci di Lorenzo)

61. Coronation of the Virgin
 Pescia, Biblioteca capitolare, panel painting
 Angels play fiddle and lute.
 Photo: SalmiS
 Bibl.: BerensonF, 1:31 (not traceable in 1963);
 and SalmiS, pp. 216–221 (fig. 6)

62. Christ in Glory with music-making angels,
 after 1430
 Signa, S. Martino a Gangalandi, Baptistery,
 panel painting
 Angels play seven trumpets, harp, two lutes,
 portative organ, fiddle, and incurved trapezoi-
 dal psaltery.
 Photo: None available
 Bibl.: BerensonF, 1:29

63. Virgin and Child, with saints and angels, dated
 1430
 Siena, Pinacoteca nazionale, on deposit from
 Vertine in Chianti, S. Bartolommeo, panel
 painting
 Angels play portative organ and lute.
 Photo: Foto Grassi
 Bibl.: BerensonF, 1:32 (fig. 504); Fremant-
 leFG, p. 476 (fig. 989); van Marle, 9:15–16;
 and TorritiPNS, pp. 411f. (fig. 494)

64. Four angels and five saints
 Homeless, panel painting
 Angels play lute, portative organ, and shawm.
 Photo: BerensonH
 Bibl.: BerensonH, p. 142 (fig. 246)

Bonsi, Giovanni. See **Giovanni di Bonsi.**

Capanna, Puccio. See **Antonio Vite.**

Catarino Veneziano (active 1362–1382), Venice

65. Coronation of the Virgin
 Turin, Sandri Collection (formerly?), panel
 painting
 Angels play tambourine, portative organ, and
 lute.
 Photo: None available

66. Coronation of the Virgin, with angels, 1375
 (signed: »MCCLXXV D MEXE. D MARCO
 CHATARINUS PINXIT«)
 Venice, Accademia, no. 16, panel painting
 Angels play lute, portative organ, and fiddle.
 Photo: Osvaldo Böhm
 Bibl.: BerensonV, 1:61; Crowe/Cavalcaselle,
 3:277; van Marle, 4:62; PallucchiniPV, pp.
 197–199 (fig. 604); and Symeonides Venice
 Cat, pp. 32–34 (fig. 7)

61.

64.

63.

66.

(Catarino Veneziano)

67. Coronation of the Virgin, with saints and angels (signed »CHATA PINXIT«)
 Venice, Accademia, no. 702, panel painting
 Angels play lute, portative organ, and fiddle.
 Photo: Osvaldo Böhm
 Bibl.: BerensonV, 1:61; Crowe/Cavalcaselle, 3:277; van Marle, 4:62–63 (fig. 31); PallucchiniPV, pp. 198f. (fig. 609); and Symeonides Venice Cat, p. 34 (fig. 8)

68. Coronation of the Virgin, with angels, painted with Donato di San Vitale in 1372 (signed »MCCLXXII MEXE AGUSTI DONATUS ET CATARINUS PICXIT«)
 Venice, Pinacoteca Querini-Stampalia, no. 30, panel painting
 a) Angels above the central figures play gittern, fiddle, portative organ, lute and trapezoidal psaltery.
 b) An angel in the foreground plays portative organ.
 Photo: Osvaldo Böhm
 Bibl.: BerensonV, 1:61; Crowe/Cavalcaselle, 3:276–77; van Marle, 4:59–62 (fig. 30); and PallucchiniPV, pp. 195–196 (pl. XXVII in color, and figs. 601 and 603)

Catarino Veneziano. See also **Paolo Veneziano**

Cavallini, Pietro (ca. 1245/50–ca. 1330/40), Rome

69. Last Judgment, ca. 1289–1293
 Rome, S. Cecilia in Trastevere, fresco
 Four angels play trumpets.
 Photo: HetheringtonPC
 Bibl.: BerensonCN, 1:82; HetheringtonPC, pp. 37–58 (figs. 32, 33, 62, 64, 65, and 68); MatthiaePC, pp. 91–93 (fig. 66); SindonaC, pp. 126f. (figs. 89 and pls. LVII–LXIV); and ToescaPC, pp. 11f.

70. Life of the Virgin: Nativity, ca. 1293–1300
 Rome, S. Maria in Trastevere, mosaic
 Shepherd plays a curved horn.
 Photo: MatthiaePC
 Bibl.: BerensonCN, 1:82; HetheringtonPC, pp. 13–36 (figs. 9 and 11); MatthiaePC, pp. 32–34 (figs. 17 and 19); PrevitaliG, fig. 11; SindonaC, p. 125 (fig. 84 and pl. LVI); and ToescaPC, pls. 3 and 4

Cavallini, Pietro, follower of

71. Last Judgment, ca. 1325
 Naples, S. Maria di Donna Regina, fresco
 Four angels play trumpets.
 Photo: BerensonCN
 Bibl.: BerensonCN, 1:81 (pl. 159); and HetheringtonPC, pp. 158f.

72. Last Judgment: Angelic choirs, ca. 1325
 Naples, S. Maria di Donna Regina, fresco
 Angels sing.
 Photo: Soprintendenza ai Beni Artistici e Storici di Napoli
 Bibl.: BerensonCN, 1:81; HammersteinME, fig. 66; and HetheringtonPC, pp. 158f.

67.

70.

68.

71.

69.

72.

(Cavallini, Pietro, follower of)

73. Life of St. Agnes: St. Agnes taken to a brothel, ca. 1325
 Naples, S. Maria di Donna Regina, fresco
 St. Agnes is led through the streets by two men playing trumpets and one playing cymbals.
 Photo: Alinari
 Bibl.: BerensonCN, 1:82 (pl. 161); and HetheringtonPC, pp. 158f.

74. Life of St. Elisabeth of Hungary: Her Wedding, ca. 1325
 Naples, S. Maria di Donna Regina, fresco
 Two men play trumpets. One man plays a harp or harp-psaltery. What may be the peg box of a stringed instrument can be seen in front of the harpist, but its exact nature is obscure because the fresco has been damaged. In a scene above the main panel, at least four people dance in a garden.
 Photo: Alinari
 Bibl.: BerensonCN, 1:81–82; BertauxSM, pp. 39–42 (fig. 4); and HetheringtonPC, pp. 158f.

Cenni di Francesco di Ser Cenni (active by 1369, died ca. 1415), Florence

75. Virgin and Child, with saints and angels, ca. 1375–1380
 Florence, Bellini Collection (in 1969–1971), panel painting
 Angels play fanciful harp, shawm, tambourine, and psaltery.
 Photo: BoskovitsPF
 Bibl.: BoskovitsPF, p. 288 (fig. 313)

76. Nativity, ca. 1395–1400
 Florence, Gallerie fiorentine, no. 6139, panel painting
 Angels play shawm, bagpipe, shawm, tambourine, fiddle, and two trumpets.
 Photo: BoskovitsC
 Bibl.: BoskovitsC, p. 285 (fig. 12); and BoskovitsPF, p. 287

77. Virgin and Child, with apostles and angels, ca. 1380–1385
 Lugano-Castagnola, Thyssen-Bornemisza Collection, panel painting
 Angels play on the left: fiddle, psaltery, harp, shawm, psaltery, and rebec or bowed gittern; and on the right: fiddle, lute, psaltery, shawm, fiddle, and psaltery.
 Photo: Museum
 Bibl.: AntalFP, p. 335 (fig. 133); BoskovitsC, p. 273 (fig. 1); BoskovitsPF, pp. 128, 220, and 289 (fig. 308); Rohoncz Cat, no. 71 (fig. 76; attributed to Jacopo di Cione); and Heinemann Thyssen Cat

78. Polyptych with Coronation of the Virgin and saints, ca. 1385–1390
 Malibu, J. Paul Getty Museum, panel painting
 Angels play harp and psaltery.
 Photo: Museum
 Bibl.: BoskovitsPF, pp. 128, 289f. (fig. 138); Fredericksen Getty Cat, pp. 8f. (fig. 10); and Offner III/V, p. 249 (attributed to follower of Orcagna)

73.

76.

74.

77.

75.

78.

(Cenni di Francesco di Ser Cenni)

79. Coronation of the Virgin, with saints and angels, ca. 1390–1395
Formerly Pistoia, Baldi Papini Collection, panel painting
Angels play portative organ, two shawms, and psaltery.
Photo: BoskovitsC
Bibl.: BoskovitsC, pp. 285–287 (fig. 14); and BoskovitsPF, p. 292

80. Christ and the Virgin in Glory, with saints and angels, ca. 1380–1385
Princeton, Princeton University, The Art Museum, The Caroline G. Mather Fund, no. 94, panel painting
Around the mandorla, angels play on the left: trapezoidal psaltery, portative organ, fiddle, and shawm; and on the right: shawm, bagpipe, tambourine, and lute.
Photo: Museum
Bibl.: BoskovitsC, p. 275 (fig. 3); BoskovitsPF, p. 292; and Offner IV/II, p. 50 (as Rohoncz Orcagnesque Master)

81. Virgin and Child in Glory, with angels, ca. 1410–1415 (head of the Virgin by Simone Martini or Memmo di Filipuccio)
San Gimignano, S. Lorenzo in Ponte, fresco
Angels play on the left: trumpet, cymbals, shawm, fiddle, and portative organ; and on the right: trumpet, bagpipe, tambourine, double recorder, and portative organ.
Photo: Alinari
Bibl.: BoskovitsPF, p. 293; CecchiniSG, p. 80 (fig. XVI); FremantleFG, p. 390 (fig. 797); Offner Suppl., p. 4; and San Gimignano Guide, pl. 16

82. Virgin and Child in Glory, with angels and apostles
San Gimignano, S. Lorenzo in Ponte, fresco
Angels play on the left: fiddle, shawm, and harp; and on the right: harp, shawm, portative organ, psaltery, and two trumpets. Originally, there were probably two more trumpets on the left side, and one other instrument (the fresco is damaged).
Photo: San Gimignano Guide
Bibl.: CecchiniSG, p. 86; Offner Suppl., p. 4; and San Gimignano Guide, pl. 17

Cimabue (active ca. 1272–1302), Florence

83. Christ the Judge (one of a series of scenes from the Apocalypse), ca. 1280–1283
Assisi, S. Francesco, Upper Church, fresco
Each of the seven angels plays a trumpet.
Photo: Assisi, S. Francesco
Bibl.: BattistiC, pp. 27–55 and 104 (pls. 15 and 17); BerensonF, 1:48 (pl. 11); van Marle, 1:461–468; NicholsonC, p. 7 (fig. 9); SindonaC, pp. 102f. (fig. 25 and pls. XXVII–XXVIII); and SupinoFSA, p. 100 (ill.)

84. Adoration of the Throne (one of a series of scenes from the Apocalypse), ca. 1280–1283
Assisi, S. Francesco, Upper Church, fresco
The badly damaged fresco includes the Elders of the Apocalypse in a circle below the mandorla, some of whom seem to be holding unclear instruments. The front Elder on the left may be holding a cittern, and the front Elder on the right a fiddle (with no bow).
Photo: Alinari
Bibl. BattistiC, pp. 27–55 and 104 (pls. 24–25); BerensonF, 1:48; van Marle, 1:461–468; NicholsonC, pp. 8–10 (fig. 11); SindonaC, pp. 101–102f. (fig. 23 and pls. XXIII–XXV); and SupinoFA, p. 95 (ill.)

79.

82.

80.

83.

81.

84.

Cimabue, follower of

85. Last Judgment
 Milan, private collection, panel painting
 Angel plays a horn.
 Photo: SindonaC
 Bibl.: GarrisonIRP, no. 159 (attributed to Venetian painter, ca. 1313–1335); and SindonaC, p. 119 (fig. 66), with a summary of earlier studies

Cola di Pietro (active from the 1370s to the second decade of the fifteenth century), Camerino (Marches)

86. Crucifixion, ca. second decade of the fifteenth century
 Camerino, Monastero di S. Chiara, fresco
 On extreme left, a mounted soldier plays a trumpet.
 Photo: VitaliniSC
 Bibl.: VitaliniSC, pp. 49f. (pl. VIII)

87. Death of the Virgin, ca. 1383 (assisted by Francesco di Antonio?)
 Vallo di Nera (Perugia), S. Maria, fresco
 In Heaven, two angels play lute and fiddle.
 Photo: VitaliniSC
 Bibl.: VitaliniSC, pp. 42f. (pl. VI)

88. King David, ca. 1383 (assisted by Francesco di Antonio?)
 Vallo di Nera (Perugia), S. Maria, fresco
 King David plays an incurved trapezoidal psaltery.
 Photo: VitaliniSC
 Bibl.: VitaliniSC, pp. 42f. (fig. 16)

89. Angels
 Vallo di Nera (Perugia), S. Maria, fresco (fragment)
 In the fragment shown in VitaliniSC, an angel plays a lute.
 Photo: VitaliniSC
 Bibl.: VitaliniSC, p. 46 (fig. 20)

Coppo di Marcovaldo (active 1260–1274), Florence

90. Crucifix, Mocking of Christ (middle panel to the right), ca. 1270
 San Gimignano, Museo civico, no. 30, panel painting
 Two men blow horns.
 Photo: Alinari
 Bibl.: BattistiC, pp. 18–23 (fig. 1); SindonaC, pp. 84f. (pl. II and fig. 2); SinibaldiPI, no. 57 (with ill.); and VavalàCD, pp. 755–764 (fig. 479)

85.

88.

86.

89.

87.

90.

Cristiani, Giovanni di Bartolomeo (documented 1366–1398), Florentine active in Pistoia

91. Virgin and Child, with angels, ca. 1375–1380
Crespina (Pisa), S. Michele Arcangelo, panel painting
Bottom: Angels play fiddle and rebec played upright.
Photo: Alinari
Bibl.: BoskovitsPF, p. 316; CarliPPT, 2:24 (pl. 43); and FremantleFG, p. 257 (fig. 514)

92. Triptych: Virgin and Child, with saints and angels, ca. 1370–1375
Florence, Sir Harold Acton Collection, panel painting
Angels play two rebecs played upright.
Photo: BerensonF
Bibl.: BerensonF, 1:51 (figs. 331 and 333); BoskovitsPF, p. 317; FremantleFG, p. 257 (fig. 516); and van Marle, 5:305 (figs. 190 and 191)

93. Virgin handing her girdle to St. Thomas
Formerly London, Robert Straus Collection, panel painting
Angels play on the left: tambourine and fiddle; and on the right: tambourine (strung with pellet bells), and trapezoidal psaltery.
Photo: Fototeca Berenson
Bibl.: none; attributed from Fototeca Berenson

94. Coronation of the Virgin
Longleat, Marquess of Bath, no. 177, panel painting
Angels play trapezoidal psaltery and bagpipe.
Photo: By permission of the Marquess of Bath; photograph courtesy of the Courtauld Institute of Art, London
Bibl.: none; attribution from Fototeca Berenson

95. Virgin and Child, with angels, ca. 1365–1370
Moscow, Pushkin Museum, no. 176, panel painting
Angels play fiddle and lute.
Photo: Moscow Pushkin Cat
Bibl.: BerensonF, 1:51; BoskovitsPF, p. 317 (pl. 164c); FremantleFG, p. 264 (fig. 536); Moscow Pushkin Cat, no. 6 (color ill.); and Offner Suppl., p. 65

96. St. Lucy enthroned, ca. 1375–1380
New Haven, Yale University Art Gallery, Bequest of Maitland F. Griggs, B. A. 1896, no. 1943.215, panel painting
Angels play fanciful harp and fiddle.
Photo: Museum
Bibl.: BerensonF, 1:51 (pl. 328); BerensonH, p. 126 (fig. 210); BoskovitsPF, pp. 317f.; Offner Suppl., p. 65; and Seymour Yale Cat, pp. 61–63 (pl. 42)

91.

94.

92.

95.

93.

96.

(Cristiani, Giovanni di Bartolomeo)

97. Virgin and Child, with angels
Pistoia, Museo civico, Inv. 1975, no. 24 (formerly no. 27), panel painting
Angels play on the left: two rebecs played upright; and on the right: shawm and bagpipe.
Photo: Aurelio Amendola, Pistoia
Bibl.: BerensonF, 1:51 (pl. 335); BoskovitsPF, p. 319; FremantleFG, p. 257 (fig. 515); van Marle, 5:484; Offner Suppl., p. 66; and Pistoia Cat MC, pp. 197f. (ill.)

98. Last Judgment, ca. 1380–1385
Pistoia, S. Domenico, fresco
On the left side of the fresco only: angels play two trumpets, shawm, and two rebecs held upright.
Photo: FremantleFG
Bibl.: BoskovitsPF, p. 318; and FremantleFG, p. 264 (fig. 535)

99. Polyptych with St. John Evangelist and scenes from his life, dated 1370
Pistoia, S. Giovanni Fuorcivitas, panel painting
Central panel with John enthroned: angels play fiddle and portative organ.
Photo: Alinari
Bibl.: BerensonF, 1:51 (pls. 325 and 327); BoskovitsPF, p. 318; FremantleFG, p. 261 (fig. 527); van Marle, 5:305; and Offner Suppl., p. 66

100. Coronation of the Virgin
Homeless, panel painting
Angels play trapezoidal psaltery, portative organ, double recorder, and fiddle.
Photo: Fototeca Berenson
Bibl.: none; attributed from Fototeca Berenson

Cristiani, Giovanni di Bartolomeo. See also under Sculpture: Pistoia, Cathedral.

Cugino dei romagnoli. See **Jacopino di Francesco.**

Daddi, Bernardo (active by 1312, died ca. 1348), Florence

101. Coronation of the Virgin, ca. 1340–1345
Altenburg, Staatliches Lindenau-Museum, no. 13, panel painting
a) On either side of the Virgin and Child stand saints and heavenly beings, including King David playing a trapezoidal psaltery.
b) Below the central figures, angels play two fiddles and two portative organs.
Photo: Museum
Bibl.: BerensonF, 1:51; van Marle, 3:400; Oertel Altenburg Cat, pp. 114f. (pl. 38 and fig. 31); Offner III/IV, pp. 85–87 (pl. XXXVI; attributed to close following of Daddi)

102. Triptych: Coronation of the Virgin, with Nativity and Crucifixion, ca. 1345
Berlin, Staatliche Museen Preußischer Kulturbesitz, no. 1064, panel painting
Coronation: angels play two trumpets, two fiddles and two portative organs. Nativity: a shepherd plays a shawm or other rustic wind instrument.
Photo: Museum
Bibl.: BerensonF, 1:52; van Marle, 3:379 (fig. 221); and Offner III/IV, pp. 82f. (pls. XXXV, 1–2; attributed to close following of Daddi)

97.

100.

98.

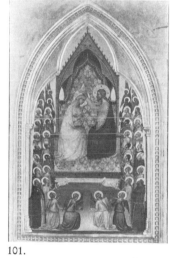

101.

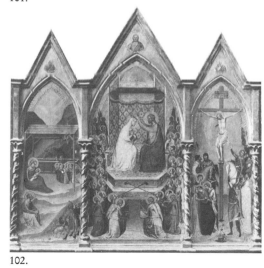

99.

102.

(Daddi, Bernardo)

103. Triptych: Crucifixion, with Nativity and other scenes, dated 1338
Edinburgh, National Gallery of Scotland, no. 1904, panel painting
Nativity: a shepherd holds a bagpipe.
Photo: Museum
Bibl.: BerensonF, 1:53; BerensonH, p. 84 (fig. 126); Brigstocke Edinburgh Cat, pp. 36–38 (pl. 22a); FremantleFG, p. 57 (fig. 113); van Marle, 3:379; and Offner III/IV, p. 78 (pl. XXXIV and XXXIV,3)

104. Crucifix
Florence, Accademia, no. 442, panel painting
In upper panel: Last Judgment with angels playing two trumpets.
Photo: Alinari
Bibl.: BerensonF, 1:53; and Offner III/V, pp. 134f. (pls. XXVIII and XXVIII,4; attributed to assistant of Daddi)

105. Polyptych: Coronation of the Virgin, with saints and angels, ca. 1340–1348
Florence, Accademia, no. 3449, panel painting
Angels play psaltery, fiddle, and portative organ.
Photo: Alinari
Bibl.: BerensonF, 1:53; Offner III/V, pp. 108–112 (pls. XXII, and XXII, 3–4; attributed to assistant of Daddi); and Uffizi Cat, p. 237 (also attributed to school of Giotto and Agnolo Gaddi)

106. San Pancrazio Polyptych: Virgin and Child, saints and angels, and other scenes ca. 1338
Florence, Uffizi, no. 8345, panel painting
a) Virgin and Child: angels play two fiddles and two portative organs.
b) Predella panel, extreme right: Nativity, with angels hovering over the manger, playing fiddle, lute, two shawms, trapezoidal psaltery, and portative organ. In the background, a shepherd holds a bagpipe.
Photo: Alinari
Bibl.: BerensonF, 1:53 (pls. 177 and 179); BoskovitsPF, p. 47 (pl. 9); van Marle, 3:386–388 (pl. VI and fig. 225); Offner III/III, pp. 54–57 (pls. XIV, XIV, 1, XIV, 8, and XIV, 29); and Uffizi Cat, p. 237

107. Nativity
Formerly Florence, Eugenio Ventura Collection, panel painting
A shepherd holds a bagpipe.
Photo: Offner
Bibl.: Offner III/VIII, p. 92 (pl. XXI)

108. Musical angels, ca. 1340
Oxford, Christ Church Library, no. 5, panel painting
Angels play tambourine, two portative organs, and fiddle.
Photo: The Governing Body, Christ Church, Oxford, England
Bibl.: BerensonF, 1:63 (attributed to Orcagna); FremantleFG, p. 145 (fig. 291; attributed to Orcagna); Offner III/V, p. 116 (pl. XXIV; attributed to assistant of Daddi); and Shaw Oxford Cat, no. 5 (attributed to Florentine school)

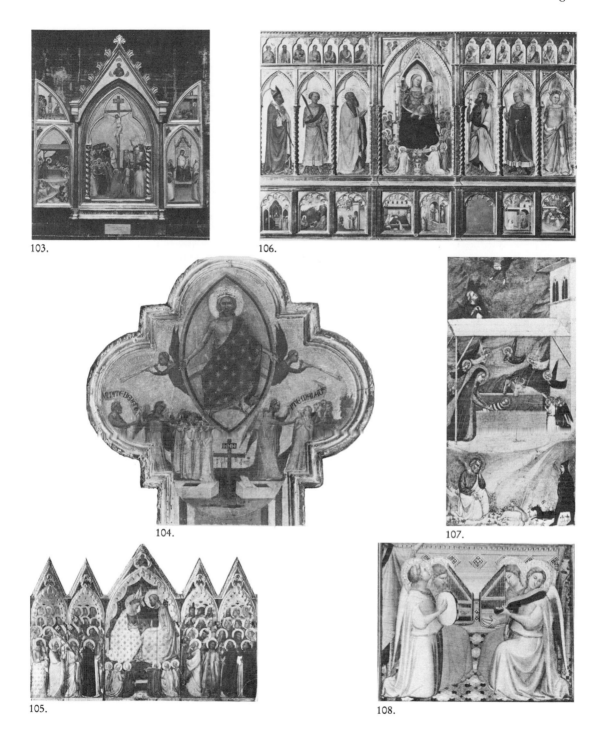

103.

106.

104.

107.

105.

108.

(Daddi, Bernardo)

109. Triptych: Virgin and Child, with Nativity and Crucifixion
Paris, Louvre, M. I. 410 (formerly 1667), panel painting
Virgin and Child: angels play two fiddles. Nativity: a shepherd holds a bagpipe.
Photo: Paris, Réunion des musées nationaux
Bibl.: BerensonF, 1:56; Offner III/IV, pp. 106f. (pl. XLII); and Paris Louvre Cat, p. 170 (ill.)

110. Virgin and Child, with Nativity and Crucifixion, ca. 1350 (by a follower of Daddi), central panel of the Aldobrandini triptych
Portland, Oregon, Art Museum, no. 61.51, panel painting
Angels play on the left: fiddle and gittern; and on the right: double recorder, and demi-trapezoidal psaltery.
Photo: Museum
Bibl.: BellosiDN, p. 192 (fig. 23; attributed to Pietro Nelli); BoskovitsPF, p. 420 (pl. 64; attributed to Pietro Nelli); and ShapleyPK, p. 28 (pl. 63)

111. Triptych: Coronation of the Virgin, with Nativity and Crucifixion
Prague, National Gallery, nos. 0.11.945–11.947 (formerly no. 21188 in Konopiste Castle), panel painting
In the Coronation: two angels play fiddles. In the Nativity (left wing): a shepherd holds a bagpipe.
Photo: Museum (attributed to a master from Rimini)
Bibl.: None

112. Coronation of the Virgin, dated 1338
Radensleben, Wilfried von Quast Collection
Angels play double recorder, fiddle, tambourine, trapezoidal psaltery, and two portative organs.
Photo: Offner
Bibl.: BerensonF, 1:57; and Offner III/IV, p. 186 (Add. pl. VI; attributed to close following of Daddi)

113. Virgin and Child, with saints and angels (by a follower of Daddi)
Siena, Pinacoteca nazionale, no. 73, panel painting
On either side of the central figures angels play shawm and trapezoidal psaltery. Below the central figures angels play bagpipe (or shawm?), and portative organ.
Photo: Foto Grassi
Bibl.: BerensonF, 1:58; van Marle, 3:398–400 (fig. 232); Offner III/IV, pp. 158f. (pl. LIX); and TorritiPNS, p. 230 (fig. 271)

114. Virgin and Child, with angels (central panel of a polyptych by a follower of Daddi)
Formerly Vienna, Lanckoronski Collection, panel painting
Angels play two fiddles.
Photo: Offner
Bibl.: BerensonF, 1:58; and Offner III/VIII, pp. 42f. (pl. VIII; attributed to workshop of Daddi)

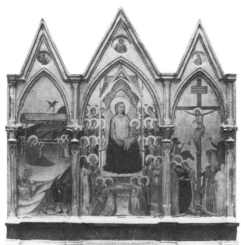

109.

112.

110.

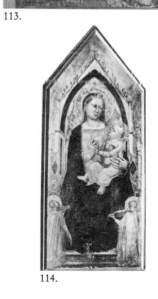

113.

111.

114.

(Daddi, Bernardo)

115. Virgin and Child, with saints and angels, 1330s
Washington, National Gallery of Art, Samuel H. Kress Collection, no. 1140, panel painting
a) On either side of the central figures angels play shawm and trapezoidal psaltery.
b) Below the central figures angels play portative organ, and fiddle.
Photo: Museum
Bibl.: BerensonF, 1:58 (fig. 130); Offner III/VIII, pp. 16f. (pl. III); ShapleyPK, p. 26 (fig. 61); and Shapley Washington IP, 1:153–154 (pl. 108)

Daddi, Bernardo. See also **Jacopo di Cione, Allegretto Nuzi, Orcagna,** and **Puccio di Simone** (Master of the Fabriano Altarpiece)

Donato di San Vitale. See **Catarino Veneziano.**

Duccio di Buoninsegna (active from 1278, died 1318/19), Siena

116. Nativity with the prophets Isaiah and Ezekiel (predella from the Sienese Maesta, 1308–1311)
Washington, National Gallery of Art, Andrew W. Mellon Collection, no. 8, panel painting
A shepherd holds a bagpipe.
Photo: Museum
Bibl.: BerensonCN, 1:118 (pl. 34); van Marle, 2:28–29 (fig. 17); Shapley Washington IP, 1:168–172 (pl. 119), with citations of earlier studies; and WhiteD, pp. 80–136 (pl. 11, with incorrect location)

Duccio di Buoninsegna, follower of

117. Coronation of the Virgin
Eindhoven, Philips-de Jong Collection, panel painting
Angels play gittern and demi-trapezoidal psaltery.
Photo: SienesePH
Bibl.: SienesePH, no. 6 (rejecting earlier attribution to Lippo Memmi)

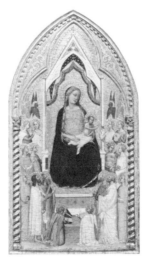

115.

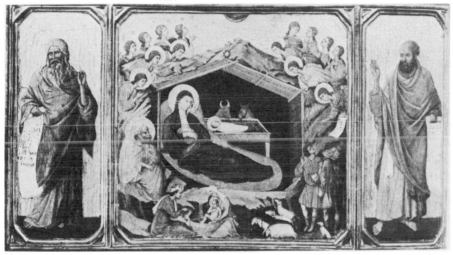

116.

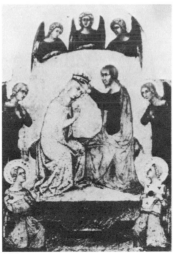

117.

Bibliographia

1975–1981

This bibliography has been compiled from approximately 120 periodicals in musicology, art history, and neighboring fields such as religion, history, etc. Unlike Frederic Crane's Bibliography of the Iconography of Music, New York, RIdIM, 1972, the bibliography does not include publications containing pictorial material merely for the sake of illustration without iconographical explanation; calendars are also excluded. (For this material we refer the reader to the RIdIM Newsletter published biannually in New York.) The material is arranged in four categories: music and art, iconography, portrait iconography, and organology; occasionally an entry appears in more than one category. At the end there is a list of cross references of publications concerned with illustrations on musical instruments (e.g., organ cases or oliphants). Addenda and corrigenda are most welcome, especially in the more recondite area of non-Western iconography.

The compilers were Mrs. Melanie Crain and Ms. Caroline Usher, Duke University, Mr. Terry Ford and Ms. Patricia Roos, RIdIM New York, and Dr. Monika Holl, RIdIM Munich. Mr. Kenneth Kreitner, Duke University, has typed the manuscript. I am very grateful to all of them.

T. S.

Music and Art

Adams, Karen C., ›Neoplatonic Aesthetic Tradition in the Arts‹, in: College Music Symposium 17/2 (1977), pp. 17–24.

Ashmore, J., ›Sound in Kandinsky's Paintings‹, in: Journal of Aesthetics 35 (1977), pp. 329–336.

Berlin Nationalgalerie. – Hommage à Schönberg. Der Blaue Reiter und das Musikalische in der Malerei der Zeit. Ausstellung 11. September–4. November 1974 [Exhibition catalogue] (Berlin 1974).
Review by Angela Schneider, ›Neue Nationalgalerie Berlin. Ausstellung....‹, in: Pantheon 33 (1975), pp. 56–58.

Biba, Otto, Der Piaristenorden in Österreich. Seine Bedeutung für bildende Kunst, Musik und Theater im 17. und 18. Jahrhundert (Eisenstadt 1975).
Reviews by:
Herbert Seifert in: Österreichische Musikzeitschrift 32 (1977), pp. 100f.
Theophil Antonicek in: Die Musikforschung 31 (1978), pp. 489f.

Bloesch, Ethel, ›Music Autographs and First Editions on Postage Stamps‹, in: Fontes Artis Musicae 25 (1978), pp. 250–263.

Breuer, J., ›Bartók and the Arts‹, in: New Hungarian Quarterly 16 (1975), pp. 117–124.

Byrnside, Ronald L., ›Musical Impressionism: The Early History of the Term‹, in: The Musical Quarterly 66 (1980), pp. 522–537.

Cleaver, Dale G., and John M. Eddins, Art and Music. An Introduction (New York 1977).

Curonici, G., ›Paul Klee e il rapporto tra musica e pittura‹, in: Cenobio No. 5 (1974), pp. 328–335.

Doubravova, Jarmila, ›Music and Visual Art – Their Relation as a Topical Problem of the Contemporary Music in Czechoslovakia‹, in: International Review of Aesthetics and Sociology of Music 11 (1980), pp. 219–228.

Ernst, Berta. See Sündermann, Hans, and Berta Ernst.

Ferrero, Mercedes Viale, ›Guglielmo Tell a Torino (1839–1840). Ovvero una »Procella« Scenografica‹, in: Rivista Italiana di Musicologia 14 (1979), pp. 378–394.

Feurich, Hans Jürgen, ›Franz Schubert und Caspar David Friedrich im Unterricht. Stilverwandtschaften und ihre Deutung durch Hegels Begriff der Romantik‹, in: Zeitschrift für Musikpädagogik 8 (1977), pp. 66–71.

Fischer, Kurt von, ›Claude Debussy und das Klima des Art Nouveau: Bemerkungen zur Ästhetik Debussys und James McNeill Whistlers‹, in: Art Nouveau: Jugendstil und Musik, herausgegeben aus Anlaß des 80. Geburtstages von Willi Schuh (Zürich 1980), pp. 31–46.

Flam, J. D., ›Matisse in Two Keys‹, in: Art in America 63 (1975), pp. 83–86.

Gainsborough and His Musical Friends: A Celebration of the 250th Anniversary of the Artist's Birth (London 1977).

Grumbacher, Rudolf, and Albi Rosenthal, ›»Dieses einzige Stückchen Welt . . .« Über ein Albumblatt von Felix Mendelssohn Bartholdy‹, in: Totum me libris dedo. Festschrift zum 80. Geburtstag von Adolf Seebass (Basel 1979), pp. 53–61.

Hannover. – Allegro barbaro. Béla Bartók und die bildende Kunst. Kunstmuseum Hannover mit Sammlung Sprengel, Hannover 25. März–14. Mai 1981 [Exhibition catalogue] (Hannover 1981).

Hegewisch, Katharina, ›Rose im Mund – Frosch verschluckt. Paul Hindemith als Zeichner. Phantasiegestalten‹, in: Neue Musikzeitung 19 (1980), p. 33.

Hermand, Jost, »Expressionism and Music«, in: Expressionism Reconsidered. Relationships and Affinities (München 1979), pp. 58–73 (= Houston German Studies 1).

Hollander, Hans, Musik und Jugendstil (Zürich 1975).

–, ›Delacroix und die Musik‹, in: Das Orchester 28 (1980), pp. 492–495.

–, ›Beethoven und Goya – Parallelen und Gegensätze‹, in: Das Orchester 28 (1980), pp. 803–805.

Ibsen al Faruqi, Lois, ›Ornamentation in Arabian Improvisational Music: A Study of Interrelatedness in the Arts‹, in: The World of Music 20/1 (1978), pp. 17–32.

Jablonsky, S., ›Graphic Artworks Based on Music: Musicographs‹, in: Leonardo (12th April 1979), pp. 308 f.

Jenkins, David, and Mark Visocchi, Mendelssohn in Scotland (London 1978).
Review by Lionel Salter in: The Musical Times 119 (1978), pp. 957 f.

Jensen, H. J., The Muses' Concord: Literature, Music, and the Visual Arts in the Baroque Age (Indiana University Press 1976).
Review by Richard Luckett in: Music and Letters 58 (1977), pp. 326–328.

Johnson, R., ›Picasso's Musical and Mallarmean Constructions‹, in: Arts Magazine 51/7 (1976–1977), pp. 122–127.

–, ›Whistler's Musical Modes: Symbolist Symphonies, Numinous Nocturnes‹, in: Arts Magazine 55/8 (1980–1981), pp. 164–176.

Kagan, Andrew, ›Paul Klee's »Kettledrummer«‹, in: Arts Magazine 51/7 (1976–1977), pp. 108–111.

–, ›Paul Klee's »Ad Parnassum«. The Theory and Practice of Eighteenth-Century Polyphony as Models for Klee's Art‹, in: Arts Magazine 52/1 (1977–1978), pp. 90–104.

–, ›Paul Klee's »Polyphonic Architecture«‹, in: Arts Magazine 54/5 (1979–1980), pp. 154–157.

Kagan, Andrew, and W. Kennon, ›The Fermata in the Art of Paul Klee‹, in: Arts Magazine 56/1 (1981–1982), pp. 166–170.

Kruz, Elizabeth. See Studing, Richard, and Elizabeth Kruz.

LeCoat, Gerard, ›Anglo-Saxon Interlace Structure, Rhetoric and Musical Troping‹, in: Gazette des Beaux-Arts 6ᵉ Période 87 (1976), pp. 1–6. Structural analogies can be drawn among interlacing, rhetorical, and troping techniques.

Lingner, Michael, ›Die Musikalisierung der Malerei bei Philipp Otto Runge‹, in: Zeitschrift für Ästhetik und allgemeine Kunstwissenschaft 24 (1979), pp. 75–94.

Loeffler, Elizabeth Ann, The Arts in the Court of Francis I 1515–1547. A Comparative Study of Selected Examples from Poetry, Music and the Visual Arts, Doctoral dissertation The Ohio State University 1979.

Lombardi, D., ›Futurism and Musical Notes‹, in: Artforum 19 (1980–1981), pp. 43–49.

McGrath, R. L., ›The Dance as Pictorial Metaphor‹, in: Gazette des Beaux-Arts 6ᵉ Période 89 (1977), pp. 81–92.

Metzger, Heinz-Klaus, ›Schönberg und Kandinsky. Ein Beitrag zum Verhältnis von Musik und Malerei‹, in: H.-K. Metzger, Musik wozu? Literatur zu Noten (Frankfurt/M. 1980), pp. 181–207.

Mies, Paul, ›Malerei und Musik bei Lyonel Feininger‹, in: Zeitschrift für Ästhetik 21 (1976), pp. 123–129.

Murray, Sterling E., and Ruth Irwin Weidner, Essays on Mannerism in Art and Music. Papers read at the West Chester State College Symposium on Interdisciplinary Studies, November 18, 1978 (West Chester/Pennsylvania 1980).

Nectoux, Jean-Michel, ›Musique, Symbolisme et Art nouveau: Notes pour une esthétique de la musique française fin de siècle‹, in: Art Nouveau: Jugendstil und Musik, herausgegeben aus Anlaß des 80. Geburtstages von Willi Schuh von Jürg Stenzl (Zürich 1980), pp. 13–30.

Ratcliff, Carter, ›Looking at Sound‹, in: Art in America 68 (1980), pp. 87–95.
 Deals with contemporary notation.
Risatti, Howard, ›Music and the Development of Abstraction in America: The Decade Surrounding the Armory Show‹, in: Art Journal 39 (1979), pp. 8–13.

Schneider, Klaus, Musik und Bildende Kunst (Hannover 1981).
 A list of selected items of the Stadtbibliothek Hannover.
Schönberg, Arnold, and Wassily Kandinsky, Briefe, Bilder und Dokumente einer außergewöhnlichen Begegnung (Salzburg 1980).
Smith, Richard Langham, ›Debussy and the Pre-Raphaelites‹, in: Nineteenth Century Music 5 (1981), pp. 95–109.
Spero, J., Rackham's Color Illustrations for Wagner's »Ring« (New York 1979).
Steiner, Ena, ›The »Happy« Hand: Genesis and Interpretation of Schoenberg's Monumentalkunstwerk‹, in: The Music Review 41 (1980), pp. 207–222.
 Includes a discussion of Schoenberg's stage sketches.
Studing, Richard, and Elizabeth Kruz, Mannerism in Art, Literature, and Music: A Bibliography (San Antonio 1979).
Sündermann, Hans, and Berta Ernst, Klang – Farbe – Gebärde. Musikalische Graphik, ed. Alois Eder (Wien and München 1981).

Vanslov, V. V., Izobrazitel'noe iskusstvo i muzyka. Očerki [The Fine Arts and Music. Essays] (Leningrad 1977).
Visocchi, Mark. See Jenkins, David, and Mark Visocchi.
Vodraska, Stanley L., ›The Flemish Octave Clavichord: Structure and Fretting‹, in: The Organ Yearbook 10 (1979), pp. 117–125.
 Discussion of painters and keyboard instrument makers in Antwerp in the same guild. Two paintings are discussed.

Weidner, Ruth Irwin. See Murray, Sterling E., and Ruth Irwin Weidner.

Werner-Jensen, Arnold, ›Malerischer und musikalischer Impressionismus. Gegenüberstellung von Monet und Debussy‹, in: Musik und Bildung 9 (1977), pp. 402–407.
Whitney, John H., Digital Harmony. On the Complementarity of Music and Visual Art (Peterborough/New Hampshire 1980).
Wilson, Michael J., ›Burne-Jones and Piano Reform‹, in: Apollo No. 165 (1975), pp. 342–347.
–, ›Gainsborough, Bath, and Music‹, in: Apollo No. 180 (1977), pp. 107–110.
Würtenberger, Franzsepp, Malerei und Musik. Die Geschichte des Verhaltens zweier Künste zueinander, dargestellt nach den Quellen im Zeitraum von Leonardo da Vinci bis John Cage (Frankfurt/M. etc. 1979; Galerie 1).

Iconography

d'Alessio, Gregory, ›On Sargent's »El Jaleo«: It May Be Art, But Is It Flamenco?‹, in: The Guitar Review No. 41 (1976), pp. 24f.
 Focusses on inaccuracies in Sargent's depiction of flamenco guitarists and dancers.
–, ›Pablo Picasso – Monument or Mountebank?‹, in: The Guitar Review No. 46 (1979), pp. 2–6; No. 47 (1979), pp. 1–7.
Antwerp – Paradisus musicus: muziek en samenleving in Rubens' tijd. Tentoonstelling [Exhibition catalogue] (Antwerp 1977).
Anderson, Udo, Musiktitel aus dem Jugendstil. 64 Beispiele aus den Jahren 1886 bis 1918 (Dortmund 1981).
Aparicio, Octavio, La musica en la pintura (Madrid 1975).
Asio, E., Il postiglione nella storia e nell'arte (Roma 1976).
Azarpay, G., ›Allegory of dēn in Persian Art‹, in: Artibus Asiae 38 (1976), pp. 37–48.
 Discusses representations of female instrumentalists.

Bach, Ivan, ›Andeli s glazbalima na pokaznici Zagrebačke katedrale iz 1406. godine‹ (Vier musizierende Engel auf der Monstranz aus dem Jahr 1406 in der Schatzkammer der Zagreber Domkirche), in: Arti Musices 7 (1976), pp. 137–157.
Bachmann, Werner, ›Probleme musikikonographischer Forschung und der Edition von Bildquellen‹, in: RIdIM Newsletter II/2 (1977), pp. 29–34. – Summary in: Report of the Twelfth Congress Berkeley 1977 of the International Musicological Society (Kassel etc. 1981), pp. 825–827.

–, ›Gestik des Singens: Ein Beispiel für jahrtausendealte Tradition‹ (Summary), in: Report of the Twelfth Congress Berkeley 1977 of the International Musicological Society (Kassel etc. 1981), pp. 835–838.

Baltz, Trudy, ›Pageantry and Mural Painting: Community Rituals in Allegorical Form‹, in: Winterthur Portfolio 15 (1980), pp. 211–228.
Deals with late nineteenth- and early twentieth-century American allegorical mural painting, many of which have musical depictions.

Barach, M., ›A Silenus Surviving in Nicola Pisano‹, in: The Art Bulletin 58 (1976), pp. 13–18.

Barolsky, Paul, ›Piero's Native Wit‹, in: Notes in the History of Art 1 (1981), pp. 21 f.
Piero della Francesca's ›Nativity‹ in the National Gallery, London.

Bassani, Ezio, ›Un corno afro-portoghese con decorazione africana‹, in: Critica d'Arte 44, nuova serie 166–168 (1979), pp. 167–174.

–, ›Gli olifanti afro-portoghesi della Sierra Leone‹, in: Critica d'Arte 44, nuova serie 166–168 (1979), pp. 175–201.

Bauer, George and Linda, ›Bernini's Organ-Case for S. Maria del Popolo‹, in: Art Bulletin 62 (1980), pp. 115–123.

Beerli, Conrad André, ›Nicolas Manuel dans le mouvement de son temps: La part de la musique et de la danse‹, in: Zeitschrift für Schweizerische Archäologie und Kunstgeschichte 37 (1980), pp. 289–391.

Bellm, Richard, ›Liturgie und bildende Kunst‹, in: Archiv für Liturgiewissenschaft 20–21 (1978–1979), pp. 380–388.
Annotated bibliography of books published between 1973 and 1977.

Bergquist, Peter, ›The Poems of Orlando di Lasso's *Prophetiae Sibyllarum* and Their Sources‹, in: Journal of the American Musicological Society 32 (1979), pp. 516–538.
With an iconography of the Sibyls.

Berlin Nationalgalerie. – Hommage à Schönberg. Der Blaue Reiter und das Musikalische in der Malerei der Zeit. Ausstellung 11. September – 4. November 1974 [Exhibition catalogue] (Berlin 1974). – See p. 245.

Bibliographie zur Symbolik, Ikonographie und Mythologie. Internationales Referateorgan 8–14 (Baden-Baden 1975–1981).

Bisanz-Prakken, Marian, Gustav Klimt. Der Beethovenfries. Geschichte, Funktion und Bedeutung (München 1980).

Bloch, Irene, Musical Iconography in the Graphic Works of Pieter Breughel the Elder, Master's Thesis Brooklyn College of the City University of New York 1977.

Börsch-Supan, H., ›Music in Painting: A Theme in Frederick the Great's Collection‹, in: Connoisseur 195 (1977), pp. 30–41.

Boime, A., ›Thomas Couture's Drummer Boy Beating a Path to Glory‹, in: Detroit Institute of the Arts Bulletin 56/2 (1978), pp. 108–131.

Bol, L. J., ›Rembrandts musicerend gezelschap: een vanitas-allegorie‹, in: Bulletin van het Rijksmuseum 25/3 (1977), pp. 95 f.

Bowles, Edmund A., ›Iconography as a Tool for Examining the Loud Consort in the Fifteenth Century‹, in: Journal of the American Musical Instrument Society 3 (1977), pp. 100–113.

–, Musikleben im 15. Jahrhundert (Leipzig 1977; = Musikgeschichte in Bildern III/8).
Review by Willem Elders in: Tijdschrift van de Vereniging voor Nederlandse Muziekgeschiedenis 28 (1978), pp. 81–85.

Boyd, Malcolm, ›Dance of Death‹, in: The New Grove Dictionary of Music and Musicians (London 1980), vol. 5, pp. 218 f.

Braun, Hartmut, ›Musik auf Holzschnitten des 16. Jahrhunderts‹, in: Musikethnologische Sammelbände II: Historische Volksmusikforschung, Kongreßbericht Seggau 1977 (Graz 1978), pp. 51–67.

Brednich, Rolf Wilhelm, ›Liedkolportage und geistlicher Bänkelsang: Neue Funde zur Ikonographie der Liedpublizistik‹, in: Jahrbuch für Volksliedforschung 22 (1977), pp. 71–79.

Breymeyer, R., ›Zu Friedrich Christoph Oetingers emblematischer Musiktheorie‹, in: Blätter für württembergische Kirchengeschichte 76 (1976), pp. 130–175.

Brook, Barry S. (Chairman), ›Present State of Iconographical Research‹ (Roundtable), in: Report of the Twelfth Congress Berkeley 1977 of the International Musicological Society (Kassel etc. 1981), pp. 801–843.
Contributions (mostly summaries) by 12 authors and important comments by respondent H. W. Janson. See under W. Bachmann, H. M. Brown, H. R. Cohen, Z. Falvy, B. Geiser, H. W. Janson, C. LaPointe, R. D. Leppert, J. W. McKinnon, W. Salmen, H. C. Slim, and E. Winternitz.

Brook, Barry S., and Carol Oja, ›Rembrandt's Portrait of a Musician‹, in: College Music Symposium 18/1 (1978), pp. 132–135.

Brown, Howard Mayer, ›Iconography and the Study of Particular Repertoires of Music‹, in: RIdIM Newsletter II/2 (1977), pp. 27–29. –

Summary in: Report of the Twelfth Congress Berkeley 1977 of the International Musicological Society (Kassel etc. 1981), pp. 824 f.

–, ›Music in Trecento Wedding Processions‹, in: Acta scientifica: Musica Antiqua 5 (Bydgoszcz 1978), pp. 467–482.

–, ›Iconography of Music‹, in: The New Grove Dictionary of Music and Musicians (London 1980), vol. 9, pp. 11–18.

–, ›Manet's Old Musician: Portrait of a Gypsy and Naturalist Allegory‹, in: Studies in the History of Art 8 (1978), pp. 77–87.

Brückmann, Remigius, ›Das Bänkelsang-Motiv in der deutschen Karikatur von 1848/49‹, in: Jahrbuch für Volksliedforschung 22 (1977), pp. 80–94.

Busch, Gabriele, Ikonographische Studien zum Solotanz im Mittelalter (Innsbruck 1980; = Innsbrucker Beiträge zur Musikwissenschaft 7).

Butler, Gregory G., ›Music and Memory in Johannes Romberch's *Congestorium*‹, in: Musica Disciplina 32 (1978), pp. 73–85.
> Romberch's writing on the art of memory particularly in relation to music; includes discussion of frontispiece of Gafori's ›Practica Musica‹ and illustration from a copy of Guido's ›Micrologus‹.

Carapezza, Paolo Emilio, ›Regina Angelorum in Musica Picta: Walter Frye e il »Maître au Feuillage Brodé«‹, in: Rivista Italiana di Musicologia 10 (1975), pp. 134–154.

Cassou, Jean, Encyclopédie du symbolisme: peinture, gravure et sculpture, littérature, musique (Paris 1979).

Chailley, Jacques, ›Léonard de Vinci et l'harmonie des sphères‹, in: Bulletin de l'Association Léonard de Vinci 13 (1974), pp. 21–26.

–, ›De la Flûte Enchantée à Jérome Bosch‹, in: Bulletin de la Classe des Beaux-Arts de l'Académie Royale de Belgique 57/10 (1975), pp. 186 f.

Champa, Kermit S., ›Piet Mondrian's »Broadway Boogie Woogie«‹, in: Arts Magazine 54/5 (1979–1980), pp. 150–153.

Chow, Fong, ›Han Dynasty Musicians and Instruments‹, in: Journal of the American Musical Instrument Society 1 (1975), pp. 113–125.
> Discusses small statues of musicians found in a Han Dynasty tomb.

Chrisman, Jo, and Charles B. Fowler, ›Music and Performance in a Renaissance Painting‹, in: Musical Heritage Review 2/7 (1979), pp. 54–57.

Christe, Y., ›Nouvelle interprétation des mosaïques de Saint-Michel in Africisco à Ravenna‹,

in: Rivista di Archeologia Cristiana 51 (1975), pp. 107–124.
> Discusses a relief depicting a scene from the book of Revelation and relevant manuscript illuminations.

Coat, G. le, ›Anglo-Saxon Interlace Structure, Rhetoric and Musical Troping‹, in: Gazette des Beaux Arts 6ᵉ Période 87 (1976), pp. 1–6.

Coeyman, Barbara, ›Iconography of the Viol: The Soloist in Baroque Portraits‹, in: College Music Symposium 20/1 (1980), pp. 136–142.

Cohen, H. Robert, ›Les Gravures Musicales dans *l'Illustration* de 1843 à 1899: Une expérience dans le traitement de sources iconographiques‹, in: Revue de Musicologie 62 (1976), pp. 125–130.

–, ›Musical Iconography in the 19th-Century French Illustrated Press: A Method for Cataloguing and Indexing‹, in: Report of the Twelfth Congress Berkeley 1977 of the International Musicological Society (Kassel etc. 1981), pp. 838–843.

Collaer, Paul, Südostasien (Leipzig 1979; = Musikgeschichte in Bildern I/3).
> Review by Andrew Toth in: Ethnomusicology 25 (1981), pp. 541 f.

Collins, David, ›A 16th-Century Manuscript in Wood: The Eglantine Table at Hardwick Hall‹, in: Early Music 4 (1976), pp. 275–279.

Connolly, Thomas H., ›The Legend of St. Cecilia‹, in: Studi Musicali 7 (1978), pp. 3–38, and 9 (1980), pp. 3–44.
> St. Cecilia's musical symbolism as represented in medieval art.

Conradin, Hans, and Günter Birkner, ›Bernhard Seidmann und »Die Musik in der Darstellung der Schweizerischen Malerei«‹, in: Schweizerische Musikzeitung 121 (1981), pp. 96–98.

Conti, G., ›Un »madrigale« del Piccolpasso‹, in: Faenza 67/1–6 (1981), pp. 143 f.

Coover, James, Musical Instrument Collections: Catalogues and Cognate Literature (Detroit 1981; = Detroit Studies in Music Bibliography 47).
> Includes a few titles of iconographic publications.

Corbett, Margery, and Ronald Lightbown, The Comeley Frontispiece: The Emblematic Title Page in England 1550–1660 (London and Boston 1979).

Cran, Robert, ›The Manley Rāgamālā: An Album of Indian Illustrated Musical Modes‹, in: Music and Civilization. The British Museum Yearbook 4 (1980), pp. 181–215.

Cunningham, David Wynn, Jr., Music Notation

in Netherlandish Paintings of the 15th and 16th Centuries, Ph.D. dissertation The Ohio State University 1978.

Dahmen-Dallapiccola, Anna Libera, Rāgamālā-Miniaturen von 1475 bis 1700 (Wiesbaden 1975).
Review by Harold Powers, ›Illustrated Inventories of Indian Rāgamālā Painting‹, in: Journal of the American Oriental Society 100 (1980), pp. 473–493.

Daniélou, Alain, Südasien: die indische Musik und ihre Traditionen (Leipzig 1978; = Musikgeschichte in Bildern I/4).
Review by Bruno Nettl in: Ethnomusicology 25 (1981), pp. 337f.

Deconinck, Cécile, ›Le luth dans les arts figurés des Pays-Bas au XVIᵉ siècle. Étude iconologique‹, in: Revue Belge d'Archéologie et d'Histoire de l'Art 48 (1979), pp. 3–43.

Degrada, Francesco, ›Prolegomeni a una lettura della *Sonnambula*‹, in: Il Melodramma Italiano dell' Ottocento: Studi i ricerche per Massimo Mila (Torino 1977), pp. 319–350.
Discusses stage settings of Bellini's ›Sonnambula‹.

Dickey, Stephanie S., ›Letter to the Editor‹, in: Art Bulletin 62 (1980), p. 183.
Takes issue with the article by Wendy Wood on van Eyck's Tymotheus portrait (see below).

Diehl, George K., ›The Illuminated Music Books of a Renaissance Merchant‹, in: Studies in Musicology in Honor of Otto E. Albrecht (Kassel 1980), pp. 88–109.

Di Giampaolo, Mario, ›Alessandro Bedoli »after« Girolamo?‹, in: Prospettiva. Rivista di storia dell'arte antica e moderna 22 (1980), pp. 87f.
Deals with attributions of two paintings and a drawing of St. Cecilia.

Dinnerstein, Louis, ›Beyond Revisionism: Henry Lerolle's »The Organ«‹, in: Arts Magazine 54/5 (1979–1980), pp. 172–176.

Disertori, Benvenuto, La musica nei quadri antichi (Trento 1978).

Dixon, Laurinda S., ›Bosch's »Garden of Delights« Triptych: Remnants of a »Fossil« Science‹, in: Art Bulletin 43 (1981), pp. 96–113.

Downey, Peter, ›A Renaissance Correspondence Concerning Trumpet Music‹, in: Early Music 9 (1981), pp. 325–329.

Dufrenne, Suzy, Les illustrations du Psautier d'Utrecht. Sources et apport carolingien (Paris 1978; = Association des Publications près des Universités de Strasbourg 151).

Duggan, Mary Kay, ›Queen Joanna and her Musicians‹, in: Musica Disciplina 30 (1976), pp. 73–96.

Dyer, Joseph, ›A Thirteenth-Century Choirmaster: The *Scientia Artis Musicae* of Elias Salomon‹, in: The Musical Quarterly 66 (1980), pp. 83–111.
Includes a discussion of the illustrations in the treatise.

Ebeling, Klaus, Rāgamālā Painting (Basel 1977).
Review by Harold Powers, ›Illustrated Inventories of Indian Rāgamālā Painting‹, in: Journal of the American Oriental Society 100 (1980), pp. 473–493.

Eidelberg, M., ›»Le Flûtiste« de Grenoble remis en question‹, in: La Revue du Louvre 28/1 (1978), pp. 12–19.

Emblem und Emblematikrezeption, vergleichende Studien zur Wirkungsgeschichte vom 16. bis zum 20. Jahrhundert, herausgegeben von Sibylle Penkert (Darmstadt 1978).
Review by Walter Salmen in: Die Musikforschung 34 (1981), p. 87.

Falvy, Zoltan, ›Images, Instruments, History of Music = Musical Iconology‹, in: RIdIM Newsletter II/2 (1977), pp. 9–12. – Summary in: Report of the Twelfth Congress Berkeley 1977 of the International Musicological Society (Kassel etc. 1981), pp. 804f.

Fau, E., ›La gravure de musique à Paris des origines à la Révolution (1660–1789)‹, in: Positions Thèses de l'École des Chartes (1978), pp. 47–58.

Ferrero, Mercedes Viale, ›Le feste a Torino tra Rivoluzione e Restaurazione. I modelli francesi e le varianti locali‹, in: Chigiana 33, nuova serie 13 (1976), pp. 283–297.

–, ›Die Bühnenausstattung des »Teatro Regio di Torino« (1667–1740)‹, in: Hamburger Jahrbuch für Musikwissenschaft 3 (1978), pp. 239–272.

–, La Scenografia dalle origini al 1936 (Torino 1980; = Storia del Teatro Regio di Torino 1/III).

Feuchtwanger, Franz, ›Tlatilco-Terrakotten von Akrobaten, Ballspielern, Musikanten und Tanzenden‹, in: Baessler-Archiv, Neue Folge 28 (1980), pp. 131–153.

Finney, P. Corby, ›Orpheus – David: A Connection in Iconography between Greco-Roman Judaism and Early Christianity‹, in: Journal of Jewish Art 5 (1978), pp. 6–15.

Fischer, Pieter, Music in Paintings of the Low Countries in the 16th and 17th Centuries (Amsterdam 1975).

Review by Howard Mayer Brown in: Early Music 5 (1977), pp. 101 f.

Foster, Genette, The Symbolism of Music and Musical Instruments in Thirteenth-Century French Manuscript Illuminations, Ph.D. dissertation City University of New York 1977.

Friedman, Mira, ›David-Orpheus in »The Sources of Music« by Chagall‹, in: Orbis Musicae/ Assaph: Studies in the Arts 7 (1979–1980), pp. 108–118.

Gáras, Klára, ›Giorgione e il giorgionismo: ritratti e musica‹, in: Giorgione. Atti del convegno internazionale di studio per il 5° centenario della nascità (Asolo etc. 1979), pp. 165–170.

Gentili, A., ›La Musica di Orfeo. Elogio e critica dell'armonia nella cultura giorgionesca‹, in: Annuario. Istituto Storia dell'Arte, Università degli Studi (Roma 1974–1976), pp. 145–166.

Germann, Sheridan, ›Monsieur Doublet and his *confrères*: The Harpsichord Decorators of Paris, I and II‹, in: Early Music 8 (1980), pp. 435–453, and 9 (1981), pp. 192–207.

Giesel, Helmut, Studien zur Symbolik der Musikinstrumente im Schrifttum der alten und mittelalterlichen Kirche (von den Anfängen bis zum 13. Jahrhundert) (Regensburg 1978; = Kölner Beiträge zur Musikforschung 94).

Godwin, Joscelyn, ›»Main divers acors«: Some instrument collections of the Ars Nova period‹, in: Early Music 5 (1977), pp. 148–159.

 Discusses carvings of musicians from the nave of Beverly Minster (Yorkshire) and the monumental brass of Bishops Gottfried and Frederic von Bülow in Schwerin Cathedral (Mecklenburg).

Grandjean, Serge, ›Le guéridon de Madame Du Barry provenant de Louveciennes‹, in: La Revue du Louvre et des Musées de France 29 (1979), pp. 41–49.

 Deals with a table of 1774 which has an enamel after Charles van Loo, ›Le Concert du Grand Sultan‹.

Gropengiesser, H., ›Sänger und Sirenen: Versuch einer Deutung‹, in: Archäologischer Anzeiger 4 (1977), pp. 582–610.

Gruber, Gernot, ›Mozart, das Lieblingskind Österreichs‹, in: Österreichische Musikzeitschrift 35 (1980), pp. 569–577.

 Deals with the decoration of the Wiener Hofoper by Moritz von Schwind.

Grunfeld, Frederic V., ›»L'Accord Parfait en Amour«: Incidental Notes to the Graphic Music of Balzac's Paris‹, in: The Guitar Review 44 (1978), pp. 1–33.

Günther, Ursula, ›Les anges musiciens et la Messe de Kernascléden‹, in: Les Sources en Musicologie. Actes des Journées d'Études de la Société Française de Musicologie à l'Institut de Recherche et d'Histoire des Textes d'Orléans, La Source, 9–11 septembre 1979 (Paris 1980), pp. 109–136.

Guichard, Léon, ›L'Entrée de la reine Marie de Medicis à Avignon en 1600‹, in: Poesia e musica nell'estetica del XVI e XVII secolo (Parma 1977), pp. 23–35.

 Discusses the Labyrinthe Royale de l'Hercule Gaulois Triomphant, an account with engravings of Marie's entry.

Haifa, Music Museum. – The Old Testament in World Music. The Haifa Music Museum, Amli Library [Exhibition catalogue] (Haifa 1976).

Haill, C., Victorian Illustrated Music Sheets (London 1981).

Halász, Tünde, ›Az állatszimbólumok zenei eredetéről‹ [The Musical Origin of Animal Symbols], in: Müvészet 19 (1978), pp. 16 f.

Hammerstein, Reinhold, Diabolus in musica. Studien zur Ikonographie der Musik im Mittelalter (Bern and München 1974; =Heidelberger Studien zur Musikwissenschaft 6).
 Reviews by:
 Wolfgang Dömling in: Die Musikforschung 32 (1979), pp. 342 f.
 Michel Huglo in: Revue de Musicologie 62 (1976), pp. 296 f.
 D. Jacoub in: Bulletin monumental 133 (1975), pp. 273–275.
 Koraljka Kos in: International Review of the Aesthetics and Sociology of Music 6 (1975), pp. 320–322.
 James W. McKinnon in: The Musical Quarterly 62 (1976), pp. 119–123.
 Volker Scherliess in: Rivista Italiana di Musicologia 12 (1977), pp. 153–157
 J. Smits van Waesberghe in: Cahiers de Civilisation Médiévale 20 (1977), pp. 366–368.

–, Tanz und Musik des Todes. Studien zum mittelalterlichen Totentanz (Bern and München 1980).
 Review by Christian Meyer in: Revue de Musicologie 67 (1981), p. 251.

Hanning, Barbara R., ›Glorious Apollo: Poetic and Political Themes in the First Opera‹, in: Renaissance Quarterly 32 (1979), pp. 485–513.

Harris, T. V., ›Musical Scenes in Japanese Woodblock Prints‹, in: Music and Civilization. The British Museum Yearbook 4 (1980), pp. 215–224.

Harter, Jim, Music: A Pictorial Archive of Wood-cuts and Engravings (New York c. 1980).

Hartinger, Walter, Volkstanz, Volksmusikanten und Volksinstrumente in der Oberpfalz zur Zeit Herders (Regensburg 1980; = Quellen und Studien zur musikalischen Volkstradition in Bayern 4, Studien zur musikalischen Volkstradition 1).

Hauck, A. H. R., ›John Ruskin's Uses of Illuminated Manuscripts: The Case of the Beaupré Antiphonary, 1853–1856‹, in: Arts Magazine 56/1 (1981–1982), pp. 79–83.

Hausamann, T., Die tanzende Salome in der Kunst von der christlichen Frühzeit bis um 1500. Ikonographische Studien (Zürich 1980).

Heartz, Daniel, ›Diderot et le Théâtre Lyrique: »Le Nouveau Stile« proposé par *Le Neveu de Rameau*‹, in: Revue de Musicologie 64 (1978), pp. 229–252.

 Discusses also iconographic sources pertaining to Rameau and his editions.

Heesemann-Wilson, ›Henry Fantin-Latours Rheingold‹, in: Jahrbuch der Hamburger Kunstsammlungen 25 (1980), pp. 103–116.

Henning, E. B., ›Picasso: Harlequin with Violin (si tu veux)‹, in: Cleveland Museum of Art Bulletin 63 (1976), pp. 2–11.

Herbert, Robert L., ›»Parade de Cirque« de Seurat et l'esthétique scientifique de Charles Henry‹, in: Revue de l'Art 50 (1980), pp. 9–23.

Hess, G., ›Fracta Cithara oder die zerbrochene Laute. Zur Allegorisierung der Bekehrungsgeschichte Jacob Baldes im 18. Jh.‹, in: Formen und Funktionen der Allegorie. Germanistische Symposien. Berichtsbände 3 (Stuttgart 1979), pp. 605–631.

Hirte, Werner, Vetter Franz auf dem Esel. Heitere Bilderbogen schwarz auf weiß (Frankfurt/M. 1977).

 Review by Rolf Wilhelm Brednich in: Jahrbuch für Volksliedforschung 23 (1978), p. 236.

Hoffmann-Axthelm, Dagmar, ›Instrumentensymbolik und Aufführungspraxis. Zum Verhältnis von Symbolik und Realität in der mittelalterlichen Musikanschauung‹, in: Basler Jahrbuch für historische Musikpraxis 4 (1980), pp. 9–90.

Holst, K., ›Musikanterbilledet på Rosenborg slot og forudsaetningen for dets illusionisme i ferraresk loftsmalerei‹ [The Representation of Musicians in the Castle of Rosenborg and the understanding of the illusionism in the painting of the ceilings in Ferrara], in: Histoire 10 (1973), pp. 456–481.

Howard, Patricia, ›The Académie Royale and the Performance of Lully's Operas‹, in: The Con-sort 31 (1975), pp. 109–115.

 Discusses two engravings of operas performed outdoors at Versailles.

Ikonographie und Ikonologie. See Kaemerling, Ekkehard.

Illusione e pratica teatrale. Proposte per una lettura dello spazio scenico dagli intermedi fiorentini all'opera comica veneziana. Catalogo della mostra a cura di F. Mancini, M. T. Muraro, E. Povoledo, con contributi di L. Bianconi, P. Petrobelli, N. Pirrotta, M. V. Ferrero, M. H. Winter (Vicenza 1975; = Cataloghi di Mostre 37).

Jacobs, F. H., ›Carpaccio's »Vision of St. Augustine« and St. Augustine's Theories of Music‹, in: Studies in Iconography 6 (1980), pp. 83–93.

Janson, H. W., ›On Theme 3 [of the roundtable in iconography]: Pitfalls‹, in: Report of the Twelfth Congress Berkeley 1977 of the International Musicological Society (Kassel etc. 1981), pp. 827–831.

Janson, H. W. See also Brook, Barry S., ›Present State . . .‹.

Johnson, R. W., ›Picasso's »Old Guitarist« and the Symbolist Sensibility‹, in: Artforum 13 (1974), pp. 56–62.

Jones Hellerstedt, K., ›A Traditional Motif in Rembrandt's Etchings: The Hurdy-Gurdy Player‹, in: Oud Holland 95/1 (1981), pp. 16–30.

Jonsson, Leif, Musik mellan himmel och helvete. En musikikonografisk studie i uppländska medeltida kalkmålningar (Uppsala 1977).

Kaemerling, Ekkehard (ed.), Ikonographie und Ikonologie: Theorien, Entwicklung, Probleme. Bildende Kunst als Zeichensystem (Köln 1979).

Kagan, Andrew, ›Paul Klee's Kettledrummer‹, in: Arts Magazine 51/5 (1976–1977), pp. 108–111.

–, ›Paul Klee's »Ad Parnassum«. The Theory and Practice of Eighteenth-Century Polyphony as Models for Klee's Art‹, in: Arts Magazine 52/1 (1977–1978), pp. 90–104.

–, ›Paul Klee's »Polyphonic Architecture«‹, in: Arts Magazine 54/5 (1979–1980), pp. 154–157.

Kalmár, L., ›Über die ihrem Charakter nach »Uniformiter-Difformis« Ausdehnung des triangulums als »Musters« der mittelalterlichen Darstellung geschichtlicher Abläufe‹, in: Acta Historiae Artium 23 (1977), pp. 57–93.

 Medieval hierarchy of purity – symbolic triangular shape; includes the psaltery.

Karakhanian, G. H., ›Sculptures of Musicians on the Khatchkars of the Twelfth and Thirteenth Century‹ [in Armenian: summary in Russian], in: Lraber hasarakan gitouthiounneri 399/3 (1976), pp. 99–105.

Katowice, State Music College Library. – Musical Ex Libris Book Plates in the Collection of the State Music College Library in Katowice [Exhibition catalogue] (Katowice, State Music College Library, 1979).

Kaufmann, Walter, Altindien (Leipzig 1981; = Musikgeschichte in Bildern II/8).

Kettering, A. McNeil, ›Rembrandt's »Flute Player«: A Unique Treatment of Pastoral‹, in: Simiolus 9 (1977), pp. 19–44.

Kilinski, Karl, ›Classical Klimtomania: Gustav Klimt and Archaic Greek Art‹, in: Arts Magazine 53/8 (1978–1979), pp. 96–99.
 Among other works, ›Music II‹ is discussed.

Klerk, Magda, Muziek-Karikaturen. Music-Caricatures from The Haags Gemeente Museum (Buren and New York 1981).

Koch, Willi, Musisches Lexikon. Künstler, Kunstwerke und Motive aus Dichtung, Musik und Bildender Kunst (Stuttgart 1976).

Koller, Erwin, Totentanz. Versuch einer Textembeschreibung (Innsbruck 1980; = Innsbrucker Beiträge zur Kulturwissenschaft, Germanistische Reihe 10).

Kos, Koraljka, ›St. Kummernis and her Fiddler: An Approach to Iconology of Pictorial Folk Art‹, in: Studia Musicologica 19 (1977), pp. 251–266.

Kren, Thomas, ›Qui non vuol Baccho: Roeland van Laer's Burlesque Painting about Dutch Artists in Rome‹, in: Simiolus 11 (1980), pp. 63–80.

Kümmel, Werner Friedrich, Musik und Medizin. Ihre Wechselbeziehungen in Theorie und Praxis von 800 bis 1800 (Freiburg and München 1977; = Freiburger Beiträge zur Wissenschafts- und Universitätsgeschichte 2).

Kümmerling, Harald, ›»Anno MDCLX« von Caspar Netscher. Bild oder Abbild 1.‹, in: Gitarre und Laute (1979), Heft 3, p. 2.

–, ›»Drei musizierende Damen« vom Meister der weiblichen Halbfiguren. Bild oder Abbild 2.‹, in: Gitarre und Laute (1979), Heft 4, p. 2.

–, ›»Bruno« von Michelangelo Merisi da Caravaggio. Bild oder Abbild 3.‹, in: Gitarre und Laute (1979), Heft 5, pp. 2f.

–, ›»Amor vincit omnia« von Frans Francken. Bild oder Abbild 5.‹, in: Gitarre und Laute (1980), Heft 1, p. 48.

–, ›Dürers Männerbad. Bild oder Abbild 6.‹, in: Gitarre und Laute (1980), Heft 2, pp. 26–32.

–, ›»Der verlorene Sohn« von Hans Bol. Bild oder Abbild 7.‹, in: Gitarre und Laute (1980), Heft 3, p. 26.

–, ›Ut a corporeis ad incorporea transeamus‹, in: Ars Musica, Musica Scientia. Festschrift Heinrich Hüschen (Köln 1980), pp. 331–343 (= Beiträge zur Rheinischen Musikgeschichte 126).
 Discusses the music angels in Gaudenzio Ferrari's cupola of the Santuario de Saronno 1534–1539.

–, ›»Den Esel kennt man bei den Ohren und bei den Worten den Toren«. Bild oder Abbild 8.‹, in: Gitarre und Laute (1981), Heft 1, pp. 11 and 42.

Kuretsky, Susan Donahue, The Paintings of Jacob Ochtervelt (1634–1682) (Montclair/New Jersey 1979).
 Includes discussion of nine entrance hall paintings with street musicians.
 Review by Scott A. Sullivan in: The Sixteenth Century Journal 12 (1981), pp. 123f.

Ladendorf, Heinz, ›Das zweite Gesicht der Melodia (Paris, Bibl. Nat. Ms. gr. 139)‹, in: Kunst als Bedeutungsträger. Gedenkschrift für Günter Bandmann (Berlin 1978), pp. 19–28.

Ladner, Gerhart B., ›Medieval and Modern Understanding of Symbolism: A Comparison‹, in: Speculum 54 (1979), pp. 223–256.

Langedijk, Karla, ›Baccio Bandinelli's Orpheus: A Political Message‹, in: Mitteilungen des Kunsthistorischen Institutes in Florenz 20 (1976), pp. 33–52.

–, Index Iconologicus. Compiled by the Art Department of Duke University under the guidance of K. L. 400 microfiches and printed guide (Sanford/North Carolina 1979).

Langmuir, E., ›Letters: The Concert in European Art‹, in: Burlington Magazine 117 (1975), p. 52.

Lazarov, Stefan, ›Die Bogomilen und die Musik‹, in: Beiträge zur Musikkultur des Balkans I: Walther Wünsch zum 65. Geburtstag (Graz 1975), pp. 77–108 (= Grazer Musikwissenschaftliche Arbeiten 1).
 Uses carvings on Bogomil gravestones.

Leppert, Richard D., ›Prodigal Son: Teniers and Ghezzi‹, in: Minneapolis Institute of Arts Bulletin 61 (1974), pp. 80–91.

–, The Theme of Music in Flemish Paintings of the Seventeenth Century, 2 vols. (München 1977; = Musik und Musiker im Bild. Ikonologische Studien 1).
 Reviews by:
 François Lesure in: Fontes Artis Musicae 25 (1978), p. 197.

Albert Dunning in: Tijdschrift van de Vereniging voor Nederlandse Muziekgeschiedenis 28 (1978), pp. 85–88.

–, ›Musicology and Visual Perception: Knowledge as the Delimiter of Expectation‹, in: RIdIM Newsletter II/2 (1977), pp. 12–15. – Summary in Report of the Twelfth Congress Berkeley 1977 of the International Musicological Society (Kassel etc. 1981), pp. 806–808.

–, Arcadia at Versailles. Noble Amateur Musicians and Their Musettes and Hurdy-Gurdies at the French Court (c. 1660–1789). A Visual Study (Amsterdam and Lisse 1978).
Reviews by:
Peter Williams in: The Organ Yearbook 11 (1980), p. 144.
Ian Harwood in: Early Music 9 (1981), pp. 247f.
Volker Scherliess in: Die Musikforschung 34 (1981), pp. 232f.

–, ›David Teniers the Younger and the Image of Music‹, in: Jaarboek van het Kongelige Museum voor Schone Kunsten (Antwerpen 1978), pp. 63–155.

–, ›Concert in a House – Musical Iconography and Musical Thought‹, in: Early Music 7 (1979), pp. 3–17.

–, ›Johann Georg Plazer: Music and Visual Allegory‹, in: Music East and West: Essays in Honor of Walter Kaufmann (New York 1981), pp. 209–224.

Levy, Lester S., Picture the Songs. Lithographs from the Sheet Music of 19th-Century America (Johns Hopkins University Press 1977).

Liess, Andreas, ›Claude Debussy und der *Art Nouveau*: ein Entwurf‹, in: Studi Musicali 4 (1975), pp. 245–276, and 5 (1976), pp. 143–215.

Lightbown, Ronald. See Corbett, Margery, and Ronald Lightbown.

Little, Meredith Ellis, ›Dance under Louis XIV and XV: Some Implications for the Musician‹, in: Early Music 3 (1975), pp. 331–340.
Discusses illustrations from P. Rameau's ›Le Maître à Danser‹.

Litvinskiy, B. A., and I. R. Pichikiyan, ›The Temple of the Oxus‹, in: Journal of the Royal Asiatic Society (1981), pp. 133–167.
Brief discussion of an altar, dedicated to the Oxus, which has a figure of Silenus Marsyas playing a double flute.

Lucas, Peter J., ›Ms. Junius 11 and Malmesbury‹, in: Scriptorium 34 (1980), pp. 197–220, and 35 (1981), pp. 3–22.
With iconographic studies of Jubal.

Lugano, Villa Malpensata. – Pittura e musica, dalla fine dell'ottocento a oggi. Lugano Villa Malpensata 1974 [Exhibition catalogue] (Lugano 1974).
Anonymous review in: Goya 129 (1975), pp. 209f.

McKinnon, James W., ›Canticum Novum in the Isabella Book‹, in: Mediaevalia 2 (1976), pp. 207–222.

–, ›Musical Iconography: A Definition‹, in: RIdIM Newsletter II/2 (1977), pp. 15–18.

–, ›*O Quanta Qualia*: On the Number of Singers Depicted in 15th-Century Liturgical Representations‹, in: Report of the Twelfth Congress Berkeley 1977 of the International Musicological Society (Kassel etc. 1981), pp. 809–815.

–, ›Representations of the Mass in Medieval and Renaissance Art‹, in: Journal of the American Musicological Society 21 (1978), pp. 21–52.

–, ›Cecilia‹, in: The New Grove Dictionary of Music and Musicians (London 1980), vol. 4, pp. 45f.

–, ›David‹, in: The New Grove Dictionary of Music and Musicians (London 1980), vol. 5, pp. 261f.

McLeod, M. D., ›Music and Gold-Weights in Asante‹, in: Music and Civilization. The British Museum Yearbook 4 (London 1980), pp. 225–242.

Mainz. Mittelrheinisches Landesmuseum und Stadtbibliothek. – Hommage à Bach [Exhibition catalogue] ed. by Wilhelm Weber and Fritz Kaiser: 23. Oktober bis 19. November 1980 (Mainz 1980).

Mandeles, Chad, ›Washington Allston's »The Evening Hymn«‹, in: Arts Magazine 54/5 (1979–1980), pp. 142–145.
A picture in the tradition of the imagery of melancholy.

Marly, Diana de, ›Musician's Costumes in the Renaissance Theatre‹, in: Early Music 5 (1977), pp. 507–515.

Martin, Dennis R., ›»Eine Collection Curieuser Vorstellungen« (1730) and Thomas Lediard, an Early Eighteenth-Century Operatic Scenographer‹, in: Current Musicology 26 (1978), pp. 83–98.
Discusses set designs by Lediard for state festivals celebrated in Hamburg.

Mildenberger, H., ›Allegorie der Musik und der fünf Sinne. Deckenfresken von Livio A. Retti (1692/93–1751) im Musiksaal der Keckenburg in Schwäbisch-Hall‹, in: Württembergisch Franken 64 (1980), pp. 161–178.

Mirimonde, Albert P. de, ›A propos d'une gravure publiée par Christophe Plantin et d'un tableau

flamand du Musée de Gray: Le Temple de Jérusalem (Architecture, Culte, Musique)‹, in: Jaarboek van het Kongelige Museum voor Schone Kunsten Antwerpen (Antwerpen 1975), pp. 213–243.

–, L'Iconographie musicale sous les rois Bourbons. La musique dans les arts plastiques (XVIIᵉ–XVIIIᵉ siècles), 2 vols. (Paris 1975 and 1977; = La vie musicale en France sous les rois Bourbons 22 and 25).
Reviews by:
Frank Dobbins in: The Musical Times 117 (1976), pp. 573f.
Tilman Seebass in: Schweizerische Musikzeitung 116 (1976), pp. 211f.
Edith Borroff in: Journal of the American Musicological Society 31 (1978), pp. 149–151.

–, ›La Musique chez les peintres de la fin de l'ancienne école de Bruges‹, in: Jaarboek van het Kongelige Museum voor Schone Kunsten Antwerpen (Antwerpen 1976), pp. 83–107.

–, ›Un jardin d'amour d'après D. Vinckboons au Musée d'Orléans‹, in: La Revue du Louvre et des Musées de France 26 (1976), pp. 15–23.

–, ›Le sablier, la musique et la danse dans les Noces de Cana de Paul Véronèse‹, in: Gazette des Beaux Arts 6ᵉ Période 88 (1976), pp. 129–136.

–, Astrologie et Musique (Genève 1977; = Iconographie Musicale 5).

–, ›Rubens et la musique‹, in: Jaarboek van het Kongelige Museum voor Schone Kunsten Antwerpen (Antwerpen 1977), pp. 97–197.

–, Musique et tapisseries. Musée des Tapisseries, Aix-en-Provence [Exhibition catalogue] (Aix-en-Provence 1978).

–, ›Les vanités à personnages et à instruments de musique‹, in: Gazette des Beaux Arts 6ᵉ Période 92 (1978), pp. 115–130, and 94 (1979), pp. 61–68.

–, ›La prétendue Antiope d'Antonio Allegri, dit le Corrège, ou les enseignements d'une erreur de deux siècles et demi‹, in: Gazette des Beaux Arts 6ᵉ Période 95 (1980), pp. 107–120.

–, ›Musique et symbolisme dans l'œuvre de Theodor van Thulden‹, in: Jaarboek van het Kongelige Museum voor Schone Kunsten Antwerpen (Antwerpen 1981), pp. 195–234.

Möller, Dirk, ›Mario Castelnuovo-Tedescos 24 Caprichos de Goya. Eine Einführung‹, in: Gitarre und Laute (1981), Heft 1, pp. 42–46.

Møller, Falcon, ›Nyfundne romanske kalkmaerier i Fraugde, II: de aeldste lovsang‹ [Romanesque frescoes recently found in Fraugde], in: Den Ikonographiske Post 7/4 (1976), pp. 31–38.

–, ›Musiksymbolik pa kryds och tvaers‹ [Musical symbolism of the Road to the Cross], in: Den Ikonographiske Post 8/3–4 (1977), pp. 30–37.

Mok, Robert T., ›Ancient Musical Instruments Unearthed in 1972 from the Number One Han Tomb at Ma Wang Tui, Changsa: Translation and Commentary of Chinese Reports‹, in: Asian Music 10 (1978), pp. 39–88.
Plates of statuettes of musicians also found in this and another tomb; drawings of reliefs showing musicians and instruments; briefly discusses these in relation to instruments found in the tomb.

Moleta, Vincent, ›The Illuminated *Laudari* MGL¹ and MGL²‹, in: Scriptorium 32 (1978), pp. 29–50.
Discusses two 14th-century illuminated manuscripts of Laudi.

Montagu, Gwen and Jeremy, ›Beverly Minster Reconsidered‹, in: Early Music 11 (1978), pp. 401–415.
Discusses stone carvings of musicians.

Montagu, Jeremy, ›A Carved Wooden Figure at Haddon Hall‹, in: The Galpin Society Journal 33 (1980), pp. 128–130.

Monterosso, Anna Maria Vacchelli, ›Il »Gabinetto armonico« di Filippo Bonanni‹, in: Poesia e Musica nell'Estetica del XVI e XVII Secolo (Parma 1979), pp. 81–90.

Moser, Dietz-Rüdiger, ›Lazarus Strohmans Jülich – Volkslied, Schaubrauch, Lehre‹, in: Jahrbuch des Österreichischen Volksliedwerkes 26 (1977), pp. 31–46.
Briefly discusses five plates showing the folk dance, spanning 1545–1791.

Mueller, G. D., ›Evaristo Baschenis – der Initiator von Musikstilleben und sein Kreis‹, in: Kunst in Hessen und am Mittelrhein 17 (1977), pp. 7–26.

Müller, Mette, Keramik med musik. Musikhistorisk Museum 1974–1975 [Exhibition catalogue] (København 1974).

München. Bayerische Staatsbibliothek. – Ludwig van Beethoven. Ausstellung der Bayerischen Staatsbibliothek München, September bis November 1977 [Exhibition catalogue] (Tutzing 1977).

– Wolfgang Amadeus Mozart: Idomeneo, 1781–1981 (München 1981; = Ausstellungskataloge 24).

Mullally, Robert, ›The Polyphonic Theory of the Basse Danse‹, in: The Music Review 38 (1977), pp. 241–248.
Contains discussion of »supposed iconographical evidence« of the basse danse.

Murray, C., ›The Christian Orpheus‹, in: Cahiers archéologiques 26 (1977), pp. 19–28.

Murray, Sterling E., ›A Checklist of Funeral Dirges in Honor of General Washington‹, in: Notes 36 (1979), pp. 326–344.

Musik in der Steiermark. Katalog der Landesausstellung 1980, herausgegeben von Rudolf Flotzinger (Graz 1980).

Muzyka i izobrazitel'noe iskusstvo. Bibliografičeskij ukazatel' knig i statej na russkom jazyke 1917/74 gg. (Sost. N. G. Pavlova) [Music and Visual Arts: A Bibliography of Books and Articles in Russian from the Years 1917–1974] (Moskva 1976).

Nectoux, Jean-Michel, ›Collections et Services. Musique pour les yeux. Une série d'expositions au Département de la Musique‹, in: Bulletin de la Bibliothèque Nationale Paris 3/1 (1978), pp. 15–28.

Neff, John Hallmark, ›Matisse and Decoration: The Shchukin Panels‹, in: Art in America 63/4 (1975), pp. 38–48.

Newton, Stella Mary, ›Stage Design for Renaissance Theatre‹, in: Early Music 5 (1977), pp. 12–18.
Correspondence by Lee T. Pearcy in: Early Music 6 (1978), pp. 127f.

Oja, Carol J., ›The Still-Life Paintings of William Michael Harnett (Their Reflections upon Nineteenth-Century American Musical Culture)‹, in: The Musical Quarterly 63 (1977), pp. 505–523.

–, ›»Trollopiana«: David Claypoole Johnston Counters Frances Trollope's Views on American Music‹, in: College Music Symposium 21/1 (1981), pp. 94–102.

–. See also under Brook, Barry S., and Carol Oja.

Pachnicke, Peter, ›Wieviel weniger wüßten wir: Grafiken zu Arbeiterliedern‹, in: Bildende Kunst 3 (1981), pp. 131–134.

Parker, Ian, ›The Performance of Troubadour and Trouvère Songs: Some Facts and Conjectures‹, in: Early Music 5 (1977), pp. 184–207.

Paterak, Marta, Tematy muzyczne w grafice ze zbiorów Biblioteki Muzeum Zamku w Łańcucie. Katalog wystawy [Musical themes in graphics of the collections of the Library of the Castle Museum in Łańcut. Exposition catalogue] (Łancut 1975).

Penney, David W., ›Northern New Guinea Slit-Gong Sculpture‹, in: Baessler-Archiv Neue Folge 27 (1980), pp. 347–385.

Perales de la Cal, R., ›Alegorías musicales en los tapices del Patrimonio Nacional. (1)‹, in: Reales Sitios 14/54 (1977), pp. 21–28.

–, ›Cíara, salterio, arpa, lira, laúd, vihuela y guitarra. (2)‹, in: Reales Sitios 15/55 (1978), pp. 45–56.

–, ›Dulzainas, chirimiàs, albogues, gaitas, flautas, trompetas, trombones y percusión. (3)‹, in: Reales Sitios 15/57 (1978), pp. 45–52.

–, ›Instrumentos de cuerda frotada. (4)‹, in: Reales Sitios 16/59 (1979), pp. 17–24.

Perusse, Lyle F., ›»Der Rosenkavalier« and Watteau‹, in: The Musical Times 119 (1978), pp. 1042–1044.
Discusses Watteau's ›L'embarquement pour Cythère‹ and the influence of 18th-century French art on Strauss's ballet ›Kythere‹.

Petzoldt, Leander, Die freudlose Muse. Texte, Lieder und Bilder zum historischen Bänkelsang (Stuttgart 1978).

Pichikiyan, I. R. See Litvinskiy, B. A., and I. R. Pichikiyan.

Pilipczuk, Alexander, ›Das Musizieren am Tisch. Ikonographische Bemerkungen zur Spielpraxis vom Spätmittelalter bis zur Einführung des Quartett-Tisches im 18. Jahrhundert‹, in: Die Musikforschung 32 (1979), pp. 404–416.

–, ›The »Grand Concert dans un Jardin« by Bernard Picard and the Performing Musical Arts at the French Court around 1700‹, in: Tijdschrift van de Vereniging voor Nederlandse Muziekgeschiedenis 30 (1980), pp. 121–148.

Pirrotta, Nino, ›Musiche intorno a Giorgione‹, in: Giorgione. Atti del convegno internationale di studio per il 5° centenario della nascità (Asolo etc. 1979), pp. 41–45.

Posner, D., ›Jacques Callot and the Dances Called »Sfessania«‹, in: The Art Bulletin 59 (1977), pp. 203–216.

Poulton, Diana, ›The Black-Letter Broadside Ballad and its Music‹, in: Early Music 9 (1981), pp. 427–437.

Powers, Harold, ›Illustrated Inventories of Indian Rāgamālā Painting‹, in: Journal of the American Oriental Society 100 (1980), pp. 473–493.
A review-essay of three books: see Ebeling, Dahmen-Dallapiccola, and Waldschmidt.

Prich van Wely, M. A., ›Muzikantenfiguren in de keramiek‹, in: Antiek 11/5 (1976–1977), pp. 429–431.

Rahn'sche Farbdiapositivsammlung: eine ikonographische Klassifizierung von Meisterwerken der Malerei von 1430–1810 (Zürich 1975).

Raupp, H. K., ›Musik im Atelier. Darstellungen

musizierender Künstler in der niederländischen Malerei des 17. Jahrhunderts‹, in: Oud Holland 92/2, pp. 106–129.

Rave, A. P., ›Textile Evidence for Huari Music‹, in: Textile Museum Journal 18 (1979), pp. 5–18.

Reinhard, Kurt, ›Turkish Miniatures as Sources of Music History‹, in: Music East and West: Essays in Honor of Walter Kaufmann (New York 1981), pp. 143–166.

Reinitzer, H., ›Asinus ad tibiam. Zur Ikonographie einer Hamburger Grabplatte‹, in: Litteratura laicorum. Beiträge zur christlichen Kunst (Hamburg 1980), pp. 89–125 (= Vestigia Bibliae 2).

Ripin, Edwin M., ›A Reevaluation of Virdung's *Musica getutscht*‹, in: Journal of the American Musicological Society 29 (1976), pp. 189–223.

Rooley, Anthony, ›On *The Court of Isabella d'Este*‹, in: Early Music 4 (1976), pp. 42 f.
 Discusses Lorenzo Costa's painting of the scene.

Rosand, Ellen, ›Music in the Myth of Venice‹, in: Renaissance Quarterly 30 (1977), pp. 511–537.

Rozov, N. N., ›Muzykalnye instrumenty i ansambli v miniatjurah Hludovskoj (russkoj) psaltri‹ [The representation of instruments and musical ensembles in the Chludov Psalter], in: Drevnerusskoe iskusstvo. Problemi i atribucii (Mél. V. N. Lazarev) (USSR 1977), vol. 1, pp. 91–105.

Sakodov, R. P., ›Veselye skomorohi‹, in: Sovjetskaja etnografija 51 (1976), pp. 126–145.
 Music and musical instruments of old Russia; iconographic and archaeological studies in the Novgorod area.

Salmen, Walter, ›Ikonographie und Choreographie des Reigens im Mittelalter‹, in: RIdIM Newsletter II/2 (1972), pp. 18–24. – Summary in: Report of the Twelfth Congress Berkeley 1977 of the International Musicological Society (Kassel etc. 1981), p. 816.

–, ›Ikonographie eines Stammbuchblattes von 1590‹, in: Opernstudien: Anna Amalie Abert zum 65. Geburtstag (Tutzing 1975), pp. 221–226.

–, Musikleben im 16. Jahrhundert (Leipzig 1976; = Musikgeschichte in Bildern III/9).
 Reviews by:
 Othmar Wessely in: Österreichische Musikzeitschrift 32 (1977), p. 280.
 Leopold Schmidt in: Jahrbuch des Österreichischen Volksliedwerkes 26 (1977), p. 151.
 Willem Elders in: Tijdschrift van de Vereniging voor Nederlandse Muziekgeschiedenis 28 (1978), pp. 46–49.

Mary Rasmussen in: Notes 34 (1978), pp. 594–596.

–, ›Ikonographie der Musik in Österreich‹, in: Österreichische Musikzeitschrift 32 (1977), pp. 481–485.

–, ›Vom Musizieren in der spätmittelalterlichen Stadt‹, in: Leben in der Stadt des Spätmittelalters: Kongreßbericht (Krems 1977), pp. 77–87.

–, Bilder zur Geschichte der Musik in Österreich (Innsbruck 1979; = Innsbrucker Beiträge zur Musikwissenschaft 3).

–, ›Orgel-Allegorien in Wort und Bild‹, in: Österreichische Musikzeitschrift 34 (1979), pp. 593–600.

–, ›Zur Ikonographie musizierend-jubelnder Frauen Alt-Israels‹, in: Orbis Pictus/Assaph 7 (1979–1980), pp. 37–42.

–, ›Ikonographie des Reigens im Mittelalter‹, in: Acta Musicologica 52 (1980), pp. 14–26.

–, Katalog der Bilder zur Musikgeschichte in Österreich (Innsbruck 1980; = Innsbrucker Beiträge zur Musikwissenschaft 4).

–, ›Musizierende Sirenen‹, in: Forschungen und Funde. Festschrift Bernard Neutsch (Innsbruck 1980), pp. 393–400.

, ›The Value of Iconographical Sources in Musical Research‹, in: Modern Musical Scholarship, ed. E. Olleson (Stocksfield–Boston 1980), pp. 206–214.

Schauenburg, K., ›Herakles Musikos‹, in: Jahrbuch des Deutschen Archäologischen Instituts 94 (1979), pp. 49–76.

Scherliess, Volker, ›Notizen zur musikalischen Ikonographie, I. Gestimmte Instrumente als Harmonie-Allegorie‹, in: Analecta Musicologica 14 (1974), pp. 1–16.

–, ›Notizen zur musikalischen Ikonographie, II. Die Musik-Impresa der Isabella d'Este‹, in: Analecta Musicologica 15 (1975), pp. 21–28.

Schneider, Manfred, ›Der Teufel als Tänzer – Zu einem Motiv der Volkssage‹, in: Festschrift für Karl Horak (Innsbruck 1980), pp. 189–214.

Schröter, Elisabeth, Die Ikonographie des Themas Parnass vor Raffael; die Schrift- und Bildtradition von der Spätantike bis zum 15. Jahrhundert (Hildesheim and New York 1977; = Studien zur Kunstgeschichte 6).

Schuster, K.-P., ›Zu Dürers Zeichnung »Der Tod des Orpheus« und verwandten Darstellungen‹, in: Jahrbuch der Hamburger Kunstsammlungen 23 (1978), pp. 7–24.

Seebass, Tilman, Musikdarstellung und Psalterillustration im früheren Mittelalter. Studien ausgehend von einer Ikonologie der Handschrift Paris Bibliothèque Nationale fonds latin 1118, 2 vols. (Bern 1973).

Reviews by:

(Anonymous) in: Times Literary Supplement (June 21, 1974).

Koraljka Kos in: International Review of Aesthetics and Sociology of Music 2 (1975), pp. 322 f.

Mary Remnant in: Music and Letters 56 (1975), pp. 386 f.

James McKinnon in: Journal of the American Musicological Society 28 (1975), pp. 360–364.

J. Smits van Waesberghe in: Jahrbuch für Liturgik und Hymnologie 19 (1975), p. 290.

Michel Huglo in: Revue de Musicologie 62 (1976), pp. 149–151.

R. D. Leppert in: Speculum 51 (1976), pp. 166–171.

Joseph Dyer in: Early Music 4 (1976), pp. 469 f.

Michel Huglo in: Cahiers de Civilisation Médiévale 19 (1976), pp. 409–412.

Koraljka Kos in: Arti Musices 7 (1976), pp. 199 f.

Victor Ravizza in: Die Musikforschung 30 (1977), pp. 99 f.

Volker Scherliess in: Rivista Italiana di Musicologia 12 (1977), pp. 153–157.

Michel Huglo in: Scriptorium 31 (1977), p. 160.

–, ›Some Suggested Changes for the Revision of the Instruction Book (RIdIM Master Catalogue Card)‹, in: RIdIM Newsletter IV/2 (June 1979), pp. 11–16, and V/1 (January 1980), pp. 8 f.

–, ›Venus und die Musikwissenschaft oder Von der Universalität eines reformatorischen Buchmachers‹, in: Totum me libris dedo. Festschrift zum 80. Geburtstag von Adolf Seebass (Basel 1979), pp. 187–199.

> Discusses the illustrations of G. Rhau's ›Enchiridion‹ 1538.

Shapiro, L., ›Widener Orpheus‹, in: Studies in the History of Art 6 (1974), pp. 23–36.

Shapiro, Michael, ›Degas and the Siamese Twins of the Café-Concert: The Ambassadeurs and the Alcazar d'Été‹, in: Gazette des Beaux Arts 6ᵉ Période 95 (1980), pp. 153–164.

Shinneman, D., ›Canon in Titian's »Andrians«: A Reinterpretation‹, in: Studies in the History of Art 6 (1974), pp. 93–95.

Siegel, Linda, ›A Second Look at Schumann's »Genoveva«‹, in: The Music Review 36 (1975), pp. 17–41.

> Brief mention of relationship between Schumann's conception of stage settings, scenes, and contemporary Romantic paintings.

Simon, S. C., ›David et ses musiciennes: Iconographie d'un chapiteau de Jaca‹, in: Les Cahiers de Saint-Michel de Cuxa 11 (1980), pp. 239–248.

Slim, H. Colin, ›Some Thoughts on Musical Inscriptions‹, in: RIdIM Newsletter II/2 (1977), pp. 24–27.

–, ›Mary Magdalene, *mondaine musicale*‹, in: Report of the Twelfth Congress Berkeley 1977 of the International Musicological Society (Kassel etc. 1981), pp. 816–824.

–, ›A Motet for Machiavelli's Mistress and a Chanson for a Courtesan‹, in: Essays Presented to Myron P. Gilmore II (Firenze 1978), pp. 457–472.

–, ›Mary Magdalene, Musician and Dancer‹, in: Early Music 8 (1980), pp. 460–473.

–, ›Instrumental Versions, c. 1515–1554, of a Late 15th-Century Flemish Chanson: »O waerde mont«‹, in: Music in Medieval and Early Modern Europe (Cambridge University Press 1981), pp. 131–161.

Smits van Waesberghe, Joseph, ›Singen und Dirigieren der mehrstimmigen Musik im Mittelalter: Was Miniaturen uns hierüber lehren‹, in: Dia-Pason: Ausgewählte Aufsätze von Joseph Smits van Waesberghe (Buren 1976), pp. 165–187.

Smulikowska, Ewa, ›The Symbolism of Musical Scenes and Ornamental Motifs in Organ-Cases‹, in: Organ Yearbook 10 (1979), pp. 5–14.

Snyder, J. M., ›Aegisthos and the Barbitos‹, in: American Journal of Archeology 80/2 (1976), pp. 189 f.

›The Sociology of Music – A Selected Bibliography. Section 2: Sociology of Art; Section 18: Music and Arts‹, in: International Review of the Aesthetics and Sociology of Music 7 (1976), pp. 285 f. and 309 f., 8 (1977), pp. 98 f., 121–123, 273 f. and 295 f., and 9 (1978), p. 131, p. 138.

Solcanu, I. I., ›Représentations chorégraphiques de la peinture murale de Moldavie et leur place dans l'iconographie sud-est européenne‹, in: Revue des études sud-est européennes 14 (1976), pp. 45–65.

Somfai, László, ›Remarks on Iconography‹, in: Haydn Studies (New York 1981), p. 70.

Spero, J., Rackham's Color Illustrations for Wagner's ›Ring‹ (New York 1979).

Stäblein, Bruno, Schriftbild der einstimmigen Musik (Leipzig 1975; = Musikgeschichte in Bildern III/4).

Sternfeld, Frederick W., ›The Birth of Opera: Ovid, Poliziano, and the *Lieto Fine*‹, in: Analecta Musicologica 29 (1979), pp. 30–51.

> Includes a discussion of two woodcuts with Orpheus images.

Stradner, Gerhard, ›Neue Erkenntnisse zu Sebastian Virdung's »Musica getutscht« (Basel 1511)‹, in: Die Musikforschung 29 (1976), p. 169.

Streich, H., ›Musikalische Symbolik in der »Atlanta Fugiens« von Michael Maier (1618)‹, in: Symbolon Neue Folge 3 (1977), pp. 173–211.

Stürz, P., ›Die hl. Cäcilia in Legende, Darstellung und Brauchtum. Ein volkskundlicher Beitrag über die Patronin der Musiker und Sänger‹, in: Festschrift für Karl Horak (Innsbruck 1980), pp. 173–188.

Sutton, Denys, ›The World of Sacheverell Sitwell: Rhythm and Intoxication‹, in: Apollo (October 1980), pp. 230–237.

 Discusses the writer Sitwell's collection of writings about musical subjects, including art with musical depictions.

[Thieck, Frédéric,] »Autour de la Viole de Gambe«. An Exhibition of Photographic Reproductions of the Viol through Five Centuries, held in Paris, Chicago, and New York. Catalogue translated from the French (New York 1979; = RCMI Catalogue 2).

Thuillier, Jacques, ›La Musique et le Temps‹, in: RIdIM Newsletter II/2 (1977), pp. 1–5.

Tieri, Guglielmina Verardo, ›Il Teatro Novissimo: Storia di »Mutationi, Macchine e Musiche«‹, in: Nuova Rivista Musicale Italiana 10 (1976), pp. 555–595, and 11 (1977), pp. 3–25.

Três Séculos de Iconografia da Música no Brasil, ed. Biblioteca Nacional (Rio de Janeiro 1974).

Valdés, Samuel Claro, ›Proyecto Iconografía Musical Chilena. Informe Preliminar‹, in: Revista Musical Chilena 33 (1979), pp. 112–114.

Vandour, C., ›Nouvelles acquisitions des musées de province. Rouen. Musée des Beaux-Arts. Les boiseries d'un pavillon de musique à Rouen‹, in: Revue du Louvre et des musées de France 29 (1979), pp. 455–457.

Volek, Tomislav, and Stanislav Jareš, Dějiny české hudby v obrazech; od nejstarších památek do vybudování Národního divadla [The History of Czech Music in Pictures; text in Czech, German, French, English, Russian, Italian] (Praha 1977).

 Reviews by:

 (Anonymous) in: RIdIM Newsletter IV/2 (1979), p. 21.

 Howard Mayer Brown in: Early Music 9 (1981), pp. 244 f.

Vorreiter, Leopold, ›Musikikonographie des Altertums im Schrifttum 1850–1949 und 1950–1974‹, in: Acta Musicologica 46 (1974), pp. 1–42.

–, ›Musikgeschichte aus Münzbildern‹, in: Musica 29 (1975), pp. 117–121.

Waldschmidt, Ernst and Rose Leonore, Miniatures of Musical Inspiration in the Collection of the Berlin Museum of Indian Art, Part II: Rāgamālā Pictures from Northern India and the Deccan (Berlin 1975).

 Review by Harold Powers, ›Illustrated Inventories of Indian Rāgamālā Painting‹, in: Journal of the American Oriental Society 100 (1980), pp. 473–493.

Wijsenbeek, L. J. F., Japanese prenten met muziek (Buren 1975).

Willetts, Pamela Joan, ›The Seven-Branched Candlestick as a Psalter Illustration‹, in: Journal of the Warburg and Courtauld Institute 42 (1979), pp. 213–215.

 Discusses musical instruments from the »Dardanus«-letter by Pseudo-Jerome.

Winternitz, Emanuel, ›Der Musiker Leonardo‹, in: Unesco-Kurier 15 (1975), pp. 16–18, 35, 51.

–, ›Secular Musical Practice in Sacred Art‹, in: Early Music 3 (1975), pp. 221–226.

–, ›Images as Records for the History of Music‹, in: RIdIM Newsletter II/2 (1977), pp. 5–9. – Summary in: Report of the Twelfth Congress Berkeley 1977 of the International Musicological Society (Kassel ect. 1981), pp. 802 f.

–, Musical Instruments and their Symbolism in Western Art, 2nd [enlarged] edition (Yale University Press 1979).

Wirth, Jean, › »La Musique« et »La Prudence« de Hans Baldung Grien‹, in: Zeitschrift für Schweizerische Archäologie und Kunstgeschichte 35 (1978), pp. 244–246.

Witzenmann, Wolfgang, ›Die römische Barockoper La vita humana ovvero Il trionfo della pietà‹, in: Analecta Musicologica 15 (1975), pp. 158–201.

Wood, Wendy, ›A New Identification of the Sitter in Jan van Eyck's Tymotheus Portrait‹, in: Art Bulletin 60 (1978), pp. 650–654.

 Contests Panofsky's hypothesis that the sitter is Binchois.

Wright, Craig, ›Voices and Instruments in the Art Music of Northern France during the 15th Century: A Conspectus‹, in: Report of the Twelfth Congress Berkeley 1977 of the International Musicological Society (Kassel etc. 1981), pp. 643–649.

 Uses iconographic evidence to argue that northern French chansonniers were not used for performance.

Würtz, Roland, Verzeichnis und Ikonographie der kurpfälzischen Hofmusiker zu Mannheim nebst darstellendem Theaterpersonal 1723–1803 (Wilhelmshaven 1975).

Žak, Sabine, Musik als »Ehr und Zier«. Studien zur Musik im höfischen Leben, Recht und Zeremoniell (Köln 1979).
> Makes limited use of iconographic evidence. Review by Walter Salmen in: Die Musikforschung 34 (1981), pp. 484f.

Ziino, Agostino, ›Laudi e Miniature Fiorentine del Primo Trecento‹, in: Studi Musicali 7 (1978), pp. 39–84.

–, ›»A dimandar pietà«, laude musicale in un dipinto attribuito a Giovanni Battista Caporali‹, in: Arte e Musica in Umbria tra Cinquecento e Seicento, Atti del XII Convegno di Studi Umbri 30 nov.–2 dic. 1979 (Gubbio 1981), pp. 81–87.

Ziolek, A., ›Iluminowane rękopisy muzyczne jako źródło do badán nad kultura plastyczna i muzyczna od 13 do 15 wieku na Śląsku‹ [Illuminated musical manuscripts as a source for research on the musical and artistic culture of Silesia in the 13th through 15th centuries], in: Spraw poznańskiego Towarzystwa Przyjaciol Nauk, Poznan 96 (1978), pp. 29–35.

Portrait Iconography

Badura-Skoda, Eva, ›Eine authentische Porträt-Plastik Schuberts‹, in: Österreichische Musikzeitschrift 33 (1978), pp. 578–591.

–, ›Ein unbekanntes Schubert-Porträt – eine neu aufgefundene Maske‹, in: Das Orchester 27 (1979), pp. 572–574.

–, ›Der Bildhauer Anton Dietrich. Ein Beitrag zur Ikonographie Beethovens und Schuberts‹, in: Musik, Edition, Interpretation: Gedenkschrift Günter Henle (München 1980), pp. 30–52.

Biba, Otto, ›Neues aus dem Archiv der Gesellschaft der Musikfreunde in Wien‹, in: Österreichische Musikzeitschrift 32 (1977), pp. 90–92.
> Discusses a Monteverdi portrait by Bernardo Strozzi.

–, ›Einige neue und wichtige Schubertiana im Archiv der Gesellschaft der Musikfreunde‹, in: Österreichische Musikzeitschrift 33 (1978), pp. 604–610.
> Discusses two additions to Schubert iconography; reproduces one, a sketch by Ferdinand Georg Waldmüller.

Carley, Lionel, and Robert Threlfall, Delius: A Life in Pictures (London 1977).
> Review by Robert Anderson in: The Musical Times 119 (1978), p. 237.

Chailley, Jacques, ›Une petite superchérie de la Princesse Carolyne‹, in: Revue de Musicologie 61 (1975), pp. 319–322.
> Discusses a portrait of Princess Carolyne de Sayn-Wittgenstein and her daughter, which (except for facial features) is a copy of an engraving of a portrait by Sir Thomas Lawrence.

Comini, Alessandra, ›The Visual Brahms: Idols and Images‹, in: Arts Magazine 54/2 (1979–1980), pp. 123–129.

Gutman, Robert W., ›Friedrich Pecht's »Portrait of Richard Wagner«‹, in: Arts Magazine 53/5 (1978–1979), pp. 84–89.

Jäkel, Ilse Beate, Porträtskizzen aus dem Konzertsaal (Augsburg 1981).

Kandinsky, A. I., Aleksandr Nikolaevich Skriabin [in Russian] (Moskva 1980).

Matthews, Betty, Correspondence: ›A Handel Portrait‹, in: The Musical Times 68 (1977), p. 474.

Murray, Sterling E., ›Timothy Swan and Yankee Psalmody‹, in: The Musical Quarterly 61 (1975), pp. 433–463.

Muzykant i ego vstreči v iskusstve [The musician and his image in art. Exhibit of Russian portraits of the 19th and 20th centuries], in: Tvorčestvo 22 (1978), pp. 11–13.

Niggl, Paul, Una medaglia del 1844 per Pierluigi da Palestrina (Milano 1977).

Rosand, David and Ellen, ›Barbara di Santa Sofia and »Il Prete Genovese«: On the Identity of a Portrait by Bernardo Strozzi‹, in: The Art Bulletin 63 (1981), pp. 249–258.
> Discusses a portrait of a woman composer and musician.

Schmitt-Thomas, R., Corpus Imaginum Musicorum. Eine wissenschaftliche Bestandsaufnahme von Komponistenbildnissen aller Zeiten und Länder in Form von Einzellieferungen in periodischer Folge (Frankfurt/M. ca. 1977).

Schöne, Günter, Porträt-Katalog des Theatermuseums München. Die graphischen Serien (Wilhelmshaven 1981; = Quellenkataloge zur Musikgeschichte 19).

Thredfall, Robert. See Carley, Lionel, and Robert Thredfall.

Vining, Paul, ›Orlando Gibbons: The Portraits‹, in: Music and Letters 58 (1977), pp. 415–429.

Wagner, Wolf Siegfried, Die Geschichte unserer Familie in Bildern. Bayreuth 1876–1976. Mit Beiträgen von Winifred Wagner, Gertrud Wagner, Nike Wagner (München 1976).

Organology

Ahrens, Christian, ›Das Musikinstrument und seine technischen Gegebenheiten als Gestaltungsfaktoren der Musik‹, in: Studia Instrumentorum Musicae Popularis 6 (Stockholm 1979), pp. 19–26 (= Musikhistoriska museetsskrifter 8).
Discusses a figurine from Ptolemaic Egypt.

Baines, Anthony, Brass Instruments: Their History and Development (London 1976; corrected edition 1978).
Pen and ink drawings of figures with instruments, copied from original art works; discusses the form of instruments shown.
Review by Mary Rasmussen in: Music and Letters 59 (1978), pp. 478–480.

Bassani, Ezio, ›Antichi avori africani nelle collezioni Medicee, I.‹, in: Critica d'Arte 40, nuova serie 143 (1975), pp. 69–80.

–, ›Oggetti africani in antiche collezioni italiane, II.‹, in: Critica d'Arte 42, nuova serie 154–156 (1977), pp. 187–203.

–, ›Un corno afro-portoghese con decorazione africana‹, in: Critica d'Arte 44, nuova serie 166–168 (1979), pp. 167–174.

–, ›Gli olifanti afro-portoghesi della Sierra Leone‹, in: Critica d'Arte 44, nuova serie 166–168 (1979), pp. 175–201.

Boone, H., ›Beknopte bijdragen tot de geschiedenis van het hakkebord in de Lage Landen‹, in: Volkskunde (Belgian) 77 (1976), pp. 203–216.

Bosmans, W., ›De rommelpot in de Lage Landen tot de 19e eeuw‹, in: Volkskunde (Belgian) 78 (1977), pp. 142–150.

Bosse-Griffiths, K., ›Two Lute-players of the Amarna Era‹, in: Journal of Egyptian Archeology 66 (1980), pp. 70–82.

Bowers, Jane, ›New Light on the Development of the Transverse Flute between about 1650 and about 1750‹, in: Journal of the American Musical Instrument Society 3 (1977), pp. 5–56.
Uses French paintings and engravings as well as other evidence.

Bowles, Edmund A., ›A Checklist of Musical Instruments in Fifteenth-Century Illuminated Manuscripts at the Walters Art Gallery‹, in: Notes 32 (1976), pp. 719–726.

Boydell, Barra, ›The Instruments in Mielich's Miniature of the Munich *Hofkapelle* under Orlando di Lasso‹, in: Tijdschrift van de Vereniging voor Nederlandse Muziekgeschiedenis 28 (1978), pp. 14–18.
Re-identifies a partially visible wind instrument as a crumhorn rather than a recorder.

Braun, Joachim, ›Musical Instruments in Byzantine Illuminated Manuscripts‹, in: Early Music 8 (1980), pp. 312–327.

Brown, Howard Mayer, ›Trecento Angels and the Instruments They Play‹, in: Modern Musical Scholarship, ed. E. Olleson (Stocksfield–Boston 1980), pp. 112–140.

Brüchle, Bernhard, and Kurt Janetzky, Kulturgeschichte des Horns. Ein Bildsachbuch (Tutzing 1976).
Reviews by:
Georg Karstädt in: Die Musikforschung 31 (1978), pp. 206f.
Mary Rasmussen in: Notes 35 (1978/79), pp. 320–322.

Brülls, Holger, ›Zur Gestaltung des Orgelprospektes heute‹, in: Zeitschrift für christliche Kunst und Kunstgeschichte (Das Münster) 31 (1978), pp. 143–149.

Campbell, Richard G., ›Instrumentenkundliche Notizen zu sechs türkischen Miniaturen‹, in: Baessler-Archiv Neue Folge 23 (1975), pp. 31–37.

Croft-Murray, Edward, ›The Wind-Band in England 1540–1840‹, in: Music and Civilization. The British Museum Yearbook 4 (1980), pp. 135–180.

Damm, Peter, ›300 Jahre Waldhorn‹, in: Brass Bulletin 31 (1980), pp. 19–33.

Eliason, Robert E., ›The Dresden Key Bugle‹, in: Journal of the American Musical Instrument Society 3 (1977), pp. 57–63.
Reproduces and discusses two paintings by William Harnett (American, late nineteenth century).

Ferrari Barassi, Elena, ›Strumenti musicali e testimonianze teoriche nel medio evo‹, in: Cre-

mona 1979. Instituta et Monumenta, ed. by Scuola di Paleografia et Filologia Musicale dell'Università di Pavia Serie II, No. 8.

Friend, Robert Overton, ›Der Zink: Neue Entwicklungen und Forschungen‹, in: Das Orchester 29 (1981), pp. 98–101.

Gammie, Ian, ›Ganassi: Regola Rubertina (1542), Lettione Secunda (1543). A Synopsis of the Text Relating to the Viol‹, in: Chelys 8 (1978–1979), pp. 23–30.
Brief mention of pictorial evidence for playing position.

Geiser, Brigitte, Das Alphorn in der Schweiz (Bern 1976).
Review by Bernard Lortat-Jacob in: Revue de Musicologie 62 (1981), p. 100.

–, ›Iconography as an Aid to Research on Swiss Folk Music Instruments‹, in: Report of the Twelfth Congress Berkeley 1977 of the International Musicological Society (Kassel etc. 1981), pp. 831–834.

Giesel, Helmut, Studien zur Symbolik der Musikinstrumente im Schrifttum der alten und mittelalterlichen Kirche (Von den Anfängen bis zum 13. Jahrhundert (Regensburg 1978; = Kölner Beiträge zur Musikforschung 94).

Gill, Donald, ›Vihuelas, Violas and the Spanish Guitar‹, in: Early Music 9 (1981), pp. 455–462.

Grame, T. C., ›Sounding Statues: The Symbolism of Musical Instruments‹, in: Expedition 16 (1973), pp. 30–39.

Grijp, Louis Peter, ›Fret Patterns of the Cittern‹, in: The Galpin Society Journal 34 (1981), pp. 62–97.

Godwin, Joscelyn, ›»Main divers acors«: Some instrument collections of the Ars Nova period‹, in: Early Music 5 (1977), pp. 148–159.
Correspondence by:
Mary Remnant in: Early Music 5 (1977), p. 425.
Christopher Page in: Early Music 6 (1978), p. 309.

Günther, Robert, ›Abbild oder Zeichen: Bemerkungen zur Darstellung von Musikinstrumenten an indischen Skulpturen im Rautenstrauch-Joest-Museum zu Köln‹, in: Ars Musica, Musica Scientia: Festschrift Heinrich Hüschen (Köln 1980), pp. 198–212 (= Beiträge zur Rheinischen Musikgeschichte 126).

Guillot, G., ›La représentation des instruments de musique dans l'art roman‹, in: Annales de l'Académie de Mâcon 53 (1976), pp. 15–24.

Halfpenny, Eric, ›The Christ Church Trophies‹, in: The Galpin Society Journal 28 (1975), pp. 81–85.

Brief discussions of the various instruments which appear in two decorative wall stuccos.

Hammond, Frederick, ›Musical Instruments at the Medici Court in the Mid-Seventeenth Century‹, in: Analecta Musicologica 15 (1975), pp. 202–219.
Reproduces two paintings of court musicians by A. D. Gabbiani.

Hamoen, Dirk Jacob, ›The Arpicordo Problem: Armand Neven's Solution Reconsidered‹, in: Acta Musicologica 48 (1976), pp. 181–184.
Brief reference to pictures of harps.

Hirsch, S., ›Frühe Bildquellen zu Volksinstrumenten‹, in: Volkskunst 3 (1980), pp. 209–217.

Hood, Mantle, ›The Bronze Drums of Dongson Culture as Musical Instruments‹, in: Report of the Twelfth Congress Berkeley 1977 of the International Musicological Society (Kassel etc. 1981), pp. 852–857.
Discusses iconographic evidence (some on the drums themselves) for the use of bronze drums in Southeast Asia.

Jansen, Will, The Bassoon, Its History, Construction, Makers, Players, and Music (Buren 1978).
Final chapter covers the bassoon and contrabassoon in the pictorial arts and literature.

Jantarski, Georgi, ›Musikinstrumente auf einer steinzeitlichen Höhlenmalerei Bulgariens‹, in: Die Musikforschung 30 (1977), pp. 465–467.

Jerrentrup, Friend Ansgar, Der Zink. Ikonographische Studien zu seiner Geschichte, Bauweise und Spieltechnik an Instrumenten in europäischen Museen, Philosophische Dissertation Köln 1980.

Jones, Lewis. See Page, Christopher, and Lewis Jones.

Keuls, E., ›Apulian Xylophone: A Mysterious Musical Instrument Identified‹, in: American Journal of Archeology 83 (1979), pp. 476f.

Klobe, M., ›Dogon Figure of a Koro Player‹, in: African Arts 10 (1977), pp. 32–35.

Kobola, Alojz, and Lovro Županović, Tradicijska narodna glazbala Jugoslavije [Traditional folk musical instruments of Yugoslavia] (Zagreb 1975).

Krejci, Gerhard, ›Musikinstrumente im antiken Rom‹, in: Das Orchester 23 (1975), pp. 632–637.

Krishnaswamy, S., ›Musical Instruments in Indian Plastic Arts‹, in: Journal of the Indian Musicological Society 5/4 (1974), pp. 5–9, and 6/1 (1975), pp. 9–18.

Kümmerling, Harald, ›Lauten und Geigen soll'n auch nicht schweigen‹, in: Gitarre und Laute 6/2 (1979), pp. 59–61.

Lamaña, J. M., ›Los instrumentos en la música de la época del Barroco‹, in: Miscelánea barcinonensia 15 (1976), pp. 59–100, and 16 (1977), pp. 7–53.

LaPointe, Claude, ›Measuring the Evolution of an Instrument and Reconstituting its Major Prototypes‹, in: RIdIM Newsletter IV/11 (1979), pp. 3–12. – Summary in: Report of the Twelfth Congress Berkeley 1977 of the International Musicological Society (Kassel etc. 1981), p. 835.

Lawson, Graeme, ›An Anglo-Saxon Harp and Lyre of the Ninth Century‹, in: Music and Tradition: Essays on Asian and Other Musics Presented to Laurence Picken (Cambridge 1981), pp. 229–244.

> Discusses a sculptured column at Masham, North Yorkshire, which shows King David playing an instrument.

Leppert, Richard, ›Viols in Seventeenth Century Flemish Paintings: The Iconography of Music Indoors and Out‹, in: Journal of the Viola da Gamba Society of America 15 (1978), pp. 5–40.

Libin, Laurence, ›An 18th-Century View of the Harpsichord‹, in: Early Music 4 (1976), pp. 16–18.

–, ›Musical Instruments in the Metropolitan Museum‹, in: Metropolitan Museum of Art Bulletin 25/3 (1977–1978), pp. 1–48.

Lippmann, Friedrich, ›Volksharfen in Italien‹, in: Analecta Musicologica 29 (1979), pp. 380–392.

Lowe, Michael, ›The Historical Development of the Lute in the 17th Century‹, in: The Galpin Society Journal 29 (1976), pp. 11–25.

Mactaggart, A. and P., ›Tempera Decorated Keyboard-Instruments‹, in: The Galpin Society Journal 32 (1979), pp. 59–65.

Mahling, Christoph Hellmut, ›Musikinstrumente in der deutschsprachigen Idylle und Schäferdichtung des 17. und 18. Jahrhunderts‹, in: Studia instrumentorum musicae popularis 5 (Stockholm 1977), p. 106 (= Musikhistoriska museetsskrifter 7).

Malusi, L., ›Strumenti musicali del Quattrocento nei tempio malatestiano‹, in: Romagna Arte Storia 2 (1981), pp. 52–62.

Manniche, Lise, Ancient Egyptian Musical Instruments (München 1975).

> Contains separate catalogues of extant instruments and representations from the visual arts.

Review by Martha Maas in: Journal of the American Musical Instrument Society 4 (1978), pp. 119–121.

Markowitz, Ruth Solomon, An Iconographical Study of Viola da Gamba Holding Positions and Bow Grips as Seen in Selected Visual Examples of the Sixteenth and Seventeenth Centuries, Master's thesis University of Connecticut 1978.

Mather, Christine K., ›Maximilian I and his Instruments‹, in: Early Music 3 (1975), pp. 42–46.

> Discussion of the Weisskunig.

Meer, John Henry van der, see under Van der Meer.

Mirimonde, Albert P. de, ›Les vanités à personnages et à instruments de musique‹, in: Gazette des beaux-arts 6ᵉ Période 92 (1978), pp. 115–130.

Moorefield, Arthur A., ›James Bruce: Ethnomusicologist or Abyssinian Lyre?‹, in: Journal of the American Musicological Society 28 (1975), pp. 493–514.

> Includes reproduction and discussion of the »Theban Harp« from Burney's ›History‹ and a wall relief from the tomb of Rameses III.

Moser, Wolf, ›Vihuela, Gitarre und Laute in Spanien während des 16. Jahrhunderts‹, in: Gitarre und Laute 8 (1981), No. 2, pp. 42–46, No. 5, pp. 14–18, and No. 6, pp. 38–42.

Naylor, Tom L., The Trumpet and Trombone in Graphic Arts 1500–1800 (Nashville 1979).

Oberhuber, Josef, ›Portativ- und Positivdarstellungen auf Bildwerken Tirols vor 1600‹, in: Orgel und Orgelspiel im 16. Jahrhundert, Tagungsbericht (Innsbruck c. 1978), pp. 146–152, 255–258.

Oberlinger, Wolfgang, ›Das Entwerfen und Planen einer Orgel‹, in: Zeitschrift für christliche Kunst und Kunstgeschichte (Das Münster) 31 (1978), pp. 129–134.

–, ›Akustik in der Kirche und wie diese für die gestalterische Planung einer Orgel mitbestimmend ist‹, in: Zeitschrift für christliche Kunst und Kunstgeschichte (Das Münster) 31 (1978), pp. 135–137.

Page, Christopher, ›Biblical Instruments in Medieval Manuscript Illumination‹, in: Early Music 5 (1977), pp. 299–309.

–, Correspondence: ›A 12th-Century Street Musician‹, in: Early Music 6 (1978), p. 309.

> In reference to article by Mary Remnant, ›The Diversity of Medieval Fiddles‹ (see below).

–, ›The Earliest English Keyboard‹, in: Early Music 7 (1979), pp. 309–314.

–, ›The Myth of the Chekker‹, in: Early Music 7 (1979), pp. 482–489.

–, ›Fourteenth-Century Instruments and Tunings: A Treatise by Jean Vaillant? (Berkeley, Ms. 744)‹, in: The Galpin Society Journal 33 (1980), pp. 17–35.

–, ›The 15th-Century Lute: New and Neglected Sources‹, in: Early Music 8 (1980), pp. 11–21.

Page, Christopher, and Lewis Jones, ›Four More 15th-Century Representations of Stringed Keyboard Instruments‹, in: The Galpin Society Journal 31 (1978), pp. 151–155.

Palisca, Claude V., ›G. B. Doni, Musicological Activist, and his »Lyra Barberina«‹, in: Modern Musical Scholarship, ed. E. Olleson (Stocksfield–Boston 1980), pp. 180–205.

Palmer, Susan and Samuel, The Hurdy-Gurdy (London 1980).
Review by Doreen and Michael Muskett in: The Galpin Society Journal 34 (1981), pp. 172–175.

Parkinson, Andrew, ›Guesswork and the Gemshorn‹, in: Early Music 9 (1981), pp. 43–46.

Pejović, Roksanda, Glasbeni instrumenti na srednjeveških spomenikih v Srbiji i Makedoniji [Musical Instruments on Medieval Monuments in Serbia and Macedonia], Ph. D. Dissertation University of Ljubljana 1975.
Review in: Muzikološki zbornik 12 (1976), pp. 116–118.

Penth, H., ›Kunst im Lān Nā Thai; ein Gong aus Mandalay: Beispiel für die Entstehung von Erzählgut‹, in: Artibus Asiae 37 (1975), pp. 240–246.

Perales de la Cal, R. See under Iconography.

Prich van Wely, M., ›Mensenhoofden en dierekoppen als versiering aan oude snaarinstrumenten‹, in: Antiek (Dutch) 10 (1975–1976), pp. 412–416.

Remnant, Mary, ›The Diversity of Medieval Fiddles‹, in: Early Music 3 (1975), pp. 47–49.

–, Correspondence: ›Medieval Fiddles‹, in: Early Music 5 (1977), p. 425. In reference to article by Joscelyn Godwin, ›»Main divers acors«: Some instrument collections of the Ars Nova period‹ (see above).

Renton, Barbara Hampton, › . . . Worth a Thousand Words?‹, in: College Music Symposium 19/1 (1979), pp. 246–251.
On the hydraulis in the Utrecht Psalter and the Canterbury Psalter.

Ripin, Edward M., ›En Route to the Piano: A Converted Virginal‹, in: Metropolitan Museum Journal 13 (1978), pp. 79–86.
Discusses Jan Miense Molenaer's ›Lady at the Harpsichord‹.

Rosiny, Nikolaus, ›Räumliche und gestalterische Probleme neuer Großorgeln in alten Kirchenräumen‹, in: Zeitschrift für christliche Kunst und Kunstgeschichte (Das Münster) 31 (1978), pp. 137–143.

Salmen, Walter, ›Frühe Zeugnisse zur Volksmusik im Lande Salzburg‹, in: Jahrbuch des Österreichischen Volksliedwerkes 25 (1976), pp. 1–7.
Brief discussion of one picture: ›Verspottung Christi‹ (ca. 1430).

Schmidt-Colinet, Constanze, Die Musikinstrumente in der Kunst des Alten Orients (Bonn 1981; = Abhandlungen zur Kunst-, Musik- und Literaturwissenschaft 312).

Schneider, Hermann G., ›Die »kleine Leiter«: Addenda zum Xylophon auf italienischen Vasen‹, in: BABesch 52–53 (1977–1978), pp. 265 f.

Schrader, Arthur F., ›Musical Instruments at Old Sturbridge Village‹, in: Antiques 116 (1979), pp. 583–591.

Segerman, Ephraim, and Djilda Abbott, Correspondence: ›Stringed Instruments on the Eglantine Table‹, in: Early Music 4 (1976), p. 485.

Seidenberg, Margot, ›Ein Bassett von Hans Krouchdaler (1685): Restaurierung, Konservierung‹, in: Zeitschrift für Schweizerische Archäologie und Kunstgeschichte 38 (1981), pp. 313–316.

Solcanu, I. I., ›Les instruments de musique dans la peinture des pays roumaines (14e–17e siècles)‹, in: Revue des archéologues et historiens d'art de Louvain 12 (1979), pp. 120–148.

Spencer, Robert, ›How to Hold the Lute: Historical Evidence from Paintings‹, in: Early Music 3 (1975), pp. 352–354.

–, ›The Chitarrone Francese‹, in: Early Music 4 (1976), pp. 165 f.
Reproduction and brief discussion of two paintings by Antiveduto Grammatica and Antoine Watteau, and an engraving by Benoît (II) Audran.

–, ›Chitarrone, Theorbo and Archlute‹, in: Early Music 4 (1976), pp. 407–423.

Stauder, Wilhelm, ›Zur Entwicklung der Cister‹, in: Renaissance-Studien: Helmuth Osthoff zum 80. Geburtstag (Tutzing 1979), pp. 223–254.

Steinhaus, Hans, ›Die Orgel der Saint Peter's Church in New York‹, in: Zeitschrift für christliche Kunst und Kunstgeschichte (Das Münster) 31 (1978), pp. 112–118.

–, ›Die neue Orgel der Sankt-Hedwigs Kathedrale in Berlin‹, in: Zeitschrift für christliche Kunst und Kunstgeschichte (Das Münster) 31 (1978), pp. 149f.

Stockmann, Erich, ›Funktion und Bedeutung von Trommeln und Pfeifen im deutschen Bauernkrieg 1525/26‹, in: Beiträge zur Musikwissenschaft 21 (1979), pp. 105–123.

Thurm, Sigrid, ›Schaffhausen als Glockengießerstadt vor ihrem Eintritt in die Schweizer Eidgenossenschaft‹, in: Zeitschrift für Schweizerische Archäologie und Kunstgeschichte 33 (1976), pp. 112–118.

Tiella, Marco, ›The Violeta of S. Caterina de' Vigri‹, in: The Galpin Society Journal 28 (1975), pp. 60–70, with addendum in: The Galpin Society Journal 31 (1978), p. 146.
 Brief discussion of three paintings showing similar instruments and/or bows.

Torres, J., ›Los instrumentos de música en las miniaturas de las Cantigas de Santa María‹, in: Bellas Artes 48 (1975), pp. 25–29.

Tuchscherer, Jean Michel, ›Le clavecin de Donzelague‹, in: Revue du Louvre et des Musées de France 29 (1979), pp. 440–442.

Turnbull, Harvey, ›A Sogdian Friction-chordophone‹, in: Music and Tradition: Essays on Asian and Other Musics Presented to Laurence Picken (Cambridge 1981), pp. 197–207.
 Uses iconographic evidence to discuss Central Asian and Chinese lute-type instruments and playing techniques.

Tyler, James, ›The Mandore in the 16th and 17th Centuries‹, in: Early Music 9 (1981), pp. 22–31.

Van der Meer, John Henry, ›Ältere und neuere Literatur zur Musikinstrumentenkunde‹, in: Acta Musicologica 51 (1979), pp. 1–50.

Vorreiter, Leopold, ›The Swan-neck Lyres of Minoan-Mycenean Culture‹, in: The Galpin Society Journal 28 (1975), pp. 93–97.

Weber, Rainer, ›Tournebout-Pifia-Bladderpipe (*Platerspiel*)‹, in: The Galpin Society Journal 30 (1977), pp. 64–69.

Wells, Robin Headlam, ›Number Symbolism in the Renaissance Lute Rose‹, in: Early Music 9 (1981), pp. 32–42.

Willett, Frank, ›A Contribution to the History of Musical Instruments among the Yoruba‹, in: Essays for a Humanist: An Offering to Klaus Wachsmann (New York 1977), pp. 350–389.
 Based on evidence on stone, terracotta, and copper alloy sculptures from Ife.

Williamson, Muriel C., ›A Supplement to the Construction and Decoration of One Burmese Harp‹, in: Selected Reports in Ethnomusicology 2 (1975), pp. 109–115.

–, ›The Iconography of Arched Harps in Burma‹, in: Music and Tradition: Essays on Asian and Other Musics Presented to Laurence Picken (Cambridge 1981), pp. 209–228.

Wilson, Michael I., Organ Cases of Western Europe (London 1979).
 Review by E. A. K. Ridley in: The Galpin Society Journal 34 (1981), pp. 168f.

Witten, Lawrence C., II. ›Apollo, Orpheus and David: A Study of the Crucial Century in the Development of Bowed Strings in North Italy 1480–1580 as Seen in Graphic Evidence and Some Surviving Instruments‹, in: Journal of the American Musical Instrument Society 1 (1975), pp. 5–55.

Woodfield, Ian, ›The Early History of the Viol‹, in: Proceedings of the Royal Musical Association 103 (1976–1977), pp. 141–157.

–, ›Posture in Viol Playing‹, in: Early Music 6 (1978), pp. 36–40.

Wright, Lawrence, ›The Medieval Gittern and Citole: A Case of Mistaken Identity‹, in: The Galpin Society Journal 30 (1977), pp. 8–42.

–, ›Sculptures of Medieval Fiddles at Gargilesse‹, in: The Galpin Society Journal 32 (1979), pp. 66–76.

Ypey, J., ›Mondharpen‹, in: Antiek (Dutch) 11 (1976), pp. 209–231.
 Discusses their representation in Dutch paintings of the 17th century and in a Swedish fresco of the 15th century.

Zuck, Victor I., ›Pipe Organ Pumping‹, in: The American Organist 13/7 (1979), pp. 30–36.
 Uses several art works to demonstrate organ pumping.

Županović, Lovro. See Kobola, Alojz, and Lovro Županović.

Depictions on Instruments

See: Iconography
 Bassani »Corno«; Bassani »Olifanti«; Bauer; Germann; Smulikowska

 Organology
 Hood; Jerrentrup; Mactaggart; Wells; Wilson

Imago Musicae
International Yearbook of Musical Iconography
Directions to Contributors

The International Yearbook of Musical Iconography is issued once a year. Its purpose is the publication of original musicological and art-historical articles on the representation of music in the visual arts. The official languages are English, French, and German; contributions in Italian and Spanish will be considered. Articles concentrating on musical instruments solely as organological objects are not within the main scope of the Yearbook.

The layout allows for main text with footnotes and excursuses (in *petit*) without footnotes. Quotations in languages difficult to understand (e.g. Middle English, Middle High German, Latin, Greek) should be given in the text in their original language and translated in a footnote into the language of the article.

The manuscript should be typed on only one side of the page, double-spaced and with wide margins, and should be mailed in duplicate to the Editor. Footnotes must be numbered consecutively and typed double-spaced on separate pages. Separate sheets with double-spacing are also required for musical examples, tables, and a list of illustrations with references to copyright holders. The position of examples in the main text must be precisely indicated. It is requested that only common abbreviations be used. Full first names must be given for all proper names in the text.

Visual material must also be kept separate from the main text. It is the author's responsibility to obtain permission to reproduce material. Photographs must be numbered consecutively on the back to correspond with the exact references in the text. They should also be identified with the contributor's name and a shortened title of the article.

We urgently request that only photographs of the highest quality, unscreened, printed on high gloss paper, and no smaller than 13 by 18 cms. in size, be sent. Prints from continuous-tone negatives should be used except for reproductions of woodcuts or engravings, for which high-contrast line photographs are preferable.

Bibliographic references should conform to the following examples:

Pieter Fischer, Music in Paintings of the Low Countries in the 16th and 17th Centuries (Amsterdam 1975)

Edmund A. Bowles, Musikleben im 15. Jahrhundert (Leipzig 1977), p. 149 (= Musikgeschichte in Bildern, vol. 3, Faszikel 8)

Friedrich Winkler, ›Gerard David und die Brügger Miniaturmalerei seiner Zeit‹, in: Monatshefte für Kunstwissenschaft 6 (1913), pp. 271–280.

Prior to the preparation of an article for publication, authors will be sent their manuscript one last time for the purpose of clarifying any problems or making any final alterations. Later they will receive page proofs on which only printer's errors may be corrected.

Tilman Seebass
Editor

Imago Musicae
Internationales Jahrbuch für Musikikonographie
Hinweise für den Autor

Das Internationale Jahrbuch für Musikikonographie erscheint einmal jährlich. Sein Ziel ist die Veröffentlichung von musik- und kunstwissenschaftlichen Originalartikeln über die Darstellung der Musik in den bildenden Künsten. Die offiziellen Sprachen sind Deutsch, Englisch und Französisch; Italienisch und Spanisch sind möglich. Aufsätze, die sich ausschließlich mit instrumentenkundlichen Aspekten beschäftigen, liegen nicht innerhalb der Hauptzielsetzung des Jahrbuchs.

Die Aufsätze können aufgegliedert werden in den Haupttext mit Fußnoten und in Exkurse (in kleinerem Druck) ohne Fußnoten. Schwer verständliche Zitate (z. B. mittelenglisch, mittelhochdeutsch, lateinisch, griechisch) werden im Text im originalen Wortlaut gebracht und in einer Fußnote in der jeweiligen Sprache des Aufsatzes wiedergegeben.

Das Manuskript soll einseitig, mit doppeltem Zeilenabstand und breiten Rändern getippt sein und in zweifacher Ausfertigung an den Redakteur geschickt werden. Fußnoten müssen durchnumeriert sein und auf getrennten Blättern mit doppeltem Zeilenabstand geschrieben stehen. Gesonderte Blätter mit doppeltem Zeilenabstand sind auch für Musikbeispiele, Tabellen und eine Liste der Illustrationen mit Hinweisen auf die Copyrightinhaber erforderlich. Die Lokalisierung der Beispiele im Haupttext muß präzise sein. Es wird darum gebeten, nur die gängigen Abkürzungen zu verwenden. Alle im Text vorkommenden Namen müssen mit vollem Vornamen genannt werden.

Auch das Illustrationsmaterial ist getrennt vom Haupttext zu halten. Das Einholen der Abdrucksrechte ist Sache des Autors. Die Photos sollen auf der Rückseite eine durchgehende Numerierung aufweisen mit den entsprechenden genauen Verweisen im Text. Außerdem sollten sie mit dem Namen des Autors und dem Kurztitel des Aufsatzes versehen sein.

Wir bitten Sie dringend, nur erstklassige Photos zu schicken, unrastriert, auf Hochglanzpapier abgezogen und im Format 13 × 18 cm oder größer. Außer bei Reproduktionen von Holzschnitten und Kupferstichen, wo sich Photos mit hartem Kontrast besser eignen, sind Abzüge von Halbtonnegativen zu verwenden.

Bibliographische Angaben sollten folgendermaßen vorgenommen werden:

Pieter Fischer, Music in Paintings of the Low Countries in the 16th and 17th Centuries (Amsterdam 1975)

Edmund A. Bowles, Musikleben im 15. Jahrhundert (Leipzig 1977), p. 149 (= Musikgeschichte in Bildern, vol. 3, Faszikel 8)

Friedrich Winkler, ›Gerard David und die Brügger Miniaturmalerei seiner Zeit‹, in: Monatshefte für Kunstwissenschaft 6 (1913), pp. 271–280.

Die Autoren bekommen vor Beginn der Herstellung die Manuskripte noch einmal zugeschickt zur Klärung eventueller Fragen und erhalten damit eine letzte Möglichkeit, inhaltliche Änderungen vorzunehmen. Danach erhalten sie eine Umbruchkorrektur, bei der nur noch Satzfehler korrigiert werden können.

<div style="text-align: right">

Tilman Seebaß
Redakteur

</div>

Imago Musicae
Annuaire international d'iconographie musicale

Renseignements pour les auteurs

L'annuaire international d'iconographie musicale paraît une fois par an. Il a pour but de publier des articles originaux de caractère musicologique ou d'histoire de l'art concernant la représentation de la musique dans les beaux-arts. Les langues officielles sont l'allemand, l'anglais et le français; l'italien et l'espagnol sont admis. Les articles se rapportant uniquement aux aspects organologiques ne font pas partie des buts principaux de l'annuaire.

Les articles peuvent être composés d'un texte principal avec notes explicatives ou de digressions (imprimées en caractères plus petits) sans notes explicatives. Les citations difficilement compréhensibles (p. ex. en ancien anglais, en moyen haut allemand, en latin ou en grec) devront êtres faites dans la langue originale dans le corps du texte, et traduits dans la langue de l'article dans une note explicative.

Le manuscrit devra être tapé à la machine d'un seul côté de la feuille, avec un interligne double et des marges larges, et envoyé en double exemplaire au rédacteur. Les notes explicatives devront porter une numérotation ininterrompue et être tapées sur des feuilles séparées, avec interligne double. Il en est de même pour les exemples musicaux, les tableaux, et une liste des illustrations avec des renseignements concernant les propriétaires de copyright. La localisation des exemples dans le texte principal doit être faite avec précision. Il est instamment recommandé de n'employer que les abréviations courantes. Tous les noms de personnes cités dans le texte doivent comporter le prénom en entier.

Le matériel d'illustration devra également être séparé du texte principal. Il appartient aux auteurs d'obtenir les droits de reproduction. Les photos devront porter au dos une numérotation consécutive et un renvoi exact au texte principal. Elles devront en outre toutes porter le nom de l'auteur et le titre abrégé de l'article.

Nous prions instamment les auteurs de n'envoyer que des photos de toute première qualité, sans trame, sur papier brillant, de format minimum 13 × 18 cm. En dehors des reproductions de gravures sur bois ou sur cuivre, pour lesquelles il est préférable d'avoir des photos bien contrastées, il est recommandé d'utiliser des épreuves en dégradé.

Les indications bibliographiques devront être citées sous la forme suivante:

Pieter Fischer, Music in Paintings of the Low Countries in the 16th and 17th Centuries (Amsterdam 1975)

Edmund A. Bowles, Musikleben im 15. Jahrhundert (Leipzig 1977), p. 149 (= Musikgeschichte in Bildern, vol. 3, Faszikel 8)

Friedrich Winkler, ›Gerard David und die Brügger Miniaturmalerei seiner Zeit‹, in: Monatshefte für Kunstwissenschaft 6 (1913), pp. 271–280.

Nous renverrons aux auteurs leurs manuscrits avant le début de la mise en composition, afin d'éclaircir des questions éventuelles, et pour leur permettre une dernière mise au point du contenu. Il ne recevront ensuite plus qu'une épreuve de mise en page, sur laquelle ils ne pourront corriger que des erreurs typographiques.

Tilman Seebass
Rédacteur